WORD AND SUPPLEMENT

Word and Supplement

Speech Acts, Biblical Texts, and the Sufficiency of Scripture

TIMOTHY WARD

OXFORD
UNIVERSITY PRESS

OXFORD
UNIVERSITY PRESS

Great Clarendon Street, Oxford OX2 6DP

Oxford University Press is a department of the University of Oxford.
It furthers the University's objective of excellence in research, scholarship,
and education by publishing worldwide in

Oxford New York

Auckland Bangkok Buenos Aires Cape Town Chennai
Dar es Salaam Delhi Hong Kong Istanbul Karachi Kolkata
Kuala Lumpur Madrid Melbourne Mexico City Mumbai Nairobi
São Paulo Shanghai Singapore Taipei Tokyo Toronto
and an associated company in Berlin

Oxford is a registered trade mark of Oxford University Press
in the UK and in certain other countries

Published in the United States
by Oxford University Press Inc., New York

British Library Cataloguing in Publication Data
Data available

Library of Congress Cataloging in Publication Data
Ward, Timothy, 1967–
Word and supplement: speech acts, biblical texts, and
the sufficiency of Scripture/Timothy Ward.
p. cm.
Includes bibliographical references.
1. Bible—Evidences, authority etc. 2. Bible—Hermeneutics.
3. Word of God (Theology). 4. Speech acts (Linguistics)—
Religious aspects—Christianity. I. Title
BS480.W285 2002 220.1–dc21 2002020005
ISBN 0–19–924438–3

1 3 5 7 9 10 8 6 4 2

Typeset in Imprint
by Regent Typesetting, London
Printed in Great Britain
on acid-free paper by
Biddles Ltd.,
Guildford & King's Lynn

To Erica

If the texts that interest us *mean* something, it is the engagement and the appurtenance that encompass existence and writing in the same *tissue*, the same *text*. The same here is called supplement.

<div align="right">Jacques Derrida, Of Grammatology</div>

The fulfilment and the end of the Law, and of all Holy Scripture, is the love of an object which is to be enjoyed, and the love of an object which can enjoy that other in fellowship with ourselves . . . The whole temporal dispensation for our salvation, therefore, was framed by the providence of God that we might know this truth and be able to act upon it; and we ought to use that dispensation, not with such love and delight as if it were a good to rest in, but with a transient feeling rather, such as we have towards the road, or carriages, or other things that are merely means. Perhaps some other comparison can be found that will more suitably express the idea that we are to love the things by which we are borne only for the sake of that towards which we are borne.

<div align="right">Augustine, On Christian Doctrine</div>

Later on, the word fills with meaning.
It remained gravid and it filled up with lives.
Everything had to do with births and sounds—
affirmation, clarity, strength,
negation, destruction, death—
the verb took over all the power
and blended existence with essence
in the electricity of its beauty.

<div align="right">Pablo Neruda, 'The Word'</div>

ACKNOWLEDGEMENTS

The wealth of relationships and kindnesses which 'supplement' a life, and specifically those through which a person is enabled to bring a doctoral thesis to completion and a book to publication, accumulate a considerable debt of gratitude; that is certainly so in my case. Generous grants from the Kingham Hill Trust, the London Bible House Research Fund of the Bible Society, and the Ordination Candidates' Training Fund, allowed the project to get off the ground and come to completion. Particular thanks in this regard are also due especially to my parents, as well as to the congregation of Christ Church, Fulwood, Sheffield, and to Tim and Lucy Greenslade, Tim and Beth Hanson, Tim and Janice Houghton, Martin Mills, Elsie Rowland, Mike Smith, and John and Ursula Stevens.

I am grateful to my earlier teachers at Oak Hill Theological College, and especially to Professor Kevin Vanhoozer for his astute doctoral supervision, his commitment to the project, and not least his personal kindness.

The church families at St Thomas's Episcopal Church, Edinburgh, and All Saints Church, Crowborough, have provided communities in whose life under the Word it has been a privilege to share during the time of research and writing.

The greatest debt of gratitude, however, has accumulated very quickly, and over a shorter period of time. My wife, Erica, encountered this work and its author at late stages of development. Her life 'supplements' him and these words in ways that by these words he cannot fully express.

CONTENTS

I
Introduction

Christian faith cannot but be a biblical faith. The Christian church is the body of Christ, and it lives and moves and has its being only as it is indwelt by the life-giving Spirit of Christ. The church's only definitive source of knowledge of Jesus Christ is the Bible. Only through the Bible is the church given a knowledge of Jesus Christ which speaks to it from outside itself about the one who indwells it. If the church were not so addressed from outside itself, it would be unable to distinguish the indwelling Spirit from its own desires. The Bible continually calls the church back to its head, and the individual believer back to his or her Lord. In the testimony that it gives to the earthly life, death, resurrection, and ascension of Jesus Christ, the Bible provides the supreme means by which the church may celebrate and discern the power of God, the Spirit of Christ, at work in it and upon it. Only by an act of self-forgetfulness can Christians imagine that the Bible ought not play this role in Christian action and thought. The Bible has always been a central focus of Christian life, theology, and doctrine.

Questions about the Bible reached a particularly high level of prominence through the period of the Reformation and beyond. The Protestant Reformation represented a protest against a particular form of the exercise of ecclesial authority, and the counter-assertion of the supreme authority of the Bible over the authority of the church. The most well-known slogan from the sixteenth century, *sola Scriptura*, is intended to assert Scripture's unique role as *supreme* authority over other authorities. At the heart of the fundamental split in Western Christianity lie therefore questions about the appropriate function of the Bible. It is thus no surprise that, in the two centuries after the Reformation, debates between the heirs of the Reformation, radical Reformers, and Roman Catholic opponents on questions

of authority produced highly detailed writing on Scripture. In the writings of Protestant theologians of this period, the character and function of the Bible came to be described with increasingly great precision. Although there are of course differences in detail between, say, Lutheran and Reformed writers, there emerged what might be called the classical doctrine of Scripture. The Bible was identified directly with the Word of God. It was asserted to be the supreme source of faith and practice, which needs no authoritative interpreter external to itself. That is, the Word needs no material supplementation from another supposed authoritative source of faith and practice, and no interpretative supplementation by the teaching office of the church or the supposed individual testimony of the Holy Spirit. This core view of the Bible was expressed in the fundamental principle of *sola Scriptura*, in the assertion of the Bible as inspired by God in its writing, and in the delineation of various attributes of the Bible—predominantly necessity, perfection, clarity, and sufficiency.

The writings of orthodox Protestant theologians of this post-Reformation period are not held in high esteem by many contemporary Christian theologians. In particular, their doctrine of Scripture is widely rejected as too scholastic, and as relating the Bible insufficiently to Christology. In focusing so much on the details of the doctrine of Scripture, it is argued, they dangerously unbalance their theology. When the Bible is made so central, a focus of doctrinal and theological interest in its own right and not clearly related to the risen Christ, then, it is argued, theology itself becomes lifeless, and, even worse, the Bible comes to threaten the uniqueness of Christ as the only true focus of Christian devotion. Yet, despite this scholarly assessment of post-Reformation Protestant theology, it remains the case that the basic elements of the classical doctrine of Scripture are believed and acted upon by countless communities of believers in the world-wide church. The Bible is widely held to be the Word of God, necessary, perfect, clear, and sufficient in the most significant matters of faith and practice. Contemporary Christian writing on the classical doctrine of Scripture therefore may be said to fall broadly into two kinds. Much academic writing dismisses the classical doctrine, often quite rapidly; detailed scholarly treatments of the classical attri-

butes of Scripture are thin on the ground. Much popular conservative Christian literature, by contrast, defends the classical doctrine, often polemically, and often by means of a repetition of what was argued four centuries ago.

Writing specifically of the doctrine of the sufficiency of Scripture, G. C. Berkouwer shows awareness of the irony of this two-fold response to the classical doctrine of Scripture: 'It is not easy . . . to confess the sufficiency of Scripture: it is not a self-evident, handy chapter in systematic theology, but it is the dominating tone for the entire chorus of the church.'[1] Given this situation, it seems that the classical doctrine of Scripture requires more sustained and properly theological thought than its proponents have often devoted to it, because its theological appropriateness is neither self-evident nor easily expressed. It also deserves more considered contemporary theological reflection than it has received from its recent detractors, because it gives expression to a view of Scripture which has been and continues to be dominant in the life and thought of large sections of the church. Each of these two points needs to be considered in more detail.

The classical doctrine of Scripture can be, and has been, confessed cheaply. It is a confession which, where it is made, must be argued for carefully. It must be shown in its necessary relation to the fundamental trinitarian, christological, and pneumatological themes of Christian theology. These are of course the main themes of the Bible; thus any doctrine of Scripture must set what it says about the Bible itself in the theological context of the Bible's own content. Those who reject the classical doctrine of Scripture, if they are wrong to do so, are not self-evidently wrong, for it is not self-evident that they thereby either misrepresent the Bible or distort the rest of Christian theology.

It will soon become clear that this book is intended as a critical retrieval of the classical doctrine of Scripture in general, and the sufficiency of Scripture in particular. (The significance of the choice of the *sufficiency* of Scripture as the primary focus for this reconstruction will be explained shortly.) It is a *critical* retrieval in that the doctrine will be reconstructed in a wide

[1] G. C. Berkouwer, *Holy Scripture*, trans. and ed. Jack B. Rogers, Studies in Dogmatics (Grand Rapids: Eerdmans, 1975), 305.

contemporary theological and academic context. The book will keep up a sustained dialogue with contemporary hermeneutical and literary theory, and a specific tool for the reconstruction of the doctrine will be identified from recent work in the philosophy of language. Thus, materials for the reconstruction have been sought in areas which were simply not available to previous proponents of the doctrine, with the result that the doctrine will be articulated in a way which is clearly coloured by contemporary theological and wider academic concerns. Nevertheless, the reconstructed doctrine of the sufficiency of Scripture which unfolds in what follows is intended also to be in faithful continuity with the classical doctrine of Scripture. Although of course the present work will develop the doctrine of the sufficiency of Scripture in conceptual ways which go beyond anything found explicitly in the writings of, say, Francis Turretin, it is not intended to affirm anything here which that Genevan theologian would have found especially objectionable—difficult, of course, as such anachronistic judgements are to make.

An initial outline of the reasons for turning to such contemporary theory in order to reconstruct an old doctrine of Scripture can be briefly given. Characteristic of the intellectual and cultural life of the last century has been a focusing of interests on language. Evidence for this can be found in the so-called 'linguistic turn' of philosophy, and in the increasing notice taken by other disciplines of academic studies of literature. Both biblical studies and Christian theology have been affected by these developments in many complex ways. Significant branches of biblical scholarship have become interested in the Bible as a linguistic and literary entity, as the expanding number of different literary interpretative approaches which are now at the disposal of the biblical scholar bears witness. This growth of philosophical and biblical interest in language and literature might be thought at least to open the possibility for a renewed conception of what the Bible is and of how it functions, and therefore of a renewed confession of the doctrine of Scripture. In fact, though, among theologians who have been influenced by the focusing of interests in language and literature, new linguistic and literary conceptualities are often taken to confirm and deepen, rather than to challenge, the disrepute into which doctrines of Scripture have fallen. In contemporary

theology, John Webster notes, Christian doctrine 'has receded into the background in describing the church's reading of the Bible'; he locates the cause in 'the steady expansion of general hermeneutics' and its rise 'to become a fundamental, transcendental anthropology'.[2] This state of affairs is not necessary, however; there is no reason why new hermeneutical tools developed from the study of language in general and literature in particular cannot be put to constructive theological and doctrinal work. As general hermeneutics informs theology and doctrine, it can also serve them; it need not overwhelm them.

It will therefore be suggested throughout this book to orthodox Protestant communities that their tradition is poorly served by the mere repetition of old polemical positions, and by ignoring conceptual resources which new thought exercised across a breadth of disciplines brings to light. Theology has often found it to be the case that new thought in one area (especially an area not traditionally considered to be 'theological') can shed light on old theological questions, and that doctrines and concepts once thought untenable can be rehabilitated when seen with fresh eyes. Only the Bible is a closed canon; the fundamental Protestant principle is that every other theological and doctrinal statement must remain open to reform and reformulation. In the current widely diversifying and splintering theological scene, orthodox theologies rightly fear too great an emphasis on creativity. However, to refuse to redo old doctrinal formulations in imaginative and creative ways in new cultural and apologetic contexts is equally destructive. Indeed, it is effectively to deny the *sola Scriptura* principle, treating certain historical doctrinal formulations with a reverence sometimes barely distinguishable from that accorded to Scripture.

In any assessment of such 'conservative' doctrines of Scripture, the empirical features of some of the churches and communities which defend 'the sufficiency of Scripture' most vociferously cannot be overlooked. There is no doubt such a thing as 'bibliolatry', where the assertion of the authority of the

[2] John Webster, 'Hermeneutics in Modern Theology: Some Doctrinal Reflections', *Scottish Journal of Theology* 51 (1998), 307–41, at 311–12. This is evident in theologians influenced by literary categories: e.g. Hans Frei's narrative theology (which will be discussed in ch. 4), while focused on the Bible, is not interested in doctrines of Scripture.

Bible ceases to serve the exercise of faith in Christ, and instead threatens to take, or actually takes, a kind of idolatrous precedence over him. In some conservative Christian groups, for example, short, isolated citations from Scripture undergo forced genre-transformation, hammered into the shape of slogans of social and political ideology. In others, the sufficiency of the (whole) Scripture is proclaimed but not practised. This especially happens when individuals or groups short-circuit the polyphonic play of biblical voices, uncritically privileging certain of the Bible's theological themes and behavioural norms as 'true biblical religion', remaining deaf to the other voices and blind to the other counterbalancing viewpoints which the Bible offers. These features of some, although of course not all, 'conservative' Christian groups provide for many perhaps greater reason to be suspicious of the classical doctrine of Scripture than any theological or philosophical qualm. Any Christian confession that is articulated and defended but not faithfully lived out is at best a cheap confession. The formulation of the sufficiency of Scripture to be offered here is therefore intended both to be carefully thought out and defended, and to be lived out in the practices of Christian life and theology.

Just as the classical doctrine of Scripture can be, and is, confessed cheaply, on the other hand it can be, and is, denied hastily. Too little acknowledgement can be paid to the fact that it is a confession which, in various forms, has been widely made and cherished throughout the history of the Christian church—for most of that period by the majority of Christians—as vital to what Christians want to tell themselves and others about the Christian faith. The post-Reformation period certainly saw innovative and exaggerated claims made for the Bible (the claim for the divine inspiration of Hebrew vowel-pointing in the Old Testament is a notorious example), but, it will be argued here, the classical doctrine of Scripture as a whole developed, but did not depart from, the first fifteen hundred years of orthodox Christian theology. This book, as well as addressing proponents of the classical doctrine of Scripture, thus has a second audience in view. Many contemporary theologians wish to retain broadly orthodox Christian conceptions of God, Christology, pneumatology, and soteriology, but at various points object to the classical doctrine of Scripture. This position can

seem to have much in its favour. In many situations in the
Christian church it is felt that politicized debates about the
Bible have obscured the proclamation by the church of Jesus
Christ to the world, and have taken Christians' attention away
from their primary calling to be followers of Christ. The
sufficiency and divine inspiration of Scripture are two particu-
lar doctrines which can seem to encroach in practice on the
supremacy and uniqueness of the person and work of Christ.
Wrangling over how we come to know Christ becomes more
important than working and praying through how Christians
should now follow him. This is an ancient Christian concern:
Augustine warns that 'we are to love the things by which we are
borne only for the sake of that towards which we are borne'.[3] In
this light, the rejection of the classical doctrine of Scripture is
a tempting route by which the theologian can clear the decks,
and create the space to talk again about that which a Christian
should love most.

It will, however, be suggested that this tempting move places
Christian theology in danger of sawing off the branch on which
it wishes to sit. The classical doctrine of Scripture aims to serve
the fundamental elements of Christian theology, not to obscure
or overshadow them. It is common for modern theology to
trade on key elements of orthodox Christian theology (the
Trinity, the Holy Spirit, and creation are notable examples)
while rejecting the classical doctrine of Scripture, and to do so
without offering a new coherent account of its own theological
and epistemological bases. Without the Bible serving as the
kind of theological authority which the classical doctrine asserts
it to be, it is not always clear how we may come to know and
trust, for example, that God is love, both within his own trini-
tarian life and towards us, or that the Holy Spirit consistently
acts to bring liberation. The classical doctrine of Scripture was
intended to explicate the basis on which these central Christian
beliefs might be held to be true. Terms of criticism such as
'biblicist' and 'fundamentalist' are sometimes applied too easily
to 'conservative' theologies, with insufficient appreciation of
what a majority of orthodox theologians, from the seventeenth
century through even to Warfield, in fact said about the Bible,

[3] Augustine, *On Christian Doctrine*, Nicene and Post-Nicene Fathers 2, ed.
Philip Schaff (Grand Rapids: Eerdmans, 1956), 1. 35. 39.

and especially of the theological purpose to which their doctrinal formulations on Scripture were directed. This is to suggest that the sufficiency of Scripture is a confession more appropriate to the particular content of Christian theology than the view of Scripture expressed or implied by many contemporary alternative approaches. On the basis of the reconstruction of the sufficiency of Scripture to be offered here, both faithful to the classical Protestant formulation of that doctrine and a creative re-articulation of it, it will be argued that the classical doctrine of Scripture can in fact escape many of the criticisms most often directed against it. Overall, then, in its address to each of these two audiences—the general 'conservative' Christian audience and the contemporary critics of the classical doctrine of Scripture—this study represents a theological reflection, informed by speech act theory and some contemporary hermeneutical issues, on the doctrine of the sufficiency of Scripture, and a doctrinal reflection, informed by the classical Protestant doctrine of Scripture, on Christian theology.

The significance of the focus on the particular claimed attribute of the *sufficiency* of Scripture now needs some explanation. Three reasons may be given to justify this focus—one historical, one theological, and one methodological. First, as Berkouwer says, and as will be argued in Chapter 2, the confession of Scripture as sufficient has been largely central rather than peripheral to the church's confession of faith, both before and after the Reformation. Second, and theologically, at the time of the Reformation, and even in the post-Reformation period of Protestant orthodoxy, the sufficiency of Scripture was not one small item in a scholastic list of discrete scriptural attributes. Instead, it represented one particular way of expressing the general Protestant principle of *sola Scriptura*. Nor was the point entirely innovative in the sixteenth century, since it has clear roots, as will be noted in Chapter 2, in patristic and medieval views on Scripture. There is a great deal of overlap in substance between the different claimed attributes of Scripture; the terms are used with some interchangeability, often as different ways to express the same basic point about the Bible. The attributes of Scripture identified by post-Reformation orthodox theologians are not so much a list of items to be enumerated as a set of standpoints from which their central

theological point about the Bible may be variously expressed. In other words, the form of post-Reformation orthodox theology is often more scholastic than the content. (This claim will be discussed more fully in Chapter 2.) To focus on sufficiency, therefore, is necessarily to discuss the doctrine of Scripture as a whole. And, as Gerhard Ebeling has argued, the principle of *sola Scriptura* itself is in need of reformulation.[4]

The third reason for the choice of sufficiency as a particular focus is methodological. As a concept applied to the ontology and function of a text, 'sufficiency' is a good analytical tool for setting the classical doctrine of Scripture in dialogue with contemporary hermeneutics and literary theory. The interrelation of these two disciplines is not common—Francis Turretin and Jacques Derrida are not often discussed together!—and so requires some explanation. The current relative lack of interest shown by theologians in the doctrine of Scripture was noted above. However, this situation does not mean that the issues which earlier formulations of the doctrine were intended to address—such as the mode of God's continuing presence in the church and the world, the hierarchical relationship between different claimed sources of human knowledge of God, and the frameworks through which revelation is to be interpreted— have ceased to be of central importance for the enterprise of theology. It is clear that these issues are at heart hermeneutical as well as doctrinal. Thus any doctrine of Scripture implies a variety of hermeneutical positions, and much of this book will be taken up exploring those implied by the classical doctrine, especially as it was given expression in the doctrine of the sufficiency of Scripture. The dialogue between traditional orthodox theology and contemporary theory is also legitimate from the side of these contemporary disciplines, because they are taking up issues which have traditionally been considered to be the province of theology.[5] Such contemporary theorists as

[4] This is Ebeling's response to contemporary Protestants who argue that *sola Scriptura* is an obsolete principle (Gerhard Ebeling, '"Sola Scriptura" and Tradition', in Ebeling, *The Word of God and Tradition: Historical Studies Interpreting the Divisions of Christianity*, trans. S. H. Hooke (London: Collins, 1968), 102–47, at 102).

[5] This is argued throughout by Kevin J. Vanhoozer, *Is There a Meaning in This Text? The Bible, the Reader and the Morality of Literary Knowledge* (Leicester: Apollos, 1998).

Roland Barthes and Jacques Derrida explicitly acknowledge this. The reconstruction of the sufficiency of Scripture will emerge through this dialogue, as Christian doctrine engages with, is informed by, and critiques contemporary positions in hermeneutics and the philosophy of language. A third potential audience for this work emerges here, in addition to the orthodox Christian communities and the contemporary theological communities already noted. It will be argued that some contemporary hermeneutical and literary questions may be helpfully illuminated by the theological idea of a text as in some sense 'sufficient'.

In particular, in subsequent chapters a variety of contemporary views of texts, and related contemporary theological views of Scripture, will be characterized in terms of the *supplements* which they provide, or deny, as necessary for texts to give rise to meaning. Are texts to be supplemented by authors, readers, or something else? Or are they somehow sufficient in themselves? If so, what are they sufficient for? As regards the Bible itself—what kind of supplementary activity of the Holy Spirit or of magisterial ecclesial authority is in view, and what is ruled out, when Scripture is declared to be sufficient? How are we to conceive of a biblical text being 'supplemented' by contexts—both the textual and canonical contexts of Scripture, and the historical, cultural, and religious contexts in which it is read? The significance of these questions explains the apparent paradox of the book's overall title, which sets a discussion of the sufficiency of Scripture under the assumption of the 'supplementation' of the Word. It is intended to clarify in theological and hermeneutical terms the senses in which 'the sufficiency of Scripture' is necessarily a circumscribed concept. It is circumscribed theologically, since as a doctrine it functions in relationship to, and in the service of, other doctrinal confessions; it is circumscribed hermeneutically, as the concept of 'the text itself' is set in specific relation to the extra-textual realities of author, reader, and context. That is, it will become clear that the 'sufficiency of Scripture' is not a 'self-sufficiency of Scripture'.

The notion of the 'supplementation' of texts is drawn most directly from Jacques Derrida, who has exploited it in the service of the deconstruction of both texts and persons. In a chap-

ter entitled '. . . That Dangerous Supplement . . .', in his early work *Of Grammatology*, he picks up the term 'supplement' as it is used in the writings of Rousseau.[6] Derrida notes that Rousseau, in his public and private texts, reflects on how, in his personal experience and in his emotional life, certain 'supplementations' occurred. One thing came to supplement another: his writings and his physical presence; education and Nature; a woman he names 'Mamma' and his actual mother; masturbation and sexual intercourse. In the case of each of these pairs, Rousseau is thinking about how the first item supplements the second. Derrida argues that in these supplementations it is not the case either that one thing is simply added to another, or that one thing simply replaces another. Instead, in Rousseau's writing 'supplement' becomes a double-edged term, signifying simultaneously both the addition of one thing to another, and the replacement of one thing by another, revealing a lack in that thing. He observes: 'The supplement adds itself, it is a surplus, a plenitude enriching another plenitude, the *fullest measure* of presence. . . . But supplement supplements. It adds only to replace. It intervenes or insinuates itself *in-the-place-of*; if it fills, it is as if one fills a void.' Thus, although 'presence, always natural . . . ought to be self-sufficient', in Rousseau's texts it turns out to be far from self-sufficient.[7]

For Derrida, what is the case in Rousseau's inner life is true of the whole of reality. Derrida interprets the dynamic of supplementarity which he identifies in Rousseau's autobiographical texts as a living example of the overall deconstructive notion of *différance*, the endless deferral of metaphysical presence. That is, Derrida quickly draws general philosophical conclusions from Rousseau's reflections on his own emotional experiences. Thus, building on Rousseau's observations on his own auto-erotic sexual drives, Derrida argues that '[t]he enjoyment of the thing itself is thus undermined, in its act and in its essence, by frustration. One cannot therefore say that it has an essence or an act (*eidos*, *ousia*, *energeia*, etc.) . . . Such is the constraint of the supplement, . . . exceeding all the language of metaphysics.'[8] Derrida does the same with Rousseau's thoughts

[6] Jacques Derrida, *Of Grammatology*, trans. Gayatri Chakravorty Spivak (Baltimore and London: Johns Hopkins University Press, 1976), 141–64.

[7] Ibid., 144–5. [8] Ibid., 154.

on speech and writing. Rousseau found that he was more able to be himself towards others in his writings than when physically present with them: 'Paradoxically, he will hide himself to show himself better, and he will confide in written speech: "I would love society like others, if I were not sure of showing myself not only at a disadvantage, but as completely different from what I am."'⁹ Derrida regards this ironic mutual supplementation of presence and absence in Rousseau's texts as the formulation of 'a theory of language . . . a law of language . . . [which] operates as a power of death in the heart of living speech'. This death-dealing 'law of language' is implicated also in the deconstruction of human identity, for it is '[t]he speculary dispossession which at the same time institutes and deconstitutes me'.¹⁰ Again, Rousseau's reflections on his personal experiences are taken to be revelatory of general philosophical principles. (More prosaically, Barbara Johnson ascribes Rousseau's preference for presenting himself in writing rather than in personal speech to his shyness, which led him 'to blurt out things that represent him as the opposite of what he thinks he is'.¹¹) Derrida summarizes the necessary effects which this deconstructive dynamic of supplementarity has on his reading of Rousseau's texts thus: 'It is so little a matter of looking for the truth *signified* by these writings (metaphysical or psychological truth: Jean-Jacque's [*sic*] life behind his work) that if the texts that interest us *mean* something, it is the engagement and the appurtenance that encompass existence and writing in the same *tissue*, the same *text*. The same here is called supplement, another name for différance.'¹² Derrida supplements Rousseau's text with the web of 'textuality', a field of

⁹ Starobinski, quoting Rousseau, quoted in Derrida, *Of Grammatology*, 142.

¹⁰ Ibid., 141–2.

¹¹ Barbara Johnson, in 'Translator's Introduction' to Jacques Derrida, *Dissemination*, trans. Barbara Johnson (London: Athlone Press, 1981), p. xi. Derrida fails to demonstrate that Rousseau's inability to be truly himself in company is more paradigmatic of 'a law of language' than is the experience of those 'others' who do 'love society', i.e. who *are* able to represent what they take to be their true selves in social intercourse. Rousseau's autobiographical accounts, like the tale of Cyrano de Bergerac, are probably more illustrative of the dynamics of being deemed 'abnormal' according to certain social and societal norms and practices than they are of anything generally philosophical.

¹² Derrida, *Of Grammatology*, 150.

impersonal signifiers projected onto the world. In this world, meaning and personal identity are finally undecidable, because they are endlessly deferred. This supplement of 'textuality' is sufficiently all-encompassing and voracious to swallow up the reality of both text and author.

In the present work, as in Derrida's reading of Rousseau, existence and writing will be woven into the same 'tissue' and 'text'. The nature and meaning of texts cannot be discussed in isolation from questions about the nature and identity of authors and readers, and questions about what kind of an act it is to author and to read a text. However, when Derrida weaves 'text' and 'existence' into the same 'tissue' or 'text', the identity of text and author are unravelled, for he supplements persons and language with the universal, cold 'text' of *langue*. (In one place he speaks of deconstruction as the 'weaving or unraveling' of textual 'designs'.[13]) It will be argued here that language should indeed be regarded as already woven into human (and ultimately divine) 'tissue', but that this wovenness speaks against any unravelling of text and author. A particular concept of the act of authorship, and the ethical implications this has for the act of reading, will be central to the final understanding of the sufficiency of texts in general and of the Bible in particular. We will therefore have our own dynamic of supplementation— one which, in a direction opposite to Derrida's, necessarily supplements language with human action.[14]

In contemporary theory, there is one outstanding attempt to make personal action central to a description of language— namely, the collection of work within the philosophy of language known as *speech act theory*. The main observation that speech act theorists make is a simple one: to speak, they claim, is not merely to refer to the world or to state propositions; it is also, and more fundamentally, to perform actions. When people use language, they do so in order to make promises, to warn, to congratulate, to make assertions, and so on. Language is not a vehicle by which one mind transfers information to another mind; it is a means by which one human person acts in relation to other people. Recently, a small number of theologians have

[13] Derrida, *Dissemination*, 84.
[14] Some of Derrida's more recent work has dealt quite explicitly with the themes of religion and ethics. This will be discussed in ch. 4.

adopted the basic concepts of speech act theory for theological purposes, finding in them the resources to develop a renewed conception of Scripture which remains largely in line with orthodox Protestant doctrines of Scripture. Anthony Thiselton began putting speech act theory to work theologically in two early articles. He argued that, although language can and does convey propositions, that only serves language's fundamentally performative function. On this basis he rejected two opposing views which biblical scholars have expressed on the function of the language of the Bible: that biblical language is performative but conveys no semantic content,[15] and that the primary function of all language is to refer.[16] Thiselton has gone on in his subsequent work to apply this insight to the Bible as a whole, in the context of a sophisticated analysis of contemporary hermeneutics. He especially stresses the 'self-involving' character of biblical language: to read the Bible cannot be simply to learn things; it is to be involved in a relationship with the authors and with their subject-matter.[17]

The theologian Kevin Vanhoozer has focused specifically on the different analytical concepts provided by speech act theory. He has used these concepts (which will be discussed in detail in Chapter 3) to describe how the various biblical literary

[15] A. C. Thiselton, 'The Parables as Language-Event: Some Comments on Fuchs's Hermeneutics in the Light of Linguistic Philosophy', *Scottish Journal of Theology* 23 (1970), 437–68. Thiselton suggests in this article that light be shed on different forms of biblical literature through the adoption of the resources of 'linguistic philosophy'. This has been taken up by Dietmar Neufeld, *Reconceiving Texts as Speech Acts: An Analysis of 1 John* (Leiden: Brill, 1994); Andreas Wagner, *Sprechakte und Sprechaktanalyse im Alten Testament: Untersuchungen im biblischen Hebräisch an der Nahtstelle zwischen Handlungsebene und Grammatik* (Berlin: Walter de Gruyter, 1997). An issue of the journal *Semeia* was devoted to speech act theory and biblical studies (41 (1988)), but it proved to be rather disappointing (see Anthony C. Thiselton, review article: 'Speech Act Theory and the Claim that God Speaks: Nicholas Wolterstorff's *Divine Discourse*', *Scottish Journal of Theology* 50 (1997), 97–110, at 97 n.3).

[16] Anthony C. Thiselton, 'The Supposed Power of Words in the Biblical Writings', *Journal of Theological Studies* 25 (1974), 283–99.

[17] Anthony C. Thiselton, *New Horizons in Hermeneutics* (London: HarperCollins, 1992), esp. 274–300; 'Authority and Hermeneutics: Some Proposals for a More Creative Agenda', in Philip E. Satterthwaite and David F. Wright (eds.), *A Pathway into the Holy Scripture* (Grand Rapids: Eerdmans, 1994), 107–41.

genres, conceived of as different kinds of speech act, function in relation to truth and authority.[18] He has outlined a doctrinal description of Scripture as God's 'speech act',[19] and most recently and fully has developed a trinitarian hermeneutic, in dialogue with contemporary theology, hermeneutics, and literary theory.[20] Third, the philosopher Nicholas Wolterstorff has appropriated speech act theory quite inventively and insightfully in his philosophical defence of the claim that 'God speaks', and that he speaks in and through the Bible. In particular, he has demonstrated that speech act theory has important ethical implications.[21] The work of these three, particularly Vanhoozer and Wolterstorff, will be significant as the arguments of this book unfold. John Webster has recently commended the appropriation of speech act theory for theologians, and has also warned that in this borrowing from another discipline theology should not cease to be properly theological: 'theology has much to learn from recent work on the nature of texts, especially from those which look at texts as fields of action. . . . But theological appeal to these theories ought only to be *ad hoc* and pragmatic, a matter of finding a tool to do a job.'[22] It is not intended here that special hermeneutics should be subsumed into general hermeneutics, nor, on the other hand, that doctrines of the Bible should remain untouched by general hermeneutical questions. The basic concepts of speech act theory will be appealed to as useful tools for the task of theological and doctrinal formulation.

The constructive task of this work therefore begins, in Chapter 3, with a detailed outline of speech act theory, setting forth those elements of the general theory which will be continually appropriated for theological purposes through the rest

[18] Kevin J. Vanhoozer, 'The Semantics of Biblical Literature: Truth and Scripture's Diverse Forms', in D. A. Carson and John D. Woodbridge (eds.), *Hermeneutics, Authority and Canon* (Leicester: Inter-Varsity Press, 1986), 53–104.

[19] Kevin Vanhoozer, 'God's Mighty Speech Acts: The Doctrine of Scripture Today', in Philip E. Satterthwaite and David F. Wright (eds.), *A Pathway into the Holy Scripture* (Grand Rapids: Eerdmans, 1994), 143–81.

[20] Vanhoozer, *Is There a Meaning?*.

[21] Nicholas Wolterstorff, *Divine Discourse: Philosophical Reflections on the Claim that God Speaks* (Cambridge: Cambridge University Press, 1995).

[22] Webster, 'Hermeneutics in Modern Theology', 329.

of the work. In the second half of the chapter a speech-act conception of what it is to speak will fund an analysis of Karl Barth's notion of God as a divine speaker. Barth influentially rejected fundamental aspects of the classical Protestant doctrine of Scripture; that rejection will be assessed, and a proposal for conceiving of Scripture as a divine speech act will be offered. The concept of God as a God who speaks is identified in Chapter 2 as a fundamental theological conviction underlying the historical doctrine of the sufficiency of Scripture. Chapter 2 briefly surveys the history of the doctrine, and analyses it, especially in its post-Reformation formulation, into this theological element, and also into its *material* aspect—Scripture contains everything necessary to be known for salvation—and into its *formal* aspect—Scripture is sufficient for its own interpretation. Chapters 4 and 5 deal with these two aspects respectively. These two chapters treat various general hermeneutical approaches to texts which seem especially either to support or to conflict with the hermeneutical position implied by the doctrine of the sufficiency of Scripture. They also discuss contemporary theologians who have been informed by these contemporary hermeneutical positions and who have offered analogous approaches to the Bible. Chapter 4 focuses on the Bible as *text*, constructing an approach to texts as in some way sufficient, and to the Bible as materially sufficient. Chapter 5 focuses on the Bible as *canon*, constructing an approach to a collection of texts as in some way sufficient, and to the Bible as formally sufficient. The overall structure of this work is therefore that of a historical analysis of the sufficiency of Scripture, which identifies three core elements in the doctrine (Chapter 2), each of which is reconstructed in dialogue with a variety of contemporary views, both theological and hermeneutical, in three subsequent chapters (Chapters 3–5).

Given the extent of theological development since what might be called the heyday of the doctrine of Scripture, and particularly of the sufficiency of Scripture—from the Reformation to roughly the end of the seventeenth century—by no means all the issues raised by the possibility of a reconstruction of the doctrine can be dealt with in one piece of work. The aim of this book is to focus on some of the fundamental theological, philosophical, and hermeneutical claims implied by

the doctrine of the sufficiency of Scripture. This is not to assume that the Reformers, say, were conscious of holding such positions; in many cases, subsequent thought has revealed that a position which they and many others previously assumed to be self-evident is in fact just one of a variety of possible options, and so requires the kind of defence which they had no reason to offer or possibility of offering.

It will become evident that a number of different issues are brought together, some of which are already in debate with one another in published literature, and some not. The aim is to create an intersection of a number of topics, as the location for a reconstruction of the sufficiency of Scripture. The Reformation doctrine of Scripture has regularly been contrasted favourably with that of subsequent orthodox Protestant scholastic theologians, who articulated the doctrine most fully. It is intended to question this contrast, and to bring a carefully delineated historical doctrine of Scripture into creative discussion with some strands of contemporary Christian theology and biblical studies, increasingly informed as they are by linguistic and literary concerns. More broadly, the question of authority in church and theology has become even more pressing, as the old certainties of Scripture, reason, or tradition have been widely called into question. David Tracy, for example, recommends, as fundamental to how we are to think of God, that Christians aim at 'the extraordinary complexity of a full scriptural understanding of the many faces of God disclosed in the many scriptural genres to name God'.[23] The reconstruction of the sufficiency of Scripture offered here engages with the question of how God is to be 'named', privileging this 'extraordinary complexity' of the Bible as in some sense sufficient for the task. The circumspection required in the face of such complexity, at which Tracy here hints, is a contemporary theme which must shape any reconstruction of such a confident-sounding doctrine as the sufficiency of Scripture.

More broadly still, the approach taken here to the questions raised by discussions of the classical doctrine of Scripture is to be located within the question of how Christian theology is to orient its thinking about God in relation to the cultural

[23] David Tracy, *On Naming the Present: God, Hermeneutics, and Church* (London: SCM Press, 1994), 33.

phenomena of modernity and post-modernity. Whether post-modernity represents a shift to something quite new in Western culture, or whether it is more like a baroque form of late modernity, it is still the case that there are changes now at work in Western academic, cultural, and ecclesial life which present particular challenges and opportunities to Christian theology. At the heart of these changes lie questions of truth, meaning, and identity. A number of contemporary theologians are finding the resources to steer Christian theology through these difficult waters in traditional doctrinal themes, in order to prevent Christian theology from falling captive to either modernity or post-modernity. Catherine Pickstock, for example, has looked to recover medieval sacramental theology. She has recently articulated a conception of eucharistic practice which identifies the event of the Mass (as transubstantiation) as the very precondition of meaning, proposing a concept of divine bodily 'presence' in the elements which, she argues, is immune to Derrida's critique of Western metaphysics.[24] For Pickstock, the Mass can function as such because it is 'an essential *action* . . . [a] linguistic and significatory *action* rather than extra-linguistic presence'.[25] Kevin Vanhoozer's most recent work can be seen as performing a very similar task for a Protestant theology of the Word. He locates semantic foundations in the divine speech act by which God comes to us: 'For the Christian, the divine promise is more reliable than any metaphysical foundation in the world.'[26]

Although one of these is Catholic and the other Protestant, the identification of an old conception of divine action in the world as the ground of truth, meaning, and identity, in direct opposition to overall modern and post-modern philosophical options, is strikingly common to both. This book functions in the same general space as the thought of Pickstock and Vanhoozer, recovering and reconstructing a particular pre-critical Protestant theology of the Word, understood as a significant

[24] '[T]he inhering of bread in Body is not a relation of signification (as for a Zwinglian view) but more like a condition of possibility for all signification' (Catherine Pickstock, *After Writing: On the Liturgical Consummation of Philosophy* (Oxford: Blackwell, 1998), 263).

[25] Pickstock, *After Writing*, 253, 255 (italics hers).

[26] Vanhoozer, *Is There a Meaning?*, 434.

site of God's action in the world, in the attempt to seize the current opportunities in Western culture to escape the influence which monolithic 'modern' and 'post-modern' thought-forms exercise on Christian theology. The reconstruction of the doctrine of the sufficiency of Scripture to be offered here aims to be both creative and faithful to its chief historical formulations, allowing it to continue to serve as a necessary and ultimately life-giving component of Christian theology, especially as theology strives to think of God's active presence in the world.

2

The Development and Decline of the Sufficiency of Scripture

INTRODUCTION

This chapter offers a brief chronological survey of various articulations of the doctrine of the sufficiency of Scripture from the patristic period through to the Reformation and beyond, and concludes with an analysis of the post-Reformation decline of the doctrine. This is of course a history which has been researched and written widely and in detail elsewhere, and the reason for its inclusion in relatively brief form here needs some justification. The history of the doctrine of the sufficiency of Scripture will be outlined here in an analytical form which will set up how the subsequent constructive body of the book will unfold. The three-part nature of the reconstruction of the doctrine which this work attempts has already been outlined in Chapter 1; this chapter will show how those three elements emerged and were clarified in the development of the doctrine, and how they each began to decline. The rethinking and reconstruction of any doctrine, such as this book undertakes, if it is to be theologically and ecclesially responsible, must make clear its relationship to the traditions to whose renewal it aims to contribute. This will be especially important when the discussion turns, as it will in this chapter, to post-Reformation orthodox Protestant writing on Scripture. The most explicit doctrinal statements on the sufficiency of Scripture come from this period, but these writers are currently not held in general high theological esteem.

The doctrine of the sufficiency of Scripture, from the earliest period of the Christian church through to the Protestant Reformers and their successors, serves fundamentally as an assertion about authority in theology and in the life of the

church. It asserts Scripture as the means by which God speaks and acts authoritatively with regard to the church and the world by the Holy Spirit, and so implicitly excludes from a primary authoritative position other means by which God does not so act. The various developments of the doctrine have been influenced by new apologetic and polemical contexts in which theologians have wished to articulate and defend certain positions on the inevitable question of authority in theology and in Christian life.

Throughout this chapter, a distinction will be drawn between the *material* and *formal* aspects of the sufficiency of Scripture. Since this is not a distinction found everywhere in historical writing on this topic, it requires some comment. What is most regularly meant by 'the sufficiency of Scripture' is what is being called here its *material* aspect: that Scripture contains everything a person needs to know to be saved and to live in a way which pleases God. The *formal* aspect of sufficiency relates to the authority by which Scripture is interpreted, and asserts that Scripture is its own interpreter. It is these two elements which Chapters 4 and 5, respectively, will address. The formal aspect of the doctrine of Scripture is sometimes articulated under the heading of the perspicuity of Scripture, but it can equally be regarded as an aspect of sufficiency. Thus G. C. Berkouwer, noting the close relationship between sufficiency and perspicuity, says that 'the confession concerning sufficiency is concerned with the light of Scripture, which was confessed to be sufficient for life's journey'.[1] That a degree of fluidity of terminology is possible in the expression of a relatively stable doctrinal content will become evident when we turn to examine the post-Reformation period. Yves Congar uses this terminology of 'material' and 'formal' particularly clearly; writing of the Protestant Reformers, he makes evident the close link between the two aspects of sufficiency:

It was with the intention of restoring the sovereignty of *God alone* that they presented that of Scripture as exclusive. In order to do this effectively, they affirmed the *sufficiency* of the Scripture, not uniquely in a *material* sense, that is to say as the object *quod creditur*, but in a *formal* sense, that is to say of the means whereby we know, the

[1] G. C. Berkouwer, *Holy Scripture*, trans. and ed. Jack B. Rogers, Studies in Dogmatics (Grand Rapids: Eerdmans, 1975), 299.

constitutive light by which we understand, the principle of the rule of faith. . . . Not only was the whole of faith contained in Scripture, but the Christian, benefiting from the interior witness of the Holy Spirit, could find it there.[2]

The extent to which these two aspects of the sufficiency of Scripture are grounded in the theological claim that God speaks, and that Scripture is a medium of his speech, will be noted in the treatment of each successive historical period. It is this undergirding theological theme which will be reconstructed in Chapter 3.

Sufficiency, like many other aspects of the doctrine of Scripture, reached its highest degree of specification in the post-Reformation period, in what has become known as Protestant scholastic theology. As will be documented in our discussion of post-Reformation orthodoxy, many subsequent writers have judged the Protestant scholastics' theological exactitude to be one symptom of a malaise which is alleged to have infected much seventeenth-century orthodox Protestantism. Their theology, it is argued, fell away from the christocentric and therefore holistic and integrated conception of theology held by the earlier Protestant Reformers. This is often judged to be a declension which left Protestant orthodoxy vulnerable to the attacks on it which were rapidly gathering momentum in the same period, and which led ultimately to a widespread rejection of much traditional Christian doctrine. An attempt, such as that of the present work, to re-articulate one of the traditional claimed attributes of Scripture needs to make clear where it is to be located in relation to seventeenth-century orthodoxy—that is, to the climax, and according to many also the nadir, of the systematization of the Protestant doctrine of Scripture. This chapter will therefore come to focus on the issues raised by critical comparisons of Reformation and orthodox post-Reformation doctrines of Scripture. A critical rehabilitation of the Protestant scholastics, more favourable than the judgements most commonly given, will be briefly proposed, taking

[2] Yves M.-J. Congar, *Tradition and Traditions: An Historical and Theological Essay*, trans. Michael Naseby and Thomas Rainborough (London: Burns & Oates, 1966), 116–17. The same terminology is used by A. N. S. Lane, 'Scripture, Tradition and Church: An Historical Survey', *Vox Evangelica* 9 (1975), 37–55.

the work of the late-seventeenth-century Genevan scholastic theologian Francis Turretin as a particular example.

This engagement with the consensus position on Reformed Protestant scholasticism can only be tentative. It will be suggested that not all attempts to articulate a doctrine of Scripture in terms of various scriptural attributes necessarily fall into the same traps that the Protestant scholastics undoubtedly sometimes did. Rather, the scholastics, although inevitably working within the theological constraints and biases of their time, retained an underlying concept of theology and the place of Scripture in it which did not depart radically from that of the Reformers. To anticipate, it will be argued that a deep concern with the 'attributes' of Scripture is not necessarily detrimental to a dynamic conception of theology as reflection on the life of the church in Christ. First, though, we turn to the early period of the church's thought on the Bible.

THE PATRISTIC PERIOD

Clement of Alexandria, an early post-apostolic theologian, wrote: 'He then who of himself believes the Lord's Scripture and his actual voice is worthy of belief . . . Certainly we use it as a criterion for the discovery of the real facts.'[3] Here the content of Scripture and the voice of God are clearly equated, and the authority of Scripture derives at least in part from this identification.[4] From around two centuries later, Augustine provides a particularly strong statement of the material sufficiency of Scripture: 'among the things that are plainly laid down in Scripture are to be found all matters that concern faith and the manner of life,—to wit, hope and love'.[5] Similar statements from the period between Clement and Augustine are commonly cited. Thus Irenaeus calls Scripture 'the ground and pillar of our faith',[6] and Athanasius writes: 'To be sure, the

[3] Clement of Alexandria, *Stromateis*, VII. 16, Library of Christian Classics 2 (London: SCM Press, 1954).

[4] See Josef Rupert Geiselmann, *Die Heilige Schrift und die Tradition* (Freiburg: Herder, 1962), 228.

[5] Augustine, *On Christian Doctrine*, II. 9, Nicene and Post-Nicene Fathers 2, ed. Philip Schaff (Grand Rapids: Eerdmans, 1956).

[6] Irenaeus, *Against Heresies*, III. 1, Ante-Nicene Christian Library 5, ed. Alexander Roberts and James Donaldson (Edinburgh: T. & T. Clark, 1868).

sacred and divinely inspired Scriptures are sufficient for the exposition of the truth.'[7] Tertullian asserts that doctrines not discoverable in Scripture should not be accepted.[8]

These apparently unequivocal comments do not of course, though, tell the whole theological story. Throughout the patristic period no programmatic distinction was made between Scripture and church, with regard either to teaching or authority. The church was ascribed the right of determining the correct interpretation of Scripture, although not explicitly as an authority over against Scripture. Thus the above citation from Athanasius continues: 'but there also exist many treatises of our blessed teachers composed for this purpose, and if one reads them he will gain some notion of the interpretation of the Scriptures and will be able to attain the knowledge he desires'. Similarly, Clement of Alexandria seems to regard the teaching of the church and the message of Scripture as one and the same: 'For being ignorant of the mysteries of the knowledge of the Church, and incapable of apprehending the grandeur of the truth, they [the heretics] were too sluggish to penetrate to the bottom of the matter, and so laid aside the Scriptures after a superficial reading.'[9]

Indeed, it was the threat posed by heresy which gave rise to the need to bring the twin authorities of Scripture and church into virtual identity. In response to Gnostic heretics, who reinterpreted Scripture and claimed to know a secret apostolic tradition, orthodox theologians, says Geoffrey Bromiley, invoked 'the common teaching of the apostolic churches—the tradition—not to oppose or correct or supplement Holy Scripture, but to bring its true message into focus. The appeal to tradition was in fact an appeal to the very apostolicity that formed the main criterion of New Testament canonicity.'[10]

[7] Athanasius, *contra Gentes*, 1, Nicene and Post-Nicene Fathers 4, ed. Philip Schaff and Henry Wace (Grand Rapids: Eerdmans, 1957).

[8] J. N. D. Kelly, *Early Christian Doctrines*, 5th edn. rev. (London: A. & C. Black, 1977), 39. [9] Clement of Alexandria, *Stromateis*, VII. 16.

[10] Geoffrey W. Bromiley, 'The Church Fathers and Holy Scripture', in D. A. Carson and John D. Woodbridge (eds.), *Scripture and Truth* (Leicester: Inter-Varsity Press, 1983), 199–220, at 208. See D. Farkasfalvy's comment that for Irenaeus 'canonicity coincides with apostolicity' (D. Farkasfalvy, 'Theology of Scripture in St. Irenaeus', *Revue Bénédictine* 78 (1968), 319–33, at 332).

Gerhard Ebeling observes that neither the Fathers nor the medieval church felt the need to define 'tradition' precisely, because they never imagined that it could be in tension with Scripture.[11] One of the best known patristic statements of this position, combining a confession of the material sufficiency of Scripture with a view of the church as the chief authority in biblical interpretation, is that of the fifth-century writer Vincent of Lérins:

Here someone may possibly ask: Since the canon of Scripture is complete, and is abundantly sufficient for every purpose, what need is there to add to it the authority of the church's interpretation? The reason is, of course, that by its very depth the Holy Scripture is not received by all in one and the same sense, but its declarations are subject to interpretation, now in one way, now in another, so that, it would appear, we can find almost as many interpretations as there are men.

How, then, is the true interpretation to be reached and validated? Vincent answers: 'In the catholic church itself especial care must be taken that we hold to that which has been believed everywhere, always, and by all men. For that is truly and rightly "catholic".'[12] Increasingly through the third and fourth centuries the Roman church came to be regarded as 'the appointed custodian and mouthpiece of the apostolic tradition', although even in Vincent's case the authority of the tradition is assumed to lie in its identity as a faithful exposition of Scripture.[13]

Thus, in general the Fathers assert the material sufficiency of Scripture but deny its formal sufficiency. Further, in asserting the sufficiency of Scripture they equate, implicitly as well as explicitly, the teaching of Scripture with God's voice. This summary therefore distinguishes the three elements of the sufficiency of Scripture—an underlying theological claim and two aspects of the sufficiency of Scripture—which the present work aims to reconstruct and defend.

[11] Gerhard Ebeling, '"Sola Scriptura" and Tradition', in Ebeling, *The Word of God and Tradition: Historical Studies Interpreting the Divisions of Christianity*, trans. S. H. Hooke (London: Collins, 1968), 102–47, at 103.
[12] Vincent of Lérins, 'The Commonitory', in *Early Medieval Theology*, Library of Christian Classics 9, trans. and ed. George E. McCracken and Allen Cabaniss (London: SCM Press, 1957), 38.
[13] Kelly, *Early Christian Doctrines*, 44, 49.

Over such a long period, of course, some significant excep-
tions to this general rule can be found. In the fourth century
Basil of Caesarea distinguished what is found in Scripture from
what he thought was found in extra-scriptural apostolic tradi-
tion: 'some [of the Church's beliefs and practices] we possess
derived from written teaching; others we have delivered to us
"in a mystery" by the tradition of the apostles; and both of these
in relation to true religion have the same force'.[14] (In the cate-
gory of extra-scriptural traditions Basil has in mind here such
beliefs and practices as the use of the sign of the cross at bap-
tism, facing east to pray, the words of invocation at the Euchar-
ist and the blessing of water to be used in baptism.) Although
this breaks the strict overlap of church and Scripture by
proposing the existence of extra-scriptural sources of apostolic
tradition, it is not strictly a denial of the material sufficiency of
Scripture for knowledge of salvation, for Basil does not say that
extra-scriptural sources of apostolic tradition contain material
which is necessary for salvation and which is not also found in
Scripture. However, Basil clearly thinks the practices he men-
tions to be of vital importance in the life of the church, and a
necessary apostolic supplement to Scripture in prescribing the
practice of the church. This may be regarded as a strict appli-
cation of the increasingly important principle of the authority
of the Roman church. As we shall see, this passage of Basil's
work came to be regarded as a significant precedent by medieval
theologians who wished to go further in questioning the suf-
ficiency of Scripture.

A different kind of exception to the general rule is found in
the work of Augustine. He prefigures the Reformation con-
viction that Scripture should be its own interpreter: 'almost
nothing is dug out of those obscure passages which may not
be found set forth in the plainest language elsewhere'.[15] This
anticipates one aspect of Luther's conception of the *analogia
fidei*, developed especially in his teaching on the perspicuity of
Scripture.[16] Augustine of course did not work through the logic

[14] Basil of Caesarea, *De spiritu sancto*, 66, Nicene and Post-Nicene Fathers
8, ed. Philip Schaff and Henry Wace (Grand Rapids: Eerdmans, n.d.).

[15] Augustine, *On Christian Doctrine*, II. 6. 8.

[16] On this, and for other ways of construing the *analogia fidei*, see Henri
Blocher, "The 'Analogy of Faith" in the Study of Scripture', in Nigel M. de

of this statement in the direction which the Reformers did, for in his mind the authority of Scripture always rested on the authority of the church—by which he meant to strengthen Scripture's authority.[17] For example, later in the same work he suggests as principles for removing ambiguity in biblical interpretation that one study the immediate literary context, and that one consult the rule of faith, which he says is to be gathered from Scripture's plainer passages and from the authority of the church—apparently not thereby distinguishing two different sources of authority.[18]

Something similar can be identified in Irenaeus. Although Irenaeus also has much to say about the importance of written tradition, J. N. D. Kelly argues that for him Scripture and tradition are identical in content, and that what he calls the 'canon of truth' is 'simply a condensation' of the message of Scripture.[19] This means that when Irenaeus calls for the 'canon of truth' to be the hermeneutical principle of biblical interpretation he comes close to Luther's concern that Scripture interpret itself.[20] Moreover, central to Irenaeus' theology of Scripture is '[t]he presentation of the *trinitarian God* of the Christian creed as source of all revelation and salvation': for Irenaeus, God always manifests himself through the Logos, and at every stage it is the same Spirit who communicates knowledge of God.[21] This, too, is close to what we shall see is the christocentric understanding which Luther has of his rule of Scripture's self-interpretation.[22] Tertullian's concept of the *regula*

S. Cameron (ed.), *The Challenge of Evangelical Theology: Essays in Approach and Method* (Edinburgh: Rutherford House, 1987), 17–38, at 18–23.

[17] See Gerald Bray, *Biblical Interpretation: Past and Present* (Leicester: Apollos, 1996), 108–9. [18] Augustine, *On Christian Doctrine*, III. 2. 2.

[19] Kelly, *Early Christian Doctrines*, 39. See also Congar: 'Irenaeus often invokes the words of the presbyters or elders in reference to the faith of the Church; but he uses them to confirm, not to complete the truths of Scripture' (Congar, *Tradition and Traditions*, 107).

[20] Anthony Thiselton makes this point, taking it from the work of Skevington Wood (Anthony C. Thiselton, *New Horizons in Hermeneutics* (London: HarperCollins, 1992), 156).

[21] Farkasfalvy, 'Theology of Scripture', 320–5. In this article Farkasfalvy argues that Irenaeus does indeed have a *theology* of Scripture; the point cited here is one aspect of it.

[22] On Irenaeus' christocentrism, see Thiselton, *New Horizons*, 156; Farkasfalvy, 'Theology of Scripture', 323.

fidei functioned similarly to Irenaeus' concept of the 'canon of truth': not 'a formal creed, but rather the intrinsic shape and pattern of the revelation itself'.[23]

Behind the Reformation principle of Scripture's self-interpretation, in conscious distinction from the previous synthesis of Scripture and tradition, lies the claim that 'the very *object* of Scripture is to establish the authority of the content of Scripture'.[24] Clement of Alexandria comes remarkably close at one point to stating this in a form no different from expressions found in Luther and Calvin: 'So too we, obtaining from the Scriptures themselves a perfect demonstration concerning the Scriptures, derive from faith a conviction which has the force of demonstration.' By this 'demonstration' Clement means the confirmation from one part of Scripture of what one has concluded by studying another part, in contrast to his depiction of the Gnostics' approach to Scripture, who, he says, pick out scattered references to justify their position, focusing on individual words and even changing their meaning without warrant.[25]

A key device in maintaining the identity of the teaching and authority of church and Scripture over time was the allegorical method of biblical interpretation, which allowed a great deal of material to be 'found' in the texts of Scripture. The prime patristic example is Origen, and the method was more fully developed as the *quadriga*, the four-fold method of exegesis, in the Middle Ages; it will be discussed further below. What is primarily to be noted, however, is the Fathers' consistent affirmation of Scripture's material sufficiency for salvation, linking its content quite directly with the voice of God, and their increasing denial of Scripture's formal sufficiency, yet without an explicit establishment of the church's interpretative authority over against Scripture's self-interpreting function.

[23] Kelly, *Early Christian Doctrines*, 40. See also: 'The idea of the rule of faith as supplementing or complementing, or indeed adding anything whatever to the Bible, is wholly absent from their thoughts; indeed, such an idea would be in complete contradiction to their conception of the relation of rule to Bible' (R. P. C. Hanson, *Tradition in the Early Church* (London: SCM Press, 1962), 126).

[24] Ebeling, '"Sola Scriptura" and Tradition', 133.

[25] Clement of Alexandria, *Stromateis*, VII. 16.

THE MIDDLE AGES

The Material Extent of the Sufficiency of Scripture

Unqualified assertions of the material sufficiency of Scripture, identical to those made by the Fathers, can be found through-out medieval theology. There is a general consensus among modern writers on the period that all medieval theology strove to be 'Bible-theology'.[26] In the early medieval period, John Scotus Eriugena (b. early ninth century) states, in defence of the allegorical interpretation of Scripture, that 'the reward of those who labour in the study of Holy Scripture . . . is a pure and perfect understanding'. He then turns to prayer to Christ: 'For as there is no place in which it is more proper to seek Thee than in Thy words, so is there no place where Thou art more clearly discovered than in Thy words. For therein Thou abidest, and thither Thou leadest all who seek and love Thee.'[27]

Thomas Aquinas makes the same point succinctly, in a clear echo of the Fathers: 'The truth of faith is sufficiently plain in the teaching of Christ and the Apostles.'[28] Aquinas makes a clear distinction between the authority of Scripture and that of the church: 'Its [holy teaching's] own proper authorities are those of canonical Scripture. . . . It has other proper authori-ties, the doctors of the Church, and these it looks to as its own, but for arguments that carry no more than probability.'[29] Congar summarizes Aquinas's view of Scripture thus: 'Scrip-ture is the rule of faith, to which nothing can be added, from which nothing can be deleted.'[30] One historian has suggested Bonaventure as the writer of the twelfth and thirteenth centuries

[26] Hermann Schüssler surveys the work on this done by Yves Congar, Paul de Vooght, and others (Hermann Schüssler, *Der Primat der Heiligen Schrift als theologisches und kanonistisches Problem im Spätmittelalter* (Wiesbaden: Franz Steiner Verlag, 1977), 73 ff.).

[27] John Scotus Eriugena, *Periphyseon (The Division of Nature)*, trans. I. P. Sheldon-Williams, rev. John J. O'Meara (Montreal: Bellarmin; Washington: Dumbarton Oaks, 1987), v, *PL* 122. 1010.

[28] Aquinas, *Summa Theologiae*, II. II q. 1 a. 10 (Blackfriars, 1964–). See similar statements in II. II q. 5 a. 3; II. II q. 110 a. 3; III q. 1 a. 3.

[29] Aquinas, *Summa Theologiae*, I q. 1 a. 8.

[30] Congar, *Tradition and Traditions*, 114.

who speaks most highly of the authority of Scripture: for him, only that which can be shown to be supported by Scripture, the unique and inexhaustible source of truth, can be treated as binding for Christians.[31] Duns Scotus, too, at least in his early work, viewed Scripture the same way: 'theology does not concern anything except what is contained in scripture, and what may be drawn from this'.[32] The most vociferous proponent of the sufficiency of Scripture in the later Middle Ages was John Wyclif, who explicitly links Scripture's authority to the identity of its message with the voice of God. Among his many descriptions of Scripture are *vox Christi, unicum verbum Dei, verbum veritatis* and *unum perfecte verbum procedens de ore Dei.*[33] The same view can be found into the time of the Reformation, expressed even by those who opposed Luther's doctrine of *sola Scriptura*. For example, John Driedo, whom Congar calls 'one of the best theologians on tradition', allows that the teaching of Christ and the apostles as contained in Scripture is sufficient to teach the doctrines necessary for the salvation of humanity, while also clearly advocating the necessity of the action of the Holy Spirit in the church's tradition for correct biblical interpretation.[34]

The majority of medieval theologians seem to have restricted the material sufficiency of Scripture to soteriological matters. According to Geiselmann, the view predominated that apostolic material on issues of church practice was passed down extra-biblically, either orally (so Aquinas), or by means of customary practice (Duns Scotus). Geiselmann traces such views back through Abelard to Origen and Tertullian.[35] The question of the extent of the material sufficiency of Scripture resurfaces, as we shall see, in post-Reformation debates over the 'regulative principle'.

The overall medieval consensus briefly outlined here must be seen in the context of related theological issues, whose history

[31] Schüssler, *Primat der Heiligen Schrift*, 48.

[32] Quoted in Alister McGrath, *The Intellectual Origins of the European Reformation* (Oxford: Blackwell, 1987), 140.

[33] These are cited, as part of a much longer list of similar descriptions by Wyclif, in Geiselmann, *Die Heilige Schrift*, 237–8.

[34] Congar, *Tradition and Traditions*, 116.

[35] Geiselmann, *Die Heilige Schrift*, 257–63.

through this long period is highly complicated. Indeed, there exists no scholarly consensus on a variety of topics concerning Scripture in the Middle Ages; different and sometimes conflicting accounts have been offered by, among others, David Knowles, Beryl Smalley, Josef Geiselmann, George Tavard, Heiko Oberman and Hermann Schüssler.[36] These complexities will be briefly explored under two topics: the status of the literal sense of Scripture, and the relation between church and Scripture as authorities in medieval theology.

The Literal Sense of Scripture

The medieval church inherited from the Fathers a four-fold division of the sense of any biblical text, a scheme mediated principally by Augustine and which apparently originates with Clement of Alexandria and Origen.[37] This scheme treats the literal sense as just one of four senses, and can allow the literal sense to be regarded as less important than the spiritual senses, to which the 'carnal' sense simply provides access. According to G. R. Evans, this scheme had its basis in both a theological and a hermeneutical conviction. Theologically, medieval theologians inherited the view that '[i]f the Word was to speak to us in terms we could understand it was necessary for it to become many words, to multiply and diversify, to descend to the level of particular sounds for us; . . . the one Word of God . . . is expanded and diffused.'[38] The hermeneutical point is illustrated from Augustine's theory of signs. He distinguished words from 'natural signs' such as smoke signalling a fire, which, unlike words, are both signs and things. 'It was in making plain this

[36] David Knowles, *The Evolution of Medieval Thought*, 2nd edn., ed. D. E. Luscombe and C. N. L. Brooke (London and New York: Longman, 1988); Beryl Smalley, *The Study of the Bible in the Middle Ages*, 3rd edn. rev. (Oxford: Blackwell, 1983); Geiselmann, *Die Heilige Schrift*; George H. Tavard, *Holy Writ or Holy Church: The Crisis of the Protestant Reformation* (London: Burns & Oates, 1959); Heiko Augustinus Oberman, *The Harvest of Medieval Theology: Gabriel Biel and Late Medieval Nominalism*, rev. edn. (Grand Rapids: Eerdmans, 1967); Schüssler, *Primat der Heiligen Schrift*.

[37] G. R. Evans, *The Language and Logic of the Bible: The Earlier Middle Ages* (Cambridge: Cambridge University Press, 1984), 114.

[38] Ibid., 5.

significance of "things" that the figurative interpretations of
Scripture were believed to be illuminating.'[39] To penetrate
beneath the surface of the language 'is to come closer to what
the text really means'.[40]

In practice, this exegetical scheme gave theologians a means
by which they could find in Scripture hints of a wide range of
doctrines and traditions, allowing them to affirm the authority
of both Scripture and the church, especially in the potentially
more troublesome areas of tradition on which the literal sense
of Scripture did not clearly speak. An excellent example of this
is found in the work of Hugh of St. Victor (d. 1141), who both
asserts the material sufficiency of Scripture for faith,[41] and
retains a high view of the spiritual sense—although he qualifies
the traditional scheme somewhat by granting a significant place
to the literal sense. According to Beryl Smalley, '[i]nstead of
contrasting the lowly foundation of the "letter" with the higher
spiritual senses, he [Hugh] groups together the letter and alle-
gory. . . . The importance of the letter is constantly stressed.'[42]
Evans traces this recovery of the literal sense back to Anselm in
the eleventh century, who 'was pioneering where others were to
go in the attempt to interpret the literal sense seriously and fully
and intelligently and to find in it matter worthy to be set beside
what might be learned from figurative interpretations',[43] and
argues that from the twelfth century onwards theologians began
to regard the literal sense as the most important, and as the only
one to be used in theological arguments.[44]

Smalley's detailed account of the Victorines offers a fuller
picture of this progression, which broadly supports Evans's
general claim. Hugh of St Victor, she says, had a sophisticated
enough understanding of the literal sense to insist that it 'is not
the *word*, but what it means; it may have a figurative meaning;

[39] Evans, *Language and Logic: Earlier*, 52–3.
[40] Ibid., 56–7.
[41] 'Solum hoc quod legimus credere sine dubitatione debemus' ('Only that
which we read [in Scripture] ought we to believe without hesitation'). Quoted
in Geiselmann, *Die Heilige Schrift*, 230.
[42] Smalley, *The Study of the Bible*, 89.
[43] Evans, *Language and Logic: Earlier*, 26.
[44] G. R. Evans, *The Language and Logic of the Bible: The Road to
Reformation* (Cambridge: Cambridge University Press, 1985), 42–50.

and this belongs to the literal sense',[45] but judges that over-
all the Victorine tradition believed in the superiority of the
spiritual sense.[46] One particular exception to this judgement,
whom Smalley also discusses, is Andrew of St Victor (d. 1175),
of whom she says: 'Andrew is the only medieval commentator
known to me who fears to add anything to his author. The
others, convinced that their texts hide a plenitude of meaning,
hardly distinguish between exposition and amplification.'[47]

However the legacy of the Victorines is judged, Smalley is
sure that in the thirteenth century spiritual exegesis was on the
decline.[48] It seems that in recent years there has been increased
recognition of a development in favour of the literal sense
between the twelfth and fourteenth centuries. This recognition
arises in part from a reassessment of the philosophical and theo-
logical legacy of nominalism. David Knowles charged Ockham
with developing an epistemology which allowed philosophers
only 'the intuitive knowledge of individual things, each of
which was so irreducibly individual as to be unsusceptible of
any intelligible relationship or connection with any other indi-
vidual'. This removed '[t]he whole fabric of natural theology',
and thus demolished Thomism and Scotism.[49] With this view
of nominalism, its legacy is taken to be a philosophical void
which theologians may fill with one of two possible options:
'to reduce revealed doctrine to the message of Scripture alone',
as Wyclif did, or to take refuge in 'mystical certainty'. To
Knowles, both look like tragically impoverished options.[50] How-
ever, Knowles's posthumous editors point out that Oberman
has offered serious criticisms of this interpretation of Ockham,
and also that recent work on Wyclif has suggested that there is
a close link between his realist metaphysics and 'his belief in the
unity and indissolubility of scripture, and its literal truth', and

[45] Smalley, *The Study of the Bible*, 93.
[46] Ibid., 243.
[47] Ibid., 139.
[48] Ibid., 284–93. In the introduction to the 3rd edn. of 1983, Smalley
qualifies this judgement somewhat, acknowledging that spiritual exposition
continued to thrive, and that, for example, Aquinas continued to practise
spiritual biblical interpretation, alongside his more 'literal' expositions of Job
and Isaiah (pp. xiii–xiv).
[49] Knowles, *Evolution*, 298–9.
[50] Ibid., 302.

therefore that his view of Scripture has a more robust philo-
sophical foundation.[51]

The significance of this topic for our concerns is that the
Reformation doctrine of Scripture took a very firm stand on
the primacy of the literal sense of Scripture. By 'Scripture' in
the phrases '*sola Scriptura*' and 'the sufficiency of Scripture' the
Reformers and their successors meant 'Scripture in its literal
sense', while agreeing, of course, with Hugh of St Victor that
the literal sense can include figurative senses, and with Andrew
of St Victor that, in deciding what we should interpret as
figurative, we must be governed by the author's intention. It
was not always recognized at the time of the Reformation that
the Protestant position on the literal sense can be seen as the
coming to fruition of a trend which had been long developing.
Smalley suggests that much medieval work on the literal sense
was soon forgotten, noting that Cardinal Cajetan thought him-
self to be the first to expound the literal sense of the Psalms.[52]
These topics of authorial intention and the sense of a text will
occupy much of our attention in Chapter 4, in the attempt
to defend and re-articulate the relevant concepts underlying
the Reformation understanding of the material sufficiency of
Scripture.

Scripture and Church as Authoritative Norms

The medieval assertions of Scripture's material sufficiency
cited above can read misleadingly like assertions of an exclusive
Scripture-principle, if taken apart from the context of other
statements made by those same writers on the question of
authority.[53] Aquinas, for example, in addition to his clear asser-
tions of the sufficiency of Scripture, regards church teaching,
flowing as it should from the truth made known in Scripture,
as the 'infallible and divine rule' for believers. According to

[51] D. E. Luscombe and C. N. L. Brooke, 'Introduction' to 2nd edn. of
Knowles, *Evolution*, pp. xxiv–xxvi. Henning Graf Reventlow says that
Wyclif's doctrine of the sufficiency of Scripture arose from the application
to the Bible of a Platonic Augustinian view of the world (Henning Graf
Reventlow, *The Authority of the Bible and the Rise of the Modern World*, trans.
John Bowden (London: SCM Press, 1984), 35–6).

[52] Smalley, *The Study of the Bible*, 356–67.

[53] Schüssler, *Primat der Heiligen Schrift*, 48.

Schüssler, Aquinas in different contexts emphasizes the author-
ity of both Scripture and church. Schüssler also traces back to
Duns Scotus the beginning of the widespread use of the con-
cepts 'Scripture' and 'Church' as the basic norms of faith.[54]

The history of the relationship between scriptural and
church authority is debated, and various conflicting accounts
of it have been given in twentieth-century scholarship. George
Tavard has argued that there was a crucial turning-point
around the beginning of the fourteenth century. Before then,
he thinks, theologians generally held a 'coinherence' view of
the relationship between Scripture and church. Aquinas and
Bonaventure, like most theologians of the twelfth and thir-
teenth centuries, were faithful to the patristic legacy, which
Tavard summarizes thus: 'there is a sense in which "Scripture
alone" is an authentic expression of Catholic Christianity, inas-
much as, that is, the Scripture is, in the church, the apostolic
tradition, and vice versa.'[55] Problems arose however, according
to Tavard, when Scripture and tradition began to come apart.
This opened the way either for the church to be made sub-
servient to Scripture or for Scripture to be made ancillary to the
church; Tavard himself dislikes both possibilities.[56] The latter
option allowed the further suggestion that the church possesses
revelation independent of that found in Scripture.[57] Geisel-
mann agrees with Tavard, arguing that around the turn of the
fourteenth century there was a move away from belief in the
material sufficiency of Scripture to a view of it as materially
insufficient.[58]

Heiko Oberman offers a slightly different picture. Rather
than imagining a patristic and early-medieval consensus break-
ing down around 1300, he proposes that the medieval church
inherited a twin legacy from Augustine, which he terms Tradi-
tion I and Tradition II. The former is what Tavard proposes as

[54] Ibid., 50–2.
[55] Tavard, *Holy Writ*, 11.
[56] Ibid., 41.
[57] Tavard traces this suggestion to Heinrich Totting von Oyta (d. 1397),
professor of philosophy at the University of Prague (Tavard, *Holy Writ*, 36);
Schüssler rejects this (Schüssler, *Primat der Heiligen Schrift*, 86).
[58] Geiselmann calls this, in a chapter-heading, 'Der Übergang von der
inhaltlichen Suffizienz zur Insuffizienz der Schrift' (Geiselmann, *Die Heilige
Schrift*, ch. 9).

the consensus view, namely the coinherence of Scripture and
tradition; the latter is the treatment of tradition which arose
with Basil of Caesarea, which proposes the existence of an
authoritative extra-scriptural oral tradition.[59] Where Tavard
and Geiselmann see in the fourteenth century the disintegration
of a previous consensus, Oberman sees the surfacing of a view
of the relationship between Scripture and tradition of which
there had been growing awareness ever since the time of Basil
and Augustine.[60] He locates the increasing influence of Tradi-
tion II in the Middle Ages in canon law and its influence on
theology, mentioning especially the *Decretum* of Gratian of
Bologna, which discusses the passage in question from Basil.[61]
It has been objected, with some merit, that Oberman's two-fold
typology of the relationship between Scripture and church is
too simplistic to portray with any accuracy the complexity of
the options in relating church and Scripture which were avail-
able in the Middle Ages. For example, Oberman effectively
equates the question of the authority of the church with the
question of unwritten traditions, which excludes the question
of the exercise of church authority in biblical interpretation.[62]

As Hermann Schüssler tells it, papal authority in doctrinal
teaching began to grow in the twelfth and thirteenth centuries,[63]
but nevertheless even in the fifteenth century Scripture was
still the ultimate basis for theology and faith, although there
remained much unclarity over how the establishing of un-
written traditions could in practice avoid being at the whim of
the church.[64] In the midst of this, however, Schüssler identifies
at the turn of the fifteenth century, quite contra Tavard, the
growth of what he calls 'ein korrektives Schriftprinzip', refer-
ring especially to the writing of Nicolaus de Tudeschis (Pan-
ormitanus) (1386–1455).[65] This trend comprises those many
writers who, according to Schüssler, found a way between the
extremes of subordinating the authority of Scripture to the

[59] Oberman, *Harvest*, 370–1. [60] Ibid., 391.

[61] Ibid., 369. Alister McGrath, while affirming the existence of the two-
source theory, argues that Oberman is wrong to locate its origin in the canon-
ists, suggesting that where they give the Pope an authoritative role it is as inter-
preter of Scripture, not source of extra-scriptural tradition (McGrath,
Intellectual Origins, 143).

[62] Schüssler, *Primat der Heiligen Schrift*, 69–70.

[63] Ibid., 44. [64] Ibid., 91. [65] Ibid., 179–82.

church, or vice versa, by viewing Scripture as the foundational or limiting norm of the church's teaching, and by viewing the church, by virtue of God's gracious action on and in it, as guaranteeing access to revelation.[66]

It seems, though, that this middle way, if it existed, could not have been the solution to the problem raised by the suggestion of extra-biblical traditions which Schüssler takes it to be. He concludes that the foundational sufficiency of Scripture for faith and theology was unaffected by the contents of extra-biblical revelations, as long as these traditions contained nothing central to the faith and were not established arbitrarily by the church, but recognized (*approbiert*) by the church no differently from how Scripture was recognized.[67] However, the church recognized the authority of Scripture primarily on the basis of apostolicity, and if extra-biblical traditions were recognized on the same basis then the foundational sufficiency of Scripture for faith was clearly called into question. On the other hand, if these traditions contained nothing central to the faith, then there would be no need to call them revelations in the first place, and the problem at hand need not have arisen. It seems that, whether one prefers Oberman's progressive account of the rise of a two-source theory of revelation or Tavard's 'breakdown of consensus' model, by the fifteenth century the existence of extra-biblical traditions containing material central to the faith, relating often to issues contained in credal confessions and at the very least to important issues of church practice, was proposed by many writers, and no easy solution presented itself to the majority.[68] For example, the fifteenth century was the crucial period in the development of the doctrine of the Immaculate Conception of Mary, centred around the observance of the feast of her Conception. Rejected by Aquinas, Bonaventure, and the Dominicans, defended by Duns Scotus and the Franciscans, it came to be affirmed by the Council of Basle in 1439.[69]

[66] Ibid., 259. [67] Ibid., 294.

[68] Geiselmann mentions Duns Scotus in this regard, who, he says, moved away from belief in the material sufficiency of Scripture, arguing with regard to Christ's descent into Hades, which is an article of faith because of its credal confession, and to the sacraments, that the Holy Spirit taught the apostles about these things, and that they passed them on 'per consuetudinem' (Geiselmann, *Die Heilige Schrift*, 263).

[69] F. L. Cross and E. A. Livingstone (eds.), 'The Immaculate Conception

To the extent that writers such as Wyclif prefigured the Reformation in their strong view of *sola Scriptura* they were relatively uninfluential voices. The critique of the authority of the Roman church began to bite only when developed in the Reformation, when the two assertions of the equal authority with Scripture of extra-biblical traditions and of the church's absolute authority in biblical interpretation came to be regarded by many as identical assertions of human power over God and his Word, and therefore both to be rejected with equal force.

THE REFORMATION

The work of a Franciscan writer, who died in 1527, just as the Reformation was getting under way in earnest, provides a view of Scripture which shows in clear relief the novelty of what the Reformers proposed. Kaspar Schatzgeyer held together, according to George Tavard, the medieval synthesis of Scripture and tradition while ascribing supremacy to Scripture. He did not believe that Scripture interprets Scripture, arguing that that makes the Holy Spirit irrelevant to Scripture's meaning, enclosing it 'in the rind of the literal sense'. Instead he located the work of the Holy Spirit in the authorizing and interpreting of Scripture in the church, and especially in the councils.[70] It was in their rejection of this kind of argument, and in their rigorous assertion of the formal as well as the material sufficiency of Scripture, that the Protestant Reformers made their decisive contribution to the doctrine of Scripture. The formal aspect of sufficiency will be discussed in more detail; first, the particular development of the Reformation view of the material extent of the sufficiency of Scripture will be briefly documented.

The Material Extent of the Sufficiency of Scripture

The Reformed confessions of the first half of the sixteenth century all agree with the constant tradition observed so far, that Scripture contains everything a person needs to know to be saved. They assumed, as had most earlier writers, that 'salva-

of the BVM', in *The Oxford Dictionary of the Christian Church*, 3rd edn. (Oxford: Oxford University Press, 1997), 821–2.

[70] Tavard, *Holy Writ*, 173–7.

tion' covered both a life pleasing to God as well as a moment of 'conversion'. The First Helvetic Confession (1536) asserts that 'Biblical Scripture . . . alone deals with everything that serves the true knowledge, love and honor of God, as well as true piety and the making of a godly, honest and blessed life.'[71] One of the chief architects of this confession was Heinrich Bullinger, who in his own writings makes an identical confession: 'in the word of God, delivered to us by the prophets and apostles, is abundantly contained the whole effect of godliness, and what things soever are available to the leading of our lives rightly, well, and holily'; he quotes in support the reference in 2 Timothy 3: 16–17 to '*every* good work'.[72] Article 6 of the Church of England's Thirty-Nine Articles is similar: 'Holy Scripture containeth all things necessary to salvation: so that whatsoever is not read therein, nor may be proved thereby, is not to be required of any man, that it should be believed as an article of the Faith, or be thought requisite or necessary to salvation.'

One particular development which may be observed is that through the sixteenth century Reformed confessional statements of Scripture's material sufficiency became more specific on the actual content of Scripture. The Second Helvetic Confession (1566), whose author was again Bullinger, the head of the Zurich church, and which became the most widely used Reformed confession,[73] initially offers the traditional brief statement of Scripture's material sufficiency: 'in this Holy Scripture, the universal Church of Christ has the most complete exposition of all that pertains to a saving faith, and also to the framing of a life acceptable to God.' However, the confession then offers some specification of this basic confession: 'from these Scriptures are to be derived true wisdom and godliness,

[71] Quoted in Arthur C. Cochrane (ed.), *Reformed Confessions of the 16th Century* (London: SCM Press, 1966), 100.

[72] Heinrich Bullinger, *The Decades of Henry Bullinger*, trans. H. I., ed. Thomas Harding (Cambridge: Parker Society, 1849), 61–2.

[73] Cochrane, *Reformed Confessions*, 220. For the purpose of dividing the sections of this chapter, the Second Helvetic Confession is taken to mark the end of the Reformation period. Cochrane argues that this confession is representative of the mature Reformation, prior to the rise of Protestant scholasticism, since it avoids a theory of biblical inspiration (Cochrane, *Reformed Confessions*, 222).

the reformation and government of churches; as also instruction in all duties of piety.'[74] It is in the nature of doctrinal development, involving as it does reflection on doctrine and response to objectors, that the level of specification in doctrinal statements generally increases over time. It may be argued that the Second Helvetic Confession, in this specification, is not departing significantly from earlier Reformed confessions. For example, the Lutheran Reformation was based, as we shall see, in direct disagreement with Erasmus, on the claim that Scripture provided a sufficiently clear warrant to instigate a reformation of the church and resistance to what was seen as its false government from Rome; Bullinger's second confession can be read as simply a restatement of this basic point. Nevertheless, the increasing length of statements on Scripture in Reformed Confessions up to 1566 can be seen as a precursor to the lengthy treatises on Scripture and *loci* on the topic which appeared through the second half of the sixteenth century and especially in the seventeenth century.[75]

The material and formal aspects of the sufficiency of Scripture were very closely related in Reformation theology. Luther asserts: 'All the works of God, especially those having to do with salvation, are thoroughly set forth and attested in the Scriptures, so that no one can have any excuse';[76] he thus allows no distinction between Scripture setting forth (material sufficiency) and attesting (formal sufficiency) what is necessary for salvation. The Scottish Confession of Faith (1560), which remained in force in Scotland until superseded by the Westminster Confession of Faith in 1647, and whose main author is presumed to be John Knox,[77] is similar in this regard:

As we believe and confess the Scriptures of God sufficient to instruct and make perfect the man of God, so do we affirm and avow their authority to be from God, and not to depend on men or angels. We affirm, therefore, that those who say the Scriptures have no other

[74] Quoted in Cochrane, *Reformed Confessions*, 224.

[75] The question of the continuity and discontinuity of the orthodox Protestant doctrine of Scripture from the Reformation to the end of the seventeenth century will be addressed below.

[76] Martin Luther, *Luther's Works* (Saint Louis: Concordia Publishing House; Philadelphia: Fortress Press, 1955–86), xxxvi. 144.

[77] Cochrane, *Reformed Confessions*, 160.

authority save that which they have received from the Kirk are blasphemous against God and injurious to the true Kirk.[78]

It is important to bear in mind this close relation between the formal and material aspects of Scripture, since it is the Reformation tradition on Scripture which this work aims to reconstruct. This means that the analysis of the sufficiency of Scripture into a theological underpinning and two aspects—the structure which has arisen in this historical survey and which establishes the progression of the three subsequent chapters—describes not three separate doctrines, but three abstractions, distinguished only for the purposes of analysis, of the theological claim that in Scripture God, speaking by the Holy Spirit, sets forth and attests what it is necessary for human beings to know for salvation.

The Formal Aspect of the Sufficiency of Scripture

The distinguishing mark of the Reformation doctrine of Scripture is that it 'declares the sufficiency and independence of Holy Scripture in respect of its hermeneutic function'—that is, Scripture is self-interpreting.[79] The innovative element in '*sola Scriptura*' therefore lies in the formal aspect of the sufficiency of Scripture, and especially in what that principle was taken to imply hermeneutically. Ebeling offers three descriptions of the essential function of the principle of *sola Scriptura*: 'it preserves intact the distinction between text and interpretation'; it 'maintains that the Word of God has absolute authority over the Church as brought into existence by the Word of God'; and it 'maintains that Christ remains distinct from the Church as its Head, and that the Church is the result of and dependent on the event that constituted her a Church'.[80] The principle functioned in these ways in a particular polemical context. The orthodox Reformers claimed that both Rome and the 'enthusiasts' of the radical Reformation, by locating the authoritative work of the Spirit outside Scripture, in respectively the teaching office of the church and a particular charismatic gift of the

[78] Quoted in ibid., 177–8.
[79] Ebeling, '"Sola Scriptura" and Tradition', 127.
[80] Ibid., 136. The hermeneutical distinctions between text and interpretation, and text and community, will be defended in ch. 4.

Spirit to individuals, exalted human authority over God. The
position is stated in the Gallican Confession of Faith (1559),
which is a lightly edited version of a draft by Calvin, Beza, and
Viret:[81]

We believe that the Word contained in these books [of Scripture] has
proceeded from God, and receives its authority from him alone, and
not from men. And inasmuch as it is the rule of all truth, containing
all that is necessary for the service of God and for our salvation, it is
not lawful for men, nor even for angels, to add to it, to take away from
it, or to change it.[82]

The Second Helvetic Confession makes an identical state-
ment, adding what is implicit in the French Confession, namely
that Scripture receives its authority from God alone in that
'God himself spoke to the fathers, prophets, apostles, and still
speaks to us through the Holy Scriptures.'[83] This theme is very
prominent in Calvin: 'the highest proof of Scripture derives in
general from the fact that God in person speaks in it' is a typi-
cal statement of his position.[84] B.A. Gerrish quotes similar state-
ments from Luther. He observes that the same could have been
written by the medieval theologians Ockham, D'Ailly, or Biel.[85]
The distinctiveness of the Reformation position on the formal
sufficiency of Scripture becomes clearer when we see the her-
meneutical work which the Reformers expected God's voice in
and through the text of Scripture to do. The Second Helvetic
Confession is worth quoting at length here, for it makes clear
that for the Protestant Reformers the question of authority in
relation to Scripture, unlike for most medieval theologians, is
largely one of authority in biblical interpretation:

[81] Cochrane, *Reformed Confessions*, 138.
[82] Quoted in ibid., 145.
[83] Quoted in ibid., 224.
[84] John Calvin, *Institutes of the Christian Religion*, Library of Christian
Classics 20–1, ed. John T. McNeill, trans. Ford Lewis Battles (Philadelphia:
Westminster Press, 1960), i. 7. 4. T. F. Torrance comments on texts such as
this that, for Calvin, '[w]hile the Word of God certainly does involve the com-
munication of truths and statements, in and through these God speaks to us
directly and confronts us with the majesty and dignity of his Truth' (Thomas
F. Torrance, *The Hermeneutics of John Calvin* (Edinburgh: Scottish Academic
Press, 1988), 93).
[85] B. A. Gerrish, *The Old Protestantism and the New: Essays on the Reforma-
tion Heritage* (Edinburgh: T. & T. Clark, 1982), 53.

The apostle Peter has said that the Holy Scriptures are not of private interpretation (II Peter 1:20), and thus we do not allow all possible interpretations. Nor consequently do we acknowledge as the true or genuine interpretation of the Scriptures what is called the conception of the Roman Church, that is, what the defenders of the Roman Church plainly maintain should be thrust upon all for acceptance. But we hold that interpretation of the Scripture to be orthodox and genuine which is gleaned from the Scriptures themselves (from the nature of the language in which they were written, likewise according to the circumstances in which they were set down, and expounded in the light of like and unlike passages and of many and clearer passages) and which agree with the rule of faith and love, and contributes much to the glory of God and man's salvation.[86]

Where almost all medieval theologians had appealed to Scripture as their authority, the Reformers raised the stakes, making the issue of biblical authority an issue not just of biblical citation but of the right understanding of Scripture.[87]

Included in the principle that Scripture is its own interpreter is the privileging of the literal sense of the text. However, this was not a hermeneutical end in itself, but served a central theological purpose. Luther's primary objection to allegorical exegesis of Scripture was that 'it obscured the Christological witness of the plain, literal sense of Scripture'.[88] Luther's strong christocentrism is of course widely recognized. As well as being the basis of his argument against allegorical interpretation, it also provides for him the central focus of the interpretative activity of the Spirit in Scripture. Althaus comments on Luther: 'the self-interpretation of Scripture through the Spirit which speaks in it means that Scripture interprets itself in terms of Christ as its center, that is christocentrically'.[89] Luther expresses this particularly forcefully in two much-quoted statements: 'The Scripture must be understood in favour of Christ, not against him. For that reason they must either refer to him or must not be held to be true Scriptures'; '[t]herefore, if the adversaries

[86] Quoted in Cochrane, *Reformed Confessions*, 226.

[87] David W. Lotz, '*Sola Scriptura*: Luther on Biblical Authority', *Interpretation* 35 (1981), 258–73, at 267.

[88] Timothy George, *Theology of the Reformers* (Nashville: Broadman, 1988), 83.

[89] Paul Althaus, *The Theology of Martin Luther*, trans. Robert C. Schultz (Philadelphia: Fortress Press, 1966), 79.

press the Scriptures against Christ, we urge Christ against the Scriptures'.[90]

Luther's conception of the relationships between Scripture, Christ, the gospel, and the Word of God have been the subject of much discussion in the last century, especially among neo-orthodox theologians who have wished to enlist Luther as precedent for their arguments, contrasting his theology favourably with what they think became of Protestant orthodoxy in the two centuries following the Reformation. (This alleged contrast will be taken up in the following section.) The key theological terms and the relationships between them, as understood by Luther, have been defined with particular clarity in an article by David Lotz. For Luther, according to Lotz, the gospel does not just bear witness to a past event; rather, '[t]he gospel as spoken Word of God . . . is nothing else than the real presence of the exalted Christ, the living Lord of the church'.[91] It is this point which allows Luther to see 'the Word of God' as primarily Jesus Christ, while also usually equating 'the Word of God' with the oral proclamation of the gospel. Scripture for Luther is the Word of God written. This writtenness does not detract from its identity as the Word of God, because in this form its ultimate author is the Holy Spirit: says Lotz, 'Christ and his gospel are *in* Scripture, and Scripture is *truly* God's Word.'[92]

It should be noted, though, that this emphasis in Luther's writing is in tension with his view of the gospel as intrinsically oral proclamation, and of the writing of that proclamation in Scripture as something of a declension from the nature of the gospel: 'the need to write books was a serious decline and a lack of the Spirit which necessity [the challenge of heresy] forced upon us; it is not the manner of the New Testament'.[93] It is clear that in making this claim Luther wished to emphasize that the purpose of the Bible is only ever to convey Christ. However,

[90] Luther, *LW* xxxiv. 112.

[91] Lotz, '*Sola Scriptura*', 262. Lotz quotes Luther: 'they [who hear Paul's gospel] are not listening to Paul; but in Paul they are listening to Christ Himself and to God the Father, who sends him forth' (Luther, *LW* xxvi. 16). Biblical warrant for this can be found in 1 Thess. 2: 13.

[92] On this basis Lotz judges that Protestant neo-orthodoxy cannot enlist Luther in support (Lotz, '*Sola Scriptura*', 263).

[93] Luther, *LW* lii. 206; see also xxxv. 121–3.

this point does seem to flatten Scripture's various generic modes of expression rather quickly into sermonic form, at times privileging Christ's mode of oral proclamation over the apostolic narrative, epistolary, and apocalyptic modes of expression: 'the gospel should really not be something written, but a spoken word which brought forth the Scriptures, as Christ and the apostles have done. This is why Christ himself did not write anything but only spoke. He called his teaching not Scripture but gospel, meaning good news or a proclamation that is spread not by pen but by word of mouth.'[94]

In Chapter 5 the question of the diversity of the literary genres found in Scripture will be taken up, and it will be suggested how the sufficiency of Scripture may broadly be conceived of in a way which does not flatten that diversity. Further, in Chapters 3 and 4 a conception of the ontology of texts will be offered which ties texts very closely to the actions of their authors. This may be thought of as a way of accepting different biblical texts as a personal divine address, and therefore as 'gospel', which is what Luther always wants us to find in Scripture, but fully retaining in that conception the literary form in which they are actually found in Scripture.

All this means that, for Luther, '[t]he written Word exists *for the sake of* the personal Word and the spoken Word. Thus one can justly maintain that for Luther Scripture is God's Word in a secondary or derivative sense.'[95] The secondary nature of Scripture's identity with the Word of God is due to Scripture's epistemological role in the establishing of personal relationships between God and human beings: it is by means of the Scripture in which Christ comes to us that we may come to know him. Lotz concludes: 'in urging "Scripture alone" Luther was urging "Christ alone."'[96] It is within this Reformation trad-

[94] Luther, *LW* xxxv.123.

[95] Lotz, '*Sola Scriptura*', 263.

[96] Ibid., 266. The phrase 'Scripture alone' is open to misunderstanding. When used by the Reformers, it did not imply that there was only one authority, rather that Scripture *alone* is the *supreme* authority—not the sole authority for theology, but the final authority over other subordinate authorities. This point is lucidly made by Anthony N. S. Lane, '*Sola Scriptura*? Making Sense of a Post-Reformation Slogan', in Philip E. Satterthwaite and David F. Wright (eds.), *A Pathway into the Holy Scripture* (Grand Rapids: Eerdmans, 1994), 297–327.

ition, which links Christ and Scripture closely and also hier-
archically, that the positive proposals of the subsequent three
chapters are intended to operate. Our attempt is to establish
theological and hermeneutical frameworks for the sufficiency of
Scripture which keep the doctrine of Scripture christologically
oriented, functioning as a servant in relation to Christ.

Viewed from this functional angle, as a statement of how
Scripture serves the necessary christological focus of theology
and Christian faith, the doctrine of the sufficiency of Scripture
appears very similar to that of the perspicuity of Scripture.
Expounding Luther's concept of *claritas scripturae*, Friedrich
Beisser observes that the concept refers not primarily to a text,
but to an audible and public church proclamation: the Word is
clear not in some general sense, but because it is *God's* Word,
and God's saving Word must be clear.[97] This is what Luther
refers to as the external clarity of Scripture: 'all that is in the
Scripture is through the Word brought forth into the clearest
light and proclaimed to the whole world'.[98] Calvin makes a
very similar point when he talks of Scripture's effectiveness, by
which he means that it makes manifest to human hearts that its
truth is divine truth.[99] The clarity of the gospel in Scripture is
therefore a counterpart to Scripture's self-attestation by the
Holy Spirit.

The Reformers are not here asserting that Scripture is suf-
ficient to bring about a response of faith among its hearers and
readers. What a text says and the actual effect it has in the lives
of its readers must be kept conceptually distinct. In the case of
the Bible, faithful response to its message requires the action of
the Holy Spirit within the individual, as Calvin regularly makes
clear: 'Even if it [Scripture] wins reverence for itself by its own
majesty, it seriously affects us only when it is sealed upon our
hearts through the Spirit'; 'Scripture will ultimately suffice for
a saving knowledge of God only when its certainty is founded
upon the inward persuasion of the Holy Spirit.'[100] Luther makes

[97] Friedrich Beisser, *Claritas scripturae bei Martin Luther* (Göttingen: Vandenhoeck & Ruprecht, 1966), 83–5.
[98] Martin Luther, *The Bondage of the Will*, trans. J. I. Packer and O. R. Johnston (Edinburgh: James Clarke, 1957), 74.
[99] See Thiselton, *New Horizons*, 185, referring to Calvin, *Institutes*, i. 8. 1.
[100] Calvin, *Institutes*, i. 7. 5; i. 8. 13.

the same point through his distinction between internal and external perspicuity: the latter refers to Scripture clearly bringing forth the gospel of Christ, and the former to the fact that human failure to grasp God's word is due to our own 'blindness and dullness', not to something inherent in Scripture.[101]

For what, then, according to the Reformers, is Scripture sufficient? Thiselton explicates the epistemological and theological aspects of their answer: epistemologically, Scripture provides 'a ground on which we may confidently proceed'; theologically Scripture provides 'a witness to Christ to which we may confidently respond'.[102] The christological focus which we have observed is well expressed here. It may be added that, for the Reformers, these are two aspects of the same theological reality. The chief question which must be addressed as we come to the post-Reformation period is whether or not this focus was lost in orthodox Protestant theology, that is, whether the further elaboration of the attributes of Scripture took place in increasing abstraction from the fundamental doctrines of God, Christ, and the Holy Spirit.

THE POST-REFORMATION PERIOD

The different aspects of the doctrine of the sufficiency of Scripture remain of great importance in the post-Reformation period: 'the entire doctrine of Biblical authority in Lutheran theology stands or falls with Scripture's sufficiency'.[103] Before we come to the question of continuity and discontinuity between Reformation and post-Reformation doctrines of Scripture, we shall follow the pattern of the preceding sections by looking first at the material aspect and then at the formal aspect

[101] Luther, *The Bondage of the Will*, 72–4. Beisser says that for Luther Scripture is insufficient in that the Spirit is needed to make the word live in our hearts (Beisser, *Claritas scripturae*, 95). This distinction between the meaning and effect of a text, and the consequent clarification of what is meant by calling a text in some way 'sufficient', will become significant in chs. 3 and 4, where concepts developed by speech act theorists will be appropriated.

[102] Thiselton, *New Horizons*, 184–5 (original italics removed).

[103] Robert D. Preus, *The Theology of Post-Reformation Lutheranism: A Study of Theological Prolegomena* (Saint Louis and London: Concordia, 1970), 309.

of the sufficiency of Scripture in this period. The period under consideration is approximately from the middle of the sixteenth century to the end of the seventeenth, moving from the second-generation Reformers through to the period of what is usually known as late Protestant orthodoxy or scholasticism.

The Material Extent of the Sufficiency of Scripture

The majority of statements of the material extent of the sufficiency of Scripture in the post-Reformation period are in uncontroversial continuity with what has been noted of earlier periods.[104] For the Puritan theologian William Ames, for example, writing in 1623, '[a]ll things necessary to salvation are contained in the Scriptures and also those things necessary for the instruction and edification of the church. . . . Therefore, Scripture is not a partial but a perfect rule of faith and morals.'[105] Ames thinks that Scripture's material sufficiency covers matters of church instruction, faith, and morality. Most seventeenth-century Reformed theologians were no more specific than this, taking scriptural sufficiency to cover in general everything a Christian must know and do to please God.[106] The Genevan theologian Francis Turretin (1632–87) is a good example of a writer who takes this position, and who then clarifies the point by stating the areas to which scriptural sufficiency by consequence does not extend. In his main work, *Institutio Theologiae Elencticae*, Turretin asserts that Scripture is 'a full and sufficient rule of faith and practice' in matters 'necessary for salvation, whether of faith or of conduct', but then allows that '[t]here are many matters, appendices and by-laws, as it were, to religion, dealing with the worship and polity of the church, which are not specifically covered by Scripture,

[104] See Heinrich Heppe, *Reformed Dogmatics*, rev. Ernst Bizer, trans. G. T. Thomson (London: George Allen & Unwin, 1950), 28; Richard A. Muller, *Post-Reformation Reformed Dogmatics*, ii: *Holy Scripture: The Cognitive Foundation of Theology* (Grand Rapids: Baker, 1993), 327 ff.

[105] William Ames, *The Marrow of Theology*, trans. and ed. John D. Eusden (Boston and Philadelphia: Pilgrim Press, 1968), 187.

[106] John F. Robinson, 'The Doctrine of Holy Scripture in Seventeenth Century Reformed Theology' (Ph.D. thesis, University of Strasbourg, 1971), 140, 191.

and are left to the decision of the rulers of the church'.[107] The Westminster Confession of Faith similarly limits the material extent of scriptural sufficiency, reflecting a rationalist tendency in its description of how church leaders are to come to decisions in areas not covered directly by Scripture: 'there are some circumstances concerning the worship of God, and government of the Church, common to human actions and societies, which are to be ordered by the light of nature, and Christian prudence, according to the general rules of the word, which are always to be observed' (1. 6).

This question became a significant issue between conformists and Puritans in England in the controversy over the 'regulative principle'. On one side, Hooker argued that Scripture regulated preaching, but that matters of church polity could be decided differently in different situations. Whitgift saw no difference between something being 'not against Scripture' and 'according to Scripture'.[108] On the other side, the Puritan John Cartwright felt that all this restricted Scripture's actual reach: 'I say that the Word of God containeth the direction of all things, pertaining to the church, yea of whatsoever things can fall into any part of a man's life.'[109] One of the noteworthy elements of this debate was that all parties were agreed that Scripture is sufficient for salvation, both materially and formally, as the source and norm of preaching and doctrine. In this work no judgement will be offered on detailed questions of the actual material extent of scriptural sufficiency, for that is to be determined case by case, by biblical exegesis. We shall restrict ourselves to reconstructing the bases of the doctrine of scriptural sufficiency to the extent that it was shared by the vast majority of Protestant theologians of the Reformation and post-Reformation periods, including those on both sides of the 'regulative principle' controversy.

A common theme in this period is that 'matters necessary for

[107] Francis Turretin, *The Doctrine of Scripture: Locus 2 of Institutio Theologiae Elencticae*, ed. and trans. John W. Beardslee (Grand Rapids: Baker, 1981), 167–8.

[108] Reventlow, *The Authority of the Bible*, 116.

[109] Quoted in Graham Cole, 'Sola Scriptura: Some Historical and Contemporary Perspectives', *Churchman* 104 (1990), 20–34, at 22. Cole judges Cartwright to be 'a Scriptural totalitarian'.

salvation found in Scripture', while not extending to details of church polity, do include doctrines derived from Scripture. The Westminster Confession speaks in this regard of matters which 'by good and necessary consequence may be deduced from Scripture' (1. 6). This point needed to be made to counter claims, made especially by Socinians, that Scripture cannot be sufficient because, for example, the doctrines of the Trinity and of the deity of Christ are not directly stated in it. However, this defence against Socinians left the Protestant orthodox open to the Roman Catholic point that a positive view of the process of doctrinal deduction from Scripture implied that the church was authorized to set forth new articles of faith. Turretin responded that '[Scripture] does not lead to another who teaches, but brings forth from within itself [teachings] that were implicitly lying there.'[110]

Something may be said here about the question of the material sufficiency of Scripture in post-Reformation Roman Catholic theology. Muller notes that many Catholic theologians of this period, in order to counter the Protestant doctrine of Scripture, found themselves arguing against the high view of Scripture articulated by such medieval theologians as Aquinas and Duns Scotus.[111] However, in the twentieth century Josef Geiselmann sparked a debate over whether or not the final text of the Council of Trent on Scripture and tradition, which consolidated the Catholic position in opposition to that of the Reformation, did in fact affirm the existence of two sources of revelation—Scripture and the church—as has traditionally been supposed. The drafts of Trent's declaration on Scripture and tradition spoke of revelation as coming partly through Scripture and partly through the church (*partim . . . partim*), but in the final text this was changed to a description of revelation as coming through both Scripture and the church (*et . . . et*). Geiselmann suggested that this change had semantic rather than merely stylistic connotations. He argued that the final text, in contrast to the drafts, advocates a view not of two

[110] Turretin, *The Doctrine of Scripture*, 179–80. Turretin is here responding to the Roman Catholic Perronius, who argued that Scripture has a 'mediate' sufficiency that leads us to the church which makes good its defects (see Muller, *Post-Reformation Reformed Dogmatics*, 334).

[111] Muller, *Post-Reformation Reformed Dogmatics*, 327.

sources of revelation but of the same revealed content coming
via two media. Those post-Reformation Roman Catholics who
did advocate a two-source view of revelation, of whom there
were many, erred, according to Geiselmann, in applying their
view to matters of faith and not just to matters of indiffer-
ence.[112] In the twentieth century, however, the majority Roman
Catholic position shifted from this, to the view that Scripture,
while still formally insufficient, requiring authoritative church
interpretation, is materially sufficient for salvation. That is
Geiselmann's own view: the content of Scripture is substan-
tively sufficient, but insufficient for knowledge of that con-
tent.[113]

The details of Geiselmann's arguments about the intentions
of the Tridentine authors lie beyond our present concerns.
They have been accepted by some[114] and rejected by others.[115]
Karl Rahner suggests that Trent's formulations were simply
not precise enough to answer the modern question of whether
Scripture is materially insufficient 'with regard to its contents
and as compared with tradition',[116] and himself comes to the
same position as Geiselmann on the sufficiency of Scripture,
which he calls a Roman Catholic *sola scriptura*.[117] What is sig-
nificant here, though, is the disagreement of this contemporary
Roman Catholic position with that of the Protestant Reforma-
tion. It is a disagreement over the *locus* of the action of the Holy
Spirit in relation to Scripture: is the *locus* of the Holy Spirit's
authoritative interpretative work the church or the text? Theo-
logically, it is this that is ultimately at stake with the Protestant
claim that Scripture is formally sufficient for its own interpre-
tation.[118]

[112] Geiselmann, *Die Heilige Schrift*, 270.

[113] Scripture is sufficient 'ihrem Sein nach', and insufficient 'der Erkenntnis
nach' (Geiselmann, *Die Heilige Schrift*, 272).

[114] e.g. Tavard, *Holy Writ*, 242–5.

[115] e.g. Oberman, *Harvest*, 407.

[116] A. N. S. Lane agrees: 'the final text of the decree remains neutral as to
the material (in)sufficiency of Scripture' (Lane, 'Scripture, Tradition and
Church', 46).

[117] Karl Rahner, *Theological Investigations*, vi trans. Karl-H. and Boniface
Kruger (Baltimore: Helicon; London: Darton, Longman & Todd, 1969),
104–7.

[118] The question of the action of the Holy Spirit in relationship to Scripture
will also be discussed in ch. 4.

The Formal Aspect of the Sufficiency of Scripture

In the foregoing brief excursus on the post-Reformation Roman
Catholic position on Scripture and tradition the question of the
formal sufficiency of Scripture has already been taken up. In his
scholastic manner, the orthodox Protestant Francis Turretin
begins his discussion of the matter, under the heading 'The
Supreme Judge of Controversies and the Interpreter of Scrip-
ture', thus: 'Is Scripture, or God speaking in Scripture, the
supreme and infallible judge of controversies and the inter-
preter of Scripture, rather than the church or the Roman ponti-
fex? (Affirmative, against the Roman Catholics).'[119] William
Ames, around fifty years earlier, makes a similar statement:
'The Scriptures need no explanation through light brought
from outside, especially in the necessary things. They give light
to themselves.'[120] A third example may be given, from the West-
minster Confession of Faith: 'The infallible rule of interpreta-
tion of Scripture is the Scripture itself: and therefore, when
there is a question about the true and full sense of any Scripture
(which is not manifold, but one), it must be searched and
known by other places that speak more clearly' (1. 9). These
statements are typical of Protestant orthodox theologians in the
post-Reformation period.[121] Scripture thus came to be spoken
of as the *principium cognoscendi* for theology and Christian faith:
'If traditions agree with Scripture they are confirmed by it; if
they oppose it they are disproved by it.'[122] As well as serving as
a polemic against Roman Catholics, this argument was also
mounted against Socinians, who based Scripture's authority on
empirical evidence.[123]

In this polemical context it is important to note what the
Protestant orthodox were not claiming. Their position was not
a flat rejection of any authoritative role for church tradition.
Historical traditions, such as those which state which books the
church received as of divine origin, and how certain passages of

[119] Turretin, *The Doctrine of Scripture*, 209.

[120] Ames, *The Marrow of Theology*, 188.

[121] Further documentation may be found in Heppe, *Reformed Dogmatics*,
33ff.; Muller, *Post-Reformation Reformed Dogmatics*, 334 ff.

[122] Edward Leigh, quoted in Muller, *Post-Reformation Reformed Dogmatics*,
337.

[123] Preus, *Post-Reformation Lutheranism*, 298–9.

Scripture were understood, could be accepted, but remained ultimately open to questioning on the basis of Scripture. What was rejected were 'dogmatic traditions'—prescriptions of aspects of faith and practice found neither explicitly nor implicitly in Scripture.[124] Nor, in relation to 'enthusiasts', does this position deny the necessary role of the Holy Spirit in relation to Scripture, as the Westminster Confession of faith states: 'The supreme Judge, by which all controversies of religion are to be determined, and all decrees of councils, opinions of ancient writers, doctrines of men, and private spirits, are to be examined, and in whose sentence we are to rest, can be no other but the Holy Spirit speaking in Scripture.'[125] Heppe argues that, for the Protestant orthodox, 'the most essential requisite [for correct interpretation of Scripture] is faith and life in the fellowship of the Holy Spirit'.[126] What is denied is that individual conviction about the meaning of a particular passage of Scripture can carry divine authority to go unchecked by traditional interpretations, by the literal verbal meaning of the biblical text in question, or by other places in Scripture.[127] Johann Gerhard, for example, accused both Roman Catholics and 'enthusiasts' of breaking the vital connection between Scripture's *verbum* and *sensus*.[128] The following discussion, which will outline the widespread rejection of post-Reformation orthodoxy, and offer some defence, will continue to focus on the formal aspect of the sufficiency of Scripture.

Continuity and Discontinuity in the Post-Reformation Period

There is a consensus of opinion that, in the two centuries after the Reformation, many Protestant articulations of the doctrine of Scripture slipped the theological moorings which had held the doctrine firmly in place during the Reformation itself.

[124] Heppe, *Reformed Dogmatics*, 30–1.
[125] Westminster Confession of Faith, 1. 10.
[126] Heppe, *Reformed Dogmatics*, 39.
[127] The Lutheran theologian Johann Gerhard (1582–1637) regarded the primary evidence of the authority of the Bible, the internal witness of the Holy Spirit, to be internal to *Scripture*, not the person (Bengt Hägglund, *Die Heilige Schrift und ihre Deutung in der Theologie Johann Gerhards* (Lund: CWK Gleerup, 1951), 94–6).
[128] Hägglund, *Die Heilige Schrift*, 221.

The basic objection is that what were taken to be Scripture's 'attributes'—typically perfection, sufficiency, perspicuity, and necessity—came to be grounded less in Christology and more in the fact of the divine inspiration of Scripture.[129] As one writer has put it, 'the objectively understood inspiredness of Scripture becomes the source from which the objective properties are derived'.[130] The attributes, understood as objective properties of the biblical texts, then become the ground of Scripture's authority, rather than its authority being located in the Christ to whom the text bears witness. Karl Barth objected that the Protestant scholastics so dislocated Scripture from its role as witness to Christ that they turned the proclamation of the gospel into 'a fixed sum of revealed propositions which can be systematised like the sections of a corpus of law'.[131] This position, and its contemporary forms, is often termed 'biblicism'. It has been well described as

[a] view of Scripture and its authority which is based on the divine attributes ('perfections') of the Bible as a 'supernatural book.' The Bible's authority is thereby located in its 'form' as an inspired book, rather than in its matter or content. The Bible's divine inspiration and factual inerrancy guarantee the truth of its message, with the result that faith, though directed ultimately to Christ, is first directed to the Bible as written Word of God.[132]

On the basis of this consensus view of post-Reformation Protestant orthodoxy, it might be argued that to focus in detail, as this entire book does, on one of the traditional attributes of Scripture is to be implicated in the theological errors of 'biblicism' and in its resultant theological distortions. A full

[129] These objective properties, or attributes, attain no definitive listing. Within the variation, the four listed here emerge as the most common and significant. For different lists of attributes in different theologians, see Heppe, *Reformed Dogmatics*, 21–2; Otto Weber, *Foundations of Dogmatics*, i, trans. Darrell L. Guder (Grand Rapids: Eerdmans, 1981), 268. A complex diagram of the attributes claimed for Scripture, listing many more than the main four, derived from Johann Friedrich König's *Theologia positiva acroamatica* (1664), can be found in Carl Heinz Ratschow, *Lutherische Dogmatik zwischen Reformation und Aufklärung*, i (Gütersloh: Gütersloher Verlagshaus Gerd Mohn, 1964), 101.

[130] Weber, *Foundations of Dogmatics*, 268.

[131] Karl Barth, *Church Dogmatics* i/1, trans. G. W. Bromiley (Edinburgh: T. & T. Clark, 1975), 137. [132] Lotz, *'Sola Scriptura'*, 268 n. 30.

theological response to this fundamental objection will only emerge as the arguments of subsequent chapters unfold. However, in order to respond here to this objection historically, appeal will be made to the work of two historical theologians. Robert Preus and Richard Muller, working in great detail on post-Reformation Lutheranism and post-Reformation Reformed theology respectively, both defend post-Reformation orthodox theologians against the charge that they departed significantly from the earlier Reformers.[133]

The defence of Protestant orthodoxy against this charge will focus especially on the late-seventeenth-century Genevan Reformed theologian Francis Turretin. He has been chosen both because he is often quoted as representing the high-point (or the nadir) of Protestant biblicism,[134] and because his work is representative of the kind of Protestant orthodoxy which was influential on the orthodox doctrines of Scripture developed by nineteenth-century theologians at Princeton, whose work has in turn had a significant impact on present-day attitudes to the orthodox doctrine of Scripture.[135] In the middle of the nineteenth century, Turretin's main work, *Institutio Theologiae Elencticae*, was translated by a classics professor at Princeton at the request of Charles Hodge, who wished his students to be able to study it in English.[136]

[133] In the overall conclusion, ch. 6, the relationship between this book's conclusions and contemporary Christian fundamentalism will be summarized. In addition, Barth's alternative to 'biblicism' will be examined in ch. 3, and ch. 5 will deal in part with the 'biblicist' doctrine of biblical inspiration of B. B. Warfield.

[134] Two writers who basically defend Turretin, although not blindly, acknowledge that he is usually seen as a 'hard case': W. Robert Godfrey, 'Biblical Authority in the Sixteenth and Seventeenth Centuries: A Question of Transition', in D. A. Carson and John D. Woodbridge (eds.), *Scripture and Truth* (Leicester: Inter-Varsity Press, 1983), 225–43, at 237; John D. Woodbridge, *Biblical Authority: A Critique of the Rogers/McKim Proposal* (Grand Rapids: Zondervan, 1982), 22.

[135] See Woodbridge, *Biblical Authority*, 22. Woodbridge cautions, however, against the tendency to think of the Princetonian view of Scripture as mostly *determined* by Turretin. Princeton theologians, he says, read very widely, and, although he used Turretin as a textbook, C. Hodge often disagreed with him, and found his overall theology too scholastic (Woodbridge, *Biblical Authority*, 135, 218 n. 84).

[136] This translation, by George Musgrave Giger, has only recently been published: Francis Turretin, *Institutes of Elenctic Theology*, ed. James T.

The choice of a Reformed theologian does not entail a focus on issues which separated the Reformed from Lutherans. As regards the doctrine of Scripture, the chief area of disagreement between Reformed and Lutheran was over the Lutheran claim, and the Reformed denial, that the Word itself is efficacious. Thus the Lutheran Johann Gerhard, in response to the claim of Rahtmann that Scripture's efficacious power (*Wirkungskraft*) is dependent on the internal illumination of the Holy Spirit, asserted that Scripture has the power to illuminate and make alive 'in and of itself'.[137] Preus says of Abraham Calov, a Lutheran who makes the same claim as Gerhard, that he is attempting only to argue that Scripture's divine origin must lend it some intrinsic power.[138] In stressing Scripture's divine origin, Lutherans were of course no different from the Reformed. According to Preus, the Lutheran assertion of the efficacy of the Word is a corollary of their refusal to answer the question of why some responded to the Word and some did not. Calvinists answered that question by stating that the call of God in the gospel was not efficacious in the case of the non-elect, since God did not send his Spirit into their hearts. Lutherans could only see this as a view of God as sometimes 'not serious' when he called through the gospel, and preferred to rescue God's action in salvation from apparent arbitrariness by ascribing efficacy to the Word itself.[139] Since we are not concerned here with the attribute of the efficacy of Scripture, we may treat Reformed and Lutheran orthodox theologians together. Indeed, the charge that orthodox theology moved towards an objectifying view of Scripture in the post-Reformation period, which is the consensus position we wish to question, is levelled at Lutheran and Reformed theologians alike. This consensus view will be outlined, in three different formulations of its objection to post-Reformation orthodox theology, and a brief response

Dennison, Jr. (Phillipsburg, NJ.: Presbyterian & Reformed, 1992–4). For a brief account of the history of Giger's translation see p. xxvii of the editor's preface in vol. i. A more recent translation by John W. Beardslee of Locus 2—the *locus* on the doctrine of Scripture—has been published separately, in a volume which has been referred to above.

[137] 'In und bey sich' (Hägglund, *Die Heilige Schrift*, 255).
[138] Preus, *Post-Reformation Lutheranism*, 368.
[139] Ibid., 376.

will be offered to each.[140] Alongside the theology of Francis Turretin, the Westminster Confession of Faith will be taken as a classic expression of post-Reformation Protestant orthodox doctrine of Scripture.

The clarity of Scripture: content and words

G. C. Berkouwer sees in the post-Reformation period a shift towards the view that 'the *words* of Scripture, particularly in their semantic function' are perspicuous, in contrast to the Reformers' conception of the clarity of Scripture, which aimed only to emphasize that the message of salvation really does come through when Scripture is read.[141] Ebeling makes the same criticism, arguing that the emphasis shifted 'from the clarity of the subject-matter to the inviolability of the actual words and letters of Scripture'.[142]

Although Turretin is of course interested in Scripture's actual words, in his discussion of the perspicuity of Scripture the emphasis is certainly on Scripture's content. What he calls Scripture's 'sublime mysteries' are so presented in Scripture, he says, that 'a believer who has enlightened eyes of the mind can comprehend these mysteries sufficiently for salvation if he reads carefully'.[143] The same is true of the Westminster Confession of Faith's statement on perspicuity: what is plain in Scripture is 'those things which are necessary to be known . . . for salvation' (1.7). Muller suggests that the Reformed orthodox were simply developing what was implicit in the Reformers' confessions, since once Scripture itself was established as the only norm for interpretation, it followed logically that 'at least the crucial *loci* would have to be grammatically clear', in order

[140] It is not argued here that no development took place between the Reformation and seventeenth-century Protestant orthodoxy—rather that whatever development there was did not represent a fundamental shift from a 'dynamic' to an 'objective' doctrine of Scripture. John Webster suggests, e.g., that post-Reformation dogmatics inadvertently prepared the way for 'non-theological construals of the Bible' by developing a theological episte-mology that was insufficiently trinitarian (John Webster, 'Hermeneutics in Modern Theology: Some Doctrinal Reflections', *Scottish Journal of Theology* 51 (1998), 307–41, at 323–4).

[141] Berkouwer, *Holy Scripture*, 272–5.

[142] Ebeling, '"Sola Scriptura" and Tradition', 139.

[143] Turretin, *The Doctrine of Scripture*, 186.

for one text to shed light on another without recourse to the church.[144] It was only by linking the clarity of Scripture's content to the clarity of its words that orthodox theologians were able to keep the confession of Scripture's perspicuity from falling into obscurantism or nonsense, especially as historical awareness of the original languages of the Bible began to grow. Luther himself makes this link at one point, noting that certain passages of Scripture are obscure to us because of our linguistic ignorance.[145] Where the content is perspicuous, that is presumably in part due to our linguistic capabilities. Thus, a necessary aspect of perspicuity as a theological confession is a semantic perspicuity, understood as a limited claim about the language, grammar, and words of Scripture. However, this logical linking of the clarity of Scripture's content with the clarity of its words does not necessarily represent a focusing of attention on the words of Scripture *over against* its content. To address semantic issues is not necessarily to fall from the example set by the Reformers.

Neither does one necessarily fall away from a dynamic view of Scripture by regarding the attributes of Scripture as implying hermeneutical principles. 'Luther observes that all books are to be interpreted in the spirit of their author', and that therefore Scripture, authored by the Holy Spirit, must be self-interpreting, since in all cases the spirit of an author is best discerned in his writings.[146] Thus in Luther we find perspicuity as a theological principle closely tied to hermeneutical and semantic claims. If the orthodox successors of the Reformers developed these hermeneutical and linguistic points, that may be seen as a natural development of, rather than a departure from, the Reformers' theological construal of Scripture's attributes.

The centre of Scripture: Christ and salvation

The consensus view of the Reformed scholastics, and particularly of Francis Turretin, is that their theology was not systematically christocentric, but was structured and grounded on a

[144] Muller, *Post-Reformation Reformed Dogmatics*, 341.
[145] Luther, *The Bondage of the Will*, 71.
[146] Althaus, *Theology of Martin Luther*, 76.

rational demonstration of Scripture's supposed attributes.[147] Carl Heinz Ratschow makes the same argument with regard to Lutheran theology, tracing what he sees as a development in the Lutheran doctrine of Scripture. Before 1600, he says, it was common for Lutheran theologians to begin their theologies with a *locus* on Scripture as the *principium cognoscendi*, followed by a *locus* on God as *principium essendi*. These two principles were regarded as two sides of the same *res*: God himself in his relation to the world. This close relationship was lost, according to Ratschow, towards the end of the sixteenth century, and he traces the end of the separation of the two elements to Johann Franciscus Buddheus, whose main work was published in 1724. Buddheus, argues Ratschow, establishes Scripture as *principium* on the basis of its attributes, treating Scripture as significant only to the extent that it provides dogmatic statements. The previous close connection with the salvific activity of God is lost.[148]

Robert Preus defends the Lutheran orthodox against this challenge. His view, documented at great length and in direct contrast to that of Ratschow, is that one of the great achievements of the Lutheran orthodox was to present a doctrine of Scripture which functioned 'soteriologically and doxologically in the service of the living Christ'.[149] On the Reformed side, Timothy Ross Phillips defends Turretin against the same charge by examining the concept of 'theology' which Turretin develops in the prolegomenon to his *Institutio*. Turretin distinguishes supernatural from natural revelation, and says of the former that it is from Christ and speaks of him, is called the Old and New Testaments, and is called Christian because Christ is its author or object.[150] Here at least, Turretin's approach to Scripture seems christocentric. He then says that supernatural theology can be considered in two different ways: systematically, 'denoting the system of saving doctrine concerning God and divine things drawn from the Scriptures', and habitually,

[147] This argument is well documented in Timothy Ross Phillips, 'Francis Turretin's Idea of Theology and Its Bearing Upon His Doctrine of Scripture' (Ph.D. thesis, Vanderbilt University, 1986), 13 ff.

[148] Ratschow, *Lutherische Dogmatik*, 72.

[149] Preus, *Post-Reformation Lutheranism*, 411.

[150] Turretin, *Institutes*, i. 1. 2. 7.

'after the manner of a habit residing in the intellect'.[151] In the rest of the prolegomenon it is the habitual aspect which becomes significant. This 'habit' is not 'intellectual' in an ordinary modern sense of that word, however. Turretin relates 'the habit of knowing' to Greek concepts of knowledge, and concludes that in the case of theology it is to be understood 'in the Stoical sense, as a collection of all habits, intellectual as well as moral'.[152]

Phillips argues in addition that Turretin's foundational concept for his theology is that it is 'ectypal' theology. This concept comes from Turretin's assertion that God, in communicating to us not his essence but a likeness—an ectype of the archetypal theology, which is 'the original and uncreated wisdom by which God knows Himself'—nevertheless gives us confidence that our theology speaks truly of him, because of his self-revelation in Jesus Christ, who is precisely divine revelation in a form suitable to the creature. Thus, '[t]he ectypal theology is grounded solely in God's action'.[153] Theology is then for Turretin, according to Phillips, 'a divine wisdom, a praxis and cognizance of God and divine things, which is revealed in Jesus Christ through the Word'.[154] This is the outline of a practical and christocentric theological epistemology. Such a view of theology could of course not be said to represent a fall away from the Reformation's christocentric and soteriological emphases.[155]

If Turretin's doctrine of Scripture is read in the light of this

[151] Turretin, *Institutes*, i. 1. 2. 8.

[152] Ibid., i. 1. 6. 7.

[153] Phillips, 'Francis Turretin's Idea of Theology', 129–32.

[154] Ibid., 331.

[155] See in addition, on orthodox Lutheran theology of the scholastic period: 'The notion of theology as *habitus* θεόσδοτος occurs frequently in Lutheran Orthodoxy . . . Theology is θεόσδοτος simply because its subject-matter, contained in Holy Scripture, is given by God. All cognitive functions which have their origin in an encounter with that subject-matter could therefore be described as "God-given" operations, and when "habitualized," as a God-given *habitus*' (Kenneth G. Appold, *Abraham Calov's Doctrine of* Vocatio *in its Systematic Context*, Beiträge zur historischen Theologie 103 (Tübingen: Mohr Siebeck, 1998), 65). In this light, Rogers and McKim are quite wide of the mark when they generalize thus: 'The desire for "certainty" among the post-Reformation scholastics was for a tangible, human certainty of the Bible's inspiration rather than for a divine certainty brought about by faith' (Jack B. Rogers and Donald K. McKim, *The Authority and Interpretation of the Bible: An Historical Approach* (San Francisco: Harper & Row, 1979), 421).

introductory delineation of the nature of theology, it is hard to conclude that he bases the authority of Scripture fundamentally not on its necessary relation to Christ, the Lord of Scripture, but on objective textual attributes. It is possible that in the subsequent *locus* on Scripture in his great *Institutio* Turretin does not in every detail consistently hold to the epistemological principles which he lays down for theology in the prolegomenon. However, the relative lack of discussion available on his theological prolegomenon suggests that Woodbridge is right to call for more research to be done on Turretin's work as a whole, both published and unpublished, before a firm but perhaps superficial stance is taken against the theological status he gives to Scripture in Locus 2 of the *Institutio*.[156] This book as a whole amounts to an argument that the doctrine of Scripture which Turretin defends in his *Institutio*, with its strong emphasis on the sufficiency of Scripture, is in no fundamental way at odds with the christocentric, practical theological epistemology which he develops in the prolegomenon to the *Institutio*.

Canon and inspiration

The post-Reformation orthodox doctrine of the inspiration of Scripture is regarded by the consensus interpretation of Protestant scholasticism as the cause of a number of different problems. The inspiration of Scripture will be dealt with at some length in Chapter 5; here, by way of introduction to that discussion, one particular point may be made.

On the question of the ground of the canon of Scripture, Edward Dowey contrasts the Westminster Confession of Faith unfavourably with the Second Helvetic Confession. Since for Bullinger, in the latter confession, Scripture is the Word of God as 'wort, will und meinung', and not as sound in the air, ink, or paper, says Dowey, the Word is there rightly related to its soteriological centre. By contrast, in the Westminster Confession it is 'left as a formally defined canon'.[157] Muller rejects this, arguing that the Westminster Confession of Faith grounds

[156] Woodbridge, *Biblical Authority*, 116–17.

[157] Edward A. Dowey, Jr., 'The Word of God as Scripture and Preaching', in W. Fred Graham (ed.), *Later Calvinism: International Perspectives*, Sixteenth Century Essays and Studies 22 (Kirksville, Mo.: Sixteenth Century Journal Publishers, 1994), 5–18, at 8–9.

Scripture's authority not on the concept of inspiration but on its nature as Word. He refers to the conclusion of John Leith that Westminster 'marks a formal development of the Reformed doctrine of Scripture without any abandonment of the premises of early Reformed doctrine'.[158] Muller agrees with Heppe that the Reformed orthodox did develop an 'increasingly rigid approach to the canon of Scripture', but argues that this is not, as Heppe thinks, because they 'set aside an earlier Protestant distinction between Holy Scripture and the Word of God', but because '[t]he early Reformers were more able than their successors to allow for an unevenness of quality in Scripture—for a clearer and fuller communication of the Word in some places than in others'.[159] In Chapter 5 a similar point will be made about the inflexibility of the terminology of 'oracle of God' which B. B. Warfield, at the turn of the twentieth century, regularly applied to Scripture; other possibilities for conceiving of the diversity of Scripture will be investigated. However, we shall question whether a direct identification of Scripture with the Word of God, and a concomitant doctrine of inspiration, necessarily entails an attempt to read the gospel of Christ directly out of every individual verse or text.

Summary

The argument of Muller, Preus, and others in defending post-Reformation orthodox theologians against the charge that they departed significantly from the Reformation understanding of Scripture is basically that their theology changed in *form* in comparison with that of the Reformers, adopting medieval scholastic models, but not to any great extent in *content*.[160] Where later Reformed theologians seem to offer a more static conception of Scripture, that is because their chosen literary genre, 'fully developed theological system', was different from that of the Reformers; yet 'nowhere do the orthodox reject the

[158] Muller, *Post-Reformation Reformed Dogmatics*, 79–81.

[159] Ibid., 417.

[160] 'The key point of Muller's analysis is that the Reformed scholastics employed medieval models for systematizing theology but retained the basic doctrinal content of the Reformation' (Martin I. Klauber, 'Continuity and Discontinuity in Post-Reformation Theology: An Evaluation of the Muller Thesis', *Journal of the Evangelical Theological Society* 33 (1990), 467–75, at 470).

Reformers' insight into the personal and subjective power of the Word'.[161]

One formal innovation over the Reformation was in the development and placing of a section on Scripture in systematic theologies immediately after the prolegomenon and before the discussion of the doctrines of God or Christ. However, defenders of orthodox theologians regularly point out that in the late sixteenth century the threats to Protestant orthodoxy were precisely formal, and increasingly sophisticated, coming from Socinianism and Roman Catholicism. The orthodox necessarily responded on their opponents' terms, while still stressing the centrality of the gospel's saving content.[162] If they had not responded to vociferous and intelligent opponents in this way, they would likely have been condemned then and now for ducking the issue. It may well be that, as often happens in theology, what began as *ad hoc* attempts to answer opponents on their own terms soon made a substantive contribution to theological formulation; Muller argues that in the period of 'high orthodoxy' (*c*.1640–1700) polemic was consistently rationalized into positive doctrine.[163] Nevertheless, a good case can be made, given a more careful reading of their work than the Protestant orthodox have sometimes received, that the form of their theology did not significantly obscure the basic theological content which they inherited from the Reformers.

THE PERIOD OF DECLINE

The reasons for the decline of the doctrine of the sufficiency of Scripture, as one aspect of belief in the Bible as supremely authoritative for Christianity, are of course highly complex, and nothing approaching a full discussion of them can be offered here. This section will take as its focus the rise to prominence of critical and sceptical thought in theology and biblical studies. Contemporary thought has furthered the decline of the sufficiency of Scripture in many ways, both directly and in attacking its hermeneutical bases. The historical description begun

[161] Muller, *Post-Reformation Reformed Dogmatics*, 67.
[162] Godfrey, 'Biblical Authority', 237; Muller, *Post-Reformation Reformed Dogmatics*, 321.
[163] Muller, *Post-Reformation Reformed Dogmatics*, 123–4.

here will later be developed, as the most significant modern hermeneutical and theological questions are addressed as they arise in Chapters 4 and 5.

Henning Graf Reventlow has traced in great detail the mutual influences exercised on each other by the Bible and intellectual and constitutional developments in England in the seventeenth and eighteenth centuries, particularly in relation to the rise of deism. He concludes that biblical criticism in England was motivated to a great extent by political concerns, as Whigs wished to deprive High Church Tories of the support they claimed in the Bible for their political positions.[164] Of greater importance, when the decline of biblical authority is considered in Western Europe as a whole, is a mixture of historical and religious motivations, galvanized by the desire to rescue Europe from the religious wars which had devastated large tracts of it. These concerns became focused for many people on the desire to have God, as Michael Buckley puts it, without either the church or Christ—that is, to have religion without an ecclesiastical structure able to wield both political and social power, and without a highly particular theological centre serving to exclude others from the 'true faith'.[165]

It is clear from even this brief description that in the period under consideration here political, historical, religious, and theological themes coincide in ways that suggest a world quite different from that of the early twenty-first century. In order to limit the following discussion by focusing on our particular concerns, the theological elements in the decline in belief in the sufficiency of Scripture will be highlighted. This decline will be analysed into treatments of the decline of each of the above-mentioned three elements of the doctrine. Since these three elements are abstractions from the doctrine for the purposes of analysis and reconstruction, there is inevitably some overlap in the discussion of their decline.

Two overall themes may be observed in the gradual decline of the authority of Scripture. First, there is a growing historical awareness, especially of the original historical locatedness of biblical texts and of the history of their redaction, canonical

[164] Reventlow, *The Authority of the Bible*, 329.

[165] Michael J. Buckley, SJ, *At the Origins of Modern Atheism* (New Haven and London: Yale University Press, 1987), 38–9.

compilation, and transmission. Second, there is a rejection of history as the *locus* of divine revelation—what Eberhard Jüngel characterizes as 'the prevailing interest in the unhistoricality of God'.[166] The simultaneous interest in and rejection of history in biblical and theological studies which these two themes represent has caused debates about critical biblical scholarship which still continue.[167] However, it is easy to see how this ambivalence might function in the rejection of biblical authority: God cannot and does not reveal himself in the particular ways which a Christian view of revelation-in-history would require, and in this theological context historical study attempts to demonstrate the Bible's inability to rise in any significant way above the specificities of its origin to a position of trans-cultural authority. J. S. Semler is an early example of a writer who regarded the New Testament as 'a witness to its own time, and not primarily as intended for today's reader'.[168]

Divine Speech

The identification of Scripture with divine speech is grounded on the theological assertion that God can and does reveal himself in particular ways in some of the specificities of history, as opposed to in history in general. It is to this theological assertion of supernatural revelation that the Enlightenment was, says Michael Buckley at the beginning of his large study of the origins of modern atheism, 'irrevocably hostile'.[169] The most well-known philosophical statement of this view is Lessing's assertion that 'accidental truths of history can never become the proof of necessary truths of reason'.[170] One of its most

[166] Eberhard Jüngel, 'Anthropomorphism: A Fundamental Problem in Modern Hermeneutics', in Jüngel, *Theological Essays*, trans. and ed. J. B. Webster (Edinburgh: T. & T. Clark, 1989), 72–94, at 86.

[167] See e.g. James Barr's rejection of B. S. Childs's claim that nineteenth-century historical criticism privileged historical over theological questions, and so operated with a reductionist approach to Scripture (James Barr, 'The Literal, the Allegorical, and Modern Biblical Scholarship', *Journal for the Study of the Old Testament* 44 (1989), 3–17).

[168] Werner Georg Kümmel, *The New Testament: The History of the Investigation of its Problems* (London: SCM Press, 1973), 65. ·

[169] Buckley, *At the Origins*, 37.

[170] Lessing, *Lessing's Theological Writings*, ed. Henry Chadwick (London: A. & C. Black, 1956), 53. In his introduction to this volume Chadwick traces

significant theological expositions is found in Spinoza's *Trac-
tatus Theologico-Politicus*, which was influential on Lessing's
work.[171] For Spinoza, the history and doctrine which the Bible
contains is of no authority for us; religion and biblical authority
are matters of morality alone. What he says of the prophets is
representative of his attitude to the whole Bible: 'the authority
of the prophets has weight only in matters of morality, and . . .
their speculative doctrines affect us little'.[172] In an argument
superficially similar to that for the sufficiency of Scripture,
Spinoza insists that the Bible alone should determine its own
meaning: 'all knowledge of spiritual questions should be sought
from it alone, and not from the objects of ordinary know-
ledge'.[173] However, as regards its *truth*, Scripture is radically
insufficient, being subject to the adjudication of reason: 'the
rule for such [biblical] interpretation should be nothing but the
natural light of reason which is common to all'.[174] Spinoza
therefore establishes something of a provisional sufficiency of
Scripture as regards its meaning, but only in order to nullify
its truth-claim and therefore to deny its actual sufficiency and
authority for theology.[175] John Webster characterizes this as a
view of the self as pre-doctrinal judge of questions of biblical
interpretation.[176]

Spinoza locates the source of natural theology especially in
the human mind. In the context of asserting that even our most

the influence of Lessing on Schleiermacher's *Christmas Eve* through to D. F.
Strauss's divorcing of Gospel history from the 'eternal truths' of Christianity,
(30–2).

[171] Chadwick, 'Introduction', in *Lessing's Theological Writings*, 30.

[172] Spinoza, *Tractatus Theologico-Politicus*, in *The Chief Works of Benedict
de Spinoza*, i, trans. R. H. M. Elwes (London: George Bell & Sons, 1883),
1–278, at 8.

[173] Ibid., 9.

[174] Ibid., 119. See also: '[theology] defines the dogmas of faith . . . only in
so far as they may be necessary for obedience, and leaves reason to determine
their precise truth' (ibid., 194).

[175] See Hans Frei's comment on the eighteenth century, i.e. the century
after Spinoza: 'Belief in the authority and unity of the Bible declined but
confidence in its meaningfulness remained strong, especially if one did not
have to believe that all of it is equally meaningful' (Hans W. Frei, *The Eclipse
of Biblical Narrative: A Study in Eighteenth and Nineteenth Century Herme-
neutics* (New Haven and London: Yale University Press, 1974), 110–11).

[176] Webster, 'Hermeneutics in Modern Theology', 315.

ordinary knowledge, including knowledge of morality, comes
from God, he says that '[a]ll that we clearly and distinctly
understand is dictated to us . . . by the idea and nature of
God.'[177] These reside particularly in the mind, which is 'the
true handwriting of God's Word'.[178] Jüngel observes that this
is an interesting rationalist version of the dictation-theory of
inspiration.[179] It is not clear that for Spinoza even Jesus was any
different from the rest of humanity in this regard: God did not
'speak' to him; rather 'Christ communed with God mind to
mind'.[180]

Thus religion in general, and specifically the 'voice' of God,
are reduced to a morality discernible by a human reason in prin-
ciple open to use by all. The same is also characteristic of the
theological views of the deists who came to prominence in Eng-
land in the seventeenth and eighteenth centuries. Most deists
tried to show that the content of the Bible was in accordance
with natural religion. Henry Chadwick summarizes thus: 'The
theologians of the Enlightenment did not reject the Bible; they
found in it only natural religion.'[181] According to Reventlow,
however, the deist Thomas Chubb, while attempting to demon-
strate the overlap between Christian revelation and natural
religion, in fact developed a 'moralistic system' with no place for
any of the historical events of Christ's life, nor for the doctrines
of substitutionary atonement and original sin. What Chubb,
like most deists, actually rescued from the Bible as authoritative
was only a small fragment containing what they thought was
Jesus' actual moral teaching.[182] Reventlow traces the origins of
this fundamental reduction of the material extent of scriptural
authority to issues of morality, and of the flat denial of its for-
mal sufficiency and replacement with the formal sufficiency
of reason, back to earlier developments within Christianity.
'[T]he basic oppositions which are to prove normative for the
later periods which will concern us'—a high estimation of a
Spirit-filled individual or group who therefore has no need of

[177] Spinoza, *Tractatus Theologico-Politicus*, 14.
[178] Ibid., 192.
[179] Jüngel, 'Anthropomorphism', 83.
[180] Spinoza, *Tractatus Theologico-Politicus*, 18–19.
[181] Chadwick, 'Introduction', in *Lessing's Theological Writings*, 45.
[182] Reventlow, *The Authority of the Bible*, 386–9.

sacraments or Scripture—'are already prefigured in late-medieval Spiritualism'. Reventlow mentions Joachim of Fiore (d. 1202) as a particular medieval example.[183] The same theological motifs can be identified in Erasmus, who bequeathed to the deists a view of religious ceremonies as fundamentally 'Jewish' and fundamentally 'law', and to be rejected on both counts.[184] John Toland's *Christianity Not Mysterious* (1696) provides a good example of deism's theological inheritance, according to Reventlow. Toland thinks that the gospel of Jesus Christ is originally about perfect morals and reasonable worship, the truth of which can be tested rationalistically against an autonomous and independently accessible morality, and that all this was obscured by priests, who introduced religious rituals.[185]

Thus, Reventlow suggests that there is a surprisingly close relationship between rationalism and spiritualism, in that each regards divine 'light' to be an individual possession apart from church or Scripture: 'once the inner light as a charismatic force has been made a sure possession, it has only to be turned into the light of reason which all human beings have at their disposal as creatures and later as autonomous subjects, for the transition to "Enlightenment" to have been made'.[186] He implicates in this shift both the Latitudinarians,[187] and the Puritans, who came to see the Decalogue as 'a codification corresponding with the *lex naturalis*'.[188]

Clearly, in the present work it is not possible to reconstruct a concept of God's speech and its relation to Scripture which counters all these concerns. However, the suggestion that, from a theological point of view, the decline in belief in the sufficiency of Scripture resulted from a dislocation of the activity of God, and particularly of the Holy Spirit, from Scripture, and that this dislocation has deep roots in the history of medieval Christian theology, is an interesting one. It is intended, in Chapter 3,

[183] Reventlow, *The Authority of the Bible*, 25–31.

[184] Ibid., 44.

[185] Ibid., 296–301.

[186] Ibid., 229. Reventlow here perhaps suggests too neat and logical a progression from spiritualism to rationalism, although the basic theological similarity between them is clear.

[187] The example given is Edward Stillingfleet (1635–99), bishop of Worcester (ibid., 229–35).

[188] Ibid., 124.

to offer a conception of God's activity as speaker in relation to Scripture which may help to re-envision orthodoxy, and make it a little more robust in defending itself against attacks which may now come from outside, but which rely in part on theological positions to which it unwittingly helped to give birth.

The Sufficient 'Voice' of God

In the eighteenth century the sufficiency of Scripture was finally replaced for many by the sufficiency of natural religion. This frontal assault on the authority of Scripture is evident in the title of a work by Denis Diderot: *De la suffisance de la religion naturelle*.[189] Diderot himself moved in the course of his life from orthodox Christianity through deism to atheism. In fact, before his time, as noted above, most deists wished to demonstrate that the Bible and natural religion both conveyed similar content. However, they also wanted the knowledge of truths necessary for eternal life to be, as Reventlow says of Lord Herbert of Cherbury (1582–1648), 'open to all men and immanent in the *instinctus naturalis*'.[190] They wished therefore to allow for Scripture as a significant 're-publication' of the morality which people have often failed to follow.[191] Spinoza, too, offers this olive branch to the Bible, suggesting that its usefulness lies in that it brings great consolation, since very few people 'can acquire the habit of virtue under the unaided guise of reason'.[192]

However, Scripture as an overlapping, confirmatory, even consolatory source of religion-as-morality, alongside a reason invested with the right to judge Scripture's truthfulness, was left in a precarious position which could not hold for long. When natural religion turns out to be directly accessible to all,

[189] See Buckley, *At the Origins*, 38–9. Buckley calls Diderot 'the first of the atheists', both chronologically and in terms of influence (p. 249).

[190] Reventlow, *The Authority of the Bible*, 187.

[191] Ibid., 376, commenting on Matthew Tindal.

[192] Spinoza, *Tractatus Theologico-Politicus*, 198–9. Spinoza thus did not share the deists' democratic view of human reason, wishing to restrict the use of reason as a means of gaining access to truth to an intellectual elite (see Roy A. Harrisville and Walter Sundberg, *The Bible in Modern Culture: Theology and Historical-Critical Method from Spinoza to Käsemann* (Grand Rapids: Eerdmans, 1995), 44–5).

being written on the heart and mind of every person, it soon becomes all-sufficient; when revealed religion requires professional interpreters it proves relatively useless and quickly loses its status as an authority for all important matters. This is evident, according to Reventlow, in the fact that earlier deists were keen to show themselves to be Christians in a way that later deists, such as Thomas Chubb, were not.[193] Thus, a theological conviction that God does not reveal himself in particular ways in history underwrites the breaking of a link between the particular texts of Scripture and divine revelation.

The deistic concern to remove the scandal of particularity from the Christian account of God's action in the world exercised an influence through the end of the eighteenth century and into the nineteenth, as attacks on Christian orthodoxy began to form part of mainstream thought.[194] D. F. Strauss, according to Robert Morgan and John Barton, wanted the idea of the unity of God and humanity to extend not just to Jesus but to the whole of humanity—an idea which he took from Schelling.[195] Strauss worked this idea out especially in his famous, and at the time of its publication notorious, *The Life of Jesus* (1835), the purpose of which was precisely to distinguish eternal truth from the historical conditioning of Jesus and the biblical accounts of him.[196]

[193] Reventlow, *The Authority of the Bible*, 390–3.

[194] 'A crucial precondition for the abandonment of classical Protestant doctrines of scripture is a shift in the social location of the "sceptical" position. As represented by the English Deists, for example, it is still a peripheral, oppositional position that parades its own radicality by attacking the claims of established churches. Its often crude unsystematic form makes it vulnerable to counter-attack from a scholarship that deploys the resources of learning to defend moderate, reasonable and orthodox positions. The shift occurred in the world of the German universities during the second half of the eighteenth century: the resources of learning were increasingly deployed in the service of non-orthodox positions, which thereby attracted to themselves not only the inevitable controversy but also the prestige of *Wissenschaft*' (Francis Watson, *Text and Truth: Redefining Biblical Theology* (Edinburgh: T. & T. Clark, 1997), 130).

[195] Robert Morgan with John Barton, *Biblical Interpretation* (Oxford: Oxford University Press, 1988), 50–1.

[196] Thus Hans Frei: Strauss 'prid[ed] himself on the congruence between the negative fruits of his *historical* analysis of the story of Jesus and a positive *philosophical* (or dogmatic) reconstruction of that very narrative' (Frei, *Eclipse*, 116). Through the nineteenth and twentieth centuries the felt problem with

The Bible reappeared as significant at the turn of the nineteenth century in another guise. Buckley notes that the atheists Diderot and d'Holbach, by accounting for nature without recourse to God, disposed of a God who had been argued for 'as the presupposition or as the corollary of nature' by Samuel Clarke, Isaac Newton, and others. Schleiermacher tried to recover God by shifting the focus of God's relationship to the world, construing him now as a presupposition or corollary of *human* nature.[197] This allowed for the Bible to be regarded as an important witness to the religious consciousness of Jews and especially of the early Christians. Once this shift has been made, the Bible has significance only as a 'window', providing access to something behind the text. This changing view of the Bible has been analysed in particular detail by Hans Frei, who argued that in the eighteenth century, '[f]irst in England and then in Germany the narrative [of the Bible] became distinguished from a separable subject matter—whether historical, ideal, or both at once—which was now taken to be its true meaning'.[198] According to Frei, three hermeneutical options were available within this overall approach at the turn of the nineteenth century, all of them locating the Bible's subject-matter in something behind the text, to which one gained access by a critical reconstruction. One could take the Bible's subject-matter, the meaning of the narratives, to be 'the state of affairs in the spatiotemporal world to which they refer', or 'the ideas or moral and religious truths (*Gehalt*) stated in them in narrative form', or the consciousness they represent—'one of necessary and unconscious mythologizing'.[199]

the Bible seems not to have been just to do with its particularity, but also, for some, with the fact that it was a written text. Francis Watson identifies a significant strand of what he calls 'Neo-Marcionism' in theology, which mistrusts textuality in general as a *mediation* of revelation. Referring to Schleiermacher, Harnack, and Bultmann, he says: 'Textuality is identified with the Jewish "letter" and contrasted with the Christian emphasis on speech or "the word". . . . The formation of a new, Christian canonical collection is seen as a re-judaizing of Christian faith that can only obscure that which lies at its heart, the "essence of Christianity"' (Watson, *Text and Truth*, 12; Watson expounds this claim in detail, 127–76.)

[197] Buckley, *At the Origins*, 331–3.
[198] Frei, *Eclipse*, 51.
[199] Ibid., 256–65. Frei's own alternative hermeneutical proposals are very stimulating, although not without problems; they will be discussed in ch. 4.

In Chapter 4, in our treatment of Scripture as materially sufficient, it will not be possible to address all these issues. In particular, there is no scope for addressing directly those who are moving or have moved towards atheism. Instead, the intention is to offer a conception of what it means to call a text 'sufficient' as the medium for a person's speech, or rather speech act, in a way which will help the orthodox position on biblical authority address contemporary concerns. It will be suggested that it is quite coherent to speak of Scripture as the sufficient speech act of God, providing a conception of Scripture which will highlight some of the problems inherent in the Romantic hermeneutics which lies behind the historical-critical approach to Scripture. It will also be argued that various hermeneutical options available today, even down to deconstruction, which can be shown to have developed from and in reaction to Romantic hermeneutics, and which deny that a text is capable of functioning as the sufficient medium of an author's meaning, are caught up in the same kinds of difficulties with regard to language and personal agency in language as earlier hermeneutical models.

The Canon of Scripture

Richard Muller argues that the use of critical tools in biblical interpretation began in the seventeenth century among orthodox theologians. Although the use of these tools created 'an increasing worry on the part of those same orthodox over the connection between text and doctrine', Protestant orthodox exegetes at first 'raised and resolved many of these issues'. However, over time a pressure arose which began to put a strain on orthodox systematics, since the link between text and doctrine began to seem more complex or even more questionable than it had before.[200]

In reaction to this pressure, some orthodox theologians claimed more for Scripture than had previously been claimed. The assertion of John Owen and others that the vowel-points

[200] Muller, *Post-Reformation Reformed Dogmatics*, 127–8. Specific critical questions about the history of the canon of Scripture, a full discussion of which lies outside our theological focus, will be referred to briefly in the treatment of B. S. Childs in ch. 5.

of the Masoretic Text are divinely inspired in the same way as the consonantal text—something which most of the Reformers had denied—is the best example of orthodox theologians over-reaching themselves, and therefore making the orthodox system 'easy prey to the inroads of rationalism in the next century'.[201] This need not be developed here, since in Chapter 5 the central question of the divine inspiration of Scripture as a unique mark which distinguishes the texts of the canon from all other texts will be taken up at some length, defending the orthodox view of inspiration (apart from its over-extended claims about Hebrew vowel-points). This will be done via a discussion of the work of B. B. Warfield, who consciously set himself in line with the main strand of orthodox Protestant thought on biblical inspiration, and of his contemporary critics.

It was the observations of biblical exegesis, as Wolfhart Pannenberg points out, that led eventually to the conclusion that the canon of Scripture is too diverse to be able to function coherently as the ultimate judge of doctrine[202]—which represents a loss of belief in the formal aspect of the sufficiency of Scripture. Of course, some of the critical challenge can only be countered, if it is to be countered at all, on a case-by-case exegetical basis. It will be suggested in Chapter 5, though, that a different account of the referential function of language, and one which lends itself particularly as a way of conceiving of the function of the biblical canon, may allow a re-examination of many of the allegations of contradictions in the canon of Scripture made by historical-critical scholarship.

CONCLUSION

Even if the doctrine of the sufficiency of Scripture had not declined as it has, reconstruction of it would now probably be called for. Doctrinal statements only ossify and come to be regarded as redundant when they fail to be subjected to re-examination in the changing contexts in which Christian faith is to be confessed—and in the industrialized West, at least, the contexts have been changing rapidly for some time now. Such

[201] Ibid., 134.
[202] Wolfhart Pannenberg, 'On the Inspiration of Scripture', *Theology Today* 54 (1997), 212–15, at 212.

reconstructions are necessary, paradoxically, to preserve the continuity of doctrine. In the case of the sufficiency of Scripture, such a continuity can indeed be identified. Both before its relatively recent decline, and in many parts of the church subsequent to its apparent demise, some form of the doctrine of the sufficiency of Scripture has been, as Berkouwer expresses it, 'the dominating tone for the entire chorus of the church'.[203]

To repeat: not all that is positively implied and explicitly stated in the doctrine of the sufficiency of Scripture can be reconstructed, nor can everything brought to bear against it in the last three centuries, from both modernity and post-modernity, be countered all at once. The particular focus of the present work is 'bottom up', selecting some of the most fundamental theological and hermeneutical issues under the headings of the three subsequent chapters, which have been shown in this chapter to be historically the three determining elements of the doctrine of scriptural sufficiency. Various possibilities will be suggested for how we may conceive of the function of language in relation to speakers, writers, readers, and hearers—that is, conceiving of words and their 'supplements'—and for how these can be used generally and theologically to articulate the bases of the orthodox doctrine of the sufficiency of Scripture, and to renew that doctrine's own systematic self-understanding.

In that sense, the present work is a theological and philosophical prolegomenon to a contemporary formulation of an orthodox doctrine of Scripture. Its construction will involve both re-configuring for a new context, with the supplementation of some modern materials, what is sometimes regarded as the rubble left over from that doctrine's dilapidation, and arguing that the doctrine's original foundations can be shown, when viewed thus, to be relatively intact. That is, the contemporary resources adopted for this reconstruction have been chosen because, it will be argued, they preserve what the orthodox doctrine of Scripture has historically aimed to express, while introducing categories and concepts which overcome some of the problems and address some of the oversights which are regularly identified in earlier modes of orthodox thought and expression on the doctrine of Scripture.

[203] Berkouwer, *Holy Scripture*, 305.

3
Scripture and the Sufficiency of Divine Speech

INTRODUCTION

The claim that God speaks has of course been used to support other doctrinal statements than the sufficiency of Scripture. A chapter is devoted to it here because this claim, as the historical overview in the previous chapter demonstrated, is both the significant theological basis on which the doctrine of the sufficiency of Scripture rested, and the theological statement whose content that doctrine aimed to clarify. The decline of the sufficiency of Scripture, as we also saw, has been closely related to a loss of the conviction that any sense can be made of the claim that God speaks, except perhaps in the broadest metaphorical senses of the word 'speak'. What has been broken, among other things, is the connection between divine activity and human language. Scripture becomes insufficient as a medium of divine revelation when it comes to be regarded as an exclusively human document. It is then of value as a window, albeit a necessarily distorting one, giving access to something else, namely, to whatever is taken to be the actual *locus* of divine revelatory activity in the world.

This was the situation in which Karl Barth, the great theologian of the Word of God in the twentieth century, found himself at the beginning of that century. He sought a way out, as is well known, through a recovery of a strong conviction that God really does speak, in the literal sense of the word. In addition, Barth is also regularly credited with restoring to the Bible a significant level of theological authority. In all this he deliberately moves beyond the orthodox Protestant doctrine of Scripture, particularly in his doctrine of inspiration and his rejection of a direct identification of the Bible with the Word of God.

Therefore, although we will be critical of Barth at some points, any contemporary suggestion that it is meaningful and true of God to say that he speaks owes much to him. Despite Barth's influence, the belief that God does speak is still an unpopular one among theologians. However, it has recently found a skilful and innovative proponent in the theologian and philosopher Nicholas Wolterstorff.[1] Wolterstorff is aware that the claim that God speaks is widely dismissed by theologians, and considered by philosophers to be, as he says, 'off the wall'.[2] In attempting to make his case he ranges widely in theology, hermeneutics, epistemology, and the philosophy of language.

We will take our cue from Wolterstorff's use of concepts developed in speech act theory, particularly the notion of an 'illocutionary act'. The conceptual tools provided by speech act theory will form the basis of our argument that good theological sense can be made of the claim that God speaks, in particular as that claim is made in relation to Scripture as a medium of divine speech. This will involve, first, an analysis of some particular topics in speech act theory from the work of the speech act theorists J. L. Austin and John Searle, as well as from Wolterstorff. The aim here will be to reach a level, sufficient for our purposes, of terminological and conceptual clarity in what is a complex philosophical field. Speech act theory is a widely debated branch of the philosophy of language. It should be noted early on that the present arguments will rest on only a small number of speech act theory's most underlying concepts, which are in fact shared more widely by a variety of philosophers of language and linguistic theorists, and not on any one of its particular analytical developments. Speech act theory has been chosen as the basis for our reconstruction of the claim that God speaks because its basic concepts allow a particularly clear

[1] The work in question here is Wolterstorff's *Divine Discourse: Philosophical Reflections on the Claim that God Speaks* (Cambridge: Cambridge University Press, 1995), which is derived from his Wilde Lectures, delivered at Oxford University in 1993. It has elicited a variety of reviews and responses. For a very positive reception, see Anthony C. Thiselton, review article: 'Speech Act Theory and the Claim that God Speaks: Nicholas Wolterstorff's *Divine Discourse*', *Scottish Journal of Theology* 50 (1997), 97–110. For a negative response, see Michael Levine, 'God Speak', *Religious Studies* 34 (1998), 1–16, with, in the same volume (pp. 17–23), Wolterstorff's 'Reply to Levine'.

[2] Wolterstorff, *Divine Discourse*, p. ix.

analysis of what is involved in the act of speaking. A key tool in this will be Wolterstorff's concept of the 'normative standing' which speakers conventionally acquire, which, it will be suggested, is a concept of great explanatory power. Wolterstorff's development of the basic concepts of speech act theory, as we will see, owes far more to ethical reflection than it does to analytical philosophy; this is in contrast to, for example, John Searle's analytical development of speech act theory.

Since Wolterstorff applies his conception of speech directly to the Bible, specifically to the question of divine authorship of the Bible, that will be treated at the end of the second section of this chapter, as a preliminary both to our treatment of Barth's view of Scripture and especially to the fuller treatment of biblical inspiration in Chapter 5. With these clarified conceptualities in mind, discussion will then turn to Barth, and to his proposal for re-establishing the meaningfulness of the claim that God speaks. The chapter will conclude by suggesting a construal of the orthodox Protestant identification of the Bible with the Word of God, that is, with God's speech, which satisfies the concerns which led Barth to reject that identification.

THE ACT OF SPEECH

Speech Act Theory in Outline

'Speech act theory' is the name given to a relatively unified area of research which arose in the philosophy of language towards the end of the twentieth century. It has its origins in the seminal and rather self-effacingly titled work, *How To Do Things With Words*, by the Oxford philosopher J. L. Austin. It has been developed in particular ways by others, notably the American philosopher John Searle. Austin's fundamental aim is to question what he calls 'an age old assumption in philosophy—the assumption that to say something . . . is always and simply to *state* something'.[3] He proposes, by contrast, that 'to say something is in the full normal sense of the word to do something'.[4] In order to explicate this conception of what it is to speak he

[3] J. L. Austin, *How To Do Things With Words*, 2nd edn. (Oxford: Clarendon Press, 1975), 12.
[4] Austin, *How To*, 94.

develops the concept of a 'speech act'. He analyses this into different kinds of act which make up the act of speaking; the most important of these categories are locutionary, illocutionary, and perlocutionary acts. In brief, a locutionary act is the act of simply uttering or writing words with a certain sense and a certain reference; an illocutionary act is what one does by means of those words—for example, promising, asserting, warning, congratulating, and so on; the perlocutionary act is the effect one normally wishes to bring about in the addressee by means of a certain illocutionary act—for example, alerting, in the case of warning, and convincing, in the case of arguing.[5]

The main focus of speech act theory is on the irreducibility of the illocutionary act. Austin describes his main purpose to be to distinguish the illocutionary from both the locutionary and perlocutionary: 'There is a constant tendency in philosophy to elide this [the illocutionary act] in favour of one or other of the other two. Yet it is distinct from both.'[6] Searle accepts this point from Austin: 'the illocutionary act is the minimal unit of linguistic communication'.[7] The tendency to make the illocutionary act of authors, especially, disappear has increased in the forty or so years since Austin's work.[8] From one perspective, much of the present work may be thought of as a recommendation that a strong sense of the irreducibility of the illocutionary acts of the Bible be applied rigorously to our conception of the Bible.

Speech act theory expands the focus of the philosophy of language to include the pragmatics of language-use in its theory of meaning, taking note of the rules and conventions which govern speech. That a certain locutionary act counts as a certain illocutionary act is determined by conventions in force at the time of speaking. For example, it is by a complex set of con-

[5] It may be objected that speech act theory introduces complicated Latinate terms for distinctions which are obvious on a moment's reflection. The concepts and distinctions which Austin introduced are, in fact, widely denied, and in any case anyone who wishes is free to suggest simpler-sounding Anglo-Saxon terms.

[6] Austin, *How To*, 103.

[7] John R. Searle, 'What Is a Speech Act?', in Heimir Geirsson and Michael Losonsky (eds.), *Readings in Language and Mind* (Oxford: Blackwell, 1996), 110–21, at 110.

[8] This trend will be documented in ch. 4.

ventions that a speaker places certain constraints on his future actions by uttering the words: 'I promise . . .'. For Searle, '[s]peaking a language is engaging in a (highly complex) rule-governed form of behaviour'.[9] That by speaking one constrains one's behaviour in various ways—that one should keep one's promises, for example—Searle calls an 'institutional fact'.[10] Searle distinguishes two kinds of rule which govern behaviour: 'Regulative rules regulate a pre-existing activity, an activity whose existence is logically independent of the rules. Constitutive rules constitute (and also regulate) an activity the existence of which is logically dependent on rules.'[11] The rules governing the performance of speech acts are constitutive: just as the act of kicking a ball into a net strung between posts under certain circumstances only counts as a goal (I am here anglicizing Searle's sporting example), given the existence of the rules of football which count that act as a goal, so the act of uttering certain words such that it counts as the performance of a certain kind of illocutionary act is only possible given a similarly constituted set of rules. '[T]he semantic structure of a language may be regarded as a conventional realization of a series of sets of underlying constitutive rules.'[12] This means that linguists and philosophers of language are mistaken when they acknowledge the usefulness of speech act theory in pragmatics, but suggest, as they sometimes do, that it has no explanatory power beyond that field.[13] As Searle says, since speech act theory is interested in the question of 'how we get from the sounds to the illocutionary acts', it must be central to our understanding not just of pragmatics, 'since it will include all of what used to be called semantics as well as pragmatics'.[14] In addition, speech act

[9] John R. Searle, *Speech Acts: An Essay in the Philosophy of Language* (Cambridge: Cambridge University Press, 1969), 12.

[10] Searle, *Speech Acts*, 184–5.

[11] Ibid., 34.

[12] Ibid., 37.

[13] For this view of speech act theory expressed from within linguistics and the philosophy of language respectively see Robert de Beaugrande and Wolfgang Dressler, *Introduction to Text Linguistics* (London and New York: Longman, 1981), 117; Michael Devitt and Kim Sterelny, *Language and Reality: An Introduction to the Philosophy of Language* (Oxford: Blackwell, 1987), 20–1.

[14] John R. Searle, *Expression and Meaning: Studies in the Theory of Speech Acts* (Cambridge: Cambridge University Press, 1979), 178. See also William

theory reconfigures the way one goes about determining the truth and falsity of a statement. Austin demanded that philosophers of language broaden the questions they consider, to include what he called 'the total situation in which the utterance is issued': '[t]he truth or falsity of a statement depends not merely on the meanings of words but on what act you were performing in what circumstances'.[15]

Given the complexity of the many philosophical issues involved in all this, it was inevitable that Austin left several important matters either only implied or just unclear. Since the concept of the illocutionary act will be central in forthcoming arguments, it is important now to examine the extent to which Austin successfully distinguished illocutionary acts from, in turn, locutionary and perlocutionary acts.

Illocutions and Locutions

Searle argues that the basis on which Austin wishes to distinguish locutionary from illocutionary acts is not precise enough to distinguish them clearly. Austin distinguishes the locutionary act itself into three aspects, which he calls the phonetic act, the phatic act, and the rhetic act. These three describe respectively three aspects of what it is to say something: 'the utterance of certain noises, the utterance of certain words in a certain construction, and the utterance of them with a certain "meaning" in the favourite philosophical sense of that word, i.e. with a certain sense and with a certain reference'.[16]

Searle observes that all of Austin's examples of rhetic acts are in the form of a report of indirect speech, and all turn the report of that speech into a report of an *illocutionary* act (they begin 'he *told* me to . . .', or 'he *asked* me whether . . .', and so on). This, argues Searle, is inevitably the case because 'no sentence is completely force-neutral'; thus, phonetic and phatic acts, when used in sentences with sense and reference (that is, when

Alston: '[if Austin is right] then the concept of an illocutionary act is the most fundamental concept in semantics and, hence, in the philosophy of language' (quoted in Kevin J. Vanhoozer, *Is There a Meaning in This Text? The Bible, the Reader and the Morality of Literary Knowledge* (Leicester: Apollos, 1998), 209).

[15] Austin, *How To*, 52, 145. [16] Ibid., 94–5.

used 'rhetically'), 'are . . . already (at least purported) illocutionary acts'.[17] Searle concludes that a rhetic act is always an illocutionary act.[18] He therefore proposes that the concept of 'locutionary act' be dropped, and that the concept of a 'propositional act' be included in the description of a speech act. Propositional acts cover only those aspects of the sentence which relate to sense and reference—for example, the two sentences "He promised to come to the party" and "He came to the party" represent identical propositional acts but different phonetic, phatic, and illocutionary acts—and so remain fully distinct from illocutionary acts. Searle notes that his concept of a propositional act is a genuine abstraction, since it is constituted 'only by those portions of the sentence which do not include the indicators of illocutionary force',[19] just as Austin's locutions and illocutions were also abstractions of a single indivisible speech act. However, it is a legitimate abstraction, he argues, because it is possible for the same reference and predication to occur in completely different speech acts, as the above example demonstrates.[20]

Searle concludes by diagramming Austin's taxonomy of the speech act thus:[21]

Locutionary phonetic
 phatic
 rhetic

Illocutionary

and proposes in its place a revised model:[22]

Phonetic act
Phatic act
Propositional act
Illocutionary act.

In his later work Searle combines the phonetic and phatic acts into one, and so offers this three-fold description of the different aspects of the speech act: utterance acts (uttering words), propositional acts (referring and predicating), and

[17] John R. Searle, 'Austin on Locutionary and Illocutionary Acts', *Philosophical Review* 77 (1968), 405–24, at 412.
[18] Ibid., 413. [19] Ibid., 421.
[20] Searle, *Speech Acts*, 22–3. [21] Searle, 'Austin', 414. [22] Ibid., 424.

illocutionary acts (stating, questioning, and so on).[23] In thus tidying up Austin's taxonomy, Searle sets the strict distinction which Austin wanted to draw between locutions and illocutions on a firmer footing. In practice, Austin's terminology will be retained in what follows, because the neat three-fold structure of locution, illocution, and perlocution is most commonly used in discussions of speech act theory; however, by 'locutionary act' will be meant what Searle terms an 'utterance act'.

Illocutions and Perlocutions

Austin also, as has been observed, protested against any eliding of the illocutionary act into the perlocutionary act. However, surprisingly, something quite like this eliding seems to occur both in Austin's own work, at one point, and in part in Searle's notion of 'illocutionary effect'. Since much of what will be proposed in Chapter 4 is based on a clear distinction between illocutionary and perlocutionary acts, it is necessary to engage with Austin and Searle on this point. Austin argues that 'the performance of an illocutionary act involves the securing of *uptake*', which he defines as 'bringing about the understanding of the meaning and the force of the locution'. This effect 'must be achieved', he says, 'if the illocutionary act is to be carried out.'[24] He gives an example: 'the doubt about whether I stated something if it was not heard or understood is just the same as the doubt about whether I warned *sotto voce* or protested if someone did not take it as a protest'.[25]

Similarly, Searle terms the understanding of the speaker's utterance 'the illocutionary effect', and states that 'in the case of illocutionary acts we succeed in doing what we are trying to do by getting our audience to recognize what we are trying to do'.[26] There is some ambiguity in Searle, however, which takes him beyond Austin on this point. He recognizes that there are different levels of the 'success' and 'lack of success' in the performance of an illocutionary act: 'There are various kinds of possible defects of illocutionary acts but not all of these defects are sufficient to vitiate the act *in its entirety*.'[27] When he relates

[23] Searle, *Speech Acts*, 24.
[24] Austin, *How To*, 116–17.
[25] Ibid., 139.
[26] Searle, *Speech Acts*, 47.
[27] Ibid., 54 (italics added).

this point to perlocutionary effects, he concludes that the act of promising has no *essential* tie to the bringing about of an effect on the hearer.[28]

Searle is right on this latter point. Imagine a situation in which I make a promise to someone, assuming, wrongly, as it turns out, that they understand the language in which I am speaking. I have thus neither secured the uptake nor brought about the illocutionary effect of my illocutionary act. This failure, though, does not mean that I did not make the promise, and that therefore there is no promise which I am bound to keep. I simply did make the promise; any person within earshot who did understand my language and knew of my mistake would likely assume so. Again: what if I shouted my promise to someone across some distance, but they never heard my words clearly enough to comprehend them as a promise, because they were carried away by the wind? That mishap would not normally absolve me of the responsibilities associated with the making of a promise.

The question of the necessary and sufficient conditions for the successful performance of an illocutionary act is a very complex one. John Searle has tried to list these conditions for a particular kind of speech act, and, as we will see, has been sharply criticized for it. Two points, though, are being argued here. The first is that Austin, especially, falls short of drawing the clear theoretical distinction between illocutionary and perlocutionary acts which he advocates, but that such a distinction can and should be made. The second point lies in the demonstration that, in attempting to answer the question, 'What constitutes and follows from the "successful" performance of an illocutionary act?', we find ourselves asking questions about *personal responsibilities*—for example, the responsibility to keep a promise one has made. It is this aspect of the act of speech which Nicholas Wolterstorff has particularly developed, under his concept of the moral rights and responsibilities which are normatively ascribed to speakers and hearers. This concept will be outlined shortly, in a discussion of Wolterstorff's work, suggesting that he has made a significant and very fruitful advance on Austin and Searle—one which we will adopt for our own arguments, especially in Chapter 4.

[28] Ibid., 71.

Speech Act Theory and Linguistics

It was noted above that the basic concept of the illocutionary act is one that is held to more widely by academic linguistics, even where it criticizes speech act theory as a whole. In the last thirty years academic linguistics as a whole has moved away from a formalist or structuralist approach, towards one which takes more account of human action and intentionality. Thus, de Beaugrande and Dressler, introducing the field of 'text linguistics', define a text as 'a communicative occurrence'. They distinguish their approach from that of 'conventional linguistics', which would look for structures in a language, as one which looks for 'operations of decision and selection' of those structures, and the implications of those operations for 'communicative interaction'.[29] The different field of 'conversation analysis' aims to describe 'the procedures by which conversationalists produce their own behaviour and understand and deal with the behaviour of others'.[30] Like speech act theory, conversation analysis stresses 'the unavoidable contextedness of actual talk', and two writers in the field ascribe the development of the view of utterances as 'conventionally grounded social actions' to a great extent to speech act theory.[31] They are also happy to use speech act terminology, referring to 'the crucial significance of an utterance's placement for the analysis of its illocutionary force'.[32] A third example can be found in the field of 'integrational linguistics'. For the integrational theorist Michael Toolan, language is fundamentally to do with how human beings act and behave towards one another: 'Language is essentially rooted in trust, goal-orientedness, memory, and acuity of perception since—like those very attributes—it is an integral part of human life.' Throughout, he says, the integra-

[29] De Beaugrande and Dressler, *Introduction to Text Linguistics*, 3, 15. Their definition of a text is very close to that of Vanhoozer: 'a communicative act of a communicative agent fixed by writing' (Vanhoozer, *Is There a Meaning?*, 225).

[30] John Heritage and J. Maxwell Atkinson, 'Introduction', in J. Maxwell Atkinson and John Heritage (eds.), *Structures of Social Action: Studies in Conversation Analysis* (Cambridge: Cambridge University Press, 1984), 1. I am grateful to Norman Fraser for calling my attention to conversation analysis.

[31] Heritage and Atkinson, 'Introduction', 6, 5.

[32] Ibid., 14.

tional linguist is attempting to keep in view what Austin called 'the total speech act in the total speech situation'.[33]

What emerges is that, where the concepts developed by speech act theory are approved of and appropriated by these areas of linguistics, the two key notions of the illocutionary act as the basic unit of speech and the need to take account of speech-context in semantics are highlighted as being the crucial concepts—as indeed they have been by Austin and Searle themselves. This is to suggest that the appropriation of speech act theory for the purposes of doctrinal reconstruction attempted in the present work does not link the fate of the doctrine of the sufficiency of Scripture exclusively to what may turn out to be a passing 'movement' in the philosophy of language and linguistics. Speech act theory has developed two particular concepts which are currently exercising a considerable amount of influence, and providing terminological clarification for distinctions often made intuitively. Speech act theory is being appropriated here to the extent that it gives expression to these two concepts, which are likely to remain significant in several areas of study beyond the possible future waning of a particular philosophy of language called 'speech act theory'. Now, before the move is made to apply speech act theory to texts, and then to the Bible, it is necessary to engage with some of the objections most commonly levelled against the theory's basic concepts.

Common Objections to Speech Act Theory

An internal debate within speech act theory

A debate has arisen among some speech act theorists over the roles of convention and intention in language. Paul Grice offered this influential definition of meaning, which focuses on the intention of the language-user: 'To say that *A* meant something by *x* is to say that *A* intended the utterance of *x* to produce some effect in an audience by means of the recognition of this intention.'[34] Searle argued that, though a good start, this fails to account for the role of conventions, and, moreover, 'by

[33] Michael Toolan, *Total Speech: An Integrational Linguistic Approach to Language* (Durham, N. C., and London: Duke University Press, 1996), 12, 22.

[34] Quoted in Searle, *Speech Acts*, 43–4.

defining meaning in terms of intended effects it confuses illocutionary with perlocutionary acts'.[35] E. D. Hirsch has argued that the emergence of this debate calls the whole project of speech act theory into question, since it represents the occurrence within speech act theory of the same polarity from which the theory was intended to provide an escape.[36] However, this debate is not as serious as Hirsch suggests. For example, Kevin Vanhoozer has argued that convention and intention are not opposing concepts, but may be defined in terms of each other, if convention is seen as a corporate intention.[37]

Necessary and sufficient conditions

One part of Searle's work on speech act theory that has attracted particular attention from critics is his attempt to list the necessary and sufficient conditions for the performance of the illocutionary act of promising. He lists nine conditions, which he regards as individually necessary conditions, and collectively a sufficient condition, for the successful performance of the act of promising.[38] Searle acknowledges that what he is reaching for is an 'idealization' of a speech act, and that the complexity of patterns of language-use in real life is such that we do not have 'absolutely knockdown necessary and sufficient conditions' for the act of, for example, promising. He admits that his work may therefore have 'a somewhat archaic and period flavor'—but he is nevertheless happy to list and discuss his nine conditions in some detail.[39]

The two text-linguists referred to above objected that speech act theory is 'rather incomplete in its usual framework', since it can only account for 'transparent' actions in which 'the uttering is itself the action'—for example, sentences which begin, 'I promise . . .', 'I apologize . . .', and so on. Everyday communi-

[35] Searle, *Speech Acts*, 43–4.

[36] E. D. Hirsch, Jr., *The Aims of Interpretation* (Chicago and London: University of Chicago Press, 1976), 300–5. Hirsch has in mind a polarity between Romantic hermeneutics and a constant refining of the tools of linguistic analysis as providing the means for the determination of meaning. We will see in our discussion of Wolterstorff below that speech act theory does in fact succeed in escaping this polarity.

[37] Vanhoozer, *Is There a Meaning?*, 244.

[38] Searle, *Speech Acts*, 57–61.

[39] Ibid., 55.

cation, they note, is 'far more diversified and far less trans-parent' than that: we simply do not say, for example, 'I hereby try to get you to comply with my plan.'[40] Similarly Toolan, the integrational linguist, says that the basic integrationist objec-tion to speech act theory is that, having outlined its grammar of, for example, a promise, speech act theory identifies as promises only those speech acts which fit the linguistic conventions it has identified as constitutive of, and the conditions it has estab-lished as necessary and sufficient for, the act of promising.[41]

However, in a later set of studies Searle deals explicitly with part of the complexities of everyday speech, under what he calls 'indirect speech acts'. These are sentences such as, 'Can you reach the salt?', in which 'one kind of illocutionary act can be uttered to perform, *in addition*, another type of illocutionary act'.[42] What in his earlier work was a qualification added to his search for the 'ideal' speech act now appears as a primary obser-vation, for he rejects as inappropriate both the philosophical search for 'a set of logically necessary and sufficient conditions for the phenomena to be explained' and the linguistic goal of 'a set of structural rules that will generate the phenomena to be explained'.[43] That Searle can make this shift and not be forced to abandon his commitment to the two central concepts of speech act theory suggests that the identification of necessary and sufficient contextual and linguistic conditions for the per-formance of an illocutionary act is not central to the theory itself.

Other linguists, this time conversation analysts, have argued that speech act theory fails to the extent that it 'has developed within a disciplinary matrix which gives analytic primacy to the isolated sentence. . . . The net result is an approach to speech acts that . . . seeks to establish the act accomplished by an utter-ance considered in isolation.' This fails to grasp that 'utterances are *in the first instance* contextually understood by reference to their placement and participation within sequences of action'.[44] This is effectively a claim that Searle's development of Austin

[40] De Beaugrande and Dressler, *Introduction to Text Linguistics*, 117–18.
[41] Toolan, *Total Speech*, 132.
[42] Searle, *Expression and Meaning*, 30.
[43] Ibid., 56.
[44] Heritage and Atkinson, 'Introduction', 5.

has failed to follow Austin's original and basic recommendation that full account be taken of 'the total situation in which the utterance is issued'.[45] That this point is made from a specialist area of linguistics suggests the increasing need for linguists and philosophers of language each to engage with the interests of the other. The objection seems fair, and it sets a particular direction in which speech act theory may enrich its account, rather than calling it into question as a whole.

The contexts of a speech act

This new direction would require speech act theorists to enquire into ever-broadening contexts of speech. It is precisely in this expansion of contexts that Jacques Derrida has attempted to get a foothold on speech act theory in order to set in motion what he sees as its internal deconstructive forces. Derrida has been one of Searle's fiercest critics, and their exchange became increasingly sharp and personal.[46] Derrida applies to both Searle and Austin a claim that he applies to the whole of Western thought: that the setting of a boundary to a context in order to distinguish one entity from another—text from context, act from agent, act from act, act from context, and so on— is always an arbitrary and rhetorical move which philosophers generally refuse to recognize as such. When Austin asks for an investigation of the '*total* speech situation', and when both he and especially Searle isolate so-called 'marginal' cases of a certain kind of illocutionary act in order to describe the 'ideal' or the 'standard', Derrida detects the totalizing and exclusionary tendencies of Western metaphysics at work. Reflecting in an interview on his debate with Searle, he concluded that 'the formation of a general theory or of an ideal concept [which does not account for what it dubs "marginal" cases] remains insufficient, weak, or empirical'. Such a project is mounted by those who cannot stand complexity: 'If things were simple, word would have gotten around, as you say in English. . . .

[45] Austin, *How To*, 52.

[46] Derrida's two contributions to the debate, along with an editorial summary of Searle's response, are collected in Jacques Derrida, *Limited Inc.*, trans. Samuel Weber and Jeffrey Mehlman, ed. Gerald Graff (Evanston, Ill.: Northwestern University Press, 1988). The debate is lucidly summarized in Jonathan Culler, *On Deconstruction: Theory and Criticism After Structuralism* (London: Routledge & Kegan Paul, 1983), 114ff.

Those who wish to simplify at all costs . . . are in my eyes dangerous dogmatists and tedious obscurantists.'[47] Speech act theory requires, he argues, 'a value of *context*, and even of a context exhaustively determined, in theory and teleologically'.[48] He wishes to assert, by contrast, that 'a context is never absolutely determinable'.[49] Derrida is out to question whether communication, in the case of performative utterances, exists 'in all rigor and in all purity'.[50] Jonathan Culler writes, in basic agreement with Derrida: 'A theory of speech acts must in principle be able to specify every feature of context that might affect the success or failure of a given speech act or that might affect what particular speech act an utterance effectively performed. . . . But total context is unmasterable, both in principle and in practice. Meaning is context-bound, but context is boundless.'[51]

A fuller response to this claim, and one which will suggest that there are ethical flaws in the deconstructive argument, must await the longer discussion of deconstruction in Chapter 4. By way of anticipation, it may be noted here that Culler and Derrida adopt an 'all or nothing' approach to meaning and context: if every aspect of the semantically significant context of a particular utterance cannot be specified, they say, then the meaning of an utterance cannot be self-identical and therefore decidable. It is indeed very difficult, perhaps impossible, to specify every aspect of the context of a speech act, to hold back 'in all rigor and in all purity' the boundlessness of context in theoretical description, yet it does not follow that an illocutionary act disappears into its context to such an extent that the very concept of an illocutionary act as the basic unit of meaning is unworkable. It is arguable that it is a philosophically reasonable position to hold that something *is*, while being unable to meet Derrida's demanding philosophical criteria for the identification of an instance of such an entity. That the edges of human actions are blurry, at least for philosophical and theoretical description, does not mean that human actions are philosophically arbitrary concepts. Toolan, for example, argues that in any instance of speech what constitutes 'text' and 'context',

[47] Derrida, *Limited Inc.*, 118–19.
[48] Ibid., 14. [49] Ibid., 3. [50] Ibid., 13; see also 20.
[51] Culler, *On Deconstruction*, 123.

although undecidable in advance theoretically, is decided locally as 'an after-the-fact sense making' by those involved.[52] This, as we have seen, is the direction in which Searle's discussion tends, perhaps in unacknowledged response to Derrida, in *Expression and Meaning* (1979), in contrast to *Speech Acts* (1969).

The Russian theorist Mikhail Bakhtin shares, apparently independently, many convictions about language with speech act theorists. He argues that what determinately separates one speech act (his term is 'utterance') from another, that is, from the wider speech context in which it occurs and by which its own identity is in part constituted, is 'a *change of speaking subjects*, that is, a change of speakers'.[53] It is precisely such a role for subjectivity which, as will be seen in Chapter 4, Derrida and other post-structuralists rule out of account in questions of language.

Conceiving of Texts as Speech Acts

Much of the speech act theory discussed so far applies most directly to speech. Can what speech act theory argues about spoken language also be true of written language? This is important, of course, because if speech act theory is to be of any value in advancing and defending a conception of the Bible as in some way doctrinally and hermeneutically sufficient then it must be carefully argued that a text is also a speech act.

In a volume of the journal *Semeia* devoted to the possibilities of literary studies being fruitfully informed by speech act theory, Hugh White suggests one of the possible advantages of applying speech act theory to literature as a whole: it moves away from formalism, towards a consideration of the text's concrete context, 'without engulfing it once again in the psychological, social and historical conditions of its production'.[54] In

[52] Toolan, *Total Speech*, 5.

[53] M. M. Bakhtin, 'The Problem of Speech Genres', in Bakhtin, *Speech Genres and Other Late Essays*, University of Texas Press Slavic Series 8, trans. Vern W. McGee, ed. Caryl Emerson and Michael Holquist (Austin: University of Texas Press, 1986), 60–102, at 71. Some particular aspects of Bakhtin's work will be appropriated for our treatment of the canon of Scripture in ch. 5.

[54] Hugh C. White, 'Introduction: Speech Act Theory and Literary Criticism', *Semeia* 41 (1988), 1–24, at 2.

speaking of 'literature' in this way, three different contrasting pairs need to be distinguished: written and oral modes of communication, so-called 'literary' and 'ordinary' discourse, and fictional and non-fictional discourse. Mary Louise Pratt's attempt to work towards a speech act theory of 'literary discourse' is helpful in documenting previous work which questions any kind of distinction between 'literary' and 'non-literary' ('ordinary') discourse,[55] but is marred by her inability to hold to a stable definition of 'literary' discourse; in her work the meaning of the term shifts between the first item of each of the three contrasting pairs listed above.[56]

The significant distinction for our concerns is that between oral and written forms of discourse.[57] Paul Ricoeur is often cited as a writer who warns against a too easy identification of oral and written communication, and especially against transferring the hermeneutical function of speakers uncritically to that of authors. He asserts, for example: 'The writing–reading relation is . . . not a particular case of the speaking–answering relation. It is not a relation of interlocution, not an instance of dialogue.'[58] In particular, in the case of texts '[t]he movement of reference towards the act of showing is intercepted', which leaves the text 'as it were, "in the air", outside or without a

[55] Mary Louise Pratt, *Toward a Speech Act Theory of Literary Discourse* (Bloomington and London: Indiana University Press, 1977), 73; Pratt refers to the work of William Labov.

[56] When she contrasts 'literary' discourse at times with 'non-literary', she seems to treat that distinction as equivalent to that between written and oral modes of communication (Pratt, *Toward a Speech Act Theory*, 73); at other times she takes 'literary' to be equivalent to 'fictional', contrasting it with non-fictional discourse (ibid., 85 ff., 113 ff.).

[57] It is not proposed to establish here explicitly whether the Bible's discourse is 'literary' or 'ordinary'. In ch. 5 an aspect of Bakhtin's view of language will be adopted in a way which suggests an agreement with Pratt's collapsing of that distinction. Neither is it necessary here to address the question of whether the Bible is fiction or non-fiction, since the aim in ch. 5 is to develop a theoretical construal of genre, and especially of the collection of genres in a canon, without arguing exegetically for the identity of any of the biblical genres in particular—although of course almost all advocates of the doctrine of Scripture which we are trying to rehabilitate see one of the Bible's 'global' genres to be non-fiction.

[58] Paul Ricoeur, *Hermeneutics and the Human Sciences: Essays on Language, Action and Interpretation*, ed. and trans. John B. Thompson (Cambridge: Cambridge University Press, 1981), 146.

world'.[59] Wolterstorff points out that in fact Ricoeur means not to contrast speech and writing themselves, but to assert 'the difference between media of discourse which do not leave their originating situation, and media which do leave it, by temporally enduring, or spatially reaching, beyond it'.[60] Wolterstorff argues that in making this distinction 'Ricoeur doesn't really doubt that the discerning of illocutionary stance is a legitimate goal of interpretation at a distance.'[61] While this is true, it is still the case that Ricoeur has doubts about the intrinsic ability of writing to convey communicative acts: 'to the extent that in spoken discourse the illocutionary force depends upon mimicry and gesture, and upon the nonarticulated aspects of discourse . . . it must be acknowledged that the illocutionary force is less inscribable than the propositional meaning'.[62]

Hans-Georg Gadamer argues similarly to Ricoeur about the relative inability of written language to convey illocutionary force: 'In writing, the meaning of what is spoken exists purely for itself, completely detached from all emotional elements of expression and communication. . . . What is fixed in writing has detached itself from the contingency of its origin and its author and made itself free for new relationships.' Yet, again like Ricoeur, he does not exclude the discerning of illocutionary stance as a legitimate goal in textual interpretation.[63]

Kevin Vanhoozer has recently offered one of the most robust assertions of the ineradicability of human agency in authoring texts. He does not share the hesitancy of either Ricoeur or Gadamer about the ability of written language to convey the illocutionary aspect of a communicative act. He argues that the illocutionary act which a text represents persists for the perception of readers by virtue of the function of literary genres: 'precisely because writing does not assume a shared situational

[59] Ricoeur, *Hermeneutics and the Human Sciences*, 148.

[60] Wolterstorff, *Divine Discourse*, 144.

[61] Ibid., 150.

[62] Paul Ricoeur, *Interpretation Theory: Discourse and the Surplus of Meaning* (Fort Worth: Texas Christian University Press, 1976), 27.

[63] 'All writing claims it can be awakened into spoken language', he says, and readers are 'addressed' by texts (Hans-Georg Gadamer, *Truth and Method*, 2nd rev. edn., trans. rev. Joel Weinsheimer and Donald G. Marshall (New York: Crossroad, 1990), 392–5.

context, genre creates the possibility of a shared *literary* context'.[64] For Vanhoozer, it is literary genre which makes illocutionary force just as 'inscribable' as propositional content: 'The concept of genre . . . describes the illocutionary act at the level of the whole.'[65] He defines a text as 'a communicative act of a communicative agent fixed by writing', suggesting that authors may say of their texts, analogically if not ontologically, 'This is my body.'[66] Thus, the role played by the non-linguistic aspects of face-to-face spoken communication in helping to convey illocutionary force is replaced in the case of written communication by the literary and especially generic qualities with which an author can invest a text. The two do not function identically, for what can be communicated by physical gesture and facial expression cannot be communicated as directly in written communication. Skilful authors, though, generally recognize this, and as compensation have at their disposal a wide range of specifically literary qualities with which they can mark their texts as a particular kind of illocutionary act. In the case of speech, a facial expression or a physical gesture often clearly determines the meaning, which includes the illocutionary force, of an otherwise semantically indeterminate short string of words. In the case of writing, a longer stretch of language is often required, in order for the generic markers to be sufficiently in place to determine the meaning. In the case of the Bible, we are always dealing with relatively long, carefully authored and compiled texts.

This issue will be taken up in more detail in Chapter 4, where the relationship between texts and authors will be discussed. Vanhoozer's conception of authorship and Wolterstorff's related conception of 'speech' will be used there as the basis of a

[64] Vanhoozer, *Is There a Meaning?*, 339.

[65] Ibid., 341 (original italics removed). The question of genre will be taken up again in the treatment of intertextuality in relation to the Bible in ch. 5, using, ironically, some work of Ricoeur on biblical genres.

[66] Ibid., 225, 229. Cf.: 'The application of speech act theory to writing enables us to understand writing as a mode of communication, indefinitely extended in time and space' (Francis Watson, *Text and Truth: Redefining Biblical Theology* (Edinburgh: T. & T. Clark, 1997), 11). Bakhtin sees all 'utterances' (speech acts), whether written or oral, as rejoinders in a dialogue, which aim to elicit a dialogical response from the audience (Bakhtin, 'Speech Genres', 75–6).

critique of the pragmatic defence of authors offered by E. D. Hirsch and of the attack on authors mounted by deconstructive writers.

SPEECH ACT THEORY, DIVINE SPEECH, AND SCRIPTURE: THE CONTRIBUTION OF NICHOLAS WOLTERSTORFF

Nicholas Wolterstorff's recent work, *Divine Discourse: Philosophical Reflections on the Claim that God Speaks*, makes a contribution to speech act theory which, it will be argued, is of great significance to the theory, and which will be adopted both in the following discussion of Karl Barth's view of the Bible and in the analysis of various hermeneutical options in Chapter 4. Wolterstorff attempts in his book to defend a claim which many philosophers would consider, as he says, 'off the wall': that God may truly be thought of as speaking.[67] He develops a general conception of speech, and argues that God legitimately may be thought of as a 'speaker' according to this conception. Then, recognizing that Judaism, Christianity, and Islam are text-based religions which have traditionally claimed that God's voice (Wolterstorff's preferred term is 'divine discourse') is mediated textually, he outlines and defends against other interpretative approaches the 'authorial discourse interpretation' which would seek to hear God's voice mediated through a text. This work will be outlined in more detail, first with regard to speech in general, and then with regard to divine speech in particular, and to how this informs his suggestion of how God may be understood to 'authorize' Scripture.

What is Speaking?

Wolterstorff wishes to separate 'speaking' from two other activities to which it is, to his mind, often closely and erroneously related. He denies, at some length, that speaking is a species of revealing—in contradiction of the widespread tendency in theology, which he documents, to subsume divine speech into divine revelation.[68] Revelation, he says, is 'the dispelling of

[67] Wolterstorff, *Divine Discourse*, p. ix. [68] Ibid., 10.

ignorance' in those cases where the dispelling has 'the character of unveiling the veiled, or uncovering the covered, of exposing the obscured to view'.[69] Speaking may on occasion function so as to reveal, but it is not in itself a kind of revelation. Here, as throughout *Divine Discourse*, he uses the act of uttering a promise as an example of speech: 'It's true that in promising someone something, one reveals various things about oneself. But the promising does not itself consist of revealing something—does not itself consist of making the unknown known.'[70] He illustrates this with the famous report by Augustine of his hearing a child saying '*Tolle, lege*', and his interpretation of that as God speaking to him, commanding him to open and read the copy of the letters of Paul in front of him. Borrowing the speech act terminology of John Searle, he analyses this command into its propositional content (that Augustine some time soon open his book) and illocutionary act (commanding Augustine to do what would make that proposition true). He argues that commanding Augustine to do what would make that content true is a quite different act from revealing its truth.[71] He concludes that speech is not to be identified with 'the transmission, the communication, of knowledge (or true belief) from one person to another': 'Speaking is not communication; it doesn't even require communication.'[72]

What then is speaking, at heart, all about for Wolterstorff? Fully accepting Austin's and Searle's argument that the basic unit of speech is the illocutionary act, he develops what he calls a 'normative theory of discourse'.[73] He suggests that the performance of a certain locutionary act comes to count as the performance of a certain illocutionary act by means of the 'normative ascription' of a 'normative standing'. What Wolterstorff means by this is best explained by simply reproducing the illustration he gives. If, while driving down the road, I switch on the left-side indicators of my car, I thereby acquire the standing of someone who has signalled his intention to turn left. My standing is *normative* because it is 'defined in part by a complex of mutual (prima facie) obligations': I acquire the duty to treat others, and they the duty to treat me, as someone who is

[69] Ibid., 23. [70] Ibid., 19. [71] Ibid., 20. [72] Ibid., 32.
[73] Ibid., 76 (original italics removed).

about to turn left.[74] The means by which the ascription of such standings comes about Wolterstorff calls 'arrangements'—for example, the signalling system for drivers. A system of arrangements itself comes into effect either by stipulation or by convention. Stipulation and convention are related, in that the latter is 'a sort of social stipulation'.[75] Hence my normative standing is *normatively* ascribed.

This, argues Wolterstorff, is how we are to understand how the utterance of a certain sentence comes to count as the performance of a certain illocutionary act. If I utter the sentence, 'Please give me a drink of water', the normative standing of someone who has requested a drink of water is normatively ascribed to me, such that the addressee is obligated to give me a drink of water. As Wolterstorff puts it, '[t]o institute an arrangement for the performance of speech actions is to institute a way of acquiring rights and responsibilities'. Moreover, these rights and responsibilities are moral ones: 'By uttering that sentence, the speaker has altered the moral relationship' between himself and his addressee. This is the case, says Wolterstorff, even with assertions, since '[a]sserting that so-and-so introduces into human relationships the (prima facie) right to be taken at one's word that so-and-so.'[76] Wolterstorff summarizes: 'Speaking introduces the potential for a whole new range of moral culpabilities—and accomplishments. At bottom, it is our dignity as persons that requires that we be taken at our word, and take ourselves at our word.'[77] A clear consequence

[74] Wolterstorff, *Divine Discourse*, 83.

[75] Ibid., 89–91. Wolterstorff comes to his understanding of what it is to speak via a critique of Searle's conception of 'institutional facts' (Wolterstorff, *Divine Discourse*, 80–1). That he returns to talk of 'social stipulations' suggests that, at this point, he has not escaped what he wished to critique. The validity of the concept of 'normative ascription', which represents a very creative direction for speech act theory, does not rest on the particular critique of Searle which Wolterstorff offers here.

[76] Ibid., 84–5.

[77] Ibid., 94. What Wolterstorff calls human 'dignity', Vanhoozer, following Alvin Plantinga, describes as an essential fact about human beings, which is the case because of our createdness: 'our design plan leads us to believe what we are told by others' (Vanhoozer, *Is There a Meaning?*, 290). Wolterstorff relates his definition of speech to Thomas Reid's argument 'that our human constitution includes an inherent *disposition* toward veracity in speech and, correspondingly, toward credulity in listeners' (Wolterstorff, *Divine Discourse*,

follows from this for anyone reading a text for what the author 'said':

The myth dies hard that to read a text for authorial discourse is to enter the dark world of the author's psyche. It's nothing of the sort. It is to read to discover what assertings, what promisings, what requestings, what commandings, are rightly to be ascribed to the author on the ground of her having set down the words that she did in the situation in which she set them down.[78]

It might be thought that this concept of 'speech' would lead to gullibility, and therefore to immorality and to oppression of various kinds. For example, should Hitler be 'taken at his word' in *Mein Kampf*? Surely, if we are going to read that text properly, something of the very 'dark world' of Hitler's psyche must be brought to bear on our reading? We must, however, carefully distinguish between reading a text in order to discover what illocutionary acts the author performed by means of it, and assessing the moral legitimacy of submitting ourselves to the perlocutionary effect which the author intended to produce by means of the text. Hitler meant to perform the speech acts he performs in his text; in that we must take him at his word. It does not follow just from that, of course, that the reader should obey what he commands.

Wolterstorff supplements his account of the moral rights and responsibilities which accrue in speaking with the qualification that we should take persons at their word, '[o]*ther things being equal, of course*'.[79] He writes of those rights and responsibilities as accruing to speakers and addressees prima facie. This is an important qualification, and it follows from the inherent moral nature of speaking that Wolterstorff describes. He allows that a speech act can be, as he says, 'undercut', if one has 'good reason to think that it is malformed in such a way that the prima facie rights and responsibilities which accrue to speakers and hearers upon its performance do not, in this case, actually

89). The theological basis of this 'dignity' is clearer in Vanhoozer than in Wolterstorff, as their respective subtitles suggest: Wolterstorff is offering *philosophical reflections*, and Vanhoozer is interested in *the Bible, the reader, and the morality of literary knowledge*.

[78] Wolterstorff, *Divine Discourse*, 93.

[79] Ibid., 94.

accrue to them'.[80] The uttering of a promise provides a good example. If someone utters a promise to do such-and-such, and the addressee has good reason to believe that the speaker either has no intention of fulfilling the promise or knows that he is not able to fulfil the promise, then the rights and responsibilities which would normally accrue to the addressee in this case do not. Using Wolterstorff's vocabulary, we could say that a person can offend against his own dignity in uttering something under conditions which serve to undercut his speech act, thereby becoming morally culpable, such that for the addressee to take him at his word would not in this case be a moral accomplishment. The ethical responsibilities which Wolterstorff places on listeners and readers therefore also include the *critical* responsibility to avoid gullibility. Vanhoozer comments aptly, in support of the epistemological legitimacy of personal testimony, '[c]redulity is not gullibility, as John Locke and other modern critics seem to think'.[81] Wolterstorff cites, as a hypothetical example of the appropriate response to an 'undercut' speech act, the situation of a Norwegian citizen in the Second World War refusing to obey an order issued by an official of the Quisling government.[82]

It will be helpful to set Wolterstorff's conception of speech briefly in the context of speech act theory in Austin and Searle, and of recent linguistic theory. The development in speech act theory from Austin through Searle to Wolterstorff is noteworthy. The heart of Austin's innovation was the recognition of the importance of the observation that even to state something is fundamentally not to communicate knowledge but to perform an act.[83] In his development of this, Searle developed a taxonomy of illocutionary acts, made up of what he calls assertives, directives, commissives, expressives, and declarations. What distinguishes declarations from the other categories for Searle is that '[d]eclarations bring about some alteration in

[80] Wolterstorff, *Divine Discourse*, 88.

[81] Vanhoozer, *Is There a Meaning?*, 290.

[82] Wolterstorff in fact justifies this by arguing that the official lacks legitimacy (presumably moral legitimacy) to issue commands in the name of the law; in effect, his position as one who may issue orders is undercut, such that his locutionary act does not even count as an order in the first place (Wolterstorff, *Divine Discourse*, 89).

[83] Austin, *How To*, 139.

the status or condition of the referred to object or objects solely in virtue of the fact that the declaration has been successfully performed'. (Searle has in mind such speech acts as the declaration of war, or the appointing of a person to a certain role or status.)[84] What Wolterstorff has done is effectively to show the failure of Searle's categories by demonstrating that what Searle describes as unique to 'declarations' is in fact true of every speech act. Even by just asserting something to someone, the speaker (prima facie) changes the status of both himself and his addressee, for his assertion implies a reference to himself as someone who undertakes to be asserting truly and on good grounds, and to the addressee as someone who is obligated to believe the speaker on those grounds.[85] In short, Wolterstorff's concept of speech may be regarded as a rigorous development of the implications for human action in general and speaking in particular of Austin's initial observation that to speak is not to communicate but to act, taking proper account of the fact that speech acts are always performed in a relational and moral environment.[86]

[84] Searle, *Expression and Meaning*, 12–17.

[85] The same observation can be made another way. Searle arranges his taxonomy of illocutionary acts according to different kinds of 'direction of fit' between speech acts and the world. 'Directives', such as requests and commands, have a 'world-to-word' direction of fit, in that their point is that the world should match the intention expressed in the illocution. 'Assertives', by contrast, have the opposite 'word-to-world' fit: the speaker commits himself to the claim that his words accurately reflect some state of affairs in the world (Searle, *Expression and Meaning*, 3–4). Only in the case of declarations, says Searle, does the direction of fit go in both directions: when a judge declares 'You are guilty', he both makes a factual claim (word-to-world) and makes a legal declaration (world-to-word). Again, Wolterstorff's concept of normative standing, by setting all speech acts in a clear context of the establishing of moral relationships, suggests that with every speech act the direction of fit goes in both directions. Even by uttering a simple assertion—say, 'It's ten o'clock'—the speaker both asserts something about reality (word-to-world) and is thereby responsible for the coming about of new normative standings in the world for himself and his addressee(s), as entailed by the performance of that illocutionary act (world-to-word).

[86] It is also noteworthy that Wolterstorff's concept of speech is paralleled and prefigured in at least one branch of linguistic research. De Beaugrande and Dressler apply von Wright's general definition of an action as 'an intentional act which changes a situation in a way that would not have happened otherwise' specifically to language. They advocate defining a discourse action in terms of the changes in 'knowledge state, social state, emotional state, and so

A final point may be made here. Is all this talk of the moral implications of even an act as mundane as telling someone the time a little heavy-handed, or overblown? Interestingly, Searle at one point seems to suggest that it is. He anticipates Wolterstorff's claim that the obligations which accrue in the case of a performance of a speech act are moral obligations, and rejects it. '[O]bligation to keep a promise probably has no necessary connection with morality,' he says: if I promise to go to a party but then don't go because I don't feel like it, that is 'remiss' of me, but not immoral.[87] In fact, Searle does not explain the distinction between being 'remiss' and behaving immorally towards others. Different people may well judge such a breaking of a promise differently—and much would depend on the complexities of the context in which it was uttered. However, once we come to see the situation of not keeping a promise as the breaking of a word to which one had committed oneself with respect to one's future behaviour in relation to others, and on the basis of which one had invited others to act in the assumption that the promise would be kept, the language of 'morality' seems more appropriate than that of simply being 'remiss'. Or, perhaps better, to suggest that the breaking of a certain promise is only 'remiss' sounds like an appeal that the person in question is responsible for only a small moral failing. In that case, talk of morality is still legitimate.[88]

Divine Speech and Scripture

Having laid out this general description of speech, Wolterstorff turns to speak of God. He argues that, in light of the above, it is reasonable to say of God that he speaks. He suggests initially that we should think of God's speech as the performance of illocutionary acts, not necessarily performed by means of verbal

on' which it effects upon the participants (De Beaugrande and Dressler, *Introduction to Text Linguistics*, 124). Wolterstorff reveals how the changes in these different states are aspects of a fundamental change in moral status and relationships.

[87] Searle, *Speech Acts*, 188.

[88] Wolterstorff argues against the suggestion that the rights and duties which accrue in the act of speaking are linguistic rather than moral (Wolterstorff, *Divine Discourse*, 94).

locutionary acts: 'perhaps the attribution of speech to God by Jews, Christians, and Muslims, should be understood as the attribution to God of *illocutionary actions*, leaving it open how God performs those actions—maybe by bringing about the sounds or characters of some natural language, maybe not'.[89] (Remember that, according to Wolterstorff, a wordless act such as turning on the indicator lights on one's car is a 'speech act'.)

He defends his version of the claim that God speaks against two possible specific objections. First, with reference to divine command theory, he argues against William Alston's view that God 'does not have and cannot acquire obligations'.[90] If Alston is right, then God cannot be thought of as a 'speaker' in Wolterstorff's sense of the word. Wolterstorff responds that '[s]ome of God's actions are such that they are required of God if God is to act "in loving character"'.[91] God does therefore acquire obligations, but only to the extent that they are imposed not from without but by his own character, specifically his loving character. God's engagement in discourse is then like human engagement in that he thereby acquires rights and duties, and unlike human engagement in that those rights and duties are not given or imposed from outside himself. This of course raises complex theological and philosophical questions which mostly go well beyond our scope here. To the extent that they touch on the question of God's freedom in relation to the Bible as in some sense his Word, they will be addressed in the following discussion of Barth's treatment of the Bible. Second, Wolterstorff notes that, more generally, his conception of divine speaking requires that God be thought of as intervening in the world, and argues that it is reasonable to think of God as able to 'bring about the events generative of God's speaking'.[92]

Wolterstorff's initial suggestion that God's speech may be thought of as consisting, in part, of illocutions performed non-verbally represents something of a move beyond Austin and Searle. Both Austin and Searle are principally concerned with verbal language; Austin is aware of the fact that certain illocutions can be performed non-verbally (he gives the example of threatening someone by waving a big stick), but is generally ambivalent on the point, insisting elsewhere on the need for

[89] Ibid., 13.　　[90] Ibid., 103.　　[91] Ibid., 111.　　[92] Ibid., 114–29.

verbal locutionary acts.[93] The illocutionary act of threatening someone can indeed be performed quite unmistakably by wielding a big stick in a certain way. The switching of traffic-light signals and car indicator lights are further examples of speech acts being clearly performed by rudimentary non-verbal sign-systems. However, when we come to the question of the speaking activity of the Christian God, verbal locutions are clearly required.[94] Central to God's (speech) actions towards humanity, according to the Bible, is the speech act of promising. The performance of the act of a promise is a complicated affair, for it commits the speaker to a certain kind of behaviour, with reference both to other persons, and probably to objects in the world, and also to the future. This web of spatial and temporal references is sufficiently complex that a promise can only be given by means of a verbal locution; it cannot be mimed.[95]

Despite his initial suggestions about illocutionary acts being performed by non-verbal locutions, in the rest of *Divine Discourse* Wolterstorff does in fact concentrate his attention on divine speech acts performed by verbal means, since Judaism, Christianity, and Islam all regard certain texts as central to the means by which God speaks to people in the present. In this regard, he notes James Barr's observation that, although most contemporary theologians take revelation to be 'revelation through history', the Old Testament regularly portrays God as engaging in verbal speech. For example, the people of Israel would never have been delivered from Egypt if God had not spoken to Moses *verbally*, as he did through the incident of the burning bush.[96]

In order to describe God's action as a speaker in relation to the language of the Bible, Wolterstorff introduces the concept of 'double agency discourse'. He observes that often 'one per-

[93] Austin, *How To*, 114, 119–20.

[94] Quasi-verbal languages, such as complex signing-systems for deaf people, or non-verbal sign-systems which copy verbal language letter by letter, such as semaphore, may also be included here.

[95] Since Christian theology regards the person and work of Jesus Christ as the primary means by which God speaks to us, we soon face the question of the coming of Jesus Christ to (verbal) speech. The relation of persons to verbal language, specifically, of God to the Bible, is one around which our subsequent discussion of Barth will revolve.

[96] Wolterstorff, *Divine Discourse*, 30.

son says something with words which he himself hasn't uttered or inscribed'.[97] He considers the case of deputization. An ambassador, for example, speaks on behalf of his own government, but mostly using entirely his own words, and sometimes with his government unaware of what he is saying and even that he is saying something. The ambassador is performing locutionary acts which count as illocutionary acts performed by his own government—although of course he may also sometimes perform illocutionary acts of his own. There is a close parallel between this case and that of the Old Testament prophets, who regularly move between delivering a message which God has deputized them to deliver, and speaking in his name in their own words because so deputized.[98] Similarly, in the case of the New Testament, Wolterstorff argues, a good case can be made for seeing the apostles, whose message is enscripturated in the texts of the New Testament, as Jesus' representatives or deputies, and therefore for seeing their texts as media of divine discourse.[99] There is another mode of double agency discourse, according to Wolterstorff, in which one person speaks by means of another's illocution, not just their locution—what he also calls speaking by means of someone else's speech, not just their text. This is an act of *appropriating* someone else's discourse—for example, when one responds to someone else's discourse with, 'I share that commitment', or 'I second the motion.'[100]

Wolterstorff argues that, if the Bible is to be treated as a medium of divine discourse, the best way to understand the relationship between the human discourse of the texts and the divine discourse of which they are a medium is as a relationship of *appropriation*: God appropriates the human discourse for his own illocutionary actions. Although some parts of the Bible, such as prophecy, are instances of deputized discourse, deputization is not satisfactory as a category for thinking of God's relationship to the whole Bible. What, he asks, are we to make of biblical narrative, Wisdom literature, and particularly the Psalms, in which human authors address God? A psalm which addresses God cannot itself carry the implicit ascription 'Thus says the Lord', for that would lead to the nonsensical conclusion that God is addressing himself.

[97] Ibid., 38. [98] Ibid., 45–6. [99] Ibid., 288–95. [100] Ibid., 52.

Although Wolterstorff sees each individual book of the Bible as appropriated by God, the real point of his introduction of the concept is to suggest a way of conceiving of the Bible as a whole as '*one* book of God'.[101] He sees the act of divine appropriation taking place not in some way prior to and in the act of the composition or redaction of the Bible's individual books, which is where the doctrine of inspiration has traditionally located God's action in identifying the Bible as his own book. For Wolterstorff, rather, 'the event which counts as God's appropriating this totality as the medium of God's own discourse is presumably that rather drawn out event consisting of the Church's settling on this totality as its canon'.[102]

Wolterstorff notes that he is not claiming that the doctrine of inspiration is false, merely that '[a] doctrine of inspiration is . . . not a doctrine of divine discourse'.[103] '[T]he phenomenon of X inspiring Y to say such-and-such is not the same as X saying such-and-such,' he says: 'a young student's paper remains very much the medium of his discourse even though he composes it very much under the inspiration of his professor.'[104] When we come to discuss the doctrine of inspiration in Chapter 5 it will be noted that some recent versions of the doctrine confuse the technical theological meaning of the word 'inspire', which it and its cognates have in the traditional formulations, with the different meaning the word usually has in everyday usage. Wolterstorff here, in his illustration of students and professors, confuses the two in the same way.

Wolterstorff is fully aware that his model of the divine appropriation of the Bible apparently requires us to answer the difficult question of how certain people might have come to say exactly what God wants to say, so that he could appropriate their texts—which is the very question which the traditional doctrine of biblical inspiration addressed. He acknowledges that 'it would be bizarre to think of God as just finding these books [those containing non-prophetic discourse, for example Psalms, Esther, Song of Songs] lying about and deciding to appropriate them; the appropriation model calls for some doctrine of inspiration'. Therefore, a doctrine of inspiration is required,

[101] Wolterstorff, *Divine Discourse*, 53.
[102] Ibid., 54 (original italics removed).
[103] Ibid., 301 n. 8. [104] Ibid., 283.

but only as 'a supplement. However these books came about, the crucial fact is that God appropriates that discourse in such a way that those speakings now mediate God's speaking.'[105]

As a preliminary to the later discussion of inspiration, a brief response can be offered here. Wolterstorff does reinstate the doctrine of inspiration, acknowledging that a strange doctrine of God would emerge from the claim that God just finds certain books lying around, finds them appropriate to his purposes and so appropriates them. Yet it seems that this reinstatement cannot in fact be to any position other than to the central characterization of God's relationship to the Bible which Wolterstorff wishes to reserve for appropriation. He wishes to preserve some kind of doctrine of providence with regard to God's relationship as speaker to Scripture, and he does not think that a purely human text could ever be suitable as it stands to express God's speech. Once this has been established, it is hard to see that Wolterstorff really means what he says when he claims that 'a doctrine of inspiration is really only a supplement'. Given sensibilities about theology and anthropology which Wolterstorff seems to hold, it cannot just be a supplement: it is a fundamental guarantee of the possibility that any text written in human language could ever be viable as a medium of divine discourse.[106] We may, though, be able to accept Wolterstorff's concept of appropriated discourse, viewing God's action in the process of canonization as a supplementary act of appropriating texts whose production he previously superintended by the process traditionally termed 'inspiration'. This will all be taken up in detail in Chapter 5.

[105] Ibid., 187. The divine speech act performed by, for example, a psalm of lament, is presumably to be regarded as something like an authorization that the sentiments expressed to God in the psalm may legitimately be so expressed.

[106] Howard Marshall makes a similar point in response to Wolterstorff, in I. Howard Marshall, '"To Find Out What God Is Saying": Reflections on the Authorizing of Scripture', in Roger Lundin (ed.), *Disciplining Hermeneutics: Interpretation in Christian Perspective* (Leicester: Apollos, 1997), 49–55, at 51.

KARL BARTH ON SCRIPTURE AS THE WORD OF GOD

We turn now, in light of the elements of speech act theory out-
lined so far, to a study of Karl Barth's notion of God's speech,
and of its relation to his view of the Bible. Karl Barth is unusual
among recent theologians in that he insists that God speaks.
Moreover, he sees God's speech as a communicative act. When
Barth says that God speaks, he is clear that he means it literally:

> Church proclamation is talk, speech [*Rede*]. So is Holy Scripture. So
> even is revelation in itself and as such. If we stay with God's Word in
> the three forms in which it is actually heard in the Church, if we do
> not go outside the Church and think of things God might have willed
> and done but has not done and not so willed in the Church, we have
> no reason not to take the concept of God's Word primarily in its
> literal sense. God's Word means that God speaks. Speaking is not a
> 'symbol'. . . . [I]n this form in which the Church knows God's Word
> . . . God's Word means that 'God speaks,' and all else that is to be said
> about it must be regarded as exegesis and not as a restriction or a nega-
> tion of this statement.[107]

A recent intellectual biography of Barth summarizes the
position which Barth came to hold: 'It was this presupposi-
tion—God is speaking—and the attitude of brokenness it im-
plied which had to be recovered.' Barth arrived at this position
through a consideration of the Scripture-principle of Reformed
theology, which 'said simply that revelation means that *God* is
speaking'.[108] In addition, the Protestant principle that the Bible
interprets itself was, according to another commentator, deter-
minative for Barth's work throughout his life.[109] This influence
led Barth 'to attribute unique authority to the Bible as the rule
of faith and life',[110] as is often recognized. He restored the Bible

[107] Karl Barth, *Church Dogmatics* I/I, trans. G. W. Bromiley (Edinburgh:
T. & T. Clark, 1975), 132–3.

[108] Bruce L. McCormack, *Karl Barth's Critically Realistic Dialectical The-
ology: Its Genesis and Development 1909–1936* (Oxford: Clarendon Press, 1995),
317. McCormack dates this realization in Barth to his 1922 lectures on Calvin.

[109] It was (quoting Lindemann) 'zeitlebens bestimmend' (David Ford,
Barth and God's Story, Studies in the Intercultural History of Christianity 27
(Frankfurt am Main: Peter Lang, 1981), 19).

[110] McCormack, *Karl Barth's Critically Realistic*, 305–7.

to its traditional place 'as matrix and norm in which the church can be viewed'.[111] Yet Barth is also well-known for departing from the orthodox Protestant position on Scripture, in his rejection of the direct identification of the Bible with the Word of God, and in his criticism of the traditional Protestant conception of the inspiration of the Bible. For these three reasons— that he insists that God speaks, and sees his speech as a communicative act, that he gives the Bible supreme authority, and that he nevertheless moves away from the view of Scripture and revelation with which the doctrine of the sufficiency of Scripture is most regularly associated—Barth's work requires particular attention here. Speech act theory will provide the central analytical tool in this discussion.

Barth's Theological Motives

It has been well documented that the controlling concern of Barth's work is that human beings, in our living, thinking, and speaking of God, should continually regard God as coming to address us with a word from outside us. Attempts to reach God through human cognition, spiritual experience, and human culture are both doomed to failure and idolatrous. The history of Christian theology is far from innocent here. Thus Barth found fault with seventeenth-century Protestant orthodoxy at this point, for it wanted, he thought in regard to its doctrine of the inspiration of Scripture, 'a tangible certainty, not one that is given and constantly has to be given again, a human certainty and not a divine, a certainty of work and not solely of faith'.[112] He thought of liberalism and the Roman Catholic Church similarly, for he regarded them as treating God as (respectively) generally available as a predicate of human religious psychology or experience, or inextricably related to a human institution.[113]

[111] George Lindbeck, 'Barth and Textuality', *Theology Today* 43 (1986), 361–76, at 376.

[112] Karl Barth, *Church Dogmatics* 1/2, trans. G. T. Thomson and Harold Knight (Edinburgh: T. & T. Clark, 1956), 524.

[113] 'The assertion of fellowship between God and man in the form of an operation beyond the juxtaposition of the divine and human persons, beyond the act of divine and human decision, is at least common to both even if one has to remember that this synthetic operation is regarded as man's work on the side of Modernism and as God's on that of Roman Catholicism' (Barth, *CD* 1/1, 68).

Barth thinks of God's cognitive unavailability to us as an aspect of his sovereign lordship. It follows from this that when God does present himself to us, he always acts to do so by his entirely free sovereign choice: 'Lordship means freedom.' This freedom characterizes especially God's active relationship to the Bible: 'It is thus, as the One who is free, as the only One who is free, that God has Lordship in the Bible.'[114] Again, the seventeenth-century doctrine of biblical inspiration, which Barth took to be an innovation, is found wanting, for 'the statement that the Bible is the Word of God was now transformed . . . from a statement about the free grace of God into a statement about the nature of the Bible as exposed to human inquiry brought under control'.[115] For Barth, God has 'free control over the wording [*Wörtlichkeit*] of Holy Scripture'.[116] The orthodox Protestant doctrine of inspiration ascribed to God free control over the wording of Scripture in the process of the Bible's composition in the past. Barth would rather describe that free control solely in terms of God's action in and through the Bible in the present. He treats the orthodox doctrine of inspiration as identical in this respect to the liberal tendency to find revelation 'in the heroic religious personality of the biblical witness'. They are both 'products of the same age and spirit. A common feature is that they both represent means whereby Renaissance man tried to control the Bible and also tried to set up obstacles to stop its controlling him, as indeed it ought to do.'[117] On the same grounds he also criticizes Roman Catholicism, arguing that the Bible in Roman Catholicism 'is not the Bible in itself, the emancipated Bible, the Bible which confronts the Church as an authority. The fact that the Bible in its own concreteness is the Word of God, and that as such it is the supreme criterion of Church teaching, is not acknowledged here.'[118] Barth also casts the orthodox Protestant insistence that the Bible attests to its own authority, an insistence of which he approves, in terms of the Bible's freedom, asserting that, if we could prove from somewhere else the supremacy of the Bible, 'then the Bible whose supremacy we could establish would obviously not be the free Bible which constitutes an effective court'.[119] In addi-

[114] Barth, *CD* I/1, 306–7. [115] Barth, *CD* I/2, 522.
[116] Barth, *CD* I/1, 139. [117] Ibid., 112–13.
[118] Ibid., 257. [119] Ibid., 259.

tion, Barth argues that the medium of divine revelation, if it is to function freely as that to which the church must always submit, must be in written form. A written text can 'maintain . . . its own life' against encroachments from outside. By contrast, '[i]n unwritten tradition the Church is not addressed; it is engaged in dialogue with itself'.[120] Barth thus concurs with the Protestant confession that Scripture is necessary for the faithful proclamation of the gospel of Christ.

One of Barth's fundamental claims about God is that he is an acting, relating, and addressing subject.[121] The freedom of the Word of God for Barth is therefore its identity as a living and active subject:[122] 'All that has hitherto been said about the self-affirmative, critical and assimilative power of the Word of God can be properly understood only when it is realised that the Word is first the Subject and only then the object of history.'[123] 'What God and His Word are . . . is something God Himself must constantly tell us afresh. . . . In this divine telling there is an encounter and fellowship between His nature and man but not an assuming of his nature into man's knowing, only a fresh divine telling.'[124] The Word of God has for Barth what he calls a 'purposive character . . . This might be called its relatedness or pertinence, its character as address.'[125] This is true of the Word even in the form of dogma, which Barth defines as 'the agreement of Church proclamation with the revelation attested in Holy Scripture'.[126] Barth is wary of equating revelation with dogmatic propositions; if the equation is to be made, he says, we must understand dogma as *command*.[127] It is thus evident that Barth anticipates many of the insights later articulated by speech act theorists, in that he refuses to contemplate the Word of God as existing without an illocutionary force. It is for him an address with purpose, mediating the encounter between divine and human persons. Hans Frei argued that 'Barth's

[120] Ibid., 105–6.
[121] George Hunsinger, *How To Read Karl Barth: The Shape of His Theology* (New York and Oxford: Oxford University Press, 1991), 30, 45.
[122] Geoffrey W. Bromiley, 'The Authority of Scripture in Karl Barth', in D. A. Carson and John D. Woodbridge (eds.), *Hermeneutics, Authority and Canon* (Leicester: Inter-Varsity Press, 1986), 271–94, at 285.
[123] Barth, *CD* I/2, 685.
[124] Barth, *CD* I/1, 132.
[125] Ibid., 139. [126] Ibid., 265. [127] Ibid., 271.

discussion of [revelation] in [*Church Dogmatics*] 1/1 and 1/2 can be understood as an analysis, without benefit of J. L. Austin and his successors, of the logic of performative utterances.'[128] Frei was on the right track; his observation has been followed up by Kevin Vanhoozer,[129] and it will be developed in the concluding section of this chapter.

The Word of God and Scripture

Barth's continual attempt to construe God in his relation to humanity and the world in such a way that God always remains in control of his self-revelation is particularly clear in his well-known account of the three-fold form of the Word of God. These three forms are the Word preached, written, and revealed. The Word revealed occurs in the present, for us who do not see Christ in the flesh, in identity with the Word preached and written. Revelation is therefore the form of the Word which underlies the other two: 'If "written" and "preached" denote the twofold concrete relation in which the Word of God is spoken to us, revelation denotes the Word of God itself in the act of its being spoken in time.' Revelation is, says Barth, 'the divine act in itself and as such', whereas proclamation and the Bible are God's Word only in that they become God's Word: 'Revelation is itself the divine decision which is taken in the Bible and proclamation . . . It is itself the Word of God which the Bible and proclamation are as they become it.'[130]

Barth regards the inclusion of church proclamation in this three-fold form as providing a particular bulwark against liberalism's individualistic notion of revelation. He sees this point as an advance on the orthodox scholastics, who, lacking a link between revelation and the present which is firmly related to the Word, inadvertently prepared the ground for liberalism. Of the orthodox scholastics, Barth says: 'Preaching is called "God's Word" in them too, but the real connecting point

[128] Referred to in Lindbeck, 'Barth and Textuality', 368.

[129] Kevin Vanhoozer, 'God's Mighty Speech-Acts: The Doctrine of Scripture Today', in Philip E. Satterthwaite and David F. Wright (eds.), *A Pathway into the Holy Scripture* (Grand Rapids: Eerdmans, 1994), 143–81.

[130] Barth, *CD* 1/1, 117–18.

between revelation and Scripture in the present is increasingly something far different from the act of Church proclamation; it is the knowledge, faith, sanctification and blessedness of the individual.' This 'private divine institution for so many private persons' left the church easy prey to modernism.[131]

Barth's doctrine of revelation expresses the (for him) fundamental theological principle that only God can reveal God. This point is directly linked with his view of God as an acting subject. We only know God as he is in his revelation of himself to us: '*God* reveals Himself. He reveals Himself *through Himself*. He reveals *Himself*. If we really want to understand revelation in terms of its subject, i.e., God, then the first thing we have to realise is that this subject, God, the Revealer, is identical with his act in revelation and also identical with its effect.'[132] McCormack relates this theological principle to the Scripture-principle which influenced Barth early in his career: 'God can only be known through God: that is the point of the Scripture-principle.'[133] The only permanent, true 'Word of God' in itself is therefore Jesus Christ. Barth's strongly Chalcedonian Christology insists that Christ really is the second person of the Trinity in human form, God come in the flesh. To identify anything else directly and permanently, in itself, with revelation or with the Word of God, as the Protestant orthodox did with Scripture, is, for Barth, to threaten the supremacy of Jesus Christ.

Therefore, 'the Bible is not in itself and as such God's past revelation. . . . We thus do the Bible poor and unwelcome honour if we equate it directly with this other, with revelation itself.'[134] Barth most often describes the relation between the Bible and revelation as an event, an event entirely of God's free choosing, in which the Bible becomes revelation under his control as he speaks in and through it directly to people:

Recollection of God's past revelation, discovery of the Canon, faith in the promise of the prophetic and apostolic word, or better, the self-imposing of the Bible in virtue of its content, and therefore the

[131] Ibid., 124. It is for this reason that Barth sees the focus of his theological project being the reformation of preaching: 'Hence the direct object of dogmatics today must be Church proclamation.' [132] Ibid., 296.

[133] McCormack, *Karl Barth's Critically Realistic*, 317.

[134] Barth, *CD* I/1, 111–12.

existence of real apostolic succession, is also an event, and is to be understood only as an event. In this event the Bible is God's Word. . . . The Bible is God's Word to the extent that God causes it to be his Word, to the extent that He speaks through it.[135]

Barth thus holds to what Vanhoozer calls 'the indirect identity thesis' of the relationship between the Bible and the Word of God.[136] Wolterstorff describes his view of God's speech in the Bible as 'a relentless eventism'.[137]

A question may be raised over whether the 'event' of the identity of the Bible and the Word of God should be thought of as one in a series of discrete events in which it happens that God chooses to address someone in and through the Bible, which ceases at the end of the Bible-reading, or when God stops speaking, or even when the addressee closes his or her heart and mind.[138] Two of Barth's best-known expositors, T. F. Torrance and Eberhard Jüngel, understand this 'event' as something other than one in a series of discrete temporal events.

In his exposition of Barth on the event of revelation through the Bible, Torrance asserts that 'the bond between the Word of God and the Bible is not a static or necessary one but a dynamic one, freely established by God which he is pleased *unceasingly* to affirm and maintain through the real presence and activity of his Word.' Similarly: 'The Holy Bible is the Word of God as God himself utters it and thereby acts upon us, and *remains* the Word and act of God as God *continues* to utter it and act upon us.'[139] Torrance seems to have in mind not a series of discrete events but a continuous event of 'becoming'—a word which in Barth means, he says, 'being in action and time as it continuously becomes what it really is'.[140]

[135] Barth, *CD* I/1, 109.

[136] Vanhoozer, 'God's Mighty Speech-Acts', 169.

[137] Wolterstorff, *Divine Discourse*, 71.

[138] The latter possibility, that the 'event' of the Bible becoming the Word of God might end when a reader or hearer closes his heart or mind to the Word, might seem odd. However, it should be remembered that at one point, cited above, Barth says that God the revealer is identical with the *effect* of revelation. In the case of divine speech, Barth here seems to be eliding illocution into perlocution. This observation will be developed further below.

[139] Thomas F. Torrance, *Karl Barth, Biblical and Evangelical Theologian* (Edinburgh: T. & T. Clark, 1990), 91, 95 (italics added).

[140] Torrance, *Karl Barth*, 97.

This is analogous to Jüngel's particular exposition and development of Barth's doctrine of God in the concept that 'God's being is in becoming'. John Webster argues that by this designation Jüngel does not make God an exemplar of metaphysical categories, but is attempting 'to specify the voluntary nature of God's self-sacrifice in identifying himself with the crucified Jesus'.[141] Jüngel, therefore, likewise regards the 'event' of revelation as a *sui generis* theological category, rather than a general temporal category. There is, he says, no *analogia entis* between revelation and human language; rather, 'the language in which revelation should be able to come to speech must, [quoting Barth] "as it were, be commandeered" by revelation. Where such "commandeering" of the language by revelation for revelation becomes event, then there is a *gain to language*. It consists in the fact that God as God comes to speech.'[142] The term 'event' here refers to the gracious God-wrought miracle by which human language can achieve something which is impossible according to its own inherent qualities: it comes to refer to God.[143] Thus Jüngel continues: 'When language aims to be revelation it loses itself as language. But where revelation commandeers language, *the word of God* takes place. The word of God *brings* language to its true essence.'[144] The 'event' of revelation refers to this gain to language, not to occasions on which the gain takes place. Elsewhere, Jüngel contrasts 'event' with a supposed inherent capacity of human language to speak of God, requiring us to choose between God's address to man conceived of as an 'event' and as '[a] datum of talk about God given with the existence of man'.[145] Understood this way, there is nothing about the nature of the 'event' which determines (how could it?, since God is radically free) that God cannot bring the event about continuously or even permanently. What it does fundamentally challenge is a permanent tying, resulting in an onto-

[141] J. B. Webster, *Eberhard Jüngel: An Introduction to His Theology* (Cambridge: Cambridge University Press, 1986), 20–2.

[142] Eberhard Jüngel, *The Doctrine of the Trinity: God's Being Is In Becoming* (Edinburgh: Scottish Academic Press, 1976), 11.

[143] For this theme in Barth, see Hunsinger, *How To Read Karl Barth*, 44.

[144] Jüngel, *The Doctrine of the Trinity*, 14.

[145] Eberhard Jüngel, *God as the Mystery of the World: On the Foundation of the Theology of the Crucified One in the Dispute Between Theism and Atheism*, trans. Darrell L. Guder (Edinburgh: T. & T. Clark, 1983), 248–9.

logical identity, by God of his Word to the Bible, such that one could construe his action quasi-deistically as resulting in a quasi-divine or even divine set of texts now left at human disposal. This is Torrance's point when he asserts, restating a sentence of Barth's, that the Bible is tied to the Word of God, not the Word of God to the Bible.[146]

Two issues arise here: the ability of human language to refer to God, and the question of the two possible senses of 'event' in Barth's use of the term. As regards the first, Jüngel thinks of the event of divine revelation in human language as a gain to language's referential capabilities, which brings language 'to its true essence'. John Webster has argued cogently that this has the effect of devaluing all other human language.[147] In Chapter 5, some work of Paul Ricoeur's will be discussed, developing a suggestion made by Vanhoozer,[148] on the question of how the Bible qua human language might be thought of as referring to God by means of its polyphonic discourse, while alleviating Barth's concern that Bible-readers might then think of themselves as 'possessing' God. What Ricoeur offers, we will suggest, is a more nuanced account of the referential capabilities of human language by means of a full recognition of the Bible's generic diversity.[149] As regards the two possible senses of 'event' in Barth's use of the term, even granting the legitimacy of Jüngel's and Torrance's expositions, there remains a sense in Barth's use of 'event' that the Bible sometimes is God's Word

[146] Torrance, *Karl Barth*, 102.

[147] Jüngel stresses that the 'gain' to language, by which it comes to refer to God, brings language 'to its true essence'. Webster comments: 'It is difficult to see how this process can be a "gain to language" when the corollary is that language which does not "bring God to speech" has somehow failed to attain its essence. For all Jüngel's concern to validate human speech from the prevenient divine Word, there is a real danger of absorption of our language into the divine speech-act, or at least of the implication that a purely "natural" language is a bastard form of speech' (Webster, *Eberhard Jüngel*, 42).

[148] Vanhoozer, 'God's Mighty Speech-Acts', 174 n.96.

[149] Jüngel's concept of the whole Bible as 'parabolic', which will be discussed below, is analogous to Ricoeur's notion that in the case of literary texts in general the normal mode of reference is suspended, and a 'world' is 'projected' 'in front of' the text; for this comparison, see Webster, *Eberhard Jüngel*, 43–5. What will be referred to in ch. 5 is Ricoeur's particular conception of how, in the particular case of the Bible, the whole refers 'polyphonically' to God.

and sometimes is not. This is particularly the case because he ties its identity as Word in part to its having an effect in and on its readers and hearers. Once this link has been made, the Bible can be said continually to become the Word of God, but it cannot be said continuously to remain the Word of God. When the intended perlocutionary effect is brought about in a reader, it is the Word of God; when that effect is not brought about, it is not. To read 'event' as at least in part a temporal category in Barth seems legitimate.

Precisely the same dynamic is at work in Barth in the relationship between present church proclamation and revelation as has been described between the Bible and revelation. He refers to 'the event of God's own speaking in the sphere of earthly events, the event of the authoritative vicariate of Jesus Christ', and then relates this event to proclamation: 'Real proclamation as this new event, in which the event of human talk is not set aside by God but exalted, is the Word of God.'[150] It is true, as McCormack observes, that precedent can be found for drawing no distinction between the Bible and preaching, in that each can become revelation, in Heinrich Bullinger's statement in the Second Helvetic Confession that 'The Preaching of the Word of God is the Word of God'.[151] It will shortly be argued that certain problems arise in Barth's doctrine of Scripture because of his identical treatment of Scripture and proclamation, in their separate relationships with the Word of God, as equally events of revelation.

However, despite the identical nature of the relationships between the Word of God and each of the Bible and preaching as revelation, Barth retains in practice a very strong reliance on the authority of the Bible over the church and over all human activity and speech. Although he establishes great similarities between Scripture and proclamation, there remains 'a dissimilarity in order, namely the supremacy, the absolutely constitutive significance of the former for the latter, the determination of the reality of present-day proclamation by its foundation upon Holy Scripture'.[152] He bases this supremacy on the fact of Scripture's authority as witness to divine revelation, Jesus

[150] Barth, *CD* I/I, 95.
[151] McCormack, *Karl Barth's Critically Realistic*, 340.
[152] Barth, *CD* I/I, 102.

Christ, the Word made flesh: 'Why and in what respect does the biblical witness have authority? Because and in the fact that he claims no authority for himself, that his witness amounts to letting that other itself be its own authority.'[153] It was and is now the church's experience that the canon of Scripture by this witness to revelation presents itself to the church. Except in the most trivial sense, the church does not write the Bible: 'It is the canon because it imposed itself on the church as such and continually does so.' Its authority is demonstrated in that it is in the Bible alone that the church has heard God speak in this way: 'When the Church heard this Word—and it heard it only in the prophets and apostles and nowhere else—it heard a magisterial and ultimate word which it could not ever again confuse or place on a level with any other word.'[154]

The whole Bible is the authoritative witness to revelation, that is, to Jesus Christ, because every part of it arises out of a history in which Jesus has been present with God's people, both before and after his physical appearing on earth: 'although the Bible is a source and norm which specifically addresses its readers and hearers in the power of the Holy Spirit, it is also an abiding whole which is given to the community through its history and in which Jesus accompanies it through this history.' Scripture is therefore like the pillars of cloud and fire which led ancient Israel—'an invariably authentic direction to the knowledge of its [the community's] Lord'. Thus, Scripture's authority is 'based on a direct relationship to the history of Israel and that of Jesus Christ Himself'.[155] Barth's grounding of the authority of Scripture may be further investigated through an interpretation of his notion of God as a speaking God.

God as Speaker according to Barth

It has been observed at the outset that Barth insisted that 'God speaks', and that in saying this he meant to take 'speaks' literally. He insisted that everything else he would go on to say 'must be regarded as exegesis and not as a restriction or a nega-

[153] Barth, *CD* I/I, 112.
[154] Ibid., 107–8.
[155] Karl Barth, *Church Dogmatics* IV/3, trans. G. W. Bromiley (Edinburgh: T. & T. Clark, 1961), 126–30.

tion of this statement'.[156] We will follow Barth's arguments in the section of *Church Dogmatics* I/1 on 'The Word of God as the Speech of God',[157] to which these claims form an introduction, in order to see how Barth expounds the claim that God speaks, and what in practice he means by the claim. He argues that three implications follow from the assertion that God speaks.

First, the Word of God is spiritual in nature, that is, spiritual, 'as distinct from naturalness, corporeality, or any physical event'. Yet 'there is no Word of God without a physical event'; such events are the sacraments, 'the letter [*Buchstäblichkeit*] of Holy Scripture', and 'supremely . . . the corporeality of the man Jesus Christ'.[158] It becomes clear that the notion of God speaking describes the relation between this spiritual nature of the Word and these particular physical realities:

The Word of God is primarily spiritual and then, in this form, in this spirituality, for the sake of it and without prejudice to it, it is also a physical and natural event. *This particularity is what is meant when in accordance with the three forms in which we hear this Word we call it the speech of God*. Speech, including God's speech, is the form in which reason communicates with reason and person with person.[159]

To say that God 'speaks', for Barth, is thus to say that God takes on certain particularities in the world in the event of the revelation of his Word—supremely Jesus Christ, derivatively Scripture and sacrament—in order to communicate with human beings.

Second, the Word of God has a 'personal quality': 'It is not "a truth," not even the very highest truth. It is *the* truth as it is God's speaking person, *Dei loquentis persona*.' When Barth talks here about a 'personal *quality*' to the Word of God, he means to assert the identity of the Word of God with the person of Jesus Christ: 'Understanding the Word of God not as proclamation and Scripture alone but as God's revelation in proclamation and Scripture, we must understand it in its identity with God Himself. God's revelation is Jesus Christ, the Son of God.' Barth understands this equation as protecting Scripture from the reduction to a set of propositional statements which he

[156] Barth, *CD* I/1, 132–3. [157] Ibid., 132–43.
[158] Ibid., 133. [159] Ibid., 135 (italics added).

thinks it underwent in the seventeenth century: 'In this equation, and in it alone, a real and effective barrier is set up against what is made of . . . Holy Scripture according to the later form of older Protestantism, namely, a fixed sum of revealed propositions which can be systematised like the sections of a corpus of law.'[160]

There seems to be a contradiction between this equation of revelation with the person of Jesus Christ and the earlier claim that revelation is speech 'in itself and as such'. Barth recognizes this, and does not want either of the Word's personal or verbal 'qualities' to erase the other: 'The personalising of the concept of the Word of God, which we cannot avoid when we remember that Jesus Christ is the Word of God, does not mean its deverbalising. But it (naturally) means awareness that it is person rather than thing or object even if and in so far as it is word, word of Scripture and word of preaching.'[161] It is not immediately clear what Barth here means by 'thing or object', which he contrasts with 'person', as the wrong way to understand the Word. However, a clue may be found in McCormack's discussion of a similar passage from the *Göttingen Dogmatics*. At one point in this work, Barth says: 'The procedure of the self-revealing God is a *dicere*; its content is *word* . . . but not thing, matter, nature.' This, says McCormack, was written '[a]gainst those who wished to associate revelation with an experience of the holy or the irrational'.[162] Of course, Barth's prime objection to such conceptions of revelation was that God was rendered an aspect of humanity, with no capacity to address us from outside. The identity in Barth's mind of revelation-as-speech and revelation-as-person, both functioning as explications of the self-revelation of the Word of God, therefore aims to safeguard revelation from this reduction. What the concept of 'person' fundamentally conveys for Barth is the irreducible reality of the external address of an other. This is so critical for Barth that, in the case of divine revelation, he completely equates the two realities of person and Word. By doing so he is trying to safeguard the verbal forms of divine revelation from ever being treated as anything other than the external address of an Other.

[160] Barth, *CD* i/i, 136–7.
[161] Ibid., 138.
[162] McCormack, *Karl Barth's Critically Realistic*, 341.

He fears that anything short of the complete identification of 'word' and 'speech' with 'person' leaves the door ajar to the idolatrous reduction of divine revelation either to an aspect of human experience or to propositional statement.

The third implication is that, as speech, the Word of God 'has purposive character. . . . This might also be called its relatedness or pertinence, its character as address. In its form neither as proclamation, Holy Scripture, nor revelation do we know God's Word as an entity that exists merely in and for itself. We know it only as a Word that is directed to us and applies to us.'[163] Here, Barth comes close to using the concepts of speech act theory, while lacking the terminology. He wants to reject any notion of revelation which does not think of God as taking an illocutionary stance towards the world—a personal being addressing the world from outside the world, directing his Word to us and applying it to us. This is what he means when he says that God speaks, and that 'speaking' is not a symbol. By insisting that God speaks, then, Barth means to say that God in his self-revelation performs an illocutionary act towards the world, without necessarily performing verbal locutionary acts.

This point is evident elsewhere in volume 1 of *Church Dogmatics*. Barth equates God speaking with God *deciding* something with regard to his relationship with us. In particular, he decides to be present with us: 'God's presence is always God's decision to be present. The divine Word is the divine speaking.'[164] For Barth, the Word of God is God's act: 'The distinction between word and act is that mere word is the self-expression of a person, while act is the resultant relative alteration in the world around. Mere word is passive, act is an active participation in history.'[165] This derives at least in part from a general hermeneutical principle. Of 'the speaker', Barth asks rhetorically:

Did he not say anything to me at all? Did he not therefore desire that I should see him not *in abstracto* but in his specific and concrete relationship to the thing described or intended in his word, that I should see him from the standpoint and in the light of this thing? How much wrong is being continually perpetrated, how much intolerable obstruction of human relationships, how much isolation and impoverishment

[163] Barth, *CD* I/I, 139. [164] Ibid., 321. [165] Ibid., 144.

forced upon individuals has its only basis in the fact that we do not take seriously a claim which in itself is as clear as the day, the claim which arises whenever one person addresses a word to another?[166]

This again is very close to speech act theory, and to Wolterstorff's definition of speech in particular. Barth insists that for God to speak is for him to change states of affairs in the world; he breaks the necessity of any link between divine speech and either verbal locutions or the communication of propositions, in order to see it as fundamentally a way of acting in and on the world. This is related to a general conception of speech as personal address. However, he is hampered by his lack of the conceptual distinctions offered by speech act theory. He certainly defines speaking as something very like performing illocutions (which in the case of divine speech he describes as addressing another in the form of certain particularities: Jesus Christ, Scripture, sacrament), but he also defines speaking directly as 'being a person', as we have seen. Barth sees this identification as necessary, we suggest, because he lacks the concept of an 'illocutionary act'. This concept allows us to think of language as existing both qua language and in fundamentally dynamic and inseparable relation to a person and to that person's acting in the world. If words are not conceived of in this double way, then in and of themselves they can only be, as Barth fears, 'mere' words.

Questions may be raised over whether Barth's double definition of speech, as both personal address and person, blurs some issues in the divine act of revelation which require coherent explanation. Paul Helm observes that 'in the interests of divine freedom Barth has wanted to compress the whole of God's revelation into what Reformed theology would call *illumination*'—that is, the perlocutionary effect which God brings about by the Holy Spirit. This, he argues, means that, for Barth, in revelation the biblical texts actually change their meaning: 'Christ bore our sins in his own body on the tree' becomes, for example, 'John Smith, Christ bore *your* sins in his own body on the tree.' Helm comments: 'Yet surely Karl Barth cannot mean

[166] Barth, *CD* 1/2, 465. On the relation of special and general hermeneutics in Barth, see Eberhard Jüngel, *Karl Barth: A Theological Legacy*, trans. Garrett E. Paul (Philadelphia: Westminster Press, 1976), 74–8. This topic will be taken up directly in the concluding chapter.

that when the Bible becomes the Word of God the Bible changes its meaning.'[167] Vanhoozer makes the point this way: 'It is not clear how, or even whether, Barth accounts for the properly semantic moment of God's self-disclosure. In the last resort, Barth's doctrine of Scripture moves to Christ *too fast*.'[168] The means by which the personal Word and the words of the Bible are related, so that human cognition of God's saving action in Christ, a condition of faithful response to God, is possible, is never made clear at the level of grammar and semantics in Barth. Wolterstorff is getting at the same point when he argues, strikingly, that 'there's less in Barth on God speaking than first appears'.[169] For Barth, God speaks, in the strict sense, only in Jesus Christ; everything else is not speech, but is what Barth calls God's 'activating, ratifying and fulfilling of the word of the Bible and preaching'.[170] God supplements the words of the Bible with the miracle by which they may come to refer to him, and with the event by which they may come to speak to human hearts.

Jüngel expounds Barth on this point under the question of how revelation comes to speech, especially with regard to what he terms 'the analogy of advent'. '[God] introduces himself in that he arrives. And this his arrival belongs to his very being which he reveals as arriving. But this is possible only when this arrival takes place as an arrival-in-language.'[171] The analogy works thus: 'God relates to his word in such a way that he thereby relates to man, and in a very particular way relates to man's relationship to his own word. . . . The analogy is in an eminent sense a *language event*.'[172] This event, for Jüngel, occurs paradigmatically in the case of the literary genre of parable. Jüngel relates Jesus to language by defining his being in terms of a parabolic speech act: 'the man Jesus is *the parable of God* (*Gleichnis*), understanding the being of the man Jesus on the basis of the Easter kerygma. This christological statement is to

[167] Paul Helm, *The Divine Revelation: The Basic Issues* (London: Marshall, Morgan & Scott, 1982), 42–3.

[168] Vanhoozer, 'God's Mighty Speech-Acts', 169.

[169] Wolterstorff, *Divine Discourse*, 72 (original italics removed).

[170] Quoted in ibid., 73.

[171] Jüngel, *God as the Mystery*, 285–6.

[172] Ibid., 289.

be regarded as the fundamental proposition of a hermeneutic of the speakability of God.'[173] He explicates Jesus as the parable of God in reference to the parables spoken by the earthly Jesus. The genre of parable is chosen because of the creative power it has to render the presence of a subject in such a way that the addressee is changed: 'In a parable, language is so focused that the *subject* of the discourse *becomes concrete in* language itself and thus defines anew the people addressed in their own existence.'[174]

When the question of revelation in the Bible as a whole arises, Jüngel rescues the possibility of this event occurring through any part, or at least many parts, of the biblical canon, as well as through other 'language forms of faith', by effectively reducing all biblical literature to the single genre of parable: 'Biblical talk about God knows the parables as one of many possible language forms in which faith expresses God. But basically all language forms of faith participate in the structure of parabolic language. In that sense parables serve as the language of faith generally.'[175] (It has been argued that Barth similarly regards revelation as mediated through one literary genre, namely narrative.[176]) Jüngel certainly does not want to restrict the event of revelation to strictly parabolic material in the canonical Gospels. However, he does not say how biblical texts which are not themselves parables of the earthly Jesus, or even words spoken by the earthly Jesus, may come to share in that parabolic structure to such an extent that God as subject is made 'concrete' in their discourse, and that Jesus, 'the parable of God', comes to speech in them. It is of this, the one Word in the diverse words of the Bible, that Jüngel, like Barth, offers no proper theological account.

Where we accuse Barth of a lack, of refusing to explicate a point we take to be vital, he of course would see a virtue, in that he refuses to speculate on the very thing which he assumes we are warned against speculating on by the mysterious event of revelation. For, as he says, in the real event of divine self-revelation through the exclusively human words of the Bible

[173] Jüngel, *God as the Mystery*, 288–9.
[174] Ibid., 292.
[175] Ibid., 293.
[176] Ford, *Barth and God's Story*, *passim*.

and preaching, '[the] form is not a suitable but an unsuitable medium for God's self-presentation'.[177] He might have taken as a compliment Vanhoozer's judgement that 'Barth fails to provide anything like a clear conceptual analysis of this event [of the Bible becoming God's Word]. . . . God's Word for Barth is a semantic miracle.'[178] The lack of such an analysis is not an oversight on Barth's part but the centre around which his understanding of revelation and Scripture is deliberately built. Vanhoozer thinks that this is not a suitable place to invoke miracle, since revelation has a 'properly semantic moment'; Barth insists on miracle here in order to fend off human attempts to master God. When we come shortly to offer a positive proposal, which will build on Vanhoozer's suggestion of speech act theory as providing an excellent way forward for a doctrine of Scripture, it will be suggested that it is possible to identify the Bible permanently with the Word of God, and so account for the 'properly semantic moment' of revelation, in a way that takes account of Barth's underlying concerns that human beings should not be able to control God in his self-revelation. This is not to explain away 'miracle', but to suggest the possibility of a comprehensible conceptual account of a divine action which nonetheless lies beyond human control. The intention is to respect Barth's desire that we never grasp revelation in such a way that we prevent it grasping us.

The Question of the Unique Authority of the Bible in Barth

It was noted above that, according to Helm, Barth collapses the Reformed distinction between revelation and illumination, shifting the focus of God's inspiring activity away from what God did in the past in the preparation and composition of the Bible and onto what God does in the present in pressing the Word on our hearts. This elides illocution into perlocution and fails, therefore, to offer an intelligible theological distinction between text and reception. Neither does Barth offer a distinction between the Bible and proclamation in the relation of each to revelation. Scripture, he says, is the Word of God 'in exactly the same sense in which we have said this of the event of real

[177] Barth, *CD* I/I, 166.
[178] Vanhoozer, 'God's Mighty Speech-Acts', 172.

proclamation'.[179] McCormack, narrating Barth's theological development, says that, when the question of language as the bearer of revelation arose in his thinking, 'the problem of Scripture and preaching as the Word of God entailed for Barth the affirmation of *qualified words*', that is, of words qualified to bear revelation.[180] It is noteworthy that at this developmental stage, which became determinative for his later work, Barth treated Scripture and proclamation identically in their individual theological relations to revelation. If McCormack is right, then Barth drew no theological distinction between Scripture and preaching, or, as we might say, between text and commentary.[181]

This raises the question of the scope of human language which God selects or commandeers, empowering it by his grace to refer to him. Barth, as has been seen, insists on and generally puts into practice the supreme authority of the Bible. However, the lack of an intelligible theological or ontological link between God's action and the Bible suggests that Barth may not give a sufficient theoretical account of his practical treatment of the Bible. This can be illustrated through an examination of two contemporary writers on Barth, each of whom suggests surprising parallels between Barth and a later writer: first, Stanley Fish, and then Jacques Derrida.

Barth and Stanley Fish

It is precisely the distinction between text and commentary that has been the focus of attack in the neo-pragmatic hermeneutics of the literary critic and theorist Stanley Fish. His work will be read in some detail in our treatment of contemporary hermeneutical approaches to authors in Chapter 4. The main feature of it may be summarized here as a proposal that neither the formal features nor meaning of a text reside objectively in the text, but that both are the product of particular interpretative practices. The choice of one interpretative practice over another is determined by the interests of the particular interpretative community to which one happens to belong.

[179] Barth, *CD* I/1, 109.
[180] McCormack, *Karl Barth's Critically Realistic*, 340.
[181] It was largely in order to distinguish text and commentary, and text and reception, that the Reformation principle of *sola Scriptura* developed in contrast to Roman Catholic and 'enthusiast' doctrines of Scripture (see ch. 2).

In a recent article, Scott C. Saye draws strong parallels between Barth and Fish.[182] At first sight this may seem a surprising comparison, for Fish has little interest in religion, denies the supposed 'objectivity' of an authorial voice addressing the reader from outside, and asserts that we make texts and meanings in our own image. It would be hard to be further from Barth's basic convictions! However, Saye's argument does have merit. He notes the difficulty which commentators on Barth have had in finding an interpretative centre to his biblical exegesis, which often 'reach[es] eclectically for interpretative tools that would help him to say what he wanted to say'.[183] Saye's thesis is that these attempts have failed because they have sought to describe the coherence of Barth's hermeneutics in terms of methodology, when methodology was never Barth's concern. 'The most important issue for Barth is not *how* one should read Scripture, but rather *who* is reading it, *what* is sought, and *where* this reading takes place.' Barth's dogmatics are emphatically *church* dogmatics: 'this context, with all its commitments and practices, does more to create a right reading of scripture than any hermeneutical or methodological decision'.[184] Saye thinks that there is some truth to the claim that the role which this ascribes to the church is more Roman Catholic than Protestant.[185]

Clearly, this claim, made of the great Protestant theologian of the twentieth century, would need further substantiation. However, it is evident that Saye's radical comparison of Barth and Fish finds support in some of the points made in the present treatment of Barth. Barth's focusing of revelation on the moment of illumination gives great systematic weight to the church's reception of the Word. Barth may not mean to say, as Helm thinks he does not, that the Bible changes its meaning when God speaks through it to different people, but his view of revelation tends logically to that conclusion. Saye argues that Barth, like Fish, does not regard Scripture as 'a stable object with "objective" meaning'.[186] In by-passing the semantic aspect of revelation in his account of Scripture becoming revelation, Barth leaves open the possibility that that semantic aspect may

[182] Scott C. Saye, 'The Wild and Crooked Tree: Barth, Fish and Interpretative Communities', *Modern Theology* 12 (1996), 435–58.

[183] Ibid., 435. [184] Ibid., 436. [185] Ibid., 452. [186] Ibid., 444.

be located in the moment of illumination, the reception of reve-
lation. Such a hermeneutical position is very similar to Fish's.
It is certainly at odds with Barth's regular treatment of the
Bible as the supreme authority over the church, as the means
by which the Word of God comes to the church from outside
as an address from God. It can, however, be shown to follow
logically from his actual account of the relationship between
revelation and the Word.

Barth and Jacques Derrida

Even more surprisingly, perhaps, the theologian Graham Ward
has devoted a book-length study to the claim that Barth's view
of revelation prefigures Derrida's notion of the economy of
différance. 'For both thinkers, the central problematic is the
ineradicable otherness which haunts discourse and yet the
impossibility of transcending metaphoricity and positing a real
presence.'[187] Ward's key piece of evidence to support this con-
clusion is his claim that Barth works with two conflicting and
unresolved models of language. The 'communication model'
describes what happens in the event of revelation, when lan-
guage is made to refer to God, while the 'semiotic model'
describes the function of language as a human construct. The
two, however, cannot be accommodated with one another:

The communication model (where words adequately represent and
communicate their objects) cannot be accommodated within a model
of language which understands words as constructing the reality of
objects. Similarly, the semiotic model of language (which emphasises
the ineradicable mediation of a 'meaning' which forever lies beyond it)
cannot accommodate the possibility of unmediated, direct disclosure.
Knowledge of God, then, becomes either impossible or contradictory,
for each model is the other's radical alternative.

Each of these models 'contradicts the possibility of the other'.
This is all in addition to the fact that Barth rejects the account
of how God came to speech offered by the old doctrine of the
inspiration of the Bible. Ward summarizes: in Barth's work
'[t]here is no coherent account of the Word in the words'; 'we
are given, at this point, no insight into how the Word takes pos-

[187] Graham Ward, *Barth, Derrida and the Language of Theology* (Cam-
bridge: Cambridge University Press, 1995), 247.

session of human words and thoughts; we are merely told that it does so'.[188] Barth thus lacks, as has already been observed, a particularist account of God's 'commandeering' of certain words in an event of revelation. From this, Ward draws the contentious inference that Barth's 'ultimate concern is to move on from a theology of Scriptural discourse to a theology of discourse itself'.[189]

In the course of his analysis of chapter 5 of *Church Dogmatics*, Ward observes that 'the paradox of language issues into a christological discussion. In the aporia between the two antithetical models for the operation of language Barth places Jesus Christ, the Word made human. . . . It is Barth's Christology that bears the weight of any possible explanation or synthesis: the eternal Son of God made this particular man, Jesus of Nazareth.' Ward doubts, however, that the incarnation can bear this weight, given the lack in Barth's theology which he has noted: 'Christology, as a theology of the Word, itself demands a coherent theology of language if it too is not to split irredeemably the divine from the human.'[190]

Ward's book has been very sharply criticized in a review article by the Barth specialist Bruce McCormack, who argues that Ward has seriously misread Barth. He argues that Barth had no interest in developing a general theory of language: 'God's use of language to bear witness to Himself . . . involves a selection and Barth is interested only in what occurs in that act of selection.'[191] Barth indeed makes very clear: 'It must be shown how and how far the questions already put with reference to the Bible and proclamation are not spun out of the void, are not those of random curiosity, do not spring from a logical schematisation applied here as elsewhere, but necessarily result from the fact that both the Bible and proclamation are or can become God's Word.'[192] Barth is simply not interested in the 'void' of language in general, as Derrida is, but only in what he sees as the radical presence of God in and through the language of Bible and preaching.

[188] Ibid., 30–1. [189] Ibid., 21. [190] Ibid., 32.

[191] Bruce Lindley McCormack, review article: 'Graham Ward's *Barth, Derrida and the Language of Theology*', *Scottish Journal of Theology* 49 (1996), 97–109, at 102–3.

[192] Barth, *CD* I/I, 289–90.

Further, McCormack argues that Barth did not hold two antithetically opposed epistemologies. Instead, Barth's theological epistemology completes his philosophical (neo-Kantian) epistemology, 'transcending [it] from within through the power of God'. He concludes: 'There is no aporia in Barth's theory of theological language needing to be filled by Derrida or anyone else.'[193] McCormack further charges Ward with reversing the relationship which Barth establishes between Christology and the *analogia fidei*. Barth's supposed two conflicting models of language cannot be read back into his Christology such that the divine threatens to separate from the human. 'Barth was no Nestorian!', objects McCormack; rather, it is his Christology that grounds the *analogia fidei*.[194]

McCormack is right to assert, too, that Barth does not think of God's presence to us as endlessly deferred, for a key element of his theology is that what is impossible for human language is made possible in and through human language by God's gracious activity. McCormack thinks that Ward lacks 'a sound grasp of Barth's relationship to neo-Kantianism': 'To make theology a frank impossibility is to invalidate the incarnation and the speaking of God which occurs here and now on that basis.'[195] When the human words of Scripture and preaching become revelation, as Barth insists they can and do, God is really present, by an action dependent not on the qualities of human words but on God's transforming of human words into his Word. As Barth says: 'Human words are never final words. They are never the promise of a specific and definitive coming of the Other. It is proper to God's Word and to God's Word alone to be also the full and authentic presence of the Speaker even if this be as the coming One.'[196] The note of deferral in the final phrase strikes a note quite different from the deferral of metaphysical presence which is Derrida's constant theme, since it is motivated by theological, specifically eschatological, concerns, which do not undercut the fullness of the presence of God here and now.

These detailed objections raised by McCormack to Ward's work call the latter's overall thesis on Barth into serious ques-

[193] McCormack, 'Graham Ward's *Barth*', 105–6.
[194] Ibid., 107. [195] Ibid., 104–5. [196] Barth, *CD* I/1, 142.

tion. Nevertheless, something of Ward's reaction to reading Barth's account of the Word in words, which gave rise to his attempt to read him together with Derrida, survives as a legitimate insight. To align Barth's account of the presence of God in Scripture with Derrida's deconstruction of metaphysics pushes Barth too far, but Ward's fundamental observations about Barth's theological account of the Bible, from which basis he makes this move, highlight a genuine problem in Barth's theology. Ward points out that, for Barth, God selects certain words to become revelation, but that neither the scope of the selection nor the relationship between that scope and Scripture is made clear.[197] This same point has been argued above.[198] Once the scope of God's selection of human words has been left theologically vague, the question of language in general in relation to theology is one that Barth's readers may legitimately raise, even though faithful expositors such as McCormack may be right to insist that it was not one of his conscious concerns.

McCormack thinks that there is no aporia in Barth needing to be filled by anyone, let alone by Derrida. He holds this view because he finds Barth's 'miraculous' account of the Bible and preaching becoming revelation satisfactory, sufficient to limit the scope of discussion of Barth's views of revelation and language to the Bible and church proclamation. In other words, McCormack finds the 'miraculous' account sufficient because he thinks that Barth's coherent Christology *just is* a coherent account of what Barth also believes about the coming of the Word in the words of the Bible and preaching. Ward, by contrast, thinks that theology requires a supplementary coherent account of how a coherent Christology moves to revelation-as-speech. He does not find Barth's 'miraculous' account sufficient to limit the discussion of revelation to a definite set of words, for he seems to equate mystery with absence: 'The revelation of the Word does not occur and cannot occur in Barth's theology, and so its meaning is maintained in mystery.'[199] Ward's basic observations about Barth's account of revelation coming to

[197] Ward, *Barth, Derrida*, 27.
[198] Geoffrey Bromiley, who certainly offers a less creative reading of Barth than Ward, also makes this point (Bromiley, 'The Authority of Scripture in Karl Barth', 291).
[199] Ward, *Barth, Derrida*, 250.

speech are therefore sound. The close comparisons he draws between the unique theological mystery which Barth sees in the coming-to-speech of divine revelation and the universal metaphysical lack of presence which Derrida sees in all language remain, however, dubious, or at least require a more convincing account than Ward has so far provided.

A good case can therefore be made that Ward is wrong to read Barth as Derridean before his time. Whether or not one thinks that Derrida can, in a much more limited way, gain the kind of purchase on Barth which Ward proposes, opening up at least a general discussion about presence and absence in language, depends on whether or not one thinks that 'miracle' may be appropriately invoked in answer to the question of God's present speaking in human words. That is, a basic issue separating Ward and McCormack is whether or not one finds Barthian Christology to be itself a sufficient account of revelation in and through human language. Here we side with Ward, since it has been argued above that Christology is not itself a sufficient account of how revelation comes to speech. To speak only of mystery here, as Barth does, is to leave the door to Derrida ajar. However, the leap from Barth's particular account of divine revelation in language to Derrida's all-consuming anti-metaphysics is, in the end, too great.[200] The gap which Ward and others have identified in Barth's account of revelation, which results from his rejection of the orthodox doctrine of Scripture, in particular the inspiration of Scripture, is better addressed initially through a theological appropriation of a speech-act account of language.[201] That is what is attempted in the positive proposal now to be outlined.

POSITIVE PROPOSAL: SCRIPTURE AS THE SPEECH ACT OF GOD

One of Barth's overriding concerns is that God's revelation never be conceived of such that human beings could 'possess' it, and by possessing it possess God. He wants to protect God

[200] Derrida will be discussed further, and more fully, in ch. 4.

[201] We will need in due course to appeal also to a doctrine of the inspiration of Scripture, suitably reworked, in light of the current discussion, in a way which accounts for Barth's objections to the orthodox doctrine (see ch. 5).

in both his freedom and transcendence. For Barth, to identify the Bible directly and permanently with God's Word is to compromise both God's freedom as a *personal* being and God's free transcendence as *God*. We will look at each of these in turn, and suggest the extent to which a construal of the orthodox Protestant doctrine of Scripture cast in terms of speech act theory can alleviate these concerns.

Free Speech

If I make a promise to someone, and she responds with an expression of trust that I will keep my promise, there seems to be little or no semantic difference between these three ways of expressing that trust: 'I trust you to be true to your words,' 'I trust your promise,' and 'I trust you'. It seems that in many everyday linguistic interactions we identify (without subsuming into each other) words with actions, and actions with persons. Speech act theory, as developed by Austin and Searle, accounts for the identification of words with actions: to speak is to act. Wolterstorff's further development of speech act theory accounts for the identification of actions with persons: to act, to perform a speech act, is to acquire for oneself a new normative standing. There are clearly profound anthropological issues at stake here. It is not claimed that a person is nothing but the sum of her actions, nor that human identity is always unstable, such that her whole identity necessarily changes every time she performs a new speech act. What is claimed is that a person's identity, to the extent that her identity is revealed and given definition by her actions, is partly a function of the normative standings she acquires, and therefore of the speech acts she performs, and therefore of the words she utters.[202]

[202] A helpful survey and analysis of a recent related trend in theological anthropology is found in Harriet A. Harris, 'Should We Say That Personhood Is Relational?', *Scottish Journal of Theology* 51 (1998), 214–34. She rejects the view of Alistair McFadyen and others that personhood is *constituted* by personal relations, since it establishes an infinite regress that is unable to identify what the relationships that bring persons into being are initially formed out of. Moreover, Harris argues, it leads into the ethical problem that personhood becomes a matter of degree, making some human beings apparently less qualified as persons than others, by virtue of the differing quality of relationships by which they are supposedly constituted (232–3). Harris prefers John

For a person to identify herself with her speech actions and her words therefore does not represent a reduction of her personhood as external to other persons; nor is it automatically to hand herself over to possession by, rather than personal encounter with, others. Indeed, it is fundamental to interpersonal relationships that we do so identify ourselves. Without such an identification it would be impossible to perform the acts of commanding, requesting, warning, promising, and so on, that we freely choose to perform. It is not that the identification of a person with her words entails a limitation of personal freedom, but rather that personal freedom is just not conceivable outside the context of persons who act and in part are precisely by means of such an identification.

The same is true of God's personhood. For God to limit his freedom in this way as an ethical speaker-in-relation is actually the means by which, in certain particularities (which Barth rightly recognized to be necessary for speech), he can be freely present to us and act towards us as a personal being in revelation. This is not to say that the identification of a person with acts and words carries no risks. Barth's fear, that in the process of interpretation we may grapple with words, syntax, and semantics not in order to understand a person so as to be able to encounter him as other but in order to gain cognitive 'possession' of him, is realized every day, as he recognized. However, that the identification can be and is abused does not prove that it should not be made. It demonstrates that inherent in personhood is an ethical responsibility towards others, the observance of which can never be taken for granted.

The person of Jesus, as himself a divine speech act, which is how Barth constantly sees him, and Jesus' relation to the Bible, can be described here in the terms provided by speech act theory. As a *person* who is also an act of revelation, Jesus is a divine illocutionary act performed without a verbal locution. As such, the act may well be incomprehensible, for the words spoken by the earthly Jesus through the course of his life were

Macmurray's account, in which our very brief account of personhood here finds support, the thrust of which 'is not that a being becomes a person through relations, but that humans are persons because relationality is central to human life' (225). The relation of the present study to anthropological questions will reappear in the final chapter.

necessary (though not sufficient) for most people who met him to comprehend his identity; one needed at least ears which could hear. The person *and life* of Jesus, including the words he uttered, for those who were present to hear them, is an illocutionary act performed in part by verbal locutions. The Bible is the performance of the same illocutionary act by verbal means to later generations, not in that it shares in the 'parabolic structure' of the language of faith, as Jüngel has it, but in that God speaks through the totality of its various generic and thematic voices to render the person of Jesus to the reader and hearer.[203] In that an action is an extension of the existence of a person, Jesus can be said to be present in the reading and faithful preaching of the Bible. This is what Luther insisted on: Jesus is really present in the proclamation of the gospel.

Transcendent Speech

It may be objected to the previous section that Barth's concerns relate mainly not to the personhood that humans and creatures share in common with God but to the transcendence that is characteristic of God's personhood alone. This is the real problem, according to Jüngel: 'the fundamental distinction between God and man threatens to be lost if God's word is not basically differentiated from all the words of human language'.[204]

This question will be addressed in part in the discussion of 'biblical polyphony' in Chapter 5. Here, a different point may be made in response to Barth. It is fundamental to Barth's convictions that God acts in the world. He rescues God's cognitive transcendence by identifying in the world only the person of Jesus Christ directly with revelation, with God's self-identifying act. Barth is right to insist that when we think of God coming to act in the world for salvation we must think of him as coming to possess us, not as coming to be an object of our knowledge. Yet God identifying himself directly with an

[203] This is to anticipate a conception of the canon of Scripture which will be developed in ch. 5. What is argued there about the capacity of the polyphonic language of the Bible to refer to God, and about the necessary role for a doctrine of the inspiration of Scripture, will develop the view of the Bible outlined here.

[204] Jüngel, *God as the Mystery*, 230.

action and supremely with a person in the world is a revelation no less susceptible to human cognitive possession than God identifying himself with a set of words in the world. The Pharisees trying to trick Jesus and the crowd calling for his crucifixion represent nothing less than human attempts to gain mastery over Jesus Christ, the person who is God's Word, his saving action, his self-revealing. Thus, to identify a person's action, even in the case of divine action in the world, with a *person*, even a divine person, rather than with a set of words, does not make 'possession' impossible, or even less likely. It simply establishes a context in which any attempt to 'possess' is an immoral assault on the personhood of the other, whether that person be divine or human.

The particular contribution of Wolterstorff's development of speech act theory is to bring language-use into precisely the same moral context just described for all personal actions. Therefore, if Scripture is construed directly as God's speech act, and permanently as his Word, the same is true of it as of all other actions: it is susceptible to human attempts to possess it. This is simply the vulnerability inherent in all interpersonal communicative action, and God's self-revelation in the world, if it is to be recognizable to human persons as revelation of the divine persons, cannot be exempt. Yet possession is not a necessary corollary of reading and interpretation. Careful reading can equally well aim not just at understanding per se but at understanding so as to enable appropriate response to the personal address, the illocutionary act, which God performs in the text. As Mikhail Bakhtin says, 'all real and integral understanding is actually responsive, and constitutes nothing other than the initial preparatory stage of a response (in whatever form it may be actualized)'.[205] If Barth's Christology represents no necessary compromise of God's cognitive transcendence, no domestication of the doctrinal assertion that God speaks and of the reality of his speech, then neither does orthodox Protestantism's direct identification of the Bible with the Word of God.

Barth exalts God as the Lord of Scripture. Divine lordship, however, is revealed in Christ in the form of divine servanthood. God serves humankind, not least in undertaking to be

[205] Bakhtin, 'Speech Genres', 69.

true to promises uttered to us in human language, and to honour a covenant made with and for us in human words. Barth rightly insists that God has free control over the Bible's *Wörtlichkeit*; however, to understand this theological statement biblically it must be noted that God exercises that free control over the Bible in that he is its author, and therefore, as a moral agent, has freely chosen to tie his future action to those words and what they promise. His free control over the Bible's *Wörtlichkeit* is exercised now in that contemporary Bible-readers are unable to conjure up out of their own reading either the presence of God or their own faithful response to him, and in that they are culpable if they choose to conjure up their own meaning, rather than the one given in the texts. God freely gives himself to them to be known by the Holy Spirit in his speech, through the mediation, including the semantic mediation, of the illocutions of Scripture.

Hunsinger summarizes his lucid reading of Barth thus: 'In short, the subject matter presents itself through its scriptural mediation uniquely, spontaneously, sovereignly, objectively, and coherently.'[206] It is only with the second of these adverbs—God *spontaneously* presenting himself in Scripture—that we are taking issue, suggesting in its place an adverb such as 'faithfully'. God is the sovereign Lord of Scripture—but he is also the servant of Scripture, in that he promises not to absent himself from any faithful performance of the illocutions of Scripture. Yet the God who always presents himself to us when the Bible is read is no more a God we possess than the God who was always present in the earthly life of his Son.

CONCLUSION

In this chapter speech act theory has been outlined and then appropriated, especially in Wolterstorff's development of it, to provide a means by which an ontological link between God and Scripture may be conceived of, such that the human words of the Bible, as they mediate divine illocutionary acts, may legitimately be identified directly with the Word of God. It is important to add that this direct identification does not imply either an over-identification or an under-identification of the

[206] Hunsinger, *How to Read Karl Barth*, 277.

illocutionary acts performed in the Bible with the Word of God. By 'over-identification' is meant the identification with the Word of God of every illocution narrated in Scripture—for example, a lie uttered by a character in the Bible—as opposed to an interpretation aiming to identify the divine illocution performed by means of the human discourse of the Bible. By 'under-identification' is meant the identification with the Word of God of supposed biblical illocutions derived in abstraction from, that is, with too little attention paid to, the semantics and grammar of the human words of the Bible.

There is a great deal of overlap between the basic theological concerns of Barth and those of the present work. The critique of Barth offered here is not intended as a denial of the legitimacy of his concerns about the domestication of God in his revelation. Moreover, in a broad context Barth does affirm the doctrine of the sufficiency of Scripture.[207] However, it has been argued here that Barth's rejection of the orthodox Protestant direct identification of the Bible with the Word of God, that is, with the speech of God, and his appeal to a 'supplementary' event of revelation, leads to significant problems. His rapid identification of revelation with the person of Christ rushes too quickly over the linguistic aspects of revelation, and leaves revelation insufficiently distinguished theologically from both theology and church. A permanent identification of Scripture with divine speech need not turn either God or his speech from a divine external address into an object to be possessed by human cognition.

[207] 'We have no right, then, to import into the reality of God's process of revelation to and among men any contribution learned from a source of knowledge different from Scripture. In this respect also, we must realise the adequacy [*Suffizienz*] of Holy Scripture as the source of our knowledge' (Barth, *CD* 1/2, 207–8). This affirms the material sufficiency of Scripture; Barth's acceptance of formal sufficiency—the principle that Scripture is its own interpreter—has been noted above.

4
Scripture and the Sufficiency of the Text

INTRODUCTION

It is not central to Barth's account of revelation through Scripture to enquire to any great extent what kind of a thing a text in general *is*. This is because what is important for Barth is the divine transforming of human text into divine Word. What counts in this event of transformation is more that the propositional content of the text as human witness, Jesus Christ, become the propositional content of the divine address, than that the semantic and literary qualities of the text as a human text themselves be shown to be appropriated for that divine address.[1] The question of what a text is is much more pertinent for the present proposal, however, for if God's Word is to be permanently identified with the texts of Scripture, the general hermeneutical question of what a text is, and how it therefore relates to its author and should be read, cannot be avoided.

The question of textual ontology is a large one; the discussion will be delimited and focused here by examining different proposals for supplementing, or not supplementing, a text with an extra-textual entity, in order to account for how texts give rise to meaning. The first section looks at two 'non-supplementing' accounts, both of which are often said to treat texts as in some way sufficient, or, more usually, 'self-sufficient'.

[1] Thus John Webster, on a Barthian view of Scripture: 'to talk of the text as an instrument of divine action is primarily to say something about God, not about the text. . . . Here God speaks in a veiled form, sacramentally. . . . The text is 'sacramental' in that God's agency is real and effective and yet indirect . . . God speaks through the intelligible words of this text and acts in, with and under the acts of the church's reading of it' (John Webster, 'Hermeneutics in Modern Theology: Some Doctrinal Reflections', *Scottish Journal of Theology* 51 (1998), 307–41, at 330–2).

One of these approaches, New Criticism, comes from the field of literary theory; the other is the theological application of a basically formalist approach to Scripture by the theologian Hans Frei. Since the term 'sufficiency' is regularly used to describe both these approaches to the text, the question addressed will be whether these approaches provide a model of the nature of a text which may be usefully appropriated for the formulation of a doctrine of the sufficiency of Scripture. Subsequent sections of this chapter will look at attempts to locate the text in relation to authors, and then to readers. In dealing with these topics we will face some of the most serious objections to the claim that a text could be said in any way to be sufficient for anything—that is, those coming from post-structuralist and deconstructive positions. This will focus on the interpretative practices of Jacques Derrida, and on one particular example of how a certain kind of deconstructive reading has been practised on the Bible.

Specifically ethical questions will become prominent in the course of this discussion. It will already be clear that the basic conceptualities of speech act theory, supplemented by Wolters-torff's notion of 'normative standing', will inform our analysis of these various positions on textual ontology. This chapter thus argues for a realist and ethical conception of a text: the illocu-tionary act which an author performs by means of a text exists independent of any act of reading, and places certain ethical restraints on readerly activity.

The final section moves the discussion from general to special hermeneutics. The nature of the strong links between text and reality which have been established will point the way to an understanding of the sufficiency of Scripture which, it will be argued, is different in significant respects from models of textual 'self-sufficiency'. Finally, by means of a discussion of the 'supplementary' role played by the Holy Spirit in relation to Scripture, it will be possible to suggest an answer to the question, 'If Scripture is sufficient, for what and for whom is it sufficient?' This will represent a description of the sufficiency of Scripture cast in terms of the account of Scripture as the speech act of God offered at the end of the previous chapter.

THE UNSUPPLEMENTED TEXT[2]

New Criticism: The Self-Sufficiency of Literature

The broad and fairly short-lived movement in literary criticism known as New Criticism, which arose primarily in the United States in the 1940s and '50s, is often characterized as promoting texts as self-sufficient meaningful objects. The question of possible links between this critical movement and the doctrine of the sufficiency of Scripture therefore naturally arises. Although the actual duration of the hegemony of explicitly New Critical ideas was short, its influence is often argued to have lasted long beyond the apparent demise of the movement.[3] It

[2] Some examples of structuralist readings also treat texts as 'self-sufficient' objects. 'Structuralism' as a whole has been excluded from this section because it is much broader than a theory of texts, being more like a theory of culture or of cognition; see e.g. Frederic Jameson's definition of structuralism: 'an explicit search for the permanent structures of the mind itself, the organizational categories and forms through which the mind is able to experience the world' (quoted in Mark W. G. Stibbe, 'Structuralism', in R. J. Coggins and J. L. Houlden (eds.), *A Dictionary of Biblical Interpretation* (London: SCM Press, 1990), 651). Thus, the label 'structuralist' can be applied to writers in quite different fields, e.g. to Claude Lévi-Strauss in anthropology and A. J. Greimas in literary theory. This is evident in the appropriation of structuralism by some biblical scholars, the most sophisticated of whom take structuralism as a 'meta-theory'. As such, says one of these writers, '[structuralism] makes room for all the different research agenda that envision meaning as a multi-dimensional and relational meaning-effect' (Daniel Patte, *The Religious Dimension of Biblical Texts: Greimas's Structural Semiotics and Biblical Exegesis*, SBL Semeia Studies (Atlanta: Scholars Press, 1990), 26–8). Insofar as 'structuralism' covers a set of approaches to texts which elide meaning into effect, illocution into perlocution, it will be partly critiqued in the discussions of Fish, Hauerwas, Fowl, and Gadamer below. Insofar as structuralist analysis is, as another biblical scholar says, '*relational* in the most fundamental sense'—'[n]ot only must we know *what* is said, but *who* said it and *in what context* it was said'—such that structuralism 'is nothing else than the semiotics of knowledge' (Robert M. Polzin, *Biblical Structuralism: Method and Subjectivity in the Study of Ancient Texts* (Philadelphia: Fortress Press; Missoula: Scholars Press, 1977), 33–4), we suggest speech act theory as a complementary or more profound description of the relationality of language-use. Insofar as 'structuralism' refers not to this meta-level but to the application to texts of formalist reading-practices, it is partly implicitly dealt with in the following discussions of the formalist tendencies of New Criticism and Hans Frei.

[3] This claim forms the basis of Frank Lentricchia's sharp analysis of a

has been suggested as an influence on the biblical scholar B. S. Childs,[4] whose 'canonical approach' to biblical studies bears prima facie similarities to the approach to the Bible defended in this book, and which will therefore be examined in Chapter 5. In fact, New Criticism exhibits a variety of critical concerns, and many subsequent writers affirm the difficulty of defining precisely the label 'New Critic', since the different scholars to whom it has been ascribed certainly neither represented nor saw themselves as representing a homogeneous movement.[5] Nevertheless, an identifiable core of emphases is shared by most of those labelled 'New Critics':

Though hardly homogeneous, the group is generally associated with the doctrines of the text's objectivity, its self-sufficiency and 'organic unity'; with a formalist, 'intrinsic' approach to the text; with a resistance to paraphrase and to the separation of form and content; and above all with the technique of 'close reading'—a mode of exegesis that pays scrupulous attention to the rich complexity of textual meaning rendered through the rhetorical devices of irony, ambiguity and paradox.[6]

Debates over these issues were initially focused around the question of authorial intention, as it was framed in W. K. Wimsatt and Monroe Beardsley's well-known essay of 1946, 'The Intentional Fallacy'.[7] Although New Criticism is widely perceived as slipping rapidly into disrepute from around the mid-1950s onwards,[8] questions of intentionality raised by Wimsatt and Beardsley rumbled on in the years following the publication of their essay.[9]

variety of American literary theorists: Frank Lentricchia, *After the New Criticism* (London: Athlone Press, 1980).

[4] John Barton, *Reading the Old Testament: Method in Biblical Study* (London: Darton, Longman & Todd, 1984), 141–2.

[5] See Murray Krieger, *The New Apologists for Poetry* (Minneapolis: University of Minnesota Press, 1956), 3–5.

[6] Elizabeth Freund, *The Return of the Reader: Reader-Response Criticism* (London and New York: Methuen, 1987), 40–1.

[7] First published in *Sewanee Review* (1946), repr. in W. K. Wimsatt, *The Verbal Icon: Studies in the Meaning of Poetry* (London: Methuen, 1970), 3–18.

[8] Lentricchia identifies the beginning of the end of New Criticism's hegemony as the publication of Northrop Frye's *Anatomy of Criticism* in 1957 (Lentricchia, *After the New Criticism*, 7).

[9] A collection of essays devoted to intentionality in literature published

'The Intentional Fallacy' states rather than argues for its conclusions. Nevertheless, Wimsatt and Beardsley, along with other New Critics, particularly René Wellek and Austin Warren in their textbook *Theory of Literature*,[10] followed up with more systematic arguments. The primary argument was against Romanticism and its critical descendants. In such critical approaches the text[11] is seen as a window into the mind and soul of artists whose extraordinary insight into the world allows lesser mortals to lift their eyes occasionally from the pettiness of everyday life. For the interpretation of poems it was therefore vital to know as much as possible about the writer's intention in writing, and so great weight was placed on what could be reconstructed about his life, character, and especially his intentions for a particular work, from diaries, private letters, and so on. A poem meant what the author said he wanted it to mean. This approach was characterized by New Critics as 'historicism'—the original historical meaning governs all—and as 'psychologism'—literary study is reduced to a vehicle for investigating supposedly superior literary souls and minds. Wimsatt, painting with a very broad brush, divides critics into two kinds: those interested in the literary work itself and those more interested in the culture or mind of the artist.[12]

New Critics did not somehow try and avoid all knowledge of the author, if such a thing were even possible, as intrinsically irrelevant or misleading in literary interpretation. They recognized that knowledge of the historical background in which a work was written had in practice shed much exegetical light on texts produced in different ages from our own, and that, when a writer was still living, critics had much to gain from 'the

thirty years after Wimsatt and Beardsley's article is still greatly concerned with issues which they had raised: David Newton-de Molina (ed.), *On Literary Intention* (Edinburgh: Edinburgh University Press, 1976). Most essays in this volume are critical of New Criticism, but it also contains a spirited and unrepentant contribution from Wimsatt.

[10] René Wellek and Austin Warren, *Theory of Literature* (London: Jonathan Cape, 1949).

[11] Wimsatt and Beardsley tend to speak of 'poems' rather than 'texts'. It seems that they mean by this any work of literary art, although most of the New Critics' practical critical attention was indeed focused on poems.

[12] W. K. Wimsatt, 'Genesis: A Fallacy Revisited', in Newton-de Molina, *On Literary Intention*, 116–38, at 117.

advantages we have in knowing the setting and the time and in the opportunities for personal acquaintance and interrogation or at least correspondence [with the author]'.[13] Such knowledge was especially fruitful for New Critics in the particular interpretative task of 'explain[ing] a great many allusions or even words in an author's work', in order to avoid the danger of ignoring semantic changes over time. Nevertheless, the conclusion remained that 'it is dangerous to ascribe to it [background information] any real critical importance'.[14] That 'real critical importance' may not be granted to knowledge of the author's intention meant that it could have no significant role in guiding or controlling the interpreter's view of the overall meaning of a work. In a much-quoted sentence, Wimsatt and Beardsley express this in the following way: 'The design or intention of the author is neither available nor desirable as a standard for judging the success of a work of literary art.'[15]

Later discussion, with contributions especially from Wimsatt, has clarified what they meant by this. (Whether or not this fact represents a performative contradiction of their original argument remains debatable.) The rejection of '[t]he design or intention of the author' clearly does not apply, as we have seen, to low-level verbal or metaphorical meanings. Nor does it preclude the possibility or necessity for interpretation of reconstructing an author's intention from the text itself.[16] Wimsatt and Beardsley's argument is therefore, to quote Frank Cioffi's restatement of their point, that 'biographical data about an author, particularly concerning his artistic intentions is not desirable [in interpretation].'[17] Writing in the same volume, thirty years on from 'The Intentional Fallacy', Wimsatt himself admits only one change of wording to clarify his and Beardsley's original intention:

What we meant in 1946, and what in effect we managed to say, was that the closest one could ever get to the author's intending or meaning mind, outside his work, would be still short of his effective inten-

[13] Wellek and Warren, *Theory of Literature*, 65, 36.
[14] Ibid., 73–4.
[15] Wimsatt and Beardsley, 'The Intentional Fallacy', 3.
[16] See Barton, *Reading the Old Testament*, 149–50.
[17] Frank Cioffi, 'Intention and Interpretation in Criticism', in Newton-de Molina, *On Literary Intention*, 55–73, at 58.

tion or operative mind as it appears in the work itself and can be read from the work. . . . The statement in our essay of 1946 should certainly have read: 'The design or intention of the author is neither available nor desirable as a standard for judging the meaning or value [cf. original 'success'] of a work of literary art.'[18]

Two reasons for the adoption of this position may be identified, one practical and one theoretical. Practically, New Critics felt that to make an unattainable historical intention both the primary goal of the interpretation of a work and the chief critical standard for judging it was to deny our present experience of the meaning of poetry written in past ages. We are cut off from an author's private intention both by the fact that it is private to him and therefore internal, and by its temporal distance from us, yet we still find that old poems speak to us.[19] Behind this empirical point lies a more fundamental theoretical concern. New Critics wanted poetry to be restored to a position where it could once again exert a profound and civilizing effect on society. Responding to what they saw as the repudiation of literature by science, they argued that literature has real cognitive value, since it gives access to genuine knowledge—specifically, a special kind of literary knowledge whose truth corresponds to universal human experience, and which is therefore itself universal. As one New Critic put it: 'What we cannot know constitutionally as scientists is the world which is made of whole and indefeasible objects, and this is the world which poetry recovers for us.'[20] In order not to be devalued, literature must be set in its own particular interpretative context. The techniques of close textual analysis were designed to reveal a richness and complexity in literary works which would demon-

[18] Wimsatt, 'Genesis', 136.

[19] 'The search for the author's generative intention as context of the poem is a search for a temporal moment which must, as the author and the poem live on, recede and ever recede into the forgotten, as all moments do. Poems, on this theory of their meaning, must always steadily grow less and less correctly knowable; they must dwindle in meaning and being toward a vanishing point. The best known and most valuable poem must be that written but a moment ago—and its best or only possible audience must be the author. But poems we know are not really like that. . . . Shakespeare has more meaning and value now than he had in his own day' (Wimsatt, 'Genesis', 138).

[20] John Crowe Ransom, *The World's Body* (London: Charles Scribner's Sons, 1938), pp. x–xi.

strate that a literary work is not just an occasion for 'pleasurable excitement' or political propagandizing, that it has real significance, and that it is 'more than a datum in the history of ideas or the life of the author'.[21]

Typically, New Critics came from the southern United States, and supported its agrarian traditions against the increasingly powerful technocracy in the north. They bemoaned what they saw as the disintegration of the ordered world under the impact of science and scepticism, beginning in the seventeenth century.[22] The Marxist critic Terry Eagleton does not like the ideological attitude towards the world which New Critics tried to inculcate, finding it to be 'one, roughly, of contemplative acceptance'; Eagleton acknowledges, though, that in their own way the New Critics did not wish to separate literature from life, but were committed to locating it in the world.[23]

The New Critics thus wanted poetry to be in the world but not of it: Wellek says of the New Critic Allen Tate that he always saw poetry as within history.[24] Yet New Critics strongly resisted any move which they thought reduced poetry to something else. This is what lies behind Cleanth Brooks's rejection of what he calls 'the heresy of paraphrase'.[25] It also explains why New Critics rejected the inclusion of what they sometimes called 'personal elements' in interpretation. Too great a focus on the intention of the author, as in Romanticism, reduces the

[21] Gerald Graff, 'What Was New Criticism?', in Graff, *Literature Against Itself: Literary Ideas in Modern Society* (Chicago: University of Chicago Press, 1979), 129–49, at 141. In this, at least, according to Lynn Poland, the New Critics were the heirs of the Romantic hermeneutics of Schleiermacher and Dilthey, for whom literature was the last source of revelation, 'the expression and embodiment of freedom, order, and value' (Lynn M. Poland, 'The New Criticism, Neoorthodoxy and the New Testament', *Journal of Religion* 65 (1985), 459–77, at 461–2).

[22] René Wellek, 'The New Criticism: Pro and Contra', *Critical Inquiry* 4 (1978), 611–24, at 616.

[23] Terry Eagleton, *Literary Theory: An Introduction* (Oxford: Blackwell, 1983), 47.

[24] Wellek, 'The New Criticism', 616.

[25] 'Most of the distempers of criticism come from yielding to the temptation to take certain remarks which we make *about* the poem—statements about what it says or about what truth it gives or about what formulations it illustrates—for the essential core of the poem itself' (Cleanth Brooks, 'The Heresy of Paraphrase', in Brooks, *The Well Wrought Urn: Studies in the Structure of Poetry* (London: Methuen, 1968), 157–75, at 162–3).

text either to biography or to psychology. The exegetical value of such studies is not to be denied, but literary criticism which stops at that point is stunted with respect to its object: 'causal study can never dispose of problems of description, analysis, and evaluation of an object such as a work of literary art'.[26] Similarly, any identification of the meaning of a literary text with the experience of a reader leads to 'the absurd conclusion that a poem is non-existent unless experienced and that it is recreated in every experience. . . . We end in complete skepticism and anarchy.'[27]

In sum, the New Critics tried to steer a course between objectivism and subjectivism: literature is related to us and to our world, but always rises above it. Our experience of a poem provides real but only ever partial knowledge of it: 'the real poem must be conceived as a structure of norms, realized only partially in the actual experience of its many readers. Every single experience (reading, reciting, and so forth) is only an attempt—more or less successful and complete—to grasp this set of norms or standards.'[28]

The criterion of the success of the New Critical enterprise is whether it can make coherent this particular location of and role for literature. Can a poem be other, irreducible to something else without serious loss, while also linked intelligibly to the world—that is, to its author, referents, and readers? That this is possible is, *mutatis mutandis*, what the present work attempts to argue in the case of Scripture. Murray Krieger expresses the size of the challenge which New Critics set themselves: 'They had somehow to assert at once the autonomy of art and its unique power to give meaning to our experience, a power allowed only by its autonomy. This is a highly significant, if difficult, assertion.'[29] It will therefore be profitable to pay

[26] Wellek and Warren, *Theory of Literature*, 65. There is a notable similarity between this complaint and Karl Barth's rejection of Jülicher's exegesis of Romans, in his preface to the 2nd edn. of his Romans commentary (Karl Barth, *The Epistle to the Romans*, trans. Edwyn C. Hoskyns (London: Oxford University Press, 1933), 6ff.). For some insightful observations on the relationship between New Criticism and neo-orthodoxy, see Poland, 'The New Criticism'.

[27] Wellek and Warren, *Theory of Literature*, 146.

[28] Ibid., 151.

[29] Krieger, *The New Apologists for Poetry*, 5.

particular attention to the evaluation of New Criticism's ability to make good on this claim.

It should be noted, first, that several of the criticisms often levelled at New Criticism are quite superficial. René Wellek lists three of the most frequently made criticisms, and argues that they are all baseless.[30] First, New Criticism is often accused of formalism—that is, it is charged with indulging in an 'esoteric aestheticism' which is uninterested in social function. It is accused, second, of an anti-historical bias which isolates works from their past and context, and, third, of attempting to make literary criticism a scientific enterprise. In response to the first two criticisms, Wellek points out that Cleanth Brooks's interpretations of seventeenth-century poems make full use of the work of lexicographers and historians, and that New Critics had a philosophy of history, 'a total historical scheme', in light of which they offered a reinterpretation of the whole of English poetry. The third criticism Wellek calls 'preposterous'. The New Critics' interpretation of Western history in fact placed much of the blame for the destruction of 'the community of man' on science, and '[n]one of the New Critics has any sympathy for the mechanistic technological views of the Russian formalists'. Where New Critics did insist that criticism should be a systematic and rational discipline, they did not mean 'a modern value-free social science, for they always stressed the necessity of judgment, the qualitative experience poetry gives us. . . . criticism is always subordinated to creation. Its humility contrasts precisely with the aggressions, the impositions of science.'[31] Wellek's conclusion is worth quoting at length:

The New Criticism surely argues from a sound premise, that no coherent body of knowledge can be established unless it defines its object, which to the New Critic will be the individual work of art clearly set off from its antecedents in the mind of the author or in the social situation, as well as from its effect in society. The object of

[30] Wellek in fact lists a fourth—that New Criticism was merely a pedagogical device to help American university students who have to read poetry—but this lies beyond our concerns here, and Wellek does not rebut it directly (Wellek, 'The New Criticism', 611).

[31] Wellek, 'The New Criticism', 615–19. The literary critic Gerald Graff agrees: the New Critical technique of 'close reading' was, he says, 'designed not to imitate science but to refute its devaluation of literature' (Graff, 'What Was New Criticism?', 133).

literary study is conceived not as an arbitrary construct but as a structure of norms which prescribes a right response. This structure need not be conceived of as static or spatial in any literal sense, though terms such as the well-wrought urn, or Joseph Frank's spatial form, or Wimsatt's verbal icon suggest such a misinterpretation. All these metaphors aim at a genuine insight: although the process of reading is inevitably temporal in criticism, we must try to see a work as a totality, a configuration, a gestalt, a whole.[32]

New Criticism is thus fundamentally committed to the realist view of texts which, it will be argued below in reference to Stanley Fish and others, is essential if solipsism is to be avoided. It is also committed to distinguishing the meaning of a text from its perlocutionary effect, and from some mental intention of its author. However, the New Critics' regular preference for static and spatial metaphors, to which Wellek refers here, cannot be so easily excused as simply a clumsy way of expressing a basic insight. In his later defence of 'The Intentional Fallacy', Wimsatt asserts: 'The poem conceived as a thing in between the poet and the audience is of course an abstraction. The poem is an act. The only substantive entities are the poet and the audience. But if we are to lay hold of the poetic act to comprehend and evaluate it, and if it is to pass current as a critical object, it must be hypostatized.'[33] If the poem is in fact an act, while what is studied is a hypostatized form of that act, one may wonder whether the criticism which Wimsatt advocates is in fact *literary* criticism at all, for the object of its work of comprehending and evaluating is not the poem, but an object to which the poem bears some unspecified relation: the relation, broadly, of an act to an object. Wimsatt seems, ironically, to have committed the capital offence in New Critical eyes of reducing a poem to something else. Violence has been done here to the nature of poetry in the service of a literary criticism which prizes scientific objectivity above all else; a statement that begins in basic agreement with speech act theory, defining poems as acts, ends in opposition to it.

This suggests that Wellek's attempt to get New Critics off the hook is a little naive. Referring to the work of the New Critic Cleanth Brooks, he asserts that the stress on 'close reading'

[32] Wellek, 'The New Criticism', 620.
[33] Wimsatt, *The Verbal Icon*, p. xvii.

and the rejection of 'the heresy of paraphrase' 'cannot mean a lack of relation to reality or a simple entrapment in language', since for New Critics poetry 'is turned to the world', and like everything else human, 'cannot be absolute or pure'. Wellek concludes that it is a false dilemma to imagine that a poem characterized by 'coherence and integrity' cannot point to the outside world, for it is in '[t]he very nature of words' to point in such a way.[34] Although perhaps a false dilemma, it is certainly a prima facie dilemma, and how it is to be resolved Wellek does not say; he appeals to 'the very nature of words', without telling us what that nature might be.

New Critics wanted to assert both the autonomy of the work of art and its relation to reality; both are appropriate concerns, but they lacked the conceptual apparatus for describing how both might be true at the same time. Thus, Lentricchia says of the New Critical claim that 'literature gives a "special kind of knowledge" of nonliterary, nonlinguistic phenomena' that 'the New Critic cannot justify that claim, and probably is trapped in an aestheticism of his own'.[35] Similarly, Gerald Graff concludes that New Critics sometimes contradicted themselves on this point. Quoting from Brooks, he asks how literary truth can correspond to the outside world, to 'the facts of experience', if the critic may not go 'outside the poem': 'In short, the doctrine of the objectivity of literature was ambiguous: it might be invoked in order to close the work off from the objective world or to point the work back towards this world.'[36] The results of this unresolved ambiguity are ironic. By often ending up in a position approaching 'art for art's sake', contrary to their intentions, the New Critics developed a view of literary texts as self-sufficient aesthetic objects. Such a view, although designed 'to combat the fragmentation of a presumably hyperrational society . . . only deepens the divisions of modern culture'.[37] As a conclusion regarding New Criticism's actual success, that is a fair judgement. However, Wellek rightly locates their intention in broader and continuing discussions: 'The humanities would surely abdicate their function in society if they surrendered to

[34] Wellek, 'The New Criticism', 617.
[35] Lentricchia, *After the New Criticism*, 18.
[36] Graff, 'What Was New Criticism?', 142.
[37] Ibid., 147.

a neutral scientism and indifferent relativism or if they suc-
cumbed to the imposition of alien norms required by political
indoctrination. Particularly on these two fronts the New Critics
have waged a valiant fight which, I am afraid, must be fought
over again in the future.'[38]

It seems, then, that the present work has a great deal in sym-
pathy with New Critical intentions, but can find little material
of positive constructive benefit in its formulations. However,
the process of identifying its most serious weakness is instruc-
tive. Wellek papers over the cracks by saying that it is 'the
nature of words' which gives a literary work the paradoxical
characteristics of 'coherence and integrity' and the ability to
point away from itself to the objective world. Speech act theory
provides, we have suggested, a powerful description of 'the
nature of words' as they exist in relation to speakers, hearers,
and referents. 'Human beings . . . refer; words do not', as Morse
Peckham says in his response to 'The Intentional Fallacy'.[39] In
other words, New Critics, while not doing away with human
subjectivity, do not take sufficient account of human *agency*.
Finding the only model of human agency in literature available
to them, Romantic criticism, to be unacceptable, they were
unable to articulate a coherent ontology of the literary work in
relation to its author on which to ground their different claims
for the role of literature.[40]

[38] Wellek, 'The New Criticism', 624. There is, however, also a cautionary
note to be sounded here, in that some New Critics might themselves have had
a political agenda which they tried to impose on literature. Eagleton suggests
that they saw poetry as 'the final solution to science, materialism, and the
decline of the "aesthetic" slave-owning South' (Eagleton, *Literary Theory*, 49).
Nevertheless, their apparent aim that literature never be rendered fully sub-
servient to political ideology holds out the possibility that any a priori politi-
cal agenda is open to correction in the process of reading and criticism.

[39] Morse Peckham, 'The Intentional? Fallacy?', in Newton-de Molina, *On
Literary Intention*, 139–57, at 146.

[40] See Anthony Thiselton's observation that New Critics 'were addressing
a pre-Wittgensteinian notion of intention as inner mental processes. H. P.
Grice, John Searle and others have since argued that what an utterance means
is explicable in terms of what a *person* means by his or her utterance. . . . There
are ways of expressing intention which identify the directedness of a speech act
without presupposing some psychological notion of "inner mental states"'
(Anthony C. Thiselton, *New Horizons in Hermeneutics* (London: Harper-
Collins, 1992), 59).

Peckham draws an interesting comparison between New Critics' understanding of the nature of a literary work and Roman Catholic sacramental theology. Expanding on Wimsatt and Beardsley's notion that a poem is embodied in language, he observes that

[t]he notion of something suprasensible being embodied in something sensible—for both written and spoken words are phenomenal and sensible—has an irresistibly transcendental ring about it. . . . Now anyone familiar with Christian doctrine can recognize this embodiment thesis as structurally identical with the theory of transubstantiation. . . . A suprasensible quality, poetry, is embodied in a sensible quality, language, and the result is a unique category of language, which requires a unique kind of interpretation.[41]

New Critics have, according to Peckham, created a 'doctrine of semantic real presence'.[42] In light of the previous chapter's use of speech act theory to describe God's speaking activity, 'semantic real presence' may also be conceived of in relation to Word, as well as in relation to sacrament.[43] The concluding sections of this chapter will articulate the sufficiency of Scripture in relation to what we will call divine semantic presence.

Hans Frei: The 'Hyper-Sufficiency' of Scripture

The theologian Hans Frei is sometimes said to borrow heavily from New Critical convictions and practices, and to offer a strong description of Scripture as sufficient.[44] It will be argued here that Frei's appropriation of New Criticism was not sophisticated enough, since he advocated reading practices that were more formalist than those of the New Critics (given our partial acceptance of Wellek's defence of New Critics as not truly formalists). Moreover, his particular conception of Scripture as an autonomous object, sufficiently able to render the identity of Jesus Christ, advocates a 'hyper-sufficiency' of Scripture which goes so far beyond what the Reformers and their successors

[41] Peckham, 'The Intentional? Fallacy?', 143–4.

[42] Ibid., 145.

[43] Two recent attempts to rethink God's presence by rehabilitating pre-critical theologies of Word (Kevin Vanhoozer) and sacrament (Catherine Pickstock) were referred to briefly in ch. 1.

[44] e.g. Poland, 'The New Criticism', 459.

ever meant by 'the sufficiency of Scripture' that his theology encounters serious problems. Nonetheless, Frei's work is often rightly praised for its profundity and imaginative innovations. It is equally true that some of his writing is, as Nicholas Wolterstorff says, difficult and obscure; Wolterstorff judges that Frei never found 'a satisfactory set of concepts' for what he wanted to say.[45]

Frei's most typical and oft-repeated point is that the character of Jesus Christ as portrayed in the (Synoptic) Gospels is unsubstitutable: the Messiah of Israel and Saviour of the world is none other than Jesus of Nazareth, narratively rendered especially in the Gospel accounts of his passion and resurrection. The Gospels, unlike the Gnostic redeemer-myths which were roughly contemporary with them, do not describe some 'everyman' character; the identity of Jesus Christ is irreducible to something else. This is what Frei means when he describes the Gospels' passion and resurrection narratives as 'history-like'; he implies no particular historical claim, but firmly excludes myth as a legitimate category for understanding the story of Jesus Christ. This is an ingenious argument against nineteenth-century interpretations of the Gospels as myths. It offers not the external and historical objection, common to conservative biblical scholars, that the events depicted in the Gospels really did happen as reported there, but instead the internal and literary objection that the narratives are not susceptible to mythological interpretation anyway, since, unlike mythological texts, the central Saviour-figure functions as a character with unsubstitutable identity. It is therefore not that those whom Frei calls 'mythophiles' are wrong in under-estimating the extent to which Scripture in fact refers accurately to history; they have rather simply made a fundamental mistake of genre-recognition.

In his detailed work *The Eclipse of Biblical Narrative*, Frei gives an interpretation of the history of Western European hermeneutics in the eighteenth and nineteenth centuries, arguing that the pre-critical age held the meaning of the Gospel narratives to be simply their literal sense. This conviction was lost, however, in the wake of the introduction of 'a logical

[45] Nicholas Wolterstorff, 'Will Narrativity Work as Linchpin? Reflections on the Hermeneutic of Hans Frei', in Charles M. Lewis (ed.), *Relativism and Religion* (Basingstoke and London: Macmillan, 1995), 71–107, at 73.

distinction and a reflective distance between the stories and the "reality" they depict', with the result that in the eighteenth century 'the sense of . . . a passage came to depend on the estimate of its historical claims, character, and origin'.[46] This shift affected the reading practices of both orthodox (Frei mentions Cocceius and Bengel) and sceptic (for example, Spinoza), the only difference between the two being the extent to which they thought that the depiction corresponded to historical reality.[47] Thus, according to Frei, whether one locates the meaning of the Gospel narratives in the events which they depict, assuming those events to be actual historical events, as most conservative theologians do, or whether one locates the meaning in the religious consciousness which produced the texts, assuming that consciousness to be unreflectively mythologizing, as most liberal theologians do, amounts to the same thing. Both strategies bring about 'the eclipse of biblical narrative'. Frei thought of this 'eclipse' as the shift in equating the meaning of the narrative no longer with its literal sense but now with its referents.[48]

Commentators often find themselves using the term 'sufficiency' to describe Frei's concept of Scripture; Frei himself rarely uses the term. James Fodor says that for Frei, 'biblical narrative features a sort of internal referent in so far as it creates its own world. Moreover, this textual world of the Bible is not only the *necessary* basis for our orientation within the real world, but is also *sufficient* for that purpose.'[49] For Frei, everything happens within the text: the meaning lies neither 'behind' the text in some referent, nor 'in front of' it in some fusion between text and reader, but inside it. The textually rendered Jesus Christ is therefore rendered to us as a sufficient hermeneutical basis for Christian theology and life: 'We must neither look for his identity in back of the story nor supply it from

[46] Hans W. Frei, *The Eclipse of Biblical Narrative: A Study in Eighteenth and Nineteenth Century Hermeneutics* (New Haven and London: Yale University Press, 1974), 5, 41.

[47] Frei, *Eclipse*, 5.

[48] Frei says that in the eighteenth-century debate between Deists and orthodox over Old Testament prophecy, 'the *meaning* of the earlier texts is their *reference.* . . . their meaning is determined by their reference or failure to refer beyond themselves to certain events' (Frei, *Eclipse*, 41).

[49] James Fodor, *Christian Hermeneutics: Paul Ricoeur and the Refiguring of Theology* (Oxford: Clarendon Press, 1995), 268.

extraneous analytic schemes. . . . No. He *is* what he appeared to be—the Savior Jesus from Nazareth who underwent "all these things" and who is truly manifest as Jesus, the risen Christ. Such, it appears, is the story of Jesus in the Gospels.'[50] In this citation, at least, Frei's view of Scripture appears very similar to that expressed by the confession of Scripture as materially sufficient. However, there is a significant difficulty here, which has regularly been identified in the theology of Frei and his Yale colleagues.[51] It will be argued that Frei has severed the links between Scripture, on the one hand, and its author(s) (both human and divine), its readers, and its historical referents, on the other, thereby establishing such a profound autonomy, or *self*-sufficiency, of Scripture, that it becomes unclear how the theology which he wishes to build on this basis can come to touch reality.

Frei's position on historical reference seems to be that the Gospel narratives become more historically reliable as their accounts of events move towards the passion and resurrection. He makes the general comment that, '[a]bout certain events reported in the Gospels we are almost bound to ask, Did they actually take place?', but suggests that, before the passion and resurrection accounts, this is an irrelevant question in the sense that 'the meaning of these texts would remain the same, partially stylized and representative and partially-focused on the history-like individual, whether or not they are historical'.[52] This is in contrast to the final stages of the story; at the beginning, Jesus' identity is defined for him by the traditions of Jewish Messianic expectation, but by the end he enters into his unsubstitutable identity, redefining those traditions by his own being and actions. The question of historicity surfaces most pointedly with the singular event of the resurrection. Myths, says Frei, do not lead us to ask the question, 'did this happen?', but the very singularity of Jesus' identity in the resurrection forces us to ask that question.[53] Thus, although Frei says that

[50] Hans W. Frei, *The Identity of Jesus Christ: The Hermeneutical Bases of Dogmatic Theology* (Philadelphia: Fortress Press, 1975), 138.

[51] See e.g. Gary Comstock, 'Two Types of Narrative Theology', *Journal of the American Academy of Religion* 55 (1987), 687–717.

[52] Frei, *Identity*, 132.

[53] Ibid., 140.

the history-likeness of a narrative implies nothing about its historicity, it does seem that the more un-mythical a narrative is, the more the text forces the question of factuality on us. This is further borne out by another conclusion which he draws: '*if* the Gospel story is to function religiously in a way that is at once historical and Christological, the central focus will have to be on the history-like narration of the final sequence, rather than on Jesus' sayings in the preaching pericopes'.[54]

A confusion in Frei's work arises here, in that he immediately undercuts the point he has just made, suggesting that, although there are places in the narrative where the individual becomes more clearly accessible to us ('life-likeness to the point of intimate knowledge of the depicted individual'), it may well be that the more enigmatic episodes (Frei cites the cursing of a fig tree in Mark 11: 12ff. as an example) 'are much more nearly reliable historical reports'.[55] Is 'life-likeness' synonymous with 'history-likeness'? Perhaps not. Would Frei categorize the resurrection as 'history-like' but not 'life-like'—an 'enigmatic' episode? It is hard to say. Yet his view of the resurrection does seem to depend on it being the climactic because most accessible element in Jesus' enactment of his identity. It is very difficult to systematize Frei's work coherently at this point; it certainly seems that he is confused about the criteria for historicity in the Gospel narratives.[56]

What is evident is Frei's opinion that Christians should regard the resurrection as a historical 'extra-literary' event. He says early on in *The Identity of Jesus Christ* that Christ is present to the church now as the one who lived and died in Nazareth and Jerusalem because he was raised from the dead: 'His having been raised from the dead is not his presence now, but is the necessary local basis for his presence.'[57] The matter becomes more complex when we ask why this basis, in its par-

[54] Frei, *Identity*, 140–1.

[55] Ibid.

[56] '[W]hen, at the end of *The Identity of Jesus Christ*, Frei suddenly asserts that the fundamental truthfulness of the resurrection narratives is actually very important, he has no conceptuality available for making this assertion plausible and is reduced to gnomic utterances about the mysteriousness of faith' (Francis Watson, *Text, Church and World: Biblical Interpretation in Theological Perspective* (Edinburgh: T. & T. Clark, 1994), 224).

[57] Frei, *Identity*, 16.

ticularity ('local-ness'), is a necessary basis for the presence of Christ now. Frei is always keen not to ground Christian faith in events which are open to historical investigation, which would lead to attempts to evaluate the historical reliability of the Gospels.[58] He therefore argues, from what he sees to be 'the logic of . . . faith', that believers must affirm that the New Testament writers were correct in affirming that 'it is more nearly correct' to think of Jesus raised physically than in any other way. This keeps Christian faith from basing itself on a claim about the relationship of Scripture to history: 'belief in Jesus' resurrection is more nearly a belief in something like the inspired quality of the accounts than in the theory that they reflect what "actually took place"'.[59] What is 'the logic of faith' that leads to this position? Frei means by this to propose something like a literary version of the ontological argument for the existence of God:

This, then, is the identity of Jesus Christ. He is the man from Nazareth who redeemed men by his helplessness, in perfect obedience enacting their good in their behalf. As that same one he was raised from the dead and manifested to be the redeemer. As that same one, Jesus the redeemer, he cannot *not* live, and to conceive of him as not living is to misunderstand who he is.[60]

This quotation may serve as a good starting-point for trying to unravel some of the threads of Frei's complex text. Wolterstorff says of this argument that 'Frei's Anselmian language has led him into confusion', and offers an illustration of his point. If in a work which we knew to be a novel there were a character who had the essential property that he would be resurrected if killed, the question of factuality would *not* arise, as Frei says it does with the character of Christ in the Gospels. This is so, says Wolterstorff, because '[s]tories *qua* stories, no matter how realistic, do not invite the question of factuality'; rather, what raises that question 'is one's belief that the story has been presented as (in part, at least) a true description of someone'.[61] Frei in fact anticipated something very like this objection, casting his response as a *reductio ad absurdum*:

Someone may reply that in that case the most perfectly depicted char-

[58] Ibid., 51. [59] Ibid., 150–2. [60] Ibid., 149.
[61] Wolterstorff, 'Will Narrativity Work?', 98.

acter and most nearly lifelike fictional identity ought always in fact to have lived a factual historical life. We answer [Frei is here hypothesizing how the Synoptic Evangelists might have summarized their position] that the argument holds good only in this one and absolutely unique case, where the described entity (who or what he is, i.e., Jesus Christ, the presence of God) is totally identical with his factual existence. He *is* the resurrection and the life. How can he be conceived as not resurrected?[62]

Wolterstorff would presumably respond that this reformulates his point without answering it: on what basis do we say that these texts are unique in precisely this way? Frei regularly describes his prescribed method of reading the Gospels as privileging the literal sense, but when we need an argument explaining why we should not ignore the literal sense, says Wolterstorff, 'Frei begs off—or gives the impression of begging off'. He does want to intervene in the Christian practice of reading Scripture, but he wants to ground his plea not in hermeneutical theory but in 'religious utility. . . . Yet he is remarkably chary of stating what he thinks that religious utility to be.'[63] This is an accurate criticism, echoed by other writers. Gary Comstock compares Frei unfavourably with Ricoeur on this point, saying that whereas Frei thinks it sufficient to say that the biblical narratives are *meaningful*, Ricoeur wants additionally to show that Christians can say that they are *true*.[64] If Christians claim to have a meta-narrative, as Frei would agree they do, 'then we must accept responsibility for showing not only *how* one ought to understand the claim, but *why* it should be affirmed.'[65]

Wolterstorff goes to the heart of the problem from a literary angle by pointing out a problem with Frei's understanding of the 'literal sense' of Scripture, and of how a reader reading for this sense may arrive at it. Frei wants us to isolate the discerning of the propositional content of the literal sense of the Gospels as the first stage of Bible-reading, not allowing 'our judgements as to the propositional content of the literal sense of

[62] Frei, *Identity*, 145–6.

[63] Wolterstorff, 'Will Narrativity Work?', 96–7.

[64] Gary Comstock, 'Truth or Meaning: Ricoeur versus Frei on Biblical Narrative', *Journal of Religion* 66 (1986), 117–40, at 117–18.

[65] Comstock, 'Truth or Meaning', 130–1.

the Gospels to be influenced by our views as to the truth or falsehood, utility or inutility, of that content'.[66] Wolterstorff makes two objections to this. First, it does not work 'as a general policy': we regularly conclude that a statement in a text is to be taken metaphorically, for example, because we decide that the words, if taken literally, would yield a falsehood which the writer would not have wished to assert. Thus, no reader actually does or indeed can keep the stages separate, as Frei wishes. Second, Wolterstorff suggests that Frei tends to think of 'sense' as a sequence of propositions, whereas he (Wolterstorff) thinks of it as a sequence of speech acts. This means that Frei holds back the fact that the Gospels are presented as historical claims and testimonies until after the interpretation of the 'literal sense'. Wolterstorff objects that 'part of what goes into the skilled exegesis of works of fiction is discerning where, amidst the fictionalizing, assertions are being made, wishes expressed, etc.'[67] As Searle and Austin continually assert, the various components of a speech act (locutionary act, propositional content, illocutionary force, perlocutionary effect) are only abstractions from one indivisible act. Frei's interpretative strategy tries to treat propositional content and illocutionary force as if they were separate elements, susceptible of entirely distinct levels of treatment by readers, with all aspects of interpretative judgement held back to a second stage. In fact, Frei never gets much beyond a lengthy defence of the literal sense, understood purely propositionally, and in practice pays little attention to the Bible's illocutionary force. Frei's approach therefore reads against the grain of how language is used. This explains why many readers of Frei are left confused over whether the Jesus he is talking about is present in anything more than a literary sense: the writer's illocutionary stance with regard to the 'literal sense' of the text (as Frei understands the term) is excluded from the definition of 'who Jesus is'. The same kind of exclusion occurs at the level of the divine, as well as the human authors; Wolterstorff points out rightly that nothing in Frei's arguments requires that the Scriptures be the Word of God.[68]

[66] Wolterstorff, 'Will Narrativity Work?', 102.
[67] Ibid., 103.
[68] Ibid., 101.

Towards the end of his life, Frei attempted to deal with the problem of the relation between the sense of the text and extra-textual reality. He did this by identifying the literal sense of the text with the Christian community's interpretation of the text.[69] Frei makes clear that by privileging the 'literal sense' he is not making a hermeneutical claim about the nature of the Gospel texts, but is attempting to remain faithful to the Christian community's '"rule" for faithful reading': 'There is no a priori reason why the "plain" reading could not have been "spiritual" in contrast to "literal," and certainly the temptation was strong. The identification of the plain with the literal sense was not a logically necessary development, but it did begin with the early Christian community.'[70] This begins to solve the problem, according to one commentator, because '[a]fter all, it is the actual lives of believers and not words or narratives which refer'.[71] There is of course another option for the referring agent of a text, as was argued at length in Chapter 3: the author. In ignoring this option, and grounding the text in reality by privileging as the 'plain' sense the sense which the church has chosen, Frei brushes against what will be seen below, in the dis-cussion of Stanley Fish, to be the solipsistic dangers inherent in locating meaning in the reading-community.

Kathryn Tanner, a pupil of Frei, has attempted to defend this particular development in Frei's work, arguing that she can retain Frei's definition of the literal sense without losing a grip on the possibility that the community may change its practices in the light of the text speaking to the community in some way from outside it.[72] Her main argument is that the privileging of the 'plain sense' is protected from 'promoting a rigid uniformi-ty in community life' by two Christian practices. First, the practice of canonizing a limited set of texts as scriptural means that the canon's material content cannot be given universal

[69] For a clear discussion of this, see Fodor, *Christian Hermeneutics*, 301.

[70] Hans W. Frei, 'The "Literal Reading" of Biblical Narrative in the Christian Tradition: Does It Stretch or Will It Break?', in George Hunsinger and William C. Placher (eds.), *Theology and Narrative: Selected Essays* (New York and London: Oxford University Press, 1993), 117–52, at 139, 122.

[71] Fodor, *Christian Hermeneutics*, 301.

[72] Kathryn E. Tanner, 'Theology and the Plain Sense', in Garrett Green (ed.), *Scriptural Authority and Narrative Interpretation* (Philadelphia: Fortress Press, 1987), 59–78, at 66–7.

relevance 'without some display of exegetical ingenuity', which inevitably leads to diversity of practice (there being, perhaps by definition, innumerable ways of exercising ingenuity). Second, the practice of identifying the plain sense of the texts as *a narrative*, as opposed to identifying it as 'cultic regulations or general teachings about beliefs and behaviors', means that communal practices are not specified; Christian beliefs and behaviours cannot be drawn with obvious clarity from the particularities of a narrated unique life.[73]

Tanner's essay, though illuminating, is problematic in that she equivocates in her definition of the 'plain sense' of the text. Her goal is to develop Frei's argument, and to offer a description of a theological enterprise that would be almost sociological, largely avoiding questions of epistemology, offering reasons which begin and end with 'This is what we do.' Her initial definition of the 'plain sense' of a scriptural text is therefore this: 'what a participant in the community automatically or naturally takes a text to be saying on its face insofar as he or she has been socialized in a community's conventions for reading that text as scripture'.[74] However, right here at the beginning there is ambiguity. The sense which a reader has been socialized into treating as 'plain' may not be related at all to what the text could be construed as saying 'on its face'. Tanner includes as possible formal definitions of the plain sense 'the sense that God intends' and 'the sense Church authorities designate'[75]— but these two criteria for determining the sense of the biblical text can be and have been used to produce senses which cannot possibly be construed as that which the text says 'on its face'. Her definition, therefore, equivocates between precisely the two kinds of theological description between which her thesis requires her not to equivocate: sociological and hermeneutical description in theology. She smuggles in at the beginning a tendency to define the material content of the 'plain sense' as something very close to 'the verbal and grammatical sense' of the text. This in the end is what leads her to identify the 'plain sense' of the Gospels as a narrative: that identification is in line with how the Gospels present themselves to us. This move, however, is precisely the kind of epistemological move which

[73] Ibid., 72–4. [74] Ibid., 61–3. [75] Ibid., 65.

Tanner has claimed to be able to avoid. Thus, her effort to bolster Frei's attempt to link Scripture back up to reality fails. To make her point, and to guarantee that Scripture is not subsumed into the community's use of it, she must make precisely the kind of hermeneutical and epistemological appeals to the text which she and Frei want to eschew.

A balanced reading of Frei's work must take account of his theological context, for he offers a provocative alternative to the 'Chicago school' of narrative theology. Gary Comstock insightfully analyses the areas of agreement and disagreement between Yale and Chicago, and the strengths and weaknesses of each, citing Frei's reading of the Bible as a helpful corrective to the tendency of David Tracy and others to reduce the Christian gospel to something else.[76] Frei's intention to safeguard the Gospel texts from mythologizing accounts which do violence to the most fundamental characteristics of the Gospels' depiction of the identity of Jesus Christ is an admirable one. However, it is a safeguard bought at too high a price. He secures theological autonomy for the biblical narratives with a formalist approach to interpretation which leaves the Christ depicted in the Gospels in uncertain relationships to the realities of authors, readers, and history.[77] Particularly with regard to the text–reader relationship, he secures a rejection of the imposition of 'alien explanatory structures' on our understanding of biblical narratives at the cost of leaving us with no way of understanding the narratives 'against the readers' world'.[78] Frei makes the Gospel narratives so other that the one whom they depict threatens to float off into unreality. This is what we described as Frei's 'hyper-sufficiency' of Scripture, at least in his earlier work. An 'unsupplemented' word remains for that reason of questionable value for life. Lynn Poland comments that Frei

[76] To explain Christianity as a 'limit-experience', as Tracy does, just begs the question, argues Comstock. 'Why accept the categories of hermeneutic phenomenology? Why not turn to the categories of process theology, pragmatism, deconstruction, or empirical theology for an explanatory paradigm?' (Comstock, 'Two Types of Narrative Theology', 703).

[77] 'Frei appears to confuse a literary, textual formalism with a theological notion of autonomy; that is to say, he seems to blur certain structuralist insights with claims regarding the perspicuity and sufficiency of Scripture' (Fodor, *Christian Hermeneutics*, 283).

[78] Ibid., 295, quoting Terrence W. Tilley.

substitutes the autonomous biblical text for Barth's sovereign Word.[79]

The same anxiety has been expressed about post-liberal theology, on which Frei's work exerted considerable influence, and which is exemplified by the writing of George Lindbeck. Anthony Thiselton, for example, approves of Lindbeck's view that '[i]t is the text, so to speak, which absorbs the world, rather than the world the text',[80] because it helpfully serves 'to question this tendency to give privilege to the present in a necessary way'. Thiselton is also, however, 'extremely cautious about George Lindbeck's tendency to locate the meaning of biblical texts in intralinguistic or "intratextual" categories to the exclusion of presuppositional and extra-linguistic contextual factors about states of affairs in the world'.[81]

What is required, for the purposes of the present reconstruction of the sufficiency of Scripture, is a way of guaranteeing the otherness, the theological autonomy, of Scripture, while retaining a firm description of its existence in relationship to the world, especially to its author(s) and readers. A proposal for how this may be done was begun in Chapter 3, with the reading of Barth in light of speech act theory. The following two sections of this chapter will continue this by examining recent literary and theological options for understanding the relationship between texts and authors, and then texts and readers.

TEXTS AND AUTHORS

E. D. Hirsch: Defending Authors

E. D. Hirsch is well-known as the most unabashed advocate in contemporary literary theory of the supplementation of texts with authors, arguing that the right of the determination of textual meaning should lie with the author. His defence of the author serves his overall academic purpose, which is to guarantee that literary interpretation has a determinate object of study, so that particular interpretations may lay claim to be objectively valid in the sense that they do more than just appeal to the

[79] Poland, 'The New Criticism', 469.
[80] George Lindbeck, *The Nature of Doctrine* (London: SPCK, 1984), 118.
[81] Thiselton, *New Horizons*, 557.

biases of the interpreter.[82] This desire for objectivity is, then, a primary motivation which Hirsch shares with New Critics.

He takes Gadamer as his chief hermeneutical opponent, arguing against him that his notion of a fusion of the horizons of text and reader makes no sense as an account of textual meaning if the reader takes on the role of author of meaning, for the meaning must exist in some sense prior to and other than the activity of readers. 'How can a fusion take place unless the things to be fused are made actual, which is to say, unless the original sense of the text has been understood?'[83] Hirsch safeguards this determinate sense by distinguishing between a text's 'meaning', which does not change, and its 'significance', which does. 'Meaning' he calls 'a principle of stability' in interpretation, and 'significance' a principle of change.[84] He makes clear that, in his usage, '[d]eterminacy does not mean definiteness or precision. . . . [It] first all means self-identity. This is the minimum requirement for sharability. . . . Determinacy also means that verbal meaning is changeless.'[85]

Hirsch intends by this distinction between meaning and significance to safeguard what he takes to be a fundamental epistemological point. Without such a distinction, he says, we could not know anything in the world, for we know an object to be the same object in different contexts precisely by distinguishing 'an object of knowledge and the context in which it is known'.[86] Hirsch looks to Husserl to provide the philosophical foundation for this distinction, finding in Husserl's concept of 'bracketing' 'a simplified, visual metaphor for our ability to demarcate not only the content but also the mental acts by which we attend to that content, apart from the rest of our experience.

[82] E. D. Hirsch, Jr., *Validity in Interpretation* (New Haven and London: Yale University Press, 1967), 27.

[83] Ibid., 254. In a recent essay, Hirsch modifies his stance towards Gadamer somewhat, although he does not state that he is thereby going back on his earlier work: E. D. Hirsch, Jr., 'Transhistorical Intentions and the Persistence of Allegory', *New Literary History* 25 (1994), 549–67. This essay will be discussed in ch. 5, in the concluding part of the section on the hermeneutics of B. S. Childs. Gadamer's hermeneutics will be treated later in the present chapter.

[84] E. D. Hirsch, Jr., *The Aims of Interpretation* (Chicago and London: University of Chicago Press, 1976), 80.

[85] Hirsch, *Validity*, 44–6.

[86] Hirsch, *Aims*, 3.

This demarcation, corresponding to the distinction between meaning and significance, alone assures the potential sameness of objects in experience over time.'[87] Expressed particularly in relation to literary knowledge, then, 'the term "meaning" refers to the whole verbal meaning of a text, and "significance" to textual meaning in relation to a larger context, i.e. another mind, another era, a wider subject matter, an alien system of values, and so on. In other words, "significance" is textual meaning as related to some context, indeed any context, beyond itself.'[88]

Hirsch claims that the objectivity of 'meaning' (in this sense) can be guaranteed only if the author's intention is treated as the norm for interpretation. His argument is explicitly pragmatic, based neither on an ontological claim about the nature of texts nor on an ethical claim about the human agency of authors. Authorial intention, he argues, is probably the only norm which 'can be universally compelling and generally sharable. . . . On purely practical grounds, therefore, it is preferable to agree that the meaning of a text is the author's meaning.'[89]

It has been argued that in all this Hirsch assumes too great a degree of objectivity in interpretation, ignoring the nature of understanding itself—the very issue which has been at the centre of hermeneutical enquiry in recent times. As Kevin Van-hoozer says, he is concerned with how to adjudicate between conflicting understandings, not with how understanding is possible in the first place.[90] However, Hirsch also acknowledges that the author's intended meaning can only ever be known probably, not certainly: we might actually have the author's intended meaning, but we could never know for certain that we have it.[91] It must follow, according to David Couzens Hoy, that

[87] Ibid., 4–5. Hirsch traces the origin of his distinction to Husserl's concept of the 'inner and outer horizons' of any act of knowing (pp. 1–2).

[88] Ibid., 2–3. Hirsch's meaning/significance distinction will be re-articulated in relation to the Bible and the Holy Spirit towards the end of this chapter. In that it is fundamentally undermined by practitioners of neo-prag-matic hermeneutics and deconstruction, it will be defended in subsequent sections of this chapter.

[89] Hirsch, *Validity*, 25.

[90] Kevin J. Vanhoozer, 'A Lamp in the Labyrinth: The Hermeneutics of "Aesthetic" Theology', *Trinity Journal* 8 (1987), 25–56, at 30.

[91] Hirsch, *Validity*, 16–17, 170–1.

understanding, the goal of interpretation, 'is set out as an ideal [goal]. Such a notion gives an interpreter grounds on which to assert that his interpretation is correct—insofar as he *believes* that it approaches the right understanding and that there is a right understanding to be approached.' This, concludes Hoy, can be an empty principle, forgetting the need for self-criticism.[92] In fact, in *The Aims of Interpretation* Hirsch acknowledged that in his previous work, *Validity in Interpretation*, he had come close to advocating that the whole process of understanding in hermeneutics be ignored, and said that he now saw clearly that 'the process of understanding is itself a process of validation . . . a validating, self-correcting process—an active positing of corrigible schemata which we proceed to test and modify in the very process of coming to understand an utterance'.[93] He thus comes to articulate his description of human understanding with the same set of concepts and dynamics which he uses to adjudicate between interpretations.

The literary critic P. D. Juhl has offered some of the most insightful comments on Hirsch's work. He acknowledges that Hirsch's advocacy of authorial intention as the norm for interpretation is meant only as 'a stipulative definition or recommendation', rather than as a truth-claim about literary meaning, and asks contentiously whether the suggestion of this as the norm for interpretation is any less arbitrary than, say, a panel of literary critics, who could equally provide what Hirsch wants, namely 'a genuinely discriminating norm'.[94] Juhl points out that, in fact, Hirsch's arguments rest on an implicit truth-claim about textual meaning. Hirsch observes that when critics talk about multiplicity of meanings, and conclude that meaning changes, they are often not talking about meaning at all but about significance. However, observes Juhl, in order to demonstrate this Hirsch 'presupposes that the meaning of a work *is* as a matter of fact (or rather of logic) what the author intended to convey'. This, of course, is more than just a recommendation about the norm of textual meaning.[95]

[92] David Couzens Hoy, *The Critical Circle: Literature, History and Philosophical Hermeneutics* (Berkeley, Los Angeles and London: University of California Press, 1978), 33. [93] Hirsch, *Aims*, 33–4.

[94] P. D. Juhl, *Interpretation: An Essay in the Philosophy of Literary Criticism* (Princeton: Princeton University Press, 1980), 18–20. [95] Ibid., 27–8.

This point needs to be pressed further, for it is a fault-line that runs deep in Hirsch's hermeneutics. His pragmatism is strong; for example: 'the object of interpretation is no automatic given, but a task that the interpreter sets himself. *He* decides what he wants to actualize and what purpose his actualization should achieve.'[96] Hirsch in fact acknowledges that a moral argument can be offered to justify the identification of textual meaning with authorial meaning—specifically, an argument based on viewing texts as speech acts. However, he bases his pragmatism on the assertion that a reader may or may not accept the notion that language-uses 'carry moral imperatives' as interpersonal acts; certainly, 'nothing in the mute signs before him will compel him to change his mind or bring him ill fortune if he does not'.[97] In contrast to this, Wolterstorff's concept of normative standing, which, it was argued previously, is a persuasive description of the nature of language-use, asserts that moral imperatives accrue *normatively* to speakers and hearers, authors and readers. A person may not recognize that they have been so ascribed, or may recognize the fact but choose to ignore it—that is, there is nothing in a speech act which *compels* us to act in a certain way—but it does not follow that we may offer only a pragmatic defence of the primacy of the author in determining textual meaning.[98]

The following section of this chapter will offer a practical demonstration of the weakness of this pragmatic refusal to use moral arguments in the face of the deconstruction of authors in literary theory and biblical exegesis. Certain kinds of 'ill fortune', it will be suggested, do indeed befall the reader who refuses to recognize that language-uses 'carry moral imperatives'. We agree with Hirsch's basic observation that the concept of 'meaning' is only meaningful if it is understood to be the meaning of a person, that is, if human agency is invoked;[99] our

[96] Hirsch, *Validity*, 25.
[97] Ibid., 25–6.
[98] Hoy observes that the question at the heart of issues of textual meaning is philosophical rather than practical—'must the interpreter believe that there is one right understanding of the text?'—and therefore that Hirsch's argument for the determinacy of meaning, which operates only at the practical level, is circular (Hoy, *The Critical Circle*, 17–19).
[99] Hirsch, *Validity*, 3–23, argues this simple point succinctly and convincingly.

discussion of deconstruction will outline the ethical structures needed to support this hermeneutical view of authorship. It is here that the practical benefits of Wolterstorff's addition of a strong ethical dimension to a speech-act view of language will become especially apparent.

Before coming to that section, it may be observed that Hirsch's pragmatic defence of the author leads him into some positions which rather conflict with the popular interpretation of him as a robust defender of the author. In *Validity in Interpretation,* Hirsch concludes the argument for his pragmatic approach by observing that what he has to say should also serve other interpretative goals, for, even if the critic regards his role as replacing the original author as the author of the text's meaning, his point that all meanings require an author still stands.[100] He reflects on this further in his later book on the subject. In the period between the writing of the two books, Hirsch came to see, he says, that his distinction between meaning and significance applies equally to constructions of meaning 'where authorial will is partly or totally disregarded. . . . The important feature of meaning as distinct from significance is that meaning is the determinate representation of a text *for an interpreter.*'[101] Here Hirsch begins to sound like Stanley Fish, the reader-response critic who will be discussed below. He pulls back somewhat, though, concluding: 'Most interpreters retain a respect for original meaning, and recognition of this might mollify some of our disagreements.' He therefore holds out the hope that consensus may be reached that, '[u]nless there is a powerful overriding value in disregarding an author's intention (i.e. original meaning), we who interpret as a vocation should not disregard it'.[102] If, as argued throughout this book, simply through being addressed by another I acquire ethical obligations and so am called upon to act in certain ways and to refrain from certain actions, then interpretation is not just the 'vocation' of professional scholars, but is a universal human calling.

In this light, Hirsch turns out not to be the robust defender of the author which he is conventionally taken to be. In the end what he seems to want most of all is that professional inter-

[100] Hirsch, *Validity*, 27.
[101] Hirsch, *Aims*, 79–80 (italics added).
[102] Ibid., 90 (original italics removed).

preters of texts should agree that, however much they might come to understand textual meaning as polyvalent, they should begin at some point with a recognition of what the author may have meant; this will provide them with a shared object of discussion, before they move, however quickly, on from there. Hirsch defends authorial meaning since he thinks it the best way to foster methodological consensus; in the face of the fundamental attacks from deconstruction, though, it will be argued, authors require more directly committed defenders.

A final point may be made here with regard to the ambiguous references which Hirsch occasionally makes to speech act theory. Although he sees the 'convention–intuition' debate within speech act theory as quite a problem,[103] he nevertheless appeals to some of the insights of ordinary-language philosophy in order to argue his fundamental point that 'absolutely identical meaning' can be expressed through different linguistic forms.[104] He argues that most tests conducted on ordinary speech conclude that absolute synonymity of meaning in different expressions is impossible because the tests usually confront people with isolated words and sentences. When longer texts are used—'when we encounter words in actual use'—most people conclude that in such texts different words (for example, 'bachelors' and 'unmarried men') can indeed be used synonymously.[105] He makes a similar appeal to rectify what he sees as the one-sidedness of a strictly aesthetic conception of literature (a view he attributes to New Criticism): 'The first step would be to regard literature as verbal discourse, not as merely verbal artifact.'[106]

Hirsch's weakness is that these positive appeals to the view of language advocated by speech act theory remain scattered on the surface of his texts, and are not woven into the fabric of his conception of authorship.[107] Since he has apparently so much to say about human authorship, but offers very little on either

[103] Ibid., 25–6. This debate was discussed in ch. 3.
[104] Ibid., 50.
[105] Ibid., 59–62.
[106] Ibid., 124, 143.
[107] See Hoy on Hirsch: 'The further "explanation" achieved by linking sentences to consciousness is either extraneous or explains something else, such as speech acts or practical activity' (Hoy, *The Critical Circle*, 23).

its effects (human *agency*) or limitations (*human* agency),[108] it is not surprising that one commentator, Vern Poythress, has concluded that 'Hirsch needs an author whose human nature is perfectly clearly defined, whose language is perfectly defined, who somehow knows perfectly what he means, who expresses it perfectly without manipulation or conniving, and whose intentions can therefore be read off from the text more or less unproblematically. . . . Hirsch's general theory of *human* meaning virtually requires a divine author.'[109] Poythress takes Hirsch's silence on the effects and limitations of authorial agency to be an expression of worshipful awe in the face of the author. If Hirsch would object to this interpretation, Poythress might respond that he is only attempting to draw an inference about what must fill the material void in Hirsch's account of what an author actually is and does. A powerful but purely formal principle of authorship, which is what Hirsch's pragmatism turns out to offer, lacking a substantive account of what authorship actually is, simply invites such interpretations as that of Poythress to fill the gap. Hirsch ends up with a curiously vague concept of what a text is, for the author, the one on whose terms textual meaning is to be defined, turns out to be a purely formal, content-less principle.

Jacques Derrida: Deconstructing Authors

Deconstruction and authors

Post-structuralism in general has been particularly hard on the concept of the author. The stakes here are high, being not just hermeneutical but also theological, as the post-structuralist theorist and critic Roland Barthes recognizes: 'to refuse to fix meaning is, in the end, to refuse God and his hypostases— reason, science, law'—which is precisely what Barthes wants to do. Barthes's other reason for rejecting an authoritative role for the author in the process of determining meaning is to facilitate the liberation of the reader: 'the birth of the reader must be at

[108] Wolterstorff's description of how the normative ascription of normative standing may be undercut in various speech situations, outlined in the previous chapter, represents a reflection on the limitations of human agency.

[109] Vern Sheridan Poythress, 'God's Lordship in Interpretation', *Westminster Theological Journal* 50 (1988), 27–64, at 40–1.

the cost of the death of the Author'.[110] The reader, so long sub-jugated under the tyranny of the author, must now be freed at the cost of the death of his persecutor. Michel Foucault, who makes a similar move to Barthes regarding the author, argues that there is nothing natural about the concept, but rather that it is a fairly recent innovation in Western thought: 'The coming into being of the notion of "author" constitutes the privileged moment of *individualization* in the history of ideas, knowledge, literature, philosophy, and the sciences.'[111] Barthes agrees: 'The author is a modern figure, a product of our society insofar as, emerging from the Middle Ages with English empiricism, French rationalism and the personal faith of the Reformation, it discovered the prestige of the individual, of, as it is more nobly put, the "human person".'[112] A discussion of the extent to which the Reformation can legitimately be implicated in the phenomenon of individualization lies beyond our present scope. However, it is important to see exactly what Barthes and Foucault mean by 'author' here, and to ask whether or not the hermeneutical underpinnings of the orthodox Protestant doc-trine of Scripture imply a similar understanding of authorship. With Barthes, at least, it is clear that his target is a Romantic conception of the author. He laments that, in much literary-critical work, '[t]he *explanation* of a work is always sought in the man or woman who produced it, as if it were always in the end, through the more or less transparent allegory of fiction, the voice of a single person, the *author* confiding in us'.[113]

The legitimacy of reinterpreting the orthodox doctrine of Scripture in light of contemporary hermeneutical theory has been argued for previously (see Chapter 1); a further point in this regard may be made here. The Westminster Confession of Faith, the fullest confessional example of the orthodox Protest-ant doctrine of Scripture, does not prescribe a methodology for the interpretation of Scripture. Nevertheless, some tentative

[110] Roland Barthes, 'The Death of the Author', in Barthes, *Image Music Text*, trans. Stephen Heath (London: Fontana, 1977), 142–8, at 147–8.
[111] Michel Foucault, 'What Is an Author?', in Josué V. Harari (ed.), *Textual Strategies: Perspectives in Post-Structuralist Criticism* (Ithaca, NY: Cornell University Press, 1979), 141–60, at 141.
[112] Barthes, 'The Death of the Author', 142–3.
[113] Ibid., 143.

conclusions may be drawn which suggest that the Confession's view of Scripture largely escapes Barthes's and Foucault's critique of authorship. First, the Westminster Confession does not suppose that the goal of Bible reading is the gaining of insight into the psychology of the authors, either human or divine. From the divine perspective what it 'pleased the Lord to commit . . . wholly unto writing' was not the divine 'psyche' but his self-revelation and his will. Nor, with the human authors of Scripture, does the Confession suppose that the reader's task is to delve into the writer's psyche. When a text is found to be obscure the difficulty is to be dealt with not by enquiring into the mental processes of the writer, but by interpreting the text in the light of other texts: 'The infallible rule of the interpretation of Scripture is the Scripture itself: and therefore, when there is a question about the true and full sense of any Scripture (which is not manifold, but one), it must be searched and known by other places that speak more clearly' (1.9). In modern terminology, individual biblical texts are to be interpreted intertextually. (This is the topic that will be taken up in the next chapter.) This means that the individual human authors of Scripture do not function as supreme arbiters of meaning—the role that is deconstructed when Barthes and Foucault try to overturn the power of the author.[114]

[114] It is perhaps noteworthy that one of the most important works on literary theory published in England in the seventeenth century appeared in 1641, five years before the Westminster Assembly. *Timber*, a posthumously published collection of Ben Jonson's most important critical observations, represents, according to one history of literary criticism, this clearly non-Romantic viewpoint: for Jonson, '[l]iterary work was not primarily personal expression but objective imitation . . . of nature' (William K. Wimsatt, Jr., and Cleanth Brooks, *Literary Criticism: A Short History*, ii: *Neo Classical Criticism* (London: Routledge & Kegan Paul, 1957), 179). 'Imitation', in the context of neo-classical literary criticism, has no naturalist overtones, meaning merely representation, and 'nature' means reality in general, and especially human reality. A further neo-classical principle was an emphasis on 'the impersonality and objectivity of the poet' (René Wellek, *A History of Modern Criticism*, i: *The Later Eighteenth Century* (London: Jonathan Cape, 1955), 14, 1). Of course, literary-critical conventions were not at the forefront of the minds of the writers of the Westminster Confession. However, it is perhaps possible to argue that the Confession, with its anti-Romantic assumption which still takes account of the personal intention represented by the text, represents, in its cultural context, a set of *sui generis* hermeneutical convictions.

Derrida's reading strategy

Derrida's deconstruction of the author is the most sophisticated example of the post-structuralist undoing of the primacy of authorial intention. Much of his work is in the form of extended, tortuously detailed and complex readings of philosophical and literary texts. Especially in his early works, which undergird the fundamental view of the history of Western philosophy which governs the direction of much of his later work, Derrida's strategy is to identify how a certain recurring term or concept in a text itself works to deconstruct the text. For example, in *Of Grammatology* Derrida traces Rousseau's use of the word 'supplement' in certain of his autobiographical texts, in the service of an argument that the dynamic of *différance*, the endless deferral of metaphysical presence, constantly insinuated itself into Rousseau's personal relationships and into his texts.[115] In the course of this deconstructive reading, Derrida comments on the interpretative process in which he is engaged, and these are among his best-known statements on the methodology of deconstructive interpretation. He wishes initially to observe, he says, the conventional critical demand of 'reproducing, by the effaced and respectful doubling of commentary, the conscious, voluntary, intentional relationship that the writer institutes in his exchanges with the history to which he belongs thanks to the element of language'. He certainly wants to push beyond this standard description of the meaning of Rousseau's texts, but he wants to push beyond it by pushing *through* it, rather than by simply by-passing it. Without this, 'critical production would . . . authorize itself to say almost anything'.[116] Derrida is thus prepared to argue his way out of the straitjacket of Rousseau's authorial intention, starting from within the text, cutting the cords with a knife sharpened on an intricate dialogue with the text. He offers a rigorous demonstration that the text which the author wrote itself reveals aporias which themselves invite deconstructive criticism.[117] In a later interview, Derrida pro-

[115] Jacques Derrida, *Of Grammatology*, trans. Gayatri Chakravorty Spivak (Baltimore and London: Johns Hopkins University Press, 1976), 141–64. This was discussed earlier, in ch. 1.

[116] Ibid., 158.

[117] Christopher Norris notes that deconstruction is often popularly thought to be far less rigorous in its treatment of texts than this: in Derrida's interpre-

tested, against what he thought was misinterpretation of some
of his work, that he is 'one of those who love "arguing"'.[118]

The same interpretative strategy is evident in another of
Derrida's fundamental texts: his reading of Plato's *Phaedrus*.
Again, Derrida comments on his own interpretation of the
themes of writing and speech in Plato's text: 'It will involve a
certain amount of violence to the text, but a violence that comes
not so much from "outside"—from a reading bent upon its
own perverse design—but rather from within the text itself, in
those strains and contortions of sense which characterise its lan-
guage.'[119] Simon Critchley sees this as an aspect of the basically
ethical character of deconstructive textual interpretation, con-
cluding that the act of deconstruction, which brings out the
text's alterities, must work from a basis of a minimum inter-
pretative consensus: 'It is of absolutely crucial importance that
this second moment, that of alterity, be shown to arise neces-
sarily out of the first moment of repetitive commentary.'[120] It
should be noted, however, that the term or concept in the text
which Derrida selects as his point of entry into it, in order to
reveal what he takes to be the deconstructive forces at work
within it, is often a very minor one, and one which is relatively
marginal to the author's intention. Thus, his close readings
sometimes seem perversely close—a wilful losing of the wood
in the trees.[121] There will be more to say below on how this
affects the assessment of deconstruction as an ethical enterprise.

tation of Rousseau's texts, he says, 'it is a question of locating very precisely
the divergence between logic and rhetoric which twists Rousseau's meaning
against his avowed intentions. And this requires a rigour and scrupulous
adherence to the letter of the text which could scarcely be further removed
from that popular idea of what "deconstruction" is all about' (Christopher
Norris, *Derrida* (London: Fontana, 1987), 109).

[118] Jacques Derrida, *Limited Inc*, trans. Samuel Weber and Jeffrey
Mehlman, ed. Gerald Graff (Evanston: Northwestern University Press, 1988),
156–8. The protest is directed against Habermas.

[119] Quoted in Norris, *Derrida*, 35. See e.g. the detail into which Derrida
goes in order to justify the inclusion in his reading of *Phaedrus* of a word which
Plato does not actually use (*pharmakos*), although cognate to one he does use
(*pharmakeus*) (Jacques Derrida, *Dissemination*, trans. Barbara Johnson
(London: Athlone Press, 1981), 129–31).

[120] Simon Critchley, *The Ethics of Deconstruction: Derrida and Levinas*
(Oxford: Blackwell, 1992), 27.

[121] Vanhoozer judges that Derrida is guilty of 'attending overmuch to the

Deconstruction in biblical studies: Stephen Moore

The reception of Derrida in American literary criticism had an especial impact on the course of deconstruction in general. Such literary critics as Harold Bloom, Geoffrey Hartman and J. Hillis Miller developed deconstructive interpretation as a mode of reading which gives great freedom to the imagination of the interpreter to make of the text what he wills. The initial step of hard and close reading from within the text is passed over, and the interpreter freely reads the text in whatever semiotic, literary, or cultural context he chooses. One writer calls this deconstruction 'on the wild side'.[122]

Clear examples of both kinds of deconstruction—'wild-side' and free-playing, and rigorously working from within the text— can be found in recent biblical scholarship. Stephen Moore is one of the leading exponents of deconstruction in biblical studies, and he aims to narrow the gap between biblical criticism and general literary criticism. His early forays into deconstructive interpretation largely follow Derrida's early model. In an interpretation, informed also by the work of the psychoanalytic philosopher Jacques Lacan, of Jesus in the Fourth Gospel as subject to desire, Moore argues that the text attempts to establish a fundamental separation of flesh and glory, material and spiritual realms, which however falls apart at the climax of the narrative.[123] Early on in the narrative, Jesus tries to show the Samaritan woman at the well that he has a spiritual 'water' to give, the power of which far exceeds anything that physical water can do (John 4: 4–26). Similarly, Jesus says at one point: 'What is born of the flesh is flesh, and what is born of the Spirit is spirit' (3: 6). However, argues Moore in typical early Derridean style, the crucial term 'water' reappears at the

inconsequential' (Kevin J. Vanhoozer, *Is There a Meaning in This Text? The Bible, the Reader and the Morality of Literary Knowledge* (Leicester: Apollos, 1998), 397).

[122] Christopher Norris, *Deconstruction: Theory and Practice*, rev. edn. (London: Routledge, 1991), 99.

[123] Stephen D. Moore, *Poststructuralism and the New Testament: Derrida and Foucault at the Foot of the Cross* (Minneapolis: Fortress Press, 1994), 43–64. This has also appeared in substantially the same form as Stephen D. Moore, 'Are There Impurities in the Living Water that the Johannine Jesus Dispenses? Deconstruction, Feminism, and the Samaritan Woman', *Biblical Interpretation* 1 (1993), 207–27.

moment of Jesus' death in a way which deconstructs this carefully established opposition. First, Jesus' cry of thirst on the cross shortly before his death (19: 28) appears as a material precondition of the release of his spirit, which will subsequently come into believers in order to establish a new spiritual order.[124] Second, the flow of 'water' (and blood) from Jesus' side, following on from the climactic release of his spirit, introduces into the text a term which is 'neither simply material and literal . . . nor fully spiritual and figurative'. Jesus' earlier words about the exaltation of the spiritual over the physical are therefore nullified by the actual events immediately preceding and following his death.[125] In all this, Moore is, he says, 'as interested in what might be said to be out of the control of this author as in anything that might be said to be within his control'.[126]

What is noteworthy, for present purposes, is that this kind of deconstruction, which works largely from within the text, can be engaged with on the same level by a non-deconstructive reader who claims to have read the same text more closely. One writer, for example, has responded that Moore's reading of the text is not thorough enough. The Fourth Evangelist *is* in control of the themes of matter, spirit, and water in his text, since Jesus' cry of thirst, as a reference to Psalm 69: 21, is to be taken figuratively as an expression of his desire to fulfil his Father's will and to return to him.[127] We might add to this that the mingling of material and spiritual realms in the account of Jesus' death is entirely consistent with the rest of the Gospel: the Evangelist is developing to a climax the claim he makes in his prologue that the Word became flesh, and that divine glory is literally seen in the physical person of Jesus Christ (1: 14). The new exalted spiritual reality into which Jesus tried to draw the Samaritan woman comes to life through a very real and earthly death. In this debate with Moore, the question at issue is whether or not the author is in control of a certain theme in his text, and whether, as a consequence of possible lack of

[124] Moore, *Poststructuralism*, 56–7.

[125] Ibid., 57–9.

[126] Ibid., 75.

[127] L. Th. Witkamp, 'Jesus' Thirst in John 19:28–30: Literal or Figurative?', *Journal of Biblical Literature* 115 (1996), 489–510.

control at that point, the text invites legitimate deconstructive analysis.

Some of Moore's more recent work, by contrast, moves clearly over into 'wild-side' interpretation. He develops, for example, a Foucauldian interpretation of Yahweh in the Old Testament and Jesus in the New as dangerous projections of male narcissism against which Bible-readers may legitimately fight. Focusing especially on the Bible's physical anthropomorphisms of God, Moore interprets the Bible in a surprising intertextual context, reading it together with two very different kinds of texts, which have in common with each other an obsession with (massive male) physical anatomy. These texts come from mystical Jewish and apocryphal Christian writings which contain explicit and fantastical descriptions of the massive dimensions of the bodies of Yahweh and the resurrected Christ,[128] and from the popular literature of the modern cult of body-building, which is deeply concerned with the precise physical measurements of its muscle-bound star performers. Moore acknowledges that, by contrast, in the Old Testament '[e]xtreme circumspection in the representation of the divine body is the norm. . . . References to certain synecdochically charged body parts do abound—Yahweh's face, eyes, mouth, ears, arm, hand and feet are frequently mentioned—but anything approaching a head-to-toe description of the divine physique would be unimaginable.'[129] Moore therefore supplements the Bible with a set of bizarre intertexts, forcing the Bible's descriptions of God into a cultural and literary context in which, he freely admits, they do not naturally belong. This context provides the basis on which Moore interprets God as, for example, similar to contemporary male body-builders: the Bible's regular references to people appearing before God's *face* allegedly point to divine unwillingness to show the rest of his (gendered) body, which, Moore speculates, would reveal the shrunken testicles common in male body-builders who have achieved massive physical size through the abuse of steroids. Divine anger, too, is typical of the aggressive behavioural

[128] God's shoulders are millions of kilometres across, according to the Jewish text on which Moore relies most heavily (Stephen D. Moore, *God's Gym: Divine Male Bodies of the Bible* (New York and London: Routledge, 1996), 87). [129] Ibid., 86.

outbursts induced by excessive use of steroids (' 'roid rage'); in addition, the quantity of animals to be sacrificed to him constitutes the massive diet required by muscle-men.[130] Moore establishes his intertextual context for Bible-reading, and then declares the Bible 'guilty by association' with the narcissism of the other texts which he has chosen.

Moore acknowledges that the intertextual context which produces this interpretation both is anachronistic and does violence to the biblical texts.[131] He brushes aside the fact that the Bible, in its reticence to speculate on the divine physique, resists the Foucauldian interweaving with anatomically obsessed texts to which he subjects it. Moore recognizes that much of what he has said about the Bible has been caricature: 'Caricature is the necessary instrument of this uncovering [of the God of the Bible as a narcissistic male projection], serving to bring the projection into sharper focus.'[132] The justification for this strategy is found in Moore's autobiographical accounts of his own need to escape from an early and profound personal Christian commitment in his native Ireland—an escape which he graphically portrays as the necessary murder of Jesus, the 'controlling twin' to whom he was 'joined at the hip'.[133] Sometimes, as Moore tries with Jesus and God, the best way to kill the power of an enemy is to mock him.

A number of points may be made about Moore's brand of 'freewheeling' deconstructive interpretation. First, his establishing of an outrageous intertextual context for biblical interpretation is an authorial power-play which mirrors the power which he sees and despises in the biblical God. Just as Yahweh governs the nations, so Moore is in control of texts as diverse as the Bible and modern body-building magazines, setting them in relation to each other just as he chooses. He takes for himself

[130] Moore, *God's Gym*, 90–102.

[131] Moore remarks: 'The avoidance of anachronism is not, perhaps, my strongest suit as an exegete. Indeed, I have deliberately employed anachronism throughout this book (taking my cue from the fact that anachronism is what biblical scholars fear most, that fear is the obverse of fascination, and that the fascinating merits pursuit rather than flight)' (Ibid., 123).

[132] Ibid., 139.

[133] Ibid., 70–1. Much of Moore's work is openly autobiographical; see *God's Gym*, p. xi; also 'True Confessions and Weird Obsessions: Autobiographical Interventions in Literary and Biblical Studies', *Semeia* 72 (1995), 19–50.

the right to determine the contexts in which he may legitimately read the Bible. Because he does not do the hard work of showing how the texts allegedly subvert themselves from within—which, as we have seen, Derrida often does through a rigorous analysis of how one particular term or concept is used in a text—all he can do is undermine the Bible from outside. He does this by exalting himself as a master-reader, in competition with what he sees as a hyper-masculine deity. Moore therefore only inverts, without subverting (and thereby truly deconstructing), the structures which he sees at work in the biblical texts. David Rutledge, another writer on deconstruction in biblical studies, writing specifically on the relation between deconstruction and feminist biblical criticism, is more conscious than Moore of the irony of deconstructive practices being caught in the very structures of oppression which they seek to deconstruct. He tries to defuse the point this way: 'In the practice of feminist deconstruction, then, the interpreter claims the power to mean, or signify, while simultaneously relinquishing that power in the knowledge that the desired attribution of centrality or authority to her "egalitarian" discourse will serve only to marginalise somebody else's.'[134] It is not clear, though, how coherent it is to say that this (or any) power can simultaneously be claimed and relinquished.

Second, the target of Derrida's deconstructive work has been the foundations of Western metaphysics. He reaches the point where he claims to understand *his own* inherited philosophical tradition profoundly, and argues that it falls apart on its own terms, within its own discourse.[135] Moore, by contrast, assumes for himself the right to read the results of this deconstructive enterprise into the canonical Hebrew and Christian scriptures, taking no account of the possibility that these texts have philosophical and theological bases different from those of Western philosophical texts. This is a kind of cultural imperialism; David Tracy's general comment on post-modern theory applies well to Moore: 'Without the wider conversations of others . . . the postmoderns—proud and ironic in their centerlessness—will be

[134] David Rutledge, *Reading Marginally: Feminism, Deconstruction and the Bible* (Leiden: Brill, 1996), 101.

[135] Because of his Jewish ancestry and place of birth (north Africa), Derrida arguably stands both inside and outside the Western tradition.

tempted not to heal the breach they expose in Western modernity. Having killed the modern subject, they too must now face their own temptation to drag all reality into the laughing abyss of that centerless, subjectless, but very Western labyrinth.'[136] At one point Moore in fact suggests that the Gospel of Luke, at least, 'subtly or utterly, is other to such [Western metaphysical] categories [as voice and presence]'.[137] If the biblical texts are other to such categories, they are also other to Moore's reading strategies.

Third, Moore closes in on himself, and remains deaf to the possibility that the biblical texts might say something other than what his past experiences have led him to think they are saying.[138] The text *is* other to him, but he has already decided that it is an other to be fought, not listened to. The negotiations are over; war has been declared, and there will be no more talking; this is a fight to the death between reader and God. If a war is ever to be deemed 'just', those who wage it must be very certain that their adversary has first been listened to, comprehended, and judged on the basis of his own words and actions, not someone else's. That is no less the task of textual interpretation than it is of international diplomacy, and it is not the task of a few moments. Those who fight the Bible must show that they have first listened to it—not just to texts to which it bears some resemblance or to particular interpretations of it.

Derrida and the ethics of reading

Although the above analysis of Stephen Moore's work is intended to distinguish his approach from that of (the early) Derrida, there are occasions on which Derrida treats the author of a text he is interpreting more roughly than he does Rousseau and Plato in the texts discussed above. The most notorious example of this is his response to John Searle's essay, 'Reiterat-

[136] David Tracy, *On Naming the Present: God, Hermeneutics, and Church* (London: SCM Press, 1994), 21.

[137] Stephen D. Moore, *Mark and Luke in Poststructuralist Perspectives: Jesus Begins To Write* (New Haven and London: Yale University Press, 1992), 101–2.

[138] Norris's comment on some of the textual interpretations of the ('wild-side') deconstructive critic Geoffrey Hartman could also be applied to much of Moore's work on the Bible: 'they remain fixed at a level of self-occupied rhetorical juggling' (Norris, *Deconstruction*, 99).

ing the Differences', which was itself responding to Derrida's criticisms of J. L. Austin's philosophy of language. This Searle–Derrida exchange is interesting here because the personal friction which developed between the two writers reveals something of how each regards his personal relationship to his texts. Derrida's theoretical position on authorship needs to be studied in the light of his personal engagements with living writers who are responding to his work, and to him as an author.

In Derrida's long response to Searle, entitled 'Limited Inc a b c . . .', he deploys what has been called 'an aggressive depersonalization of the author'.[139] Within his own essay Derrida quotes the whole of Searle's essay—a device which subsumes Searle's text within his own, wresting control of that text from its author, turning it from personal communicative act to textual object. He also puns on Searle's name, calling him 'sarl', which is the French acronym for a public limited company: *société à responsabilité limitée*. These two devices are intended to be a practical undermining of the basic assumption on which Searle's speech act theory rests: that personal communicative acts are performed by unified persons who can control what those acts mean. Derrida turns Searle's text into an object he can play with, and dissolves Searle's personal identity as its author.

It is, however, difficult to be consistent in one's insistence that the author's personal identity has been dissolved, and that he is therefore practically dead. How, for example, does a living author like Derrida insist that he is really dead as an author without contradicting himself? It is not easy for a human being to say the words 'I'm dead' truthfully. Commenting on another of Derrida's exchanges with a living writer, this time with Hans-Georg Gadamer, Reed Way Dasenbrock points out that to insist that all texts, including one's own text, are not closed is to be an author who closes off the possibility that one's text is closed: 'The author may be dead, but nonetheless he is around to disagree with you if you insist that he is alive.'[140]

More recently, some of Derrida's work has been marked by concern for the themes of faith and responsibility. On occasion, he makes comments which seem to move in theory beyond his

[139] Reed Way Dasenbrock, 'Taking It Personally: Reading Derrida's Responses', *College English* 56 (1994), 261–79, at 266. [140] Ibid., 269–70.

practical treatment of Searle's text, and which in fact accord sur-
prisingly well with Wolterstorff's ethical reflections on speech
act theory. For example, reflecting on 'a principle of responsi-
bility', he concludes, 'no responsibility without a *given word*,
a sworn faith, without a pledge, without an oath'; writing of
'all address of the other', he says that '[i]t amounts to saying:
Believe what I say as one believes a miracle. Even the slightest
testimony concerning the most plausible, ordinary or everyday
thing cannot do otherwise: it must still appeal to faith as would
a miracle.'[141] In his analysis of the biblical story of the sacrifice
of Isaac, Derrida argues that the sacrifice of ethics which
Abraham makes is a sacrifice which is in fact made constantly
in human existence: 'I cannot respond to the call, the request,
the obligation, or even the love of another without sacrificing
the other other, the other others.'[142] In texts such as these
Derrida makes plain that deconstruction may legitimately lay
claim to a clearly ethical level of description.

There remains, though, the question of whether authors may
be included in this general ethical responsibility of deconstruc-
tion towards the other. What this recent ethical and religious
emphasis in Derrida's writing suggests is that Derrida thinks
of textual interpretation as bearing the responsibility to remain
continually open to the possibility of the 'other' breaking
through in the language of the text. However, the 'other' can
refer to many things, and in Derrida it seems to be a universal
and impersonal 'Other', rather than the other human being who
authored the text in front of us. It was noted above that he often
focuses in perverse detail on minute aspects of the text; this
microscopic reading aims to hold the reader open to the distant
and boundless Other. Focusing on the tiny detail in order to
search directly for the totally Other, Derrida misses the more
limited but more present other: the voice of the author. Moving
quickly from the tangential and apparently trivial in a text to
the general and universal, Derrida passes over that which is

[141] Jacques Derrida, 'Faith and Knowledge: The Two Sources of "Religion"
at the Limits of Reason Alone', trans. Samuel Weber, in Jacques Derrida and
Gianni Vattimo (eds.), *Religion* (Cambridge: Polity Press, 1998), 1–78, at 26,
63–4 (italics original).
[142] Jacques Derrida, *The Gift of Death*, trans. David Wills (Chicago and
London: University of Chicago Press, 1995), 68.

neither trivial nor all-encompassing: the individual human author. John Caputo says that '[w]e will read [Derrida] less and less well unless we hear the yes that punctuates and accents the text . . . we are responding, yes, language is happening, *il y a la langue*, the impossible is happening, yes, the *tout autre* is breaking out'.[143] Derek Attridge judges that Derrida's readings try to show that we may search for the 'other' and the 'other of language'.[144] Derrida treats a text as an instance of language itself, ignoring the individual act which made the text what it is. If his project is ethical, it is grandly ethical, in its desire to listen for the distant 'Other', the *completely* other. But in its grandeur it overlooks the immediate 'other', the author, who presents himself to us in his text. In textual interpretation what Derrida loves is the (distant and general) Other; it's just (immediate human) others he's not sure about.

Our criticisms of Moore's 'wild-side' deconstruction were mainly ethical in nature; our response to the more overtly ethical nature of Derrida's more recent work is that the flaws in his treatment of authorship in general and actual authors in practice are still basically ethical ones. This suggests that Hirsch's decision, discussed above, to avoid ethical arguments in his advocacy of the primacy of the author in the determination of meaning leaves his support for authors much weaker than at first appears. Hirsch wants literary scholarship to appear respectable before the bar of some supposed objective standard, and thinks that only authorial intention can provide this minimum consensus on the object of literary study. When confronted, however, with writers such as Derrida and Moore who are not interested in matching up to received academic notions of 'objectivity', Hirsch's single restraining principle in textual interpretation has much less purchase. 'Communicative action calls not only for hermeneutic rationality but also for communicative ethics'; Vanhoozer's comment explains the gap in Hirsch's defence of the author.[145] The final section of this

[143] John D. Caputo, *The Prayers and Tears of Jacques Derrida: Religion Without Religion* (Bloomington and Indianapolis: Indiana University Press, 1997), p. xxiii.

[144] Derek Attridge, 'Introduction: Derrida and the Questioning of Literature', in Jacques Derrida, *Acts of Literature*, ed. Derek Attridge (New York and London: Routledge, 1992), 1–29, at 20.

[145] Vanhoozer, *Is There a Meaning?*, 350.

chapter, following the discussion of texts and readers, will develop the ethical defence of authorship outlined in Chapter 3 in reconstructing an understanding of the Bible as 'sufficient'.

TEXTS AND READERS

Before coming to the final section, it is necessary to examine the other side of the 'relationality' of texts—the relationship between texts and readers. First, the work of two writers will briefly be studied: the literary critic Stanley Fish and the theologian Stanley Hauerwas, who both supplement texts with readers in order to account for textual meaning. In other words, using the terminology of speech act theory, they elide the author's illocutionary act into the perlocutionary effect of his textual speech act. Then follows a discussion of Stephen Fowl's account of how the Bible is read in Christian communities. Finally, Hans-Georg Gadamer's hermeneutical project will be outlined, as it touches on textual meaning; it will be argued that, although not apparently as subjectivist as the accounts of textual meaning offered by Fish and Hauerwas, his philosophical description of hermeneutics can be located together with their work.

Stanley Fish: Sufficient Readers

The essays which form Fish's collection, *Is There a Text In This Class? The Authority of Interpretative Communities*, document his move from a position which owed a great deal to New Criticism through what he calls the crucial anti-formalist step of giving up the notion that the text's formal patterns exist independently of the reader's experience.[146] His primary observation, and the catalyst for this step, is that textual meaning is necessarily constructed in a temporal process by the activity of readers: 'I challenged the self-sufficiency of the text by pointing out that its (apparently) spatial form belied the temporal dimension in which its meanings were actualized.'[147] 'Meaning', Fish concludes, can therefore be said to reside only in

[146] Stanley Fish, *Is There a Text in This Class? The Authority of Interpretive Communities* (Cambridge, Mass.: Harvard University Press, 1980), 7, 12.
[147] Ibid., 2.

the experiences of the reader. Fish attempts to demonstrate the truth of this claim with a description of the reader's experience in reading a certain line from Milton's *Lycidas*: 'He must not float upon his wat'ry bier | Unwept. . . .' He observes that at the end of the first line the reader is anticipating a call to action—to prevent the death of a certain character—an anticipation which the first word of the next line, 'Unwept', takes away. His analysis is that, on encountering this word, the reader must 'unresolve' the speaker's intention he had inferred at the end of the previous line, and resolve a new one, at the same time as he picks out the formal pattern of ends and beginnings of lines. 'This, then, is my thesis: that the form of the reader's experience, formal units, and the structure of intention are one, that they come into view simultaneously, and that therefore the questions of priority and independence do not arise.'[148]

The critic Gerald Graff points out that Fish makes an unwarranted logical leap. It does not follow from the temporal nature of the reading process, as Fish wishes to conclude, 'that literary meanings are not propositional, much less not referential To hold that the temporality of the reading process cancels the propositional force of a discourse is in its own way as much of a reduction as to hold that this process can always be neatly encompassed by a proposition.'[149] Fish confuses epistemology with ontology, reducing the latter into the former. However, the fact that our access to linguistic meaning, and to the formal literary structures which mediate that meaning, is never instantaneous, but requires an encounter with words in a temporal sequence, does not mean that a sentence or text considered as a whole—a whole glimpsed by reflection on the temporal sequence—does not contain reader-independent structures and meanings.

It might seem, indeed, that the example from *Lycidas* counts against Fish's argument, for, as he is aware, it could be construed as an example of a text containing 'a formal encoding, not perhaps of meanings, but of the directions for making them, for executing interpretive strategies'. Fish rejects this, arguing that 'they will only *be* directions to those who already have the

[148] Ibid., 164–5.

[149] Gerald Graff, 'How Not to Talk about Fictions', in Graff, *Literature Against Itself*, 151–80, at 167.

interpretive strategies in the first place. Rather than producing interpretive acts, they are the product of one.'[150] Again, a false conclusion is drawn from a correct observation. Fish acknowledges that we never encounter anything in a text immediately; we can never by-pass our acts of interpretation. Textual features which we take to be directions of how to interpret the text only become such directions for us once we have interpreted them to be such. This is unobjectionable to all except the most naive realist. Yet it does not follow from this that that which we perceive only by means of interpretation is only ever a product of our interpretation. Fish does not demonstrate what his position must require him to demonstrate: that that which can only be known through structures of interpretation cannot be said to be reality external to the knower. In short, Fish offers only two options: positivism and solipsism. Seeing the obvious weaknesses of the former, he pitches towards the latter.

Fish again anticipates the objection, and rejects the accusation of solipsism and relativism, invoking the concept of 'interpretive communities' as a barrier against these dangers: 'if, rather than acting on their own, interpreters act as extensions of an institutional community, solipsism and relativism are removed as fears because they are not possible modes of being'.[151] He anticipates a further objection here: how do I know that I am a member of the same interpretative community as another person? How do I know that what I perceive to be an 'interpretive community' of which I am a part is itself not simply the creation of my own interpretative structures? Fish acknowledges that we can know, although never with certainty: 'The only "proof" of membership is fellowship, the nod of recognition from someone in the same community, someone who says to you what neither of us could ever prove to a third party: "we know."'[152] This seems to provide a rather 'gnostic' basis to the concept of an interpretative community; as such it is inconsistent with the rest of Fish's work, since, as one writer has observed, '[r]esorting in this way to mystical "nods of recognition" and empathetic acknowledgements is, of course, totally illegitimate, since it violates Fish's own fundamental principle

[150] Fish, *Is There a Text?*, 173.
[151] Ibid., 321.
[152] Ibid., 173.

that there is *nothing* that we perceive or apprehend as an un-interpreted "given." [153]

Fish's concept of 'the authority of interpretive communities' is given practical expression in biblical studies in the introduction to the first volume of David Clines's commentary on the book of Job. In the introduction to this commentary Clines offers outlines of possible feminist, vegetarian, materialist, and Christian readings of Job. He justifies this with the following:

the combination of the reader's own interests, values, and commitments is what makes him or her a person with identity and integrity; *in no activity of life, and certainly not in reading the Bible, can one hide or abandon one's values without doing violence to one's own integrity.* If one is, for example, a feminist pacifist vegetarian—which are quite serious things to be, even if they are modish—it will be important to oneself to ask what the text has to say, or fails to say, about these issues. [154]

Clines says that as readers we cannot hide or abandon our values without compromising our integrity; it seems hard to disagree. However, the reasonableness of this statement masks Clines's failure to note that *hiding* and *abandoning* one's values are very different kinds of readerly activity. A reader who hides her values is indeed attempting the impossible task of coming to the text as someone other than herself, or as a kind of empty 'non-person'. However, to abandon one's values, or to find them modified in the process of reading the text, may not at all be to lose one's identity and integrity. A reader who abandons her values might have been brought to that point by a text which has addressed her, has illuminated her previously held values in unexpected ways and shown her that they were perhaps trivial, or simply wrong. Such an abandonment would not represent an act of 'violence' to one's integrity; it would, if

[153] Paul R. Noble, *The Canonical Approach: A Critical Reconstruction of the Hermeneutics of Brevard S. Childs* (Leiden: Brill, 1995), 211–12.

[154] David J. A. Clines, *Job 1–20*, Word Biblical Commentary 17 (Dallas: Word, 1989), p. xlvii (italics added). Jeffrey Stout puts this point in a quite radical manner: 'Meanings, if they exist, could turn out to be the *least* interesting thing about texts. What matters is that a reading tells us something interesting about the text under scrutiny' (Jeffrey Stout, 'What is the Meaning of a Text?', *New Literary History* 14 (1982), 1–12, at 7). By this, he means, 'something *we* find interesting'.

followed by the adoption of more truthful values, represent a move towards integrity. In order to be addressed by a text in such a way, a reader must indeed not hide her values, for the reason that it is hard to change that which one keeps hidden away. Within Clines's implicit neo-pragmatic model, however, which borrows heavily from Fish, it is far from clear how a text could ever induce a reader to abandon her values, for in her reading she seems doomed simply to inscribe her value-systems onto the texts which she reads. Frank Lentricchia assesses Fish's hermeneutics quite sharply on this point: '[Fish] posits an intersubjective idealism which amounts to a solipsism that wipes out the past as it promises the oldest of Western maxims—know thyself—in its most emasculated form, directing us to know ourselves in the absence of dialogue.'[155]

If Fish's claims about textual meaning are cast in terms of the conceptualities provided by speech act theory, his basic claims can be understood with particular clarity. We have noted above Fish's claim that texts cannot be said to contain directions which guide the interpretative activity of readers, since these directions, '[r]ather than producing interpretive acts . . . are the products of one'.[156] Since the textual directions for guiding interpretation are an aspect of the illocutionary act as it is performed in and through the text, and since the recognition by the interpreter of these directions is part of the coming about of what Austin called the 'uptake' (understanding) of the illocutionary act, then Fish's point becomes equivalent to a claim that only if 'uptake' is successfully brought about can the illocutionary act be said to exist. That is, an utterance only counts as the performance of a particular illocutionary act if someone recognizes it as such. This problematic claim has already been discussed with regard to J. L. Austin in Chapter 3. It is a quite counter-intuitive claim: speakers and writers do not regard the very existence of their illocutionary acts as dependent on others coming to understand their meaning and force—their effectiveness, yes; but not their existence. Fish therefore offers a hermeneutics of the semantic self-sufficiency of the reader: the author's locutions (merely inscribed words) are necessarily supplemented

[155] Lentricchia, *After the New Criticism*, 148.
[156] Fish, *Is There a Text?*, 173.

by the illocutionary activity of the reader, now become a writer. This results, as Lentricchia argued, in a very reduced ('emasculated') account of human being and knowing.

Stanley Hauerwas: The Sufficient Church

Stanley Hauerwas's theological conception of the church's relationship to the Bible bears particular similarities to Fish's basic hermeneutical position. In a book specifically on the Bible, he attempts to justify the assertion that '[t]he Bible is not and should not be accessible to merely anyone, but rather it should only be made available to those who have undergone the hard discipline of existing as part of God's people'.[157] He accuses both liberal biblical critics and fundamentalists of making the same mistake. They 'share the assumption that the text of the Bible should make rational sense (to anyone), apart from the uses that the Church has for Scripture'.[158] They both 'wish to make Christianity available to the person of common sense without moral transformation'.[159]

For Hauerwas, for example, the meaning of Scripture is not the original meaning intended by the author, but the meaning for the church in the use to which it puts Scripture: 'The Church returns time and time again to Scripture not because it is trying to find the Scripture's true meaning, but because Christians believe that God has promised to speak through Scripture so that the Church will remain capable of living faithful [*sic*] by remembering well.'[160] Of course, the Reformers, for example, did not see these as two separate options, but sought the Bible's 'true' meaning precisely because they thought that this was the meaning through which God had promised to speak. Hauerwas, though, concludes that the Reformation concept of *sola Scriptura*, as it has come to be applied in many Protestant churches, 'is a heresy rather than a help in the Church', since it is used 'to underwrite the distinction between text and interpretation'.[161]

Hauerwas explains that his claim is that *sola Scriptura* has *become* a heresy, saying that for the Reformers it represented an

[157] Stanley Hauerwas, *Unleashing the Scriptures: Freeing the Bible from Captivity to America* (Nashville: Abingdon, 1980), 9.
[158] Ibid., 18. [159] Ibid., 36. [160] Ibid. [161] Ibid., 27.

important protest. However, he does not make clear wherein he thinks this importance lay. This is a problem, because a fundamental aspect of this Reformation protest was precisely a determined effort to disentangle text and (church) interpretation. Hauerwas's comparison of contemporary and historical Protestant treatments of the Bible is therefore not sufficiently careful at this point. In fact, while the Reformers share with many modern Protestants, including liberals and fundamentalists, the belief that text and interpretation should ultimately be kept distinct, they worked this distinction out in the context of a great respect for the subordinate authority of creeds, councils, and the history of biblical interpretation. It may indeed be argued, as Hauerwas wishes to argue, that this is a context of which some groups of contemporary Protestants have lost sight. It is this loss which, on the fundamentalist side, has led to a significant schismatic tendency, which is evident in the claims for authority made by small and apparently autonomous groups of Christians for their own unchecked readings of certain biblical texts. Hauerwas rightly fears such tendencies—as, of course, did the Reformers before him. He wrongly and simplistically implies that a clear distinction drawn between text and interpretation leads inevitably either to schismatic tendencies grounded on eccentric interpretations of details of biblical texts, or to rationalistic views of the Bible as equally comprehensible to all.

One can introduce a distinction between text and interpretation for reasons other than those which motivate the practices of fundamentalism and liberalism, as the Reformers and many of their successors constantly demonstrate. By declaring Scripture to be 'sufficient' and 'self-interpreting', orthodox Protestant theology was not generally trying to claim that the Bible will make rational sense to all-comers. Protestant orthodoxy may have moved in this direction in the seventeenth, eighteenth, and nineteenth centuries, but rationalism rarely overwhelmed the Reformation emphasis on the testimony of the Holy Spirit to the truth of Scripture.[162] In a sermon on the events on the Emmaus road narrated in Luke 24: 13–35, Hauerwas states that 'the story of the Emmaus road makes clear that knowing the Scripture does little good unless we know it as part of a people

[162] This point will recur in more detail in the discussion of biblical inspiration in ch. 5.

constituted by the practices of a resurrected Lord. So Scripture will not be self-interpreting or plain in its meaning unless we have been transformed in order to be capable of reading it.'[163] The published sermon from which this quotation is taken is entitled, 'The Insufficiency of Scripture: Why Discipleship is Required'. He makes participation in a practising Christian community the sufficient condition for the understanding of the Bible. Apart from interpretative supplementation by such a community, Scripture remains locution; it is within the 'per-locutionary' community (the community in which the text has its theological effect) that locution becomes illocution.

However, the orthodox Protestant doctrine of the sufficiency of Scripture does not exclude the necessity of the reader being transformed by the Holy Spirit in order that his reading of Scripture not lead to a misreading. The orthodox Protestant doctrine of Scripture does not think of Scripture as 'stooping' to speak to us, accommodating itself to our understanding, to such an extent that, as a text apart from contexts of interpretation, it nullifies all the hermeneutical problems created by human failure to be 'up to' its content. This erroneous view would tear Scripture both from the trinitarian context in which the Reformers always tried to locate it (particularly in relation to the work of the Holy Spirit in and through Scripture) and from the ecclesial context which they tried to rework in the aftermath of medieval theology, but which they never regarded as unnecessary. As Vanhoozer comments on this argument of Hauerwas: 'This is unfortunate and unnecessary. We can agree with Hauerwas that spiritual training is a vital part of biblical interpretation, not because it creates the meaning of a text, but because it helps us to discover and to recognize the meaning that is already there.'[164]

Hauerwas in effect falls into the arms of Fish, then, because he thinks that all attempts to declare Scripture sufficient for something, based on an attempt to distinguish text and interpretation, are necessarily implicated in recent liberal Protestant and fundamentalist practice in Europe and North America. His failure to reflect seriously on the differences between some contemporary Protestant practice and the Reformation origins of

[163] Hauerwas, *Unleashing the Scriptures*, 49.
[164] Vanhoozer, *Is There a Meaning?*, 379.

the Protestant tradition might be regarded as an enactment of the tendency inherent in Fish's hermeneutical theory to write contemporary values and views over those of the past.

Stephen Fowl: Engaging with Scripture in the Church

In a recent work, Stephen Fowl argues that Christian interpretation of Scripture must involve a 'complex interaction' in which Christian convictions, practices, and concerns both shape and are shaped by scriptural interpretation.[165] He criticizes what he calls 'determinate interpretation', which aims to uncover a meaning it supposes to be resident in the text, for assuming a 'one-directional movement from determinate meaning to stable doctrine and practice'.[166] This assumption is mistaken in two ways, according to Fowl: it treats meaning as a property of texts, and it locates the bases of faithful Christian belief and practice 'in the text of the Bible interpreted in isolation from Christian doctrines and ecclesial practices'.[167]

The 'model' for the theological interpretation of Scripture, which the subtitle of Fowl's book promises, is a model which rejects theoretical models of meaning—especially any model which locates meaning in authorial intention. He follows an argument advanced by Jeffrey Stout, that we should stop talking about 'meaning', since we can never agree what kind of thing we are talking about when we talk about the 'meaning' of a text, and should start talking instead about our interpretative interests. This Fowl calls 'underdetermined interpretation': there is no theoretical model to determine for us exactly where the meaning lies. Christian faith and life are to shape as well as to be shaped by biblical interpretation, and there is no theoretical model to determine how this mutual relationship will work. Fowl's main recommendation concerns not a theoretical model of interpretation but the character of Christian Bible-readers: they must be self-vigilant and practised in forgiveness and reconciliation. These latter virtues of life and interpretation keep his model from falling into Fish-style hermeneutics, Fowl

[165] Stephen E. Fowl, *Engaging Scripture: A Model for Theological Interpretation* (Oxford: Blackwell, 1998), 8.

[166] Ibid., 34.

[167] Ibid., 40.

argues.[168] The second half of Fowl's work is taken up with a series of subtle exegetical engagements with Scripture on a variety of topics, which are intended to exemplify the shape which he thinks theological interpretation should take. For Fowl, a book on the topic of theological biblical interpretation should just get on and exemplify it, not sit around theorizing about it.

Fowl's explicitly non-theoretical model represents a specific challenge to the proposals offered in the present work. He is happy, he says, to use the language of 'human agency' *informally* with regard to texts, or as a shorthand for established interpretative views, but he denies that talk about human agency can ever be used conceptually to advance an argument in any case of a dispute over biblical interpretation.[169] This argument is put to work in his refusal not to determine in advance the relationship between the reciprocal dynamics by which scriptural interpretation and Christian life and faith shape each other. Wolterstorff's proposals on language, however, show that, once the language of 'human agency' has been allowed into the conversation, the reality of the authorial act leads us into ethical ramifications which require exploration. These prove to be of such a kind that we cannot stop short of some determination of the relationships of author, text, reader, and interpretative traditions— especially a determination that Bible-readers may not legitimately shape biblical interpretation in the same way that biblical interpretation must shape them. Authorial human agency is the kind of thing that cannot be treated 'informally' without ethical offence. Readers do bring much of themselves to biblical interpretation—and Fowl's work shows clearly how the Christian convictions and practices of the reader and his community often shape biblical interpretation—but the goal of interpretation must be to attend ever more clearly to the external communicative act of the text. If this represents, as in a further essay Fowl says of the work of Thiselton and Vanhoozer, the development of J. L. Austin's work (which Fowl takes as 'therapeutic' philosophy which helps to eliminate problems and emphasize practical reasoning in interpretation) into a Searle-style philosophy of language and an implicit metaphysic or

[168] Ibid., 56–61. [169] Ibid., 26.

ontology,[170] it does so only on the basis of a thorough and practical investigation of who and what is involved in what Austin calls 'the total speech situation'. That is, the proposals on the determinate role of authorial agency offered by Vanhoozer and Thiselton do have solid foundations, and these are to be located in Wolterstorff's ethics of actual speech situations rather than in Searle's philosophy of the ideal speech act. Interestingly, the suggestion that speech act theory is best conceived of in ethical terms has also been made by Derrida, in his attack on Searlean speech act theory: 'I am convinced that speech act theory is fundamentally and in its most fecund, most rigorous and most interesting aspects . . . a theory of right or law, of convention, of political ethics or of politics as ethics.'[171]

Fowl asserts, early in his book, that claims about the authority of Scripture are not assertions about a property of the text, but are instead claims about how Scripture authoritatively establishes and governs relationships between itself, its reading communities, and the texts which interpret it.[172] Yet a claim about how Scripture establishes and governs these relationships, if it is to be defensible and comprehensible, must also be a claim about the kind of thing Scripture is, both as a text like other texts and as a text for which some uniqueness is claimed. Fowl's very stimulating and helpful exegetical exercises are naturally full of statements of what the content of the biblical text *does*: what it 'makes clear', what the words and actions it relates 'demand' of us, and what response they 'call' for.[173] This is of course, as Fowl intends, very un-Fish-like interpretation— and if it is to have scriptural and theological, rather than just rhetorical, purchase on the Christian reader, as Fowl wants it to have, then an implicit claim about what the text is and (normatively) does cannot be avoided. Something more is being claimed than, 'This is exegesis done according to the interpretative goals which Christians happen to set for themselves when

[170] Stephen E. Fowl, 'The Role of Authorial Intention in the Theological Interpretation of Scripture', in Joel B. Green and Max Turner (eds.), *Between Two Horizons: Spanning New Testament Studies and Systematic Theology* (Grand Rapids and Cambridge: Eerdmans, 2000), 71–87, at 76 n. 10.

[171] Derrida, *Limited Inc.*, 97.

[172] Fowl, *Engaging Scripture*, 3, 6.

[173] See e.g. ibid., 75 ff.

they read the Bible.' Clarifications about the properties and meaning of the text of Scripture do not guarantee faithful Christian living and believing, but they are necessary in establishing the context in which Christian living and believing in general, and in particular the practice of Christian scriptural interpretation, can legitimately claim to be faithful.

Hans-Georg Gadamer: Understanding in Tradition

To include the philosopher Hans-Georg Gadamer alongside Fish and Hauerwas in a section on the supplementation of texts with readers is controversial, for Gadamer's philosophical hermeneutics, as expressed in his *magnum opus*, *Truth and Method*, is variously interpreted. Thiselton argues that Gadamer, in transcending the Enlightenment rejection of tradition and authority merely qua tradition and authority, succeeds in offering an account of understanding as not leading to 'the kind of fusion in which critical distance and tension is entirely swallowed up'.[174] Georgia Warnke similarly distances Gadamer from Fish (as well as from Hirsch), detecting in his hermeneutics 'a peculiar oscillation' between a view of the text as presenting an external challenge to its readers, and a view of it as doing so in a way which is entirely contingent upon the readers' understanding of its truth.[175] Vanhoozer, by contrast, regards Gadamer as 'abandon[ing] realism in favor of pragmatism', arguing that he blurs a text into its history of interpretation.[176]

As is widely observed, the title *Truth and Method* is ironic, for Gadamer is not interested in prescribing an interpretative methodology; his aim is rather to describe philosophically how understanding is possible, without falling into what he sees as the mistakes of Romantic hermeneutics. Where Schleiermacher had advocated that interpreters should strive to understand the author better than he understood himself, Gadamer asserts: 'it is true in every case that a person who understands, understands

[174] Anthony C. Thiselton, *The Two Horizons: New Testament Hermeneutics and Philosophical Description with Special Reference to Heidegger, Bultmann, Gadamer and Wittgenstein* (Exeter: Paternoster, 1980), 305–8.
[175] Georgia Warnke, *Gadamer: Hermeneutics, Tradition and Reason* (Stanford: Stanford University Press, 1987), 48, 98–9.
[176] Vanhoozer, *Is There a Meaning?*, 409.

himself, projecting himself upon his possibilities. Traditional hermeneutics has inappropriately narrowed the horizon to which understanding belongs.'[177] For Gadamer, the subjectivity which a reader brings to a text, formed in large part out of the reader's location in a tradition—what he calls the reader's 'prejudices and fore-meanings'—does not hinder understanding, but is a necessary condition of it.[178]

What Warnke calls the 'peculiar oscillation' between subjective and objective views of textual meaning Gadamer himself calls a 'tension' or 'play', and it is here that he locates the question which he thinks underlies the whole of hermeneutics: 'there is a tension. It is in the play between the traditionary text's strangeness and familiarity to us, between being a historically intended, distanciated object and belonging to a tradition. The true locus of hermeneutics is this in-between.'[179] Gadamer speaks of the '*real* meaning of a text, *as it speaks to the interpreter*', and of the co-determination of meaning 'by the historical situation of the interpreter and hence by the totality of the objective course of history'.[180] The apparent objectivity of meaning referred to here is a function of only one interpreter's apprehension of the text; Gadamer continues, in direct contradiction of Schleiermacher: 'Understanding is not, in fact, understanding better . . . in the sense of superior knowledge of the subject. . . . It is enough to say that we understand in a *different* way, *if we understand at all*.'[181] 'Real meaning' for Gadamer must therefore mean 'real meanings'.

The same dynamic is at work in Gadamer's famous notion of the 'fusion of horizons', that is, the horizons of the text and the reader. This concept is intended to give expression to the fact that '[p]art of real understanding . . . is that we regain the concepts of a historical past in such a way that they also include our own comprehension of them'.[182] Gadamer insists that the horizons which are fused do not in fact have prior existence

[177] Hans-Georg Gadamer, *Truth and Method*, 2nd rev. edn., trans. rev. Joel Weinsheimer and Donald G. Marshall (New York: Crossroad, 1990), 260–1.
[178] Ibid., 295–6.
[179] Ibid., 295 (original italics removed).
[180] Ibid., 296 (italics added). He also refers to 'the *true* meaning of a text', (298 (italic added)).
[181] Ibid., 296–7.
[182] Ibid., 374.

independently of one another: 'There is no more an isolated horizon of the present in itself than there are historical horizons which have to be acquired. Rather, understanding is always the fusion of these horizons supposedly existing by themselves.' That is, the horizons we are to conceive of as being 'fused' together in the process of understanding are always/already 'confused'. Gadamer himself raises the question which this claim naturally provokes: why then speak of a *fusion* of horizons, and not of the formation of a single horizon? His answer restates what, we have seen, is for him the centre of hermeneutical thought: 'Every encounter with tradition that takes place within historical consciousness involves the experience of a tension between the text and the present', and hermeneutics may not cover over this tension.[183]

One of the things at stake for Gadamer in the insistence that this tension not be overlooked, as he thinks Romantic hermeneutics overlooked it, is best seen in his construal of the act of reading a historical text as the posing of *contemporary* questions to a text which itself is the answer given by an ancient author to *ancient* questions. It is here that Gadamer's account of textual meaning sounds particularly neo-pragmatic. He argues:

understanding is always more than merely re-creating someone else's meaning. Questioning opens up possibilities of meaning, and thus what is meaningful passes into one's own thinking on the subject. Only in an inauthentic sense can we talk about understanding questions that one does not pose oneself—e.g., questions that are outdated or empty . . . [for example, perpetual motion]. . . . To understand a question means to ask it. To understand meaning is to understand it as the answer to a question.[184]

First, Gadamer is of course right to say that outdated and empty questions do exist—such as the scientific one which he gives as an example. However, by no means all historical texts are answers to such questions. Literary and religious texts, for example, give answers to questions about the human condition which often have trans-historical validity; this is why contemporary readers are regularly gripped by the content of old texts.

[183] Ibid., 306.
[184] Ibid., 375.

Second, by arguing that it is inauthentic to talk about 'under-standing' questions that one has not asked oneself, Gadamer in the above statement is strikingly similar to David Clines's assertion, discussed above as an example of neo-pragmatic hermeneutics in biblical studies, that 'in no activity of life, and certainly not in reading the Bible, can one hide or abandon one's values without doing violence to one's own integrity'.[185] Unlike Clines, Gadamer does want to preserve the text in its integral relation to the reader as an address from outside. He also sees this as a move beyond Romantic hermeneutics: 'a text is not understood as a mere expression of life but is taken seri-ously in its claim to truth'.[186] He assumes, however, that this relation will be 'inauthentic' as an event of understanding *for me* if the content of the text is not transformed into an answer to questions which *I* am asking, which are the only 'real' ques-tions: 'reconstructing the question to which the meaning of a text is understood as an answer merges with our own question-ing. For the text must be understood as an answer to a real question.'[187] This merging of questions, the reader's and the text's, may well involve the reader writing his own illocution-ary force onto the text's propositional content.[188]

This means that, as with Clines, it is unclear in Gadamer's account how a reader may ever be addressed by a text in such a

[185] Clines, *Job 1–20*, p. xlvii.

[186] Gadamer, *Truth and Method*, 297.

[187] Ibid., 374.

[188] The concept of an illocutionary act is a helpful tool for analysing the description of Gadamer's hermeneutics which Warnke offers in order to demonstrate that it is not reducible to the hermeneutics of either Fish or Hirsch. She summarizes: 'when a text is understood its meaning cannot be attributed to either writer or reader. The meaning of the text is a shared lan-guage, shared in the sense that it is no one person's possession but is rather a common view of a subject-matter' (Warnke, *Gadamer*, 48). The crux here is the definition of the 'subject-matter' of a text, with regard to which author and reader are to take a 'common view'. If 'subject-matter' refers only to the text's propositional content, then the reader provides the text's illocutionary force, and the meaning is to be attributed predominantly to *his/her* action—which, *contra* Warnke, comes very close to Fish's hermeneutics. There would then be no significant 'common view' shared by author and reader. If 'subject-matter' refers both to the propositional content and to the illocutionary force of the text, then the text's meaning is to be attributed solely to the author's action—which, also *contra* Warnke, is very like Hirsch's hermeneutics. The reader then agrees to hold a 'common view' of the text's meaning with its author.

way that he is given a new, more adequate question to ask.[189] It is true that to 'understand' in the fullest sense—for example, in the sense of existential encounter which Barth would always insist on when 'understanding' the Bible is at issue—requires that the question to which the text is an answer become also my question. That process, though, often involves something more than the 'merging' of questions. Readers faced with a text, discovering or inferring the question to which the text is an answer, often find that question forced on them as a question they must now ask for themselves because it bears a significance greater than any question they were previously asking. This is a quite authentic sense, perhaps the *most* authentic sense, in which to talk about understanding.

TOWARDS A CONCEPTION OF SCRIPTURE AS THE SUFFICIENT SPEECH ACT OF GOD

The Supplements of the Text

The initial conclusion to be drawn from the preceding analyses of various literary critics, hermeneutical theorists, and theologians is that a careful articulation of the sufficiency of Scripture requires descriptions of the relationships between authors and textual meaning, and readers and textual meaning. In other words, we need to describe how the Bible is to be conceived of as necessarily 'supplemented' by its authors and readers. Moreover, this description should be cast to a significant degree in ethical terms. This would propose Scripture as in some relational sense a sufficient rather than a *self*-sufficient entity.

As has been seen, Hans Frei and the New Critics have, in their different ways, tried to establish the objectivity of texts, in

[189] If this interpretation of Gadamer is right, it is still not his *intention* to end up in a pragmatic hermeneutical position. More recently he has written: 'It is the Other who breaks into my ego-centredness and gives me something to understand. This motif . . . has guided me from the beginning' (quoted in Roger Lundin, Clarence Walhout and Anthony C. Thiselton, *The Promise of Hermeneutics* (Grand Rapids and Cambridge: Eerdmans, 1999), 133–4). For an account of the self in community which clearly allows, in explicit contrast to Gadamer, for new understanding coming about through external intervention into the interpreter's tradition, see Calvin O. Schrag, *The Self after Postmodernity* (New Haven and London: Yale University Press, 1997), 76–109, esp. 99–100.

the desire to fend off the reduction of literary meaning to whatever the reader wishes to construct, but without taking authorial agency into account. This results in a description of texts as objects, either some quasi-religious object or some object of scientific study, which have no necessary ontological relations to any person. The objectivity of a text is mistakenly equated with the self-sufficiency of a text, and insurmountable problems arise over how texts can be linked back up to reality, and therefore over the status of textually mediated knowledge.

There is a striking similarity between deconstruction and the formalism of Hans Frei and the New Critics, in that both take an all-or-nothing approach to language. Formalism offers a description of the 'all' of language which, ironically, collapses into something very like 'nothing' as the text loses contact with reality; deconstruction delights in ingeniously developing this ironic identity of 'all' and 'nothing', pushing the text further into unreality. Both the objectification of a text in order to protect it, as the 'really real', from the ravages of history and readers, and the subsuming of all supposed 'textual reality' into the endless play of boundless semiotic systems, give us an 'unreal' account of the text.

Fish and Hauerwas see clearly the problem of formalism, and are keen to avoid it. They therefore establish a firm link between text and reality by putting the activity of real readers at the centre of their hermeneutical thought. However, since their hermeneutics lacks an ontology of the text which would protect its otherness in the text–reader relationship, the text disappears into the activity of the reader. Thus those who try hardest to recover the importance of readers end up leaving them with no relation to a distinct other—which is not a respectful service to render to a human being. Something similar happens in Gadamer's hermeneutics, although not programmatically, as in Fish's work, as he links texts with readers through an account of the understanding of texts as the answering of questions which readers are already asking.

Wolterstorff's conception of speech, which, as we saw in Chapter 3, develops speech act theory in an ethical direction, is helpful here. It shows how authors, their texts and meanings, and readers, exist meaningfully only in that they are related to one another, without the otherness of any one element being

subsumed into another. Texts, conceived of as speech acts, are never in danger of drifting away from reality because it is never possible to talk or conceive of them apart from talking or conceiving of intersubjective relationships in the world. These are the relationships which, in the first place, collectively determine that a certain locutionary act counts as a certain illocutionary (intersubjective) act.

Especially helpful in this question of the determinacy of the relationships in which a text is to be located is Wolterstorff's principle that, other things being equal, our dignity as persons requires that we be taken at our word. This principle bears directly on the question of the role of human authors in the process of textual interpretation, for it determines how the relationships between author, text, and reader should be conducted. To take the author at his word requires from readers an initial acknowledgement that the author has the right to determine the meaning, that is, the propositional content and illocutionary force, of his speech act.[190] This right, however, does not describe the entirety of the author's action and status in authoring a text; indeed, it is just the beginning. It is a right which necessarily entails responsibilities, for the illocutionary force of one's speech act establishes a new ethical relationship between oneself and one's readers, and this determines the particular moral responsibilities which accrue to both parties. These moral rights and responsibilities are determinate, and constitute the determinate relationships between author, text, and reader.

In light of this, it is evident that Derrida's deconstructive reading strategy assumes a false notion of language. A text is simply not analogous to a signifier in a semiotic system, because a sentence or speech act is not analogous to a word. A sentence is more than a string of words; the whole requires a higher level

[190] This is not to return to a Romantic hermeneutic which equates textual meaning with mental intention. It is not the case that an author can force a text to mean what he says he mentally intended it to mean, even when he composed it so carelessly that the intention embodied in it was something quite different. Authorial rights pertain to authorial intentions to the extent that the latter can be shown to be indeed embodied in the grammar and semantics of the text. To stress authorial rights in this way is therefore not to come into conflict with the emphasis laid by speech act theory on contextual factors in the determination of meaning.

of description than does the sum of the parts. Words, under-
stood as items in a semiotic system, do not refer. Groups of
words, however, constructed conventionally, can be made the
means of the performance of certain actions, and thereby also
made to refer, by the performative and referring intention of a
speaker. Texts, like all speech acts, are not mutually supple-
menting signifiers, but personal acts which exist only as the
communicative act of an agent, and therefore their ontology is
only properly accounted for by their relation to agent and
addressee. This is a necessary and determinate conceptual 'sup-
plementation' of the text 'itself'. A speech act is what it is only
in that it is an act performed and addressed by someone to
someone. Therefore, both a general textual ontology and a
doctrine of Scripture developed along the lines of speech act
theory escape the force of Derrida's deconstruction of textual
meaning. A thorough deconstruction of the stability of textual
meaning needs in the end to take the form of a deconstruction
of human personhood; we have seen above that in his recent
work Derrida does not fully and consistently take this step, for
themes of faith and responsibility have become more prominent
in his work, and because in practice he cannot but regard his
own authorial agency as very real.

Hirsch shares in Derrida's overlooking of the hermeneutical
and consequent ethical significance of authorial agency in texts
and textual meaning. This is surprising, because Hirsch wants
to speak up for the author; in doing so, though, he links textual
meaning with authorial agency for pragmatic rather than onto-
logical reasons. Similarly, Fowl acknowledges authorial agency,
but will treat the concept only in an informal way; he will not
use it as the basis of a general description of textual meaning.
However, his practical examples of biblical interpretation beg
the question, which he does not want to address in any theoret-
ical or ontological way, of where meaning in fact lies in the rela-
tionships between author, text, and reader. It is not possible,
though, to do justice to human agency in authoring a text if
ontology is excluded. If human agency really *is*, it cannot be
either a formal principle or a trivial fact to which appeal might
be made for a time to serve some other end. It must instead be
a reality from which important anthropological and consequent
moral claims follow, which in turn determine how readers are

to go about engaging with authors and their texts. The assertion of the determinacy of textual meaning is therefore to be regarded as the assertion of the determinacy of the relationships of author, text, and reader. This basic conclusion can now be further developed in the specific case of Scripture as the speech act of God.

Sufficient Scripture and the Holy Spirit

Wolterstorff, as was observed in Chapter 3, argues that God may be conceived of as a speaker who is subject to rights and responsibilities in the same way as human persons.[191] By performing a speech act to us God takes for himself the responsibility to keep his word. When God's relationship to Scripture is conceived of in this way, the right of God the author to determine the meaning of his textual speech act(s) loses the suggestion of totalitarian power which much post-modern theory assumes to be inherent in this right, since the act of authoring a text is not reduced to the exertion of individual will in the determination of meaning, with the potential to mutate into an act of tyranny. Instead, for God as author to acquire the right to determine the nature and content of his speech act(s) does not wipe out ethical relationality in an act of tyranny, but instead opens up possibilities for relations between divine and human persons in a profoundly moral environment. To grant God that right is not necessarily to subjugate oneself unthinkingly before a God who may turn out to be as malevolent and objectionable as Moore's portrayal of him, for the conditions under which a speech act can be regarded as undercut may equally apply to God's speech act(s) as to those of any human being. We can at least conceive of a supposedly divine being who would claim our allegiance while making promises which he failed, either by design or through impotence, to fulfil.

The classical Christian understanding of Scripture is that the biblical texts are the medium of the address of Another. The text is not self-sufficient in that it is a reified object of study cut off from its author (as in New Criticism), nor can its referential

[191] God can be argued to be unique in this, as was noted in ch. 3, only with regard to the source of those rights and responsibilities: they are not imposed on him from outside, but determined by his own character.

function be rendered intra-textually to the extent that doubt arises over the extra-textual status of the referents of the text (as in the work of Hans Frei). The text does not fill the stage; it is no more, and no less, than interpersonal communicative action. Scripture is sufficient for the communicative action (illocutionary force and propositional content, referring to God, humanity, and the world) which God intends to perform by means of it. However, it is not *self*-sufficient, in that it exists only in relation to its author and readers, and has as its sole purpose the mediation of a relationship between him and them.

This scriptural sufficiency can be described in terms of the action of the Holy Spirit; some traditional Latin terms will be helpful here. The text itself cannot produce faithful response; it is sufficient for *notitia* ('intelligent cognition' of 'intelligible information'), but insufficient for the two stages of faithful response, for both of which the Holy Spirit is required: *assensus* ('cognition passed into conviction . . . truth believed as applicable to ourselves, as supremely vital and important for us') and *fiducia* ('conviction passed into confidence . . . the engagement of person to person in the inner movement of the whole man to receive and rest upon Christ alone for salvation').[192] Inspired Scripture—the text itself—is sufficient for simple understanding of the message of Scripture,[193] while illuminated Scripture—the text plus the present work of the Spirit—is sufficient for a response of faith. The Spirit *is* therefore a kind of supplement to the text, but only in the sense that he brings the possibility of appropriate response to the text's illocutionary act.[194] In the terminology of speech act theory, Scripture is sufficient

[192] The definitions of the three terms are taken from John Murray, *Collected Writings of John Murray*, ii: *Systematic Theology* (Edinburgh: Banner of Truth Trust, 1977), 257–8. Vanhoozer suggests even that '[t]he Spirit enables *understanding*', because readers' ideologies are especially liable to distort readings of texts 'that require behavioral change' (Vanhoozer, *Is There a Meaning?*, 428 (italic added)).

[193] Of course, that the text of Scripture now may be described as inspired depends on the past action of the Spirit in the course of the text's composition and possible canonical editing. Thus, the concept of 'the text itself', viewed historically, is not entirely Spirit-free. The point is that it excludes the necessary continuing role of the Spirit now. (A section of the following chapter will deal specifically with the inspiration of Scripture.)

[194] 'The Spirit is not some kind of Derridean supplement that adds to or improves upon the written Word' (Vanhoozer, *Is There a Meaning?*, 410).

for the performance of the divine illocutionary act, which includes the conveying of its necessary propositional content, but insufficient to bring about the intended perlocutionary effect. For that, as, for example, the Westminster Confession acknowledges, the work of the Holy Spirit through the Word is required.[195] This is analogous to what Luther calls the external and internal perspicuity of Scripture: Scripture is 'externally' sufficient but 'internally' insufficient.[196]

Does the perlocutionary activity of the Holy Spirit change the meaning of biblical texts, as the texts impact the lives of believers throughout history and across cultures? This, we saw in Chapter 3, was a possible although unintended corollary of Barth's doctrine of Scripture: that, in each case when God addresses someone through the Bible, the Holy Spirit performs through the locutions of the Bible a new speech act with new propositional content. It would also conflict with the definition of the sufficiency of Scripture which has just been given. It can be argued that the meaning of the Bible is left unchanged by the present action of the Holy Spirit if some universal reference can be identified in the biblical texts themselves. Richard Bauckham and others, for example, have recently argued persuasively, against a consensus, that the New Testament Gospels were addressed not to particular Christian communities (the putative Markan, Matthean, Lukan, and Johannine communities), but to 'any and every Christian community in the late-first-century Roman Empire'.[197] It is not clear, given the extent of this argu-

[195] '[O]ur full persuasion and assurance of the infallible truth, and divine authority thereof, is from the inward work of the Holy Spirit, bearing witness by and with the word in our hearts' (Westminster Confession of Faith, 1. 5). 'The supreme Judge, by which all controversies of religion are to be determined, and all decrees of councils, opinions of ancient writers, doctrines of men, and private spirits, are to be examined, and in whose sentence we rest, can be no other but the Holy Spirit speaking in the Scripture' (1. 10).

[196] 'Internal perspicuity' refers to the fact that, without the Holy Spirit, even though Scripture may be discussed and quoted, '[a]ll men have their hearts darkened'; 'external perspicuity' claims that 'all that is in the Scripture is through the Word brought forth into the clearest light and proclaimed to the world' (Martin Luther, *The Bondage of the Will*, trans. J. I. Packer and O. R. Johnston (Edinburgh: James Clarke, 1957), 73–4).

[197] Richard Bauckham, 'Introduction', in Richard Bauckham (ed.), *The Gospels for All Christians: Rethinking the Gospel Audiences* (Grand Rapids and Cambridge: Eerdmans, 1998), 1.

ment, that the level of cultural diversity within the Roman Empire in this period was qualitatively lower than that between the first century and subsequent centuries. That is, there seems to be no significant hermeneutical difference between being separated from the particular culture of the writer by space and culture, or being separated by time and culture. It may be, then, that Bauckham's argument can be expanded to include the possibility that the Gospel-writers intended also a future reference to all Christians in all ages; trans-cultural reference may include trans-historical reference. People and situations of whom the Gospel-writers knew nothing are therefore referred to in the text to the extent that the particularities of the text claim to be of universal significance.[198] Thus Vanhoozer: 'the Spirit does not alter but *ministers* the meaning. . . . The Spirit's role . . . is not to change the meaning but to *charge* it with significance.'[199] This is therefore to accept the basic legitimacy of the distinction which Hirsch draws between meaning and significance, and to apply it theologically to the Bible. The action of the Holy Spirit in relation to the Bible is not to perform a new speech act, but to bring about the perlocutionary effect of the speech act(s) which God has performed and continues to perform.

CONCLUSION

Models of textual self-sufficiency break the links between text and reality and are unable to rebuild them; Frei's biblical hermeneutic does violence to the inseparability of the propositional, referential, and illocutionary aspects of a speech act. E. D. Hirsch's linking of text and author is less foundational in his work than first appears, since it is grounded entirely pragmatically, motivated only by a desire to provide a critical criterion for adjudicating between interpretations, and making no claim about the ontology of texts. Where Hirsch treats a text as a self-sufficient entity which he wishes to supplement with another self-sufficient entity, the author's intention, without

[198] This particular claim about the function of the canonical Gospels will be given a general hermeneutical basis, and related to the whole of the Bible, when the topics of human and divine authorship of Scripture, and inter-canonical exegesis, are discussed in ch. 5.

[199] Vanhoozer, *Is There a Meaning?*, 413, 421.

loss to either, deconstructionists see the supplementation of text with author as revealing a deep insufficiency in both, which authorizes deconstructive reading practices.[200] Fish and Hauerwas, it was argued, both end up with no guard against solipsism; Gadamer confuses a text with its effects, and so has no clear account of it as an address external to readers. Fowl's biblical exegesis assumes that the text is the kind of thing which can address us from outside, but avoids any description of how that can be. The notion of a text as an illocutionary act performed by an author offers, it is argued, a better way to conceive of a text in relation to its author and readers, for it protects the identity of each of the three elements, author, text, and reader, from being dissolved into any of the others. In addition, it makes clear the ethical and determinate character of the relationships which exist between authors, texts, and readers.

This conclusion was applied to Scripture, conceived of, in light of Chapter 3, as a text by which God speaks, to state what Scripture is sufficient for: Scripture is sufficient for the performance of the divine illocutionary act(s). That is, Scripture is materially sufficient for the bearing of propositional content (the presentation of Jesus Christ as the means of salvation) and for the conveying of illocutionary force (the call or invitation to have faith in him). Since it performs an illocutionary act, Scripture is integrally related to its speaker; since it is thus an active address calling for a certain perlocutionary effect and imposing, like any other text, certain ethical constraints, it is integrally related to its addressees; since, as with all speech acts, the referential function and propositional content are inseparable aspects of an indivisible act, it is integrally related to its referents: God, humanity, and the world.[201]

In the performance of this divine illocutionary act, Scripture is sufficient for the mediation to any and all readers of what was referred to in the above discussion of New Criticism as God's 'real semantic presence' to human beings. Divine

[200] The different attitudes of Hirsch and Stephen Moore towards the author therefore reflect the two different senses of the double-edged word 'supplement', which Derrida has so exploited (see ch. 1).

[201] The different elements of a speech act are conceptual aspects of what is in reality a single personal communicative act. This point was made in the exposition of speech act theory in ch. 3.

'semantic presence' becomes divine 'personal presence' when the text's perlocutionary effect is brought about in the life of the reader by the action of the Holy Spirit. This restates the christocentric thrust of Luther's understanding of the sufficiency of Scripture: to urge 'Scripture alone' is to urge it as alone the means by which Christ comes in such a way that true knowledge of him is possible. To assert this is not to assert that Scripture is a sufficient guarantee of cognition of the divine illocutionary act (*notitia*), let alone that it can bring about in the reader the appropriate perlocutionary effect (*assensus* and *fiducia*). A reader of Scripture can still fail to recognize Christ, or, recognizing him, may still reject him. This will often be, as both Hauerwas and Fowl rightly argue, because the reader is not yet sufficiently practised in the modes of biblical interpretation and Christian behaviour through which the transformative Spirit of Christ may be encountered in the biblical texts. God is semantically present to us in the biblical texts; Bible-readers are always in the process of learning to experience his personal presence mediated through the text. This chapter has therefore developed the argument of Chapter 3. It was argued there that it is meaningful to conceive of God as speaking and to identify his Word with a (set of) text(s); here a proposal has been offered of what is involved in calling those texts, thought of as a divine speech act, materially sufficient.

Does this model of the sufficiency of Scripture suggest a possible definition of a secular 'sufficiency of the text'? A full answer to this question goes well beyond the present scope, but the content of this chapter suggests an answer in the affirmative. What has been argued above about the sufficiency of Scripture in relation to the illocutionary act of God may be applied, given the parallels which Wolterstorff draws between human speakers and God as speaker, to the illocutionary act of an author. This leads to the conclusion that a text is sufficient for the performance of an illocutionary act. Authors can be 'semantically present' to readers by virtue of their texts, while lacking the unique divine capacity to be spiritually 'personally present' to them across time and space. Again, this is not to say that the text is always sufficient for our *recognition* of that act for what it is. This is especially evident in the case of the speech acts of persons separated from us by distance of culture, whether geo-

graphically or temporally, whose speech acts are mediated to us textually. Yet any extra-textual evidence invoked to establish the meaning (propositional content plus illocutionary force) of the text only provides a context which illuminates what is already there in the text, namely, what someone has *said*—understood with the richness which Wolterstorff invests in this simple word—to someone about something.

The arguments presented in this chapter can therefore be cast as a claim about general hermeneutics. This is because, with the exception of the above section on the Holy Spirit, this chapter has treated Scripture like any other text. However, Scripture is not just a text; it both is a canon, a diverse set of texts, and as Scripture is in some way set apart from all other texts. This point has clearly been lurking in the present discussion, as we have equivocated between singular and plural in referring to the 'illocutionary act(s)' which God performs in 'this (set of) text(s)'. Therefore we now turn in the third and final (re)constructive chapter to the formal aspect of the sufficiency of Scripture, which asserts that the diverse set of texts which compromise the canon of Scripture is in some way uniquely marked off from all other texts, such that they are 'self-interpreting', subject to no external authoritative interpretation. The focus will again be on hermeneutical, literary, and theological issues, in the attempt to conceive of the texts of the canon of Scripture as together uniquely rendering, as Hans Frei would say, the unique identity of Jesus Christ.

5

The Scriptures and the Sufficiency of the Canon

INTRODUCTION

Protestant orthodoxy has traditionally made two main claims regarding the canon of Scripture, namely, that there is compelling theological reason to mark off this specific set of texts as authoritative above all else in faith and practice, and that questions of the interpretation of individual canonical texts are ultimately an internal matter of canonical self-interpretation. Although the latter claim is often termed the perspicuity of Scripture, the terminology is relatively fluid, and it can equally well be described as a claim of the formal sufficiency of Scripture.[1] This is so because of the close relationship between the two claims. If Scripture is ultimately authoritative, the principle by which interpretations are to be adjudicated cannot be external to it, as is the case if either magisterial church authority or a charismatic voice of the Holy Spirit internal to the individual is invoked as the authoritative interpretative principle.

The question of the validity of this rule has been a complex one, and two particular questions can be distinguished. First, how can a set of texts exhibiting such *thematic* and *literary* diversity legitimately be said to be self-interpreting? Three models for conceiving of the relations of the individual biblical texts with one another may initially be suggested: univocity, or perhaps symphony (the diverse texts are to be resolved into one overall 'voice'); polyphony (the texts are not disunited but yet not ultimately resolvable into one); and cacophony (the texts jostle discordantly with one another). A move will be made towards a choice of one of these options through a discussion of

[1] This terminological fluidity was discussed in ch. 2.

the concept of 'intertextuality', as it has been used by both literary theorists and biblical scholars. The term 'intertextuality' covers a diverse set of theories and practices according to which a text is supplemented by other texts. Approaches as diverse as the conservative establishing of a self-interpreting canon, and the radical deconstructive opening up of every text to a limitless intertextual space, may be termed 'intertextual'. Locating on this spectrum what we propose as the principle of Scripture's self-interpretation, particularly with regard to the arguments of the previous chapter on texts in relation to authors and readers, will help to clarify the kind of arguments for the formal aspect of the sufficiency of Scripture which can be mounted in the contemporary context.

The second question to be asked of the principle of canonical self-interpretation is, on what basis can such a *chronologically* and *religiously* diverse set of texts be regarded as self-interpreting? Why and in what particular ways do *these* particular texts supplement each other? This very broad question will be engaged via an examination of the canonical hermeneutics of B. S. Childs, which Childs most often calls a 'canonical approach' to biblical interpretation, for it is particularly in relation to Childs's work over the last thirty years that discussions of this topic have been conducted.

A theological gap will be identified in Childs's work which requires supplementation by a doctrine of biblical inspiration. This is perhaps not surprising, since divine inspiration was the doctrine traditionally invoked to account for claims of the unique function of the biblical canon in theology and church.[2] The subsequent discussion of inspiration will return in part to the question of the role of that doctrine in post-Reformation Protestant orthodoxy, which was treated briefly in Chapter 2. It is often claimed that in the seventeenth century the inspiration of Scripture came to be established in orthodox circles as a formal principle on which the authority of the canon of Scripture

[2] By 'traditionally' here is meant, at least from the sixteenth century. Bruce Metzger argues that in the patristic period the Bible was regularly said to be inspired, but that 'the concept of inspiration was not used in the early Church as a basis of designation between canonical and non-canonical orthodox Christian writings' (Bruce M. Metzger, *The Canon of the New Testament: Its Origin, Development, and Significance* (Oxford: Clarendon Press, 1987), 256.

was grounded. The texts, it is argued, were regarded as authoritative not so much by virtue of their content but because their authors were uniquely protected from error by the special inspiring activity of the Holy Spirit. It will be argued here that the orthodox Protestant doctrine of biblical inspiration largely escapes these critiques. There will be a particular focus on the orthodox development of biblical inspiration as it found expression at the end of the nineteenth century in the work of B. B. Warfield, who was significantly informed by such seventeenth-century orthodox theologians as Francis Turretin, who was discussed in Chapter 2, and who will be referred to again here. A minor critique will be offered of Warfield's doctrine, supplementing it with the hermeneutical and literary concepts outlined in the first part of the chapter.

SUPPLEMENTING ONE TEXT WITH ANOTHER: THE CANON AND INTERTEXTUALITY

Introduction: The Diversity of the Canon

This chapter is concerned with the rule of canonical self-interpretation. This rule, in literary terms, represents the claim that the relationships between the canonical texts are determinate, such that the clearer places interpret the more obscure, and the whole is interpreted in the light of Jesus Christ, its thematic centre. It has always been noticed, of course, that the canon of Scripture includes a wide diversity of material—diverse in both content and literary form. From the earliest times of the Christian church, inheriting the Jewish attitude to the Hebrew Scriptures, this diversity was not generally thought to be so extensive as to lead to theological incoherence. According to John Goldingay, '[i]t is historically certain . . . that the Jewish community believed that its Scriptures were theologically coherent . . . and the first Christians naturally shared such a belief'.[3] This general view held right up to the Reformation and

[3] John Goldingay, *Theological Diversity and the Authority of the Old Testament* (Grand Rapids: Eerdmans, 1987), 27–8. This can only be described as a *general* view; Metzger argues, following Oscar Cullmann, that in the early

beyond. For example, in the sixteenth century the Lutheran theologian Martin Chemnitz concluded from his detailed examination of the four canonical Gospels that they exhibit 'a very concordant dissonance' (*concordissima dissonantia*).[4] Orthodox theologians like Chemnitz are separated from later critical biblical scholars and theologians by the different answers they give to the questions of how much dissonance there in fact is in Scripture, and of how much dissonance can be tolerated in a supposedly concordant scriptural canon before it must be judged discordant. Thus, in a recent short article on the inspiration of Scripture, Wolfhart Pannenberg argues that the doctrine of the literal inspiration of Scripture, articulated especially by Chemnitz's orthodox Protestant successors in the seventeenth century,

disintegrated in the course of time, not so much because theologians turned to other norms of truth than Scripture, but primarily because the idea of a doctrinal unity among all the sentences of Scripture without any contradiction among them, an idea that followed from the doctrine of literal inspiration, could not be defended in the long run. It was falsified by observations of scriptural exegesis. This conception of the inspiration of Scripture broke down, then, because it proved to be irreconcilable with the first principle of the Protestant Reformation, the authority of Scripture in judging all the teaching of the church.[5]

The doctrines of the literal inspiration and formal sufficiency of Scripture both collapsed under the weight of exegetical observations. The operation of the principle of the formal sufficiency of Scripture, that Scripture's self-interpreted teaching should stand over the church's teaching, breaks down if actual

church the existence of a plurality of authoritative Gospels was seen as a theological problem by those for whom to accept such a plurality was 'as good as admitting that none of them is perfect' (Metzger, *The Canon of the New Testament*, 262).

[4] Chemnitz thought that the Holy Spirit had given the Gospels this characteristic 'in order to exercise the minds of the faithful in humble and careful investigation of the truth, whereby we learn that the four evangelists did not write by mutual agreement but by divine inspiration' (quoted in Robert D. Preus, *The Theology of Post-Reformation Lutheranism: A Study of Theological Prolegomena* (Saint Louis and London: Concordia, 1970), 360).

[5] Wolfhart Pannenberg, 'On the Inspiration of Scripture', *Theology Today* 54 (1997), 212–15, at 212.

Bible-reading produces more evidence of self-contradiction in Scripture than it does evidence for the possibility of successful self-interpretation.

More recent defenders of the doctrine of the literal inspiration of Scripture are vulnerable to the charge that they have not offered a significant hermeneutical and theological response to those who conclude from scriptural exegesis that Scripture is too diverse doctrinally to function as the ultimate authority in the church. This is a serious gap, for there is at least prima facie plausibility in the claim that the diversity of denominations and practices to which Protestantism has given rise is a direct result of the Protestant attempt to take such diverse Scriptures as one's ultimate authority. B. B. Warfield, for example, persistently uses the term 'oracle(s) (of God)' and its cognates as a description of the Bible. The regularity with which he uses these terms might suggest an insensitivity to and flattening of the complex and diverse nature of Scripture, and a consequent glossing over of the difficulties involved in moving from text to theology. Warfield will be discussed in more detail in the later section on the doctrine of inspiration, where this initial judgement on him will be assessed.

'Intertextuality' in Literary Theory and Biblical Studies

Since Warfield's day, much work has been done in literary studies, especially under the topic of 'intertextuality', on the subject of how texts are to be related to one another. This is not of course an entirely new interest in literary theory, but in the last thirty years the term 'intertextuality' has become prominent, and has itself acquired a diversity of meaning, covering both old and new ways of reading texts together. This section will look first at some uses of 'intertextuality' in recent literary theory, and then at some appropriations, some more critical than others, of such literary theories by biblical scholars. Some work of the Russian theorist Mikhail Bakhtin will then be brought forward, for the recent growth of interest in his work in the West lies behind much contemporary interest in intertextuality. One attempt to appropriate his work directly for biblical studies will then be discussed. Finally, we focus on two theological attempts to develop in relation to the Bible a con-

cept of 'polyphony'—a concept for which Bakhtin, it will be argued, offers important philosophical support.

The aim is to introduce concepts of literary relationships between texts, and of literary meaning and reference, under which it is possible to conceive of textual coherence more broadly than has often been allowed in the case of the Bible. Of course, this will not provide a category of 'unity in diversity' which will be able to account for all the contradictions which critical exegesis has alleged to exist in the Bible; those who wish to respond to such allegations will always need to do so in part with biblical exegesis of their own. However, concepts will be offered which, it will be argued, provide a framework in which many conclusions drawn from biblical exegesis need not lead to allegations about the disunity of Scripture and so to challenges against the orthodox doctrine of Scripture, but should instead provoke us to offer a more nuanced description of the complex operation of the rule of scriptural self-interpretation, and of the nature of relationships between canonical texts.

There is an initial difficulty, however, in that the semantic diversity which the term 'intertextuality' has acquired in general literary theory can occasionally lead to pointless arguments about who has the best claim on the term as a description of his or her particular position. Heinrich Plett distinguishes three positions, which will be adopted here in order to focus the discussion: 'progressive intertextualists', who give the term a postmodern or deconstructive slant; 'traditional intertextualists', who use the concept to rediscover the wealth of quotations and allusions in literary works; and 'anti-intertextualists', who assert that the notion of a 'traditional intertextualist' is redundant, since even in ancient times concepts such as typology adequately described relationships between texts.[6] It will be suggested that 'traditional intertextualist' is in fact not a redundant notion, and in what follows we will concentrate on the significant substantive disagreement between the first two of Plett's categories. This discussion will clarify the particular understanding of 'intertextuality' which will be carried on into the subsequent discussions of the biblical canon.

[6] Heinrich F. Plett, 'Intertextualities', in Plett (ed.), *Intertextuality*, Research in Text Theory 15 (Berlin and New York: Walter de Gruyter, 1991), 3–29, at 3–5.

'Progressive intertextuality'

The term 'intertextuality' was introduced just over thirty years ago by Julia Kristeva, particularly in two essays written in the late 1960s: 'The Bounded Text' and 'Word, Dialogue, and Novel'.[7] The latter essay, especially, helped to introduce the work of Mikhail Bakhtin to a Western audience. What Kristeva particularly takes from Bakhtin's work is the insight that the utterance of any speaker or writer is always a borrowing of other utterances, genres, and styles, always inhabited by previous modes of speaking and writing. Thus Bakhtin: 'Language is not a neutral medium that passes freely and easily into the private property of the speaker's intentions; it is populated—over-populated—with the intentions of others.'[8] Working from a structuralist background, Kristeva casts this point in semiotic terms, describing the historical formation of the 'specific signifying system' of the novel, for example, as 'a result of a redistribution of several different sign systems: carnival, courtly poetry, scholastic discourse'.[9]

However, Kristeva wrote these essays at a time when she was moving beyond structuralism into post-structuralism, deconstructing the structuralist semiotics in which she had been trained.[10] She gives this basic understanding of the concept of intertextuality: 'any text is constructed as a mosaic of quotations; any text is the absorption and transformation of another. The notion of *intertextuality* replaces that of intersubjectivity.'[11] Thus, like Derrida, Kristeva extends the concept of textuality beyond written texts, to cover human beings as subjects. This moves beyond what can be found directly in the work of

[7] They appear in English in Julia Kristeva, *Desire in Language: A Semiotic Approach to Literature and Art*, ed. Leon S. Roudiez (New York: Columbia University Press, 1980), respectively 36–63 and 64–91.

[8] M. M. Bakhtin, 'Discourse in the Novel', in Bakhtin, *The Dialogic Imagination*, ed. Michael Holquist, trans. Caryl Emerson and Michael Holquist (Austin: University of Texas Press, 1981), 259–422, at 294.

[9] Julia Kristeva, *Revolution in Poetic Language*, trans. Margaret Waller (New York: Columbia University Press, 1984 (1974)), 59.

[10] Toril Moi says that 'Word, Dialogue, and Novel' is 'in many ways a divided text, uneasily poised on an unstable borderline between traditional "high" structuralism . . . and a remarkably early form of "post-structuralism"' (*The Kristeva Reader*, ed. Toril Moi (Oxford: Blackwell, 1986), 34).

[11] Kristeva, *Desire*, 66.

Bakhtin. The early deconstructive tone is also evident in her comments on the specific nature of written texts. She defines a text as 'a permutation of texts, an intertextuality: in the space of a given text, several utterances, taken from other texts, intersect and neutralize one another'.[12] Already here, especially in the emphasis on the mutual neutralizing in a text of the many intertexts of which it is composed, Kristeva is moving beyond structuralism. It is for her deconstructive trajectory that many have wished to preserve the term 'intertextuality'. The original meaning of the term 'intertextuality' in her two essays was therefore what Plett terms 'progressive'—that is, with a deconstructive slant.

However, the term has also been adopted by writers working on theories of influence (Plett's 'traditionalists'), who trace how particular texts, authors, and traditions influence subsequent writing. In the 1970s Kristeva objected to this broadening of the term, referring to its new use 'in the banal sense of "study of sources"', and proposed a new term for her original concept: 'we prefer the term transposition . . . If one grants that every signifying practice is a field of transpositions of various signifying systems (an inter-textuality) one then understands that its "place" of enunciation and its denoted "object" are never single, complete, and identical to themselves, but always plural, shattered, capable of being tabulated.'[13] This is now a fully-fledged deconstructive approach to all human action.

Roland Barthes is the outstanding example of a literary critic who has taken intertextuality in a post-structuralist direction, applying it to literary texts and linking it with his notion of 'the death of the author'.[14] He argues that all writers are caught between, on the one hand, the push towards freedom and creativity, committing themselves and showing themselves clearly as individuals by the choice 'of tone, of ethos' in their writing,[15] and, on the other, the power exerted by the fact that we only ever use second-hand language, whose earlier usages echo in our own. '[W]riting still remains full of the recollection of previous

[12] Ibid., 36.
[13] Kristeva, *Revolution*, 60.
[14] This was discussed in ch. 4.
[15] Roland Barthes, *Writing Degree Zero*, trans. Annette Lavers and Colin Smith (New York: Hill & Wang, 1967), 13.

usage, for language is never innocent: words have a second-order memory which mysteriously persists in the midst of new meanings.'[16] The act of writing has powerful effects on history, although its duration as a free act is only momentary: 'Writing as Freedom is therefore a mere moment. But this moment is one of the most explicit in History.' As soon as the 'moment' is past, the literary tradition in which one is writing starts to raise its own voice over that of the late-come writer. Beyond the 'moment', all our language is so shop-soiled that we can never properly clean it up and make it our own:

True, I can today select such and such a mode of writing, and in so doing assert my freedom, aspire to the freshness of novelty or to a tradition; but it is impossible to develop it within duration without gradually becoming a prisoner of someone else's words and even of my own. A stubborn after-image, which comes from all the previous modes of writing and even from the past of my own, drowns the sound of my present words.[17]

However, it is hard to understand this as a coherent claim. Barthes does not say how the previous words and 'modes of writing' ever themselves gained sufficient force over time ('within duration') to drown out the sound of his own present words. An infinite regress is established: how do the previous words manage still to sound above the din of what was said before *them*? Barthes seems to be caught between Romantic desires for a moment of the creation of an absolutely free language and deconstructive pessimism over the possibility of the distinctiveness of any authorial voice ever enduring over time. He thus establishes a false dichotomy, presenting us with a momentary

[16] Barthes, *Writing Degree Zero*, 16. As is common in post-structuralist writing, the term 'writing' is a complex one in Barthes's work. By it he means, like Derrida, primarily neither the act of putting pen to paper (or finger to keyboard) in order to produce words, nor the words so produced. Unlike Derrida, he uses it to refer to the relation between intention and language. In her introduction to *Writing Degree Zero*, Susan Sontag suggests that, rather than 'writing', '[a] more helpful translation of what Barthes means by *écriture*—the ensemble of features of a literary work such as tone, ethos, rhythm of delivery, naturalness of expression, atmosphere of happiness or malaise—might be "personal utterance". . . . In contrast to a language and a style *écriture* is the writer's zone of freedom, "form considered as human intention"' (ibid., pp. xiii–xiv).

[17] Barthes, *Writing Degree Zero*, 17.

authorial 'meaningful gesture . . . [which] reaches the deep layers of History', and then with a post-history of the created text which sees the authorial voice drowned out in the cacophony of 'all the previous modes of writing'.

A number of biblical scholars have been attracted by 'progressive intertextuality', and have applied a model of intertextuality like that of Barthes and Kristeva to the Bible. The editors of a volume of the journal *Semeia* devoted to the topic, George Aichele and Gary Phillips, reject any use of the term 'intertextuality' which functions, as they see it, 'as a restrictive tool for nailing down authorial intent and literary influence'. (They have in mind such 'traditional intertextualist' biblical scholars as Richard Hays, whose work will be discussed shortly.) 'Thinly veiled in such efforts', they argue, 'are conservative ideological and theological interests in maintaining the primacy of certain (usually Christian) texts over against secondary (usually Jewish) precursors.'[18] The application of intertextuality to the task of biblical interpretation in their volume tends in a clearly deconstructive direction. For example, Gary Phillips's essay on Luke's Gospel makes similar claims about the coerciveness of Luke's text to those made by Stephen Moore in his free-playing deconstructive readings of Luke.[19]

[18] George Aichele and Gary A. Phillips, 'Introduction: Exegesis, Eisegesis, Intergesis', *Semeia* 69/70 (1995), 1–18, at 7–8.

[19] Gary A. Phillips, '"What is Written? How are you Reading?" Gospel, Intertextuality and Doing Lukewise: Reading Lk 10:25–42 Otherwise', *Semeia* 69/70 (1995), 111–47; Stephen D. Moore, *Mark and Luke in Poststructuralist Perspectives: Jesus Begins To Write* (New Haven and London: Yale University Press, 1992). See the detailed discussion of Moore in ch. 4. Cf., from a similar collection of essays on intertextuality and the Old Testament: 'discovering intertextual connections is a reader-oriented enterprise. While some texts direct our attention to other texts through explicit allusion, more often it is the reader who perceives textual relations' (Danna Nolan Fewell, 'Introduction: Writing, Reading, and Relating', in Fewell (ed.), *Reading Between Texts: Intertextuality and the Hebrew Bible* (Louisville: Westminster/John Knox Press, 1992), 11–20, at 17–18). In the same volume, Timothy K. Beal concludes: 'Every text—as an intersection of other textual surfaces—suggests an indeterminate *surplus* of meaningful possibilities. Interpretation is always a *production* of meaning from that surplus' (Timothy K. Beal, 'Ideology and Intertextuality: Surplus of Meaning and Controlling the Means of Production', in Fewell, *Reading Between Texts*, 27–39, at 31).

'Traditional intertextuality'

The strict distinction between intertextuality (in its original deconstructive sense) and the more limited study of relationships of influence between literary texts, a distinction which all 'progressive intertextualists' make, has been called into question. The volume *Influence and Intertextuality in Literary History* is a collection of essays which argue that the two notions are more closely linked than either Kristeva or Aichele and Phillips suggest. Two of the contributors note that Derrida is an 'intertext' in Kristeva's semiotic reading of Bakhtin, since she takes observations which Bakhtin makes about the 'intertextual' nature of words and applies them to texts. (It was pointed out in Chapter 4 that Derrida regularly treats texts as if they occupied the same level of description as individual words.) This, they argue, and as was noted above, produces a concept of 'intertextuality' very different from anything which can be found in Bakhtin.[20]

The contributors to this volume all see human agency as important in literary interpretation, and locate that agency especially in the author.[21] Susan Stanford Friedman notes the irony of Kristeva's personal intervention into the subsequent intertextual history of her term 'intertextuality', her rejection of 'banal' (i.e. 'traditional') uses of 'her' term, and her attempt to substitute a new term for her original concept. This demonstrates, she argues, that post-structuralist attempts to keep the discourse of 'intertextuality' uncontaminated by the discourse of influence cannot succeed.[22] The death of the author can be declared, but authors find it hard to play dead for long.[23]

[20] Jay Clayton and Eric Rothstein, 'Figures in the Corpus: Theories of Influence and Intertextuality', in Clayton and Rothstein (eds.), *Influence and Intertextuality in Literary History* (Madison: University of Wisconsin Press, 1991), 3–36, at 18–19.

[21] Clayton and Rothstein, 'Figures in the Corpus', 29.

[22] Susan Stanford Friedman, 'Weavings: Intertextuality and the (Re)Birth of the Author', in Clayton and Rothstein, *Influence and Intertextuality*, 146–80, at 153–4.

[23] In particular, Friedman argues that the death of the author is an unhelpful notion if texts and literature are to have the kind of transformative role in society which Kristeva wishes. This is particularly pertinent to feminism, she suggests, quoting Nancy Miller: 'only those who have it [status as subject] can play with not having it' (Friedman, 'Weavings', 158).

It might be concluded from this that 'traditional' intertextualists would be better to abandon the term as redundant, and talk simply about the influence of authorial agency. However, the work of the post-structuralist thinker Jonathan Culler can be cited as evidence that this is not the case. Friedman suggests that Culler's work demonstrates that intertextuality need not necessarily take the form of 'the death of the author',[24] as in Barthes; Clayton and Rothstein note that Culler marks out a 'semiotic path that argues for increased certainty for the reader'.[25] Thus, according to Clayton and Rothstein, Kristeva's reading of Bakhtin can be taken to introduce a new and useful concept, which says something in addition to, although not separately from, theories of influence, without falling into Barthes's advocacy of 'the death of the author'. We turn then to Culler's discussions of intertextuality.

Culler's initial definition of intertextuality is little different from Kristeva's. The intertextual nature of any 'verbal construct', he says, is that it is 'intelligible only in terms of a prior body of discourse—other projects and thoughts it implicitly or explicitly takes up, prolongs, cites, refutes, transforms'.[26] This, he says, gives intertextuality a 'double focus': it is opposed to the view that texts are autonomous, that they have meaning only in relation to prior texts, and therefore it designates the text's 'participation in the discursive space of a culture: the relationship between a text and the various languages or signifying practices of a culture and its relation to those texts which articulate for it the possibilities of that culture'. He then observes, however, that the concept of intertextuality reaches an impasse. It is difficult to make the concept of a vast, undefined discursive space 'usable' without giving particular examples. This, though, tends to deny the initial definition, for the point made by the specific examples seems not to rise above traditional sourcestudy. To this extent, Culler argues, Kristeva's work does not move beyond 'the study of identifiable sources'.[27] He suggests, however, that this apparent unworkability of the concept should

[24] Ibid., 156.

[25] Clayton and Rothstein, 'Figures in the Corpus', 21.

[26] Jonathan Culler, *The Pursuit of Signs: Semiotics, Literature, Deconstruction* (London and Henley: Routledge & Kegan Paul, 1981), 101–3.

[27] Ibid., 106–9.

not lead us to abandon it. Rather, we need 'multiple strategies' to explicate it and to put it into practice.[28] Borrowing from linguistics the distinction between logical and pragmatic presuppositions, he suggests two strategies, both of which impose significant constraints on intertextual interpretative practice. First, intertextualists might look at 'the specific propositions of a given text, the way in which it produces a pre-text, an intertextual space whose occupants may or may not correspond to other actual texts'. For example, the question 'Have you stopped beating your wife?' presupposes a certain prior state of affairs.[29] Second, 'the study of rhetorical or pragmatic presupposition . . . leads to a poetics which is less interested in the occupants of that intertextual space which makes a work intelligible than in the conventions which underlie that discursive activity or space'. For example, the utterance 'Open the door' presupposes the presence of a room with a closed door. As Culler says, in these cases 'one is working on the conventions of a genre of speech act', asking about the 'discursive or intertextual space which gives rise to the conventions that make this sentence intelligible and significant as a speech act'.[30] The concept of human agency in language-use, which disappeared in the work of Barthes and Kristeva, reappears here as a significant aspect of Culler's notion of intertextuality.

Thus, where Barthes, and Aichele and Phillips, took Kristeva's early work on intertextuality in a direction which leads ultimately to textual interpretation of the kind practised by Stephen Moore, Culler develops, from a similar starting-point, discussions of genre-determination and speech act conventions. In other words, 'intertextuality', as theoretically outlined in an account such as Culler's, and distinguished from studies of influence, promises to be fruitful in the kind of description of the interrelationships between biblical texts which we aim to suggest here.

In order to show how this might work in practice we turn to the work of the New Testament scholar Richard Hays on the apostle Paul's use of the Old Testament. This is not to say that Hays directly follows Culler in enquiring into the logical and pragmatic presuppositions of the Pauline epistles. In fact, Hays takes his explicit cue from the work of John Hollander on the

[28] Ibid., 111. [29] Ibid., 118, 111. [30] Ibid., 116–18.

trope of metalepsis ('allusive echo').[31] Nonetheless, Hays's (and Hollander's) work represents a good example of the kind of intertextual practice with constraints which Culler proposes. It may be a third strategy, in addition to the two which Culler offers, in building up the 'multiple strategies' of intertextual reading; or it is perhaps a particular example of texts (Pauline epistles) becoming 'intelligible and significant as a speech act' within 'the discursive space of a culture' (Paul's inherited Jewish culture) which is itself in fact largely constituted by textual speech acts (the Old Testament).

Hays's basic assertion is that Paul 'repeatedly situates his discourse within the symbolic field created by a single great precursor text: Israel's Scripture'.[32] He sets this claim in explicit contrast to liberal Protestantism, especially as represented by von Harnack and Bultmann. In Bultmann's view, the Old Testament provides no serious constitutive elements in Paul's theology; he simply occasionally expressed the kerygma through mythological language and symbols.[33] The bulk of Hays's book is taken up with substantiating his counter-thesis in great exegetical detail from the undisputed Pauline epistles. Using Saussure's terminology, he asserts of Paul's relationship to the Old Testament the opposite of Barthes's confident assertion of his own inability to be heard above the babble of earlier language-uses. Hays writes of the epistle to the Romans:

It would be inadequate to say that Scripture was *langue* and Paul's discourse *parole*, as though Scripture were merely a pool of lexemes from which Paul draws; rather, Scripture's poetry and narratives materially govern his confession. Scripture's *parole*, already spoken, rebounds and is heard once again in Paul's discourse. Consequently, Paul's sentences carry the weight of meanings acquired through earlier narrative and liturgical utterance. This allusive evocation of earlier declarations of God's faithfulness to Israel covertly undergirds the burden of Paul's overt argument.[34]

Moreover, most of Paul's quotations from the Old Testament 'require the reader to engage in serious sustained deliberation about the relation between Scripture's *mundus significans* and the new situation Paul is addressing'.[35] Paul simultaneously

[31] Richard B. Hays, *Echoes of Scripture in the Letters of Paul* (New Haven and London: Yale University Press, 1989), 20.

[32] Ibid., 15. [33] Ibid., 7–8. [34] Ibid., 70. [35] Ibid., 175.

locates his discourse within the world-view of the Old Testament (he is fundamentally un-Marcionite) and proclaims the new message of the gospel of Jesus Christ; indeed, the latter is only possible by virtue of the former. Hays thus articulates a profound complexity of relationships between the Pauline writings and the Old Testament which justifies the description 'intertextuality', going beyond what might be attributed simply to 'influence'.[36]

Hays's reading of Paul's use of the Old Testament can therefore be cited as a significant counter-example to Roland Barthes's view of human agency in authorship, for he mounts a convincing argument that Paul's discourse both develops 'within duration' (in his own lifetime and beyond), and is enormously in debt to previous modes of writing (the Old Testament), without becoming captive to those previous modes. The Old Testament does indeed provide a 'stubborn after-image' in Paul's texts—but this fact does not drown out Paul's own voice; it is rather a necessary condition for him to say what he wanted to say. Subsequent readers of Paul can only properly hear the distinctive contours of his texts in their own right if they hear them in relation to the previous modes of writing which he indwells. Whereas Barthes sees authors moving only between absolute freedom and absolute slavery, Paul develops the particular creativity and even freedom of his discourse precisely by virtue of his captivity to earlier texts. Barthes and Hays, we might say more broadly, seem to be working with very different underlying understandings of the nature of human freedom.

Hays's work concentrates on intertextual biblical relationships at the level of citation and allusion, and suggests that they

[36] Hence, *contra* Plett's 'anti-intertextualists', 'traditional intertextualist' is not a redundant term, for it is called for by Hays's account of the relationship between Pauline texts and the Old Testament. In various asides, Hays tends to draw significant distinctions between Paul's use of the Old Testament and that of other New Testament writers. He suggests, for example, that on the whole Matthew did not wrestle with the context of the Old Testament texts he cited as Paul did (Hays, *Echoes of Scripture*, 175). Hays's work on Paul could productively be followed by equally careful work on other New Testament writers, investigating whether such comments are justified. For a hugely detailed account of intertextuality within the Old Testament itself, see Michael Fishbane, *Biblical Interpretation in Ancient Israel* (Oxford: Clarendon Press, 1985).

are complex. Paul creates his own discourse only by virtue of his indwelling of Old Testament discourse; he moves beyond the Old Testament without silencing it. How might such textual interrelationships, which are in effect mutually supplementing relations between biblical texts, themes, and genres, be described hermeneutically? A key term here is 'polyphony'. Here we turn in more detail to the work of Mikhail Bakhtin, for, under the concepts of what he calls 'heteroglossia' and 'speech genres', he offers a philosophical description of language which will pave the way towards an account of the intertextual interaction between the diverse canonical texts as 'polyphonic'.

Canon and Polyphony

Mikhail Bakhtin: heteroglossia and speech genres

Bakhtin's work is sometimes difficult and often fragmentary. His published works cover broad areas in literary theory, philosophy, ethics, and theory of culture. In addition, there are problems with deciding whether he sometimes wrote pseudonymously, and therefore the precise extent of his oeuvre is uncertain; only undisputed works will be referred to here. Not the least of the problems in the interpretation of his work are those caused by his very difficult circumstances as an intellectual in Stalinist Russia. As was noted above, Julia Kristeva was primarily instrumental in introducing Bakhtin to a Western audience, and since then his work has been quite influential.[37] However, as we also saw, even at the beginning Kristeva read Bakhtin in a particular way; given the breadth and sometimes apparently self-contradictory nature of his work, this is perhaps hard to avoid. Since the 1960s, and as interest in his work has grown, Bakhtin has been welcomed by some as a forerunner of deconstruction, on the basis particularly of his concept of carnival,[38] and by others as representative of a more restrained ethical position. Generally, those who have translated and

[37] See e.g. Gary Saul Morson (ed.), *Bakhtin: Essays and Dialogues on His Work* (Chicago and London: University of Chicago Press, 1986).

[38] Apart from Julia Kristeva's use of Bakhtin in post-structuralist literary theory, see e.g. the theological treatment of 'carnival' in Mark C. Taylor, *Erring: A Postmodern A/theology* (Chicago and London: University of Chicago Press, 1984), esp. 161–4.

edited Bakhtin's work take the latter view. One such writer, Michael Holquist, comments on Bakhtin's essay, 'The Problem of Speech Genres': 'Given its emphasis on normative restraints that control even our most intimate speech, the essay should at the very least sound a cautionary note for those who wish to invoke Bakhtin in the service of a boundless libertarianism.'[39] Similarly, Wayne Booth insists that Bakhtin establishes firm links between language and extra-linguistic reality,[40] and Gary Saul Morson that Bakhtin retains, while rendering highly complex, commitments to intention and authorship.[41]

It is important to note that what will be adopted here as a 'polyphonic' view of language is what Bakhtin outlines under the concepts of 'heteroglossia' and 'speech genres'. Confusingly, for the present discussion, Bakhtin also has a concept which he calls 'polyphony', and which is quite different from what we will come to mean by 'polyphony'. The reason for renaming Bakhtin's 'heteroglossia' 'polyphony' in this study is that the former term, apparently an English neologism translating Bakhtin's Russian neologism, has not been widely adopted by others, whereas 'polyphony' is a standard English word, and has been used by several writers on the Bible. In order to clarify this point, it will be helpful to explain briefly what is *not* being appropriated from Bakhtin—that is, his concept of 'polyphony'. This will also serve the purpose of providing a fuller picture of Bakhtin's overall work.

Bakhtin uses the term 'polyphony' to describe a particular stance which the author of a novel can take with regard to the characters in his novel. He discusses the concept in greatest detail in relation to the work of Dostoevsky, whom he credits with inventing polyphony, and with being one of its rare exponents—possibly, Bakhtin thinks, its only successful exponent. Dostoevsky, he asserts,

[39] Michael Holquist, 'Introduction', in M. M. Bakhtin, *Speech Genres and Other Late Essays*, University of Texas Press Slavic Series 8, ed. Caryl Emerson and Michael Holquist, trans. Vern W. McGee (Austin: University of Texas Press, 1986), p. xvii.

[40] Wayne C. Booth, 'Introduction', in Mikhail Bakhtin, *Problems of Dostoevsky's Poetics*, Theory and History of Literature 8, ed. and trans. Caryl Emerson (Manchester: Manchester University Press, 1984), pp. xxv–xxvi.

[41] Gary Saul Morson, 'Who Speaks for Bakhtin?', in Morson, *Bakhtin*, 1–19, at 17.

created something like a new artistic model of the world . . . A plurality of independent and unmerged voices and consciousnesses, a genuine polyphony of fully valid voices is in fact the chief characteristic of Dostoevsky's novels. . . . Dostoevsky's major heroes are, by the very nature of his creative design, not only the objects of authorial discourse but also subjects of their own directly signifying discourse.[42]

Thus 'polyphony' is for Bakhtin a theory of the creative authorial process.[43] He imagines that Dostoevsky did not plan his novels, but first created specific 'voices'. The opposite of 'polyphonic' is 'monologic'; in a 'monologic' novel, and the vast majority of novels are 'monologic', we are offered a report of a finished dialogue. In a polyphonic work, by contrast, 'we see the author addressing characters like people "actually present . . . and capable of answering him."' Thus, there is genuine (by which Bakhtin would mean open-ended) dialogue between author and characters.[44] The great virtue of the polyphonic novel for Bakhtin is that '[t]he single adequate form for *verbally expressing* authentic human life is the *open-ended dialogue*'.[45] His admiration for Dostoevsky is based on the fact that he thinks that that novelist invented a creative process which embodied this ethic in literary form. It has been suggested that even if Bakhtin's reading of Dostoevsky is wrong, we are still left with a remarkable approach to human culture, and one with significant ethical consequences.[46] To apply this concept of Bakhtin's to the Bible would entail seeing God as a 'polyphonic' author with regard to various created characters. However, the biblical texts will not allow us to go very far with a conception of God as a novelist who remains in open-ended dialogue with his 'characters', never exerting any final authority over them. This would seem to exclude eschatology, among other things.

More fruitful for our purposes is Bakhtin's concept of 'heteroglossia'. It is this that Kristeva was primarily borrowing when she first developed her concept of intertextuality. Bakhtin has a fundamental objection to viewing language in any significant

[42] Bakhtin, *Problems*, 3, 6–7 (original italics removed).
[43] Gary Saul Morson and Caryl Emerson, *Mikhail Bakhtin: Creation of a Prosaics* (Stanford: Stanford University Press, 1990), 243.
[44] Ibid., 246 (quoting Bakhtin).
[45] Bakhtin, *Problems*, 293.
[46] Morson and Emerson, *Mikhail Bakhtin*, 251.

sense as *langue*. He asserts that, despite attempts to regularize grammars and linguistic usage (for example, into 'standard' and 'non-standard'), every utterance is in fact inhabited by a variety of genres, of modes of speaking. This is the case because '[e]ach separate utterance is individual, of course, but each sphere in which language is used develops its own *relatively stable types* of these utterances. These we may call *speech genres.*' There is an 'extreme *heterogeneity* of speech genres (oral and written) . . . from the proverb to the multivolume novel'.[47] Morson and Emerson summarize the point well: for Bakhtin, language is always languages.[48] It is this characteristic of language which Bakhtin refers to as 'heteroglossia'.

Bakhtin has a fundamentally dialogical view of language. To be a listener is not simply to be a passive receptor of someone else's meaning: 'all real and integral understanding is actively responsive, and constitutes nothing other than the initial preparatory stage of a response'.[49] Bakhtin and speech act theorists thus share, apparently independently, many fundamental themes. What Austin and Searle term a speech act is identical to what Bakhtin calls an 'utterance', which he distinguishes from the sentence as 'the *real unit* of speech communication': an 'utterance' is always language in use; a 'sentence' is a string of words that could be used for a variety of utterances, that is, with a variety of illocutionary forces. The material extent of an utterance is defined precisely by its dialogical relations to the utterances of others: 'Any utterance has, so to speak, an absolute beginning and an absolute end: its beginning is preceded by the utterances of others, and its end is followed by the responsive utterances of others.'[50] This means that the speech genres which arise out of different spheres of language-use reflect different ways in which people habitually respond to the world, and especially to one another. It is by means of the multiple heteroglossia of language, then, by ourselves inhabit-

[47] M. M. Bakhtin, 'The Problem of Speech Genres', in Bakhtin, *Speech Genres and Other Late Essays*, 60–102, at 60–1.

[48] Morson and Emerson, *Mikhail Bakhtin*, 140.

[49] Bakhtin, 'Speech Genres', 69. This was referred to in our appropriation in chs. 3 and 4 of Wolterstorff's account of the ethical responsibilities which accrue to the addressees of speech acts.

[50] Ibid., 71.

ing these linguistically inherited illocutionary stances towards the world, that we come to take specific and different points of view on the world: 'All languages of heteroglossia, whatever the principle underlying them and making them unique, are specific points of view on the world, forms for conceptualizing the world in words, specific world views, each characterized by its own objects, meanings and values. As such they may be juxtaposed to one another, mutually supplement one another, contradict one another and be interrelated dialogically.'[51]

Kevin Vanhoozer, developing the insights of speech act theorists, says of literary genres exactly what Bakhtin says of heteroglossic 'speech genres': 'genres are literary practices that enable complex ways of engaging reality and of interacting with others'. He also suggests that there are generic illocutions which supervene on individual sentences. For example, following Susan Lanser's work on narrative, he argues that 'the novel's basic illocutionary activity is ideological instruction'.[52]

Bakhtin's basic observation about language is therefore strikingly similar to Barthes's: human speech is not some linguistic *creatio ex nihilo*. We cannot avoid using second-hand forms of language. However, from the same observation he draws precisely the opposite conclusion to Barthes. For Bakhtin, a complex speech genre, such as a literary genre, composed out of simpler speech genres, is sufficient to bear a mark of the author's individuality, distinguishing his utterance from that of other works: 'The speaker's will is manifested primarily in the choice of a particular speech genre.'[53] Words exist for speakers in three different aspects, he asserts: as a neutral word, belonging to no one (as in *langue*); as an other's word; and as my word.[54] Of these, Barthes allows only the first two aspects to persist. Bakhtin agrees that human linguistic creativity is not easy, since we do not always mark our speech with our own individuality: 'many words stubbornly resist, others sound

[51] Bakhtin, 'Discourse in the Novel', 291–2.
[52] Kevin J. Vanhoozer, *Is There a Meaning in This Text? The Bible, the Reader and the Morality of Literary Knowledge* (Leicester: Apollos, 1998), 338, 341.
[53] Bakhtin, 'Speech Genres', 75–8 (original italics removed).
[54] Ibid., 88. 'Speech genres' therefore functions as a third term between Saussure's *langue* and *parole*, offering a more sophisticated account of how language, considered as a semiotic system, is related to actual speech acts.

alien, sound foreign in the mouths of the one who appropriated them and now speaks them'. However, unlike Barthes, he does not think it impossible to make something of one's own out of what has been used by others: 'The word in language is half someone else's. It becomes "one's own" only when the speaker populates it with his own intention, his own accent, when he appropriates the word, adapting it to his own semantic and expressive intention.'[55] Ultimately, Bakhtin thinks, if we each had to originate our own speech genres in order to speak, communication would be impossible.[56] Barthes establishes as a necessary condition for 'free speech' that the human speaker be like God; Bakhtin thinks that, to speak for herself, a human person does not have to be the Creator.[57]

'Heteroglossia', we suggest, is a fruitful standpoint from which to consider the work of Richard Hays, outlined above. Hays's exegetical conclusions on the relationship between the Pauline epistles and the Old Testament can be expressed in Bakhtinian theoretical terms: Paul makes the languages of the Old Testament his 'own' by successfully 'populating' them

[55] Bakhtin, 'Discourse in the Novel', 293–4.

[56] Bakhtin, 'Speech Genres', 79. More recently, the American philosopher Calvin Schrag has written similarly: 'Words, whether spoken or written, live off the capital of language, albeit in different ways, and stimulate the economy of discourse as at once a creative achievement and a deliverance of meanings already uttered, at once event and system, at once articulation of that which is new and repetition of that which is old' (Calvin O. Schrag, *The Self after Postmodernity* (New Haven and London: Yale University Press, 1997), 17).

[57] Bakhtin probably had his own particular view of how his ethical and philosophical agendas were related to theology. Morson and Emerson suggest this summary of Bakhtin's attitude to Christian theology: 'To participate directly in the "world symposium," God allowed Himself to be incarnated and tested. . . . Christ "lived into" the world and proved himself to be the perfect dialogue partner, addressing people with "dialogic intuition" that never finalized them' (Morson and Emerson, *Mikhail Bakhtin*, 267). Bakhtin's ultimate image of dialogic faith is *conversation* with Christ: 'The word as something personal. Christ as Truth. I put the question to him.' Morson and Emerson suppose that Bakhtin's conversation with Christ would be interminable and absorbing disagreement (Morson and Emerson, *Mikhail Bakhtin*, 62, quoting Bakhtin). In that case, what the book Revelation says of heaven—'When the Lamb opened the seventh seal, there was silence in heaven for about half an hour' (Rev. 8: 1)—is more like Bakhtin's notion of hell; similarly Matthew's claim, presented at the end of his Gospel, of the authoritative position held by the resurrected Christ.

with and adapting them for his own intention; yet in this act of 'appropriation' the languages of the Old Testament are not silenced, for that is not at all Paul's intention.[58] Of course, it is intended here to portray these relationships in the Bible as always 'mutually supplementing', and never contradictory, as Bakhtin characterizes some relationships between 'the languages of heteroglossia'. Whether this is in fact the case with the Bible can only be established in the discussion between theology and biblical exegesis.

Bakhtin and biblical studies

The literary critic Walter Reed is so far the only person who has attempted at some length directly to relate Bakhtin's basic concepts to the Bible as a whole.[59] He adopts Bakhtin's underlying and controlling concept of 'dialogue' in order to interpret certain biblical texts. This concept lies behind other terms, such as 'polyphony' and 'heteroglossia'. As is usually the case with Bakhtin, the meaning of 'dialogue' emerges with his use of it, not by definition. In increasing order of level of description, Morson and Emerson suggest that for Bakhtin 'dialogue' is 'a term for a specific type of utterance, opposed to other, monologic utterances', 'a description of language that makes all utterances by definition dialogic', and 'a view of the world and truth (his global concept)'.[60]

In practice, Reed does not distinguish these three levels (as Bakhtin himself admittedly sometimes does not), and so approaches the task of biblical interpretation with a rather blunt analytical tool. This vagueness renders his 'Bakhtinian' readings of the Bible rather unsatisfactory. On the one hand he imposes Bakhtin's concept, usually in a mixture of the first two

[58] 'Christian' readings of the Old Testament will be discussed below, in relation to the work of B. S. Childs. We will there suggest a necessary condition if a 'Christian' reading of an Old Testament text is not to be a supercessionist imposition.

[59] Walter L. Reed, *Dialogues of the Word: The Bible as Literature According to Bakhtin* (New York and London: Oxford University Press, 1993). Kenneth M. Craig, Jr., *Reading Esther: A Case for the Literary Carnivalesque* (Louisville: Westminster John Knox Press, 1995), applies Bakhtin's particular concept of 'carnival', developed in his reading of Rabelais, to one particular biblical text.

[60] Morson and Emerson, *Mikhail Bakhtin*, 486.

senses of it given above, uncritically on the Bible, which leads to conclusions which do violence to the text and would be hard to justify exegetically. For example, he claims that Bakhtin's concept allows us to recognize that the Scriptures 'are overwhelmingly and persistently concerned with one thing': 'the ongoing dialogue between God and people'.[61] On the other hand, he reaches conclusions on certain texts which, say, a narrative criticism completely uninfluenced by Bakhtin could equally have produced—for example, that in Mark's Gospel the account of Peter's denial is set in sharp contrast to Jesus' witness to his true identity in his trial: an episode with 'dialogic character', according to Reed.[62]

Finally, Reed muses on the extent to which a 'dialogic' Scripture may be said to be a unity. He claims that the literary critic will always observe more 'coherence' in the 'anthology' (that is, in the canon of Scripture) than the historian, who views the Bible as an 'archive'. However, he notes, '[c]oherence is not the same as unity, and the diversity of the anthology and the testimony of texts outside the collection are always an embarrassment to the theologian, even the "biblical" theologian'.[63] That a high degree of canonical diversity can be tolerated before the 'biblical' theologian needs to feel embarrassment is what the following section aims to defend.

Accounts of the biblical canon as polyphonic

Karl Barth asserted that 'theology confronts in Holy Scriptures an extremely polyphonic, not a monotonous, testimony to the word and work of God'. The Scriptures have this character because of 'the objective multiplicity and inner contrasts sustained within the motion of the history of the covenant which they recount and affirm'.[64] This kind of description of the canon of Scripture has been developed at greatest theoretical length by Paul Ricoeur in two thematically overlapping essays. Before discussing Ricoeur, reference will be made first to a work by Mark Wallace which, at the end of a sustained comparison of Barth and Ricoeur, offers a reflection on biblical polyphony

[61] Reed, *Dialogues of the Word*, 16.
[62] Ibid., 32–4. [63] Ibid., 170.
[64] Karl Barth, *Evangelical Theology: An Introduction*, trans. Grover Foley (London: Weidenfeld & Nicolson, 1963), 33.

which, it will become evident, is different from Ricoeur's in one significant respect.

Wallace argues: 'If and when revelation has occurred within the Christian environment, this disclosure should be read through the polyphonic play of meaning within the Bible, a play that should not be stopped by an isolation of one trajectory of meaning within Scripture as "the" biblical message.'[65] He adds: 'all discourse about God, including that of the Bible, both is and is not adequate to that about which it speaks'.[66] Thus, the biblical texts are to be held in determinate relations to one another, in that dynamic polyphonic play occurs within the Bible, not running over the limits of the canon. It is in this dynamic set of relationships, not in the reduction of the themes of the Bible to one single theme, or in the reduction of the diversity of biblical genres to one mode of expression, that the Bible's discourse becomes in some way adequate to that about which it speaks.

However, Wallace provides in addition a significant role for the reader in the establishing of the nature of the interrelationships between different biblical trajectories. The kind of hermeneutics he advocates 'will focus on the give-and-take between text and audience; it will maintain that Scripture is more like a lively and open-ended game between its world and the world of the reader than it is a closed book whose meaning is exhausted by the standard theological lexicon'. He provides a practical example of what he means. We note, he says, that at times God is described in the Bible as a mighty warrior—'[y]et this martial and patriarchal imagery is questionable in a time when many of us have been victimized by sacralized violence'. However, the Bible also depicts God as a mother brooding over her young, and as liberator of the poor, and it is these images which we should now privilege.[67]

It seems here that, despite his stated intention, Wallace has stopped the play of inter-canonical ways of naming God somewhat, isolating, if not one trajectory of meaning in Scripture,

[65] Mark I. Wallace, *The Second Naiveté: Barth, Ricoeur and the New Yale Theology*, Studies in American Biblical Hermeneutics 6 (Macon: Mercer University Press, 1990), 117–18 (original italics removed).

[66] Ibid., 121.

[67] Ibid., 119.

then at least a group of trajectories which seem to him relatively easy to reconcile with one another—and this for modern socio- and gender-political reasons. However, it is questionable whether the biblical texts which contain this martial imagery can be so easily exculpated. It surely cannot be the case that 'sacralized violence' is only a modern phenomenon, that no one fell victim to it in the ancient world, in the period when these texts were written. If such imagery is questionable now, why not then? This is particularly curious, since Wallace also laments the present theological scene, in which, he says, the void left by the removal of the assumption that God has revealed himself has been filled with 'a dizzying array of various genitive theologies (such as liberation theology or feminist theology)'.[68] In fact, many liberation theologians do precisely what Wallace does, relegating the authoritative significance of certain biblical 'names' of God, and promoting others, such as 'liberator of the poor', in the light of modern concerns, as expressive of 'the' message of the Bible. Wallace delimits the breadth of biblical polyphony by means of precisely the same criteria whose implementation has led directly to the present splintered theological scene beyond which he wishes to move.

Wallace's suggestion can be helpfully compared with the work of Paul Ricoeur on this point. In a suggestive article, Ricoeur argues that the individual biblical texts should be understood as each separately saying something determinate of God, and collectively, in their diversity, referring to a God who, while escaping each separate attempt to refer to him, is nevertheless successfully referred to (we may say) 'canonically'. Speaking of the different ways in which the Bible 'names' God, Ricoeur says:

The referent 'God' is thus intended by the convergence of all these partial discourses. It expresses the circulation of meaning among all the forms of discourse wherein God is named. . . . The referent 'God' is not just the index of the mutual belonging together (*appartenance*) of the originary forms of the discourse of faith. It is their common goal, which escapes each of them.[69]

[68] Wallace, *The Second Naiveté*, 113–14.
[69] Paul Ricoeur, 'Naming God', *Union Seminary Quarterly Review* 34 (1979), 215–27, at 222.

Ricoeur takes the individual texts and genres of the Bible to be real, albeit partial, acts of discourse. Where texts meet or intersect they refer to something beyond themselves—to a real extra-textual and 'extra-readerly' God. Another writer, Francis Watson, outlines a conception of the mode of biblical reference very similar to Ricoeur's, which he calls 'intratextual realism', 'which would understand the biblical text as referring beyond itself to extra-textual theological reality, while at the same time regarding that reality as accessible to us only in textual form, in principle and not only in practice'.[70]

In a related article Ricoeur applies this concept to revelation. His aim, he says, is 'to carry the notion of revelation back to its most originary level, the one, which for the sake of brevity, I call the discourse of faith or the confession of faith'. His subsequent discussion of various biblical genres shows that the latter terms refer primarily to the Bible. In Bible-reading, rather than 'transforming these different forms of discourse into propositions, we encounter a concept of revelation that is pluralistic, polysemic, and at most analogical in form'.[71] This is where Ricoeur wants theology to start. We should not begin with some philosophical notion that 'God exists'; rather, if we succeed in avoiding turning the Bible into nothing other than assertion and proposition, 'we arrive at a polysemic and polyphonic concept of revelation'.[72]

This model insists on the irreducibility of biblical polyphony while, unlike Wallace, providing no extra-biblical criteria by which to de-emphasize certain biblical names for God. In

[70] Francis Watson, *Text, Church and World: Biblical Interpretation in Theological Perspective* (Edinburgh: T. & T. Clark, 1994), 224–5.

[71] Paul Ricoeur, 'Toward a Hermeneutic of the Idea of Revelation', in Ricoeur, *Essays on Biblical Interpretation*, ed. Lewis S. Mudge (London: SPCK, 1981), 73–118, at 74–5.

[72] Ibid., 90–2. For the significance of Ricoeur's proper recognition of the polyphonic nature of revelation, see David Tracy's summary of the recent history of the doctrine of revelation, in which he has Ricoeur's contribution specifically in mind: 'The need for second-order, conceptual discourse for a doctrine of revelation was studied with care and precision. The contours of the actual first-order religious discourse of the Scriptures (prophetic, narrative, poetic, wisdom, proverbial, parabolic, letters, hymnic) were, with a few notable exceptions, left largely unthematized until the last fifteen years' (David Tracy, *On Naming the Present: God, Hermeneutics, and Church* (London: SCM Press, 1994), 109–10).

Chapter 3, Karl Barth's conviction that human language is simply incapable of referring to God qua *human* language was noted. Ricoeur, by contrast, regards 'poetic discourse', by which he means a diversity of literary genres, as fundamentally capable of performing something more than an act of reference: 'My deepest conviction is that poetic language alone restores us to that participation-in or belonging-to an order of things which precedes our capacity to oppose ourselves to things taken as objects opposed to a subject.'[73] Eberhard Jüngel, we saw in Chapter 3, ascribes this capacity uniquely to the genre of parable; Ricoeur ascribes it uniquely to literary genres in their diversity. Like Barth, though, he adds that biblical poetic language is unique in that the Name of the unnameable God is the vanishing-point of all the Bible's partial discourses about God.[74] One may ask, however, whether the divine referent of human biblical language is unique in this way. Not even a human person is fully captured by a single discourse; as referents of the discourse of others and of ourselves about ourselves, we too escape each of them, but may be known and referred to, by ourselves and others, partially but nevertheless adequately and truly, as the common goal which escapes each of the discourses themselves. As God presents himself to us in the world, the biblical canon, by virtue of its polyphonic inter-canonical poetic functions, allows us to name him in the same way. Kevin Vanhoozer argues thus:

in an important sense, we can say what lies beyond our words. While we may not have nouns that 'name' God, speaking is more than a mere matter of 'labelling' the world. . . . Where individual words are unable to articulate the majesty and glory of God, sentences succeed in so doing. I do not wish to be misunderstood. I am not suggesting that sentences describe the divine reality without remainder, but rather that some sentences themselves contain a 'surplus of meaning' (Ricoeur) which is richer than any literal paraphrase.[75]

What Vanhoozer describes as a 'surplus of meaning' at the level

[73] Ricoeur, 'Toward a Hermeneutic', 101.

[74] Ibid., 104.

[75] Kevin Vanhoozer, 'God's Mighty Speech-Acts: The Doctrine of Scripture Today', in Philip E. Satterthwaite and David F. Wright (eds.), *A Pathway into the Holy Scripture* (Grand Rapids: Eerdmans, 1994), 143–81, at 172 n. 92.

of the sentence, we call, also following Ricoeur, the polyphonic circulation of meaning, exceeding the capacity of any one of the individual discourses, at the level of the canon as a whole.

Canonical polyphony and biblical authority

Walter Reed, it was noted above, thinks that the diversity of the canon is always an embarrassment to the 'biblical theologian'. However, given Bakhtin's arguments about the sheer complexity and irreducible heteroglossic nature of even the simplest utterance, and Ricoeur's work on the multiple but convergent literary means by which the Bible refers to God, it is possible to account for a greater degree of canonical diversity than Reed supposes before the 'biblical theologian' need blush in the face of the biblical texts. Both the Bible's literary forms and its content, that is, its literary genres and its thematic statements, offer different points of view on reality. The themes of election, justification, adoption, and reconciliation, for example, are each partially and truthfully expressive of the reality of God's act of salvation as it is depicted in the Bible. Moreover, when expression is given to any of these themes in different literary genres, different viewpoints on that theme, that is, different illocutionary stances, emerge. For example, on the theme of adoption, there are narratives which demonstrate the reality of God's act of adoption of a people in history, prophecies which speak direct encouragement regarding the future for those who have been adopted, psalms which provide models of praise to God for his act of adoption, sets of laws which prescribe how those adopted by God should live, and so on. As far as biblical interpretation is concerned, then, we propose a model of 'traditional intertextuality', in the sense given by Plett: the interpreter must be aware of the extent to which canonical texts, in the wealth of their mutual quotations, and especially of their literary and thematic allusions to each other, speak polyphonically of God and his action in the world.

When the Bible is viewed as a collection of diverse texts, what is described here is a set of *inter*textual relationships. Since 'canon' also implies a clearly delimited set of texts which can equally be regarded as together forming a single text, this intertextuality may also be called an '*intra*textuality'. 'Intratextuality' is a term made prominent in recent theology by George

Lindbeck, who speaks of 'intratextual theology'. Lindbeck writes: 'Intratextual theology redescribes reality within the scriptural framework rather than translating Scripture into extrascriptural categories.'[76] Viewing the Bible as basically a single text, Lindbeck argues that the Bible itself should be allowed to establish the conceptual world within which theology should think about God and the world. Although Lindbeck seems to be offering a philosophically realist approach to truth here, proposing only a redescription of reality, there is in fact disagreement over whether his overall post-liberal project adopts a basically realist or non-realist view of biblical language about God.[77] More decidedly realist is Watson's notion of 'intratextual realism', referred to above, and it is within that philosophical position on the nature of truth and reference that the present work is located. We supplement it with Ricoeur's basic hermeneutical view of the Bible, and Bakhtin's philosophical work on language, to provide an account of how the Bible speaks 'polyphonically' of the realities of God and the world.

To determine how far the diversity of the Bible's content can stretch before its polyphonic unity breaks—that is, before it becomes unworkable as the supreme authority in the church—is of course an enormous task. However, as a preliminary to such work, it can be argued, on the basis of such observations as Ricoeur's, supplemented by a Bakhtinian philosophy of language, that it can and must stretch further than is often supposed. The diverse nature of the referents of Scripture—God, humankind, the world, God's action in Christ, protology and eschatology, the history of redemption—seem to require, as regards both theme and genre, a wide range of 'partial discourses', and a high degree of heteroglossic languages (complex 'speech genres') in the canon, if the texts are to render the

[76] George Lindbeck, *The Nature of Doctrine* (London: SPCK, 1984), 118. Lindbeck's 'intratextuality' was briefly referred to in relation to Hans Frei in ch. 4.

[77] 'George Lindbeck's *The Nature of Doctrine* is . . . an extended exploration and defence of theological non-realism' (Watson, *Text, Church and World*, 133). Mark Brett takes the opposite view (referred to in Iain Provan, 'Canons to the Left of Him: Brevard Childs, His Critics, and the Future of Old Testament Theology', *Scottish Journal of Theology* 50 (1997), 1–38, at 25 n. 51).

referents to readers at all adequately.[78] If a unique hypostatic union of human and divine natures really did take place in the person of Jesus of Nazareth as the culmination of a process of divine action in history, anything less diverse than the canon of Scripture we have might be thought too simplistic to speak of such a reality.[79] John Goldingay writes, in a work which shares a similar view of the Bible's theological diversity: 'Recognizing the complexity of reality itself, we attempt the task of comprehending as fully as we can that complex reality as a whole, in the light of the witness the OT has given to various aspects of it in unsystematic ways.'[80] What confronts us in the Bible is what David Tracy has called 'the extraordinary complexity of a full scriptural understanding of the many faces of God disclosed in the many scriptural genres to name God'.[81] If the canonical texts of Scripture ultimately sing in unison about the whole complex reality of divine redemption of humankind in Jesus Christ, that is only by virtue of their singing polyphonically, in unsystematic, mutually supplementing ways. The term 'polyphony' is preferred here over 'symphony', a term which Origen used to describe the relationship between Old and New Testaments, because it better expresses the unsystematic nature of the canonical and literary shape in which the biblical material presents itself to us.[82] Biblical

[78] See Michael Fox's comment that in biblical interpretation '[m]uch of what is called indeterminacy is actually effective mimesis of a determinate but complex reality' (quoted in Vanhoozer, *Is There a Meaning?*, 302).

[79] In speaking of 'the canon of Scripture *we* have', no distinction between different Christian versions of the biblical canon, such as the different lists of Roman Catholic and Protestant canons, and the different forms of Hebrew and Greek canons, is necessarily made here. As regards diversity at the theoretical level of the present discussion, they are similar enough to one another to be described under the same categories. More specific historical questions about *which* canon is confessed to be sufficient will be addressed briefly in the following section on B. S. Childs's hermeneutics.

[80] Goldingay, *Theological Diversity*, 184.

[81] Tracy, *On Naming the Present*, 33.

[82] On Origen, see J. N. D. Kelly, *Early Christian Doctrines* 5th edn. rev. (London: A. & C. Black, 1977), 69. In this regard, Metzger offers a historical account of biblical unity-in-diversity which the present theological account serves to complement: 'The homogeneity of the canon is not jeopardized even in the face of tensions that exist within the New Testament. These tensions, however, must not be exaggerated into contradictions as a result of giving inadequate consideration to the divergent situations within the early Church

polyphony neither reduces into univocity nor dissipates into cacophony, just as Paul's discourse neither collapses into nor contradicts the Old Testament in its simultaneous indwelling of it and moving beyond it.

THE SUFFICIENCY OF THE CANONICAL FORM: THE HERMENEUTICS OF B. S. CHILDS

Childs's 'Canonical Approach'

B. S. Childs is well known for having made the most concerted recent attempt to restore the canon to a central place in biblical studies. Early in his career he offered a programmatic outline of a new direction for biblical studies, in which he assumed the necessity of moving beyond historical-critical description to 'theological exegesis'. *Theological* exegesis is legitimate, he argued, because it is commensurate to the theological content of the biblical texts in a way that historical-critical exegesis alone is not; it is necessary because exegesis must take account of the theological reality which brought into being the witness of the text.[83] As Childs later made clear, he did not aim to supersede critical readings of the Bible with a new methodological 'canonical criticism'; rather, he wanted an overall 'canonical approach', 'a stance from which the Bible can be read as sacred scripture'.[84] His chief aim has been, in the wake of the failure of the American Biblical Theology Movement, to find a means to further the Movement's basic aim of recovering 'a theologi-

to which the writers addressed themselves' (Metzger, *The Canon of the New Testament*, 280–1).

[83] Brevard S. Childs, 'Interpretation in Faith: The Theological Responsibility of an Old Testament Commentary', *Interpretation* 18 (1964), 432–49, at 438, 443.

[84] Brevard S. Childs, *Introduction to the Old Testament as Scripture* (Philadelphia: Fortress Press, 1979), 82. Mark Brett argues that this distinguishes Childs from James Sanders, whom he calls a canonical *critic*. Sanders, he says, like historical critics, is interested in the construction of the canon; Childs is interested in the final result of the process, the Hebrew canon of the first century AD (Mark G. Brett, *Biblical Criticism in Crisis? The Impact of the Canonical Approach on Old Testament Studies* (Cambridge: Cambridge University Press, 1991), 20).

cal dimension of the Bible'.[85] He has pursued this by arguing that the final canon is the most appropriate basis on which biblical theology may be done.[86] Childs has endeavoured to put his theological exegesis into practice in a series of books over the past thirty years, culminating in his most recent large work, *Biblical Theology of the Old and New Testaments* (1992).

Although Childs has changed his position on certain emphases and points of detail over the years, the key themes of his work have remained unaltered since the publication of his foundational article. He has kept to his basic claim that the concept of the canon is an intrinsic aspect of the biblical texts as we now have them, and so must be taken seriously. The canon is the end result of a process of selecting and redacting texts which served as a normative authority, first in ancient Israel and then in the early Christian church. The object of critical biblical study must be the final form of the texts, for that alone bears witness to the full history of revelation. It is precisely by taking note of this canonical aspect of the texts that the church will continue to be able to appropriate the biblical texts in its contemporary life, for the process of canonical shaping evident within the canon demonstrates how texts from earlier situations were readdressed to later generations. For example, Second Isaiah, originally a sixth-century text, has become, by virtue of its canonical placing, 'a prophetic word not tied to a specific historical referent, but directed to the future'.[87] Childs contends that critical biblical scholarship rendered the text theologically mute for the contemporary church precisely because it stripped away these canonical elements in order to arrive at some historical event or religious mind-set.[88] Overall, it has been said, Childs regards the canon as sufficient for the guidance of the church.[89] In examining here his implied concept of the sufficiency of Scripture, the focus will be on how he justifies the

[85] Brevard S. Childs, *Biblical Theology in Crisis* (Philadelphia: Westminster Press, 1970), 33.

[86] Ibid., 99.

[87] Brevard S. Childs, 'The Exegetical Significance of Canon for the Study of the Old Testament', *Vetus Testamentum Supplements* 29 (1977), 66–80, at 70.

[88] Iain Provan provides a very clear and concise summary of this aspect of Childs's programme: Provan, 'Canons to the Left of Him', 3–4.

[89] Watson, *Text, Church and World*, 43–4.

principle of canonical self-interpretation to which he holds, and which funds what he takes to be 'theological' interpretation.

In general, Childs's work has so far met with more rejection than acceptance, although of late his work has found at least three readers who think that there is some merit in defending his basic insights, while attempting to re-formulate and correct what they see to be the weaknesses of his work. These three are Mark Brett, Paul Noble, and Iain Provan.[90] Subsequent sections will take what for present purposes have been the two most significant areas of discussion relating to Childs's work: what Childs actually means by the concept 'canon', and the basis on which he proposes the final form of the texts as the proper object of biblical study.[91] A final section will reflect on what seems to be a theological assumption that Childs makes, namely, that the canon of Scripture, authored multiply by human authors, is also authored singly by God.

Childs's Concept of 'Canon'

Childs defines 'canon' as 'that historical process within ancient Israel, particularly in the post-exilic period, which entailed a collecting, selecting, and ordering of the texts to serve a normative function as Sacred Scripture within the continuing community'.[92] However, distinct from the historical-critical programme of attempting to reconstruct the interesting and complex prehistory of the biblical texts, Childs invokes the concept of 'canon' in order to limit the scope of the study of this process to the extent that it can be found embodied in the final form of the texts: 'Canon implies that the witness to Israel's experience with God lies not in the process, which has usually been lost or purposely blurred, but is testified to in the effect on the biblical text itself.'[93]

[90] Brett, *Biblical Criticism in Crisis?*; Paul R. Noble, *The Canonical Approach: A Critical Reconstruction of the Hermeneutics of Brevard S. Childs* (Leiden: Brill, 1995); Provan, 'Canons to the Left of Him'.

[91] There is a danger in reading some of the details of Childs's work synchronically and too systematically, for he has changed his position on various issues over the years. However, he has been quite consistent in emphasizing the primacy of the final form of the canon.

[92] Childs, 'The Exegetical Significance', 67.

[93] Ibid., 69.

Some writers claim to detect in this emphasis on 'the biblical text itself' the influence on Childs of general trends in wider literary theory. Mark Brett calls Childs's canonical approach to the Bible 'formalist', and one which requires 'a theory of relatively autonomous meanings'.[94] Similarly, John Barton insists that Childs has been greatly influenced by New Criticism,[95] and James Barr suggests a parallel with structuralist reading practices.[96] Noble points out, however, that when Childs comes to interpret biblical texts he does not employ formalist reading practices, which might focus on, for example, the plot and characters of biblical narrative. Rather, he is interested in the function of the text as a theological norm. In practice, he seems to work in territory very different from that of literary critics, and therefore to label him directly with a term borrowed from literary criticism involves something of a category mistake.[97]

The nature of Childs's basic concern in raising the issue of the canon becomes evident when the question of the meaning of the canonical texts arises, for here he modifies somewhat his understanding of 'the biblical text itself'. In his essay on the literal sense of the Bible, he suggests that one way in which exegesis can ensure that it does not end up divorcing text from reality is by studying the biblical text 'in closest connection with the community of faith which treasured it. . . . The literal sense of the text is the plain sense witnessed to by the community of faith'.[98] When this point is put theologically, the following conclusion results: 'the Church's *regula fidei* encompasses both

[94] Brett, *Biblical Criticism in Crisis?*, 26 (see also 69, 115). Brett argues that Childs has wrongly been called a kind of redaction critic by some, but also notes that, within Childs's focus on 'the text itself', 'his exegetical interest is actually founded on an account of editorial motives' (Brett, *Biblical Criticism in Crisis?*, 20).

[95] John Barton, *Reading the Old Testament: Method in Biblical Study* (London: Darton, Longman & Todd, 1984), 141–2. Barton acknowledges that any debt Childs owes to New Criticism is not deliberately undertaken.

[96] James Barr, *Holy Scripture: Canon, Authority, Criticism* (Oxford: Clarendon Press, 1983), 158. [97] Noble, *The Canonical Approach*, 42.

[98] Brevard S. Childs, 'The Sensus Literalis of Scripture: An Ancient and Modern Problem', in Herbert Donner et al. (eds.), *Beiträge zur alttestamentlichen Theologie* (Göttingen: Vandenhoeck & Ruprecht, 1977), 80–93, at 92. This definition of the literal sense seems to be very similar to that developed a few years later by Hans Frei in a late essay, and defended by Kathryn Tanner; both were discussed in ch. 4.

text and tradition in an integral unity as the living Word of God'.[99]

Thus, a certain blurring between text and community takes place in Childs's practical handling of the biblical canon. It follows that significant hermeneutical problems arise for Childs in what is at heart the question of authority. On the question of where the authority of Scripture is to be grounded, Douglas Knight judges that Childs does not make clear whether it is 'in the literature by virtue of some special character it has, or in the community which chooses to vest the literature with authority, or in some other source (such as the deity) external to these other two'.[100] At times, Childs seems to think of 'canon' as identifying certain features of the text, such as its witness to revelation, but at other times the term seems to refer to the community's use of the text. Childs's direct response to Knight's charge was simply to acknowledge his observation, without either resolving or defending the ambiguity.[101]

It can also be unclear in Childs's work which community it is that defines the 'literal sense' of a biblical text. In his earlier work, quoted above, the community in question seems to be the community which was responsible for the production and compilation of the final form of the canon. In a more recent work, the 'community' seems to extend broadly, as in Hans Frei's later work, to the (undefined) 'church' in general throughout history: 'The term canon as used throughout this volume functions as a theological cipher to designate those peculiar features constitutive of the church's special relationship to its scripture.'[102]

[99] Childs, 'The Sensus Literalis', 93. See also: 'the theological enterprise involves a construal by the modern interpreter, whose stance to the text affects its meaning' (Brevard S. Childs, *Old Testament Theology in a Canonical Context* (Philadelphia: Fortress Press, 1985), 12).

[100] Douglas A. Knight, 'Canon and the History of Tradition: A Critique of Brevard S. Childs' Introduction to the Old Testament as Scripture', *Horizons in Biblical Theology* 2 (1980), 127–49, at 140. Noble agrees, arguing that Childs locates authority in both text and community, without showing how these two *loci* of authority are to be correlated (Noble, *The Canonical Approach*, 62–3).

[101] Brevard S. Childs, 'A Response', *Horizons in Biblical Theology* 2 (1980), 199–221, at 209.

[102] Brevard S. Childs, *Biblical Theology of the Old and New Testaments* (London: SCM Press, 1992), 721.

The above points on the *locus* and ground of authority can be identified as the main *theological* difficulties with Childs's lack of clarity in both his defining of 'canon' and his practice of canonical interpretation. Bruce Metzger introduces a helpful distinction between theological and historical questions about the canon: 'Discussions of the *notae canonicitatis* . . . should distinguish between the ground of canonicity and the grounds for the conviction of canonicity. The former has to do with the idea of canon and falls within the province of theology; the latter has to do with the extent of the canon and falls within the domain of the historian.'[103] While it is on the former that the present discussion concentrates, it should be noted incidentally that, as a biblical scholar, some of Childs's main critics have been other biblical scholars who have presented primarily *historical* objections. It lies beyond the scope of the present work to engage these historical questions in detail. However, the two most important issues can be briefly outlined, and our reconstruction of scriptural sufficiency located in relation to these questions. The areas of historical research from which the overall thesis of this book might draw support will be noted.

First, there is the question of whether the concept of canon as a closed list of books can only be applied anachronistically to the first century. Following the basic outlines of work done by A. C. Sundberg, both James Barr and John Barton have distinguished between 'scripture' and 'canon'. They take 'scripture' to refer to an open set of authoritative religious texts, and 'canon' to a closed collection of texts.[104] They argue that the core texts of both the Old and New Testaments reveal a self-understanding as 'scripture', but that there was no sense that either the Jewish or Christian Scriptures, in the first few centuries of the Christian era, existed in the form of a closed 'canonical' list of books.[105] Barr concludes that the concept of 'scripture', that is, of certain texts which bear a religious authority, is essential for biblical Christianity, but that 'canon', a determinate list of authoritative books, is not.[106]

[103] Metzger, *The Canon of the New Testament*, 284.
[104] e.g. John Barton, *Oracles of God: Perceptions of Ancient Prophecy in Israel After the Exile* (London: Darton, Longman & Todd, 1986), 30.
[105] Ibid., 55; John Barton, *The Spirit and the Letter: Studies in the Biblical Canon* (London: SPCK, 1997), 24–8. [106] Barr, *Holy Scripture*, 63–4.

This view has been contested by Roger Beckwith, in a work on the formation of the Old Testament canon. While hostile to its conclusions, Barton calls this work 'a completely authoritative compendium of all the evidence we have on the subject'.[107] Beckwith argues that from the second century BC onwards the Old Testament had 'a settled structure', such that for Jesus only the books of the Hebrew canon were Scripture.[108] Barton argues vigorously that Beckwith has drawn wrong conclusions—wrong because anachronistic—from largely correct historical observations.[109] This debate, as conducted in Barton's and Beckwith's reviews of each other's work, seems to depend greatly on whether or not one allows that the ancient listing of books considered Scripture counts as evidence of the awareness of canon as an exclusive collection.[110]

Iain Provan and John Goldingay both question this distinction between 'scripture' and 'canon', suggesting that Barton's notion of 'scripture' implies that some books are not authoritative, such that some limitation, some 'canon', is unavoidably invoked. That at a certain point in time the canon was not closed does not mean that there was no consciousness of canon; one can be conscious simultaneously of a principle of canonicity and of the fact that there is more canonical material to come.[111]

[107] John Barton, review of Roger Beckwith, *The Old Testament Canon of the New Testament Church*, *Theology* 90 (1987), 63–5.

[108] Roger Beckwith, *The Old Testament Canon of the New Testament Church* (London: SPCK, 1985), 164.

[109] He does not contest Beckwith's facts, but argues that the conclusions he draws from them are 'pure fantasy' (Barton, review of Beckwith, 64).

[110] Barton thinks that, before the fourth century, interest in such lists had a 'comparatively abstract and theoretical character' (Barton, *The Spirit and the Letter*, 28), and that Beckwith wrongly concludes what an ancient writer intended to say from mere casual utterances (Barton, review of Beckwith, 65). Beckwith argues that Barton thereby illegitimately discounts most of the evidence that would count against his view (R. T. Beckwith, 'A Modern Theory of the Old Testament Canon', *Vetus Testamentum* 41 (1991), 385–95, at 393–5). Indeed, Barton does seem to set excessively demanding criteria for the historical evidence to count as evidence of 'canonical', rather than just 'scriptural', awareness. Beckwith might be able to mount an argument from silence, to the effect that Barton is more guilty of anachronism than he is: the 'canon' as Beckwith perceives it was self-evident to ancient writers, and, not having Barton to argue with, they did not write as discriminatingly as he now requires of them.

[111] Provan, 'Canons to the Left of Him', 5–11. See also: 'Scripture does not

The fundamental question is the extent to which inclusivity implies exclusivity, in the case of the biblical canon.[112] Childs himself questions Sundberg's original distinction, arguing that '[t]he formation of the canon was not a late extrinsic sanctioning of a corpus of writings, but involved a lengthy series of decisions deeply affecting the shape of the material'.[113] As far as the present work is concerned, it is not strictly necessary to agree with Beckwith on the precise dating of the closure of the Old Testament canon. However, that the canon is now closed, and that 'canon' as a closed list is essential to Christianity, are necessary corollaries of the claims that Scripture is fundamentally separate from the church as a voice from outside, and that Scripture interprets itself.

Second, there is the question of which Bible is to be thought of as the 'correct' Old Testament of the Christian Bible. Goldingay summarizes the two basic positions: the Protestant view is that the Hebrew canon is the right one, and the Roman Catholic and Orthodox view prefers a version of the Greek Bible.[114] Various attempts at mediation between the two positions have been made. Dominique Barthélemy has argued forcefully for a critical modification of the Roman Catholic view, asserting that the Old Testament has two mutually supplementing original forms—the Hebrew canon and the Septuagint. He asserts this on the basis that the latter was 'Holy Scripture' for the Christian church for the first four centuries of its existence, and that no biblical criticism may be allowed to undo that by declaring the Greek text inauthentic.[115] Rolf Rendtorff thinks that it makes no difference which of the two we take as that adopted into Christian Scripture, 'for in the

become canonical only when there is a formal canon. To reserve the notion of "normativity" for canon as opposed to "scripture" is to render the latter expression vacuous' (John Goldingay, *Models for Scripture* (Grand Rapids: Eerdmans, 1994), 104).

[112] 'To call some writings "scripture" is implicitly to give them a significance denied to other writings; to include is implicitly also to exclude' (Goldingay, *Models for Scripture*, 104).

[113] Childs, 'The Exegetical Significance', 67.

[114] Goldingay, *Models for Scripture*, 168.

[115] Dominique Barthélemy, 'La place de la Septante dans l'Église', in Barthélemy, *Études d'Histoire du Texte de l'Ancien Testament* (Göttingen: Vandenhoeck & Ruprecht, 1978), 111–28.

Septuagint too the Holy Scriptures are summed up as "the Torah and the Prophets," as New Testament citations show (Matt. 5:17; 7:12, and frequently)'.[116] Childs, in agreement with the Protestant Reformers, advocates the supremacy of the Hebrew Bible, which is recovered through the Masoretic Text, since, he argues, in the first century it achieved a stability which no other version did.[117] The basic doctrine of Scripture argued for in the present work presupposes the legitimacy of Childs's argument about stability, since a 'sufficient' Scripture must be a stable Scripture.

Does this mean that the doctrine of the sufficiency of Scripture can tolerate no 'fuzziness' around the edges of the canon—over the book of Esther, for example? To the extent that such a book has no substantive theological content not also found in at least one other canonical book, it may be possible to affirm the sufficiency of Scripture and also in practice live unproblematically with a canon without sharply defined edges. A canon without the book of Esther would not be substantially different theologically from one with it, although it may lack an important witness to an aspect of a particular period of the history of Israel. A canon with, say, the book of Esther permanently on the edge might seem a sensible middle option. However, what has been argued in previous chapters about the importance of offering a clear theological account of God's tying of his Word to a certain set of human texts suggests that the sufficiency of Scripture, although in practice it can and does function with unresolved questions over a small number of marginal books, cannot tolerate a *principial* 'fuzziness'. In the end, God either has or has not tied his Word in part to the book of Esther. It seems, in general, to be the case that a lack of absolute certainty over whether some marginal books do or do not belong in the canon does not overthrow the sufficiency of Scripture.[118] This is analogous to the enterprise of biblical

[116] Rolf Rendtorff, *Canon and Theology: Overtures to an Old Testament Theology*, trans. and ed. Margaret Kohl (Minneapolis: Fortress Press, 1993), 55. This is in contrast to Barton, who argues that the different ordering of the books in the two forms of the Old Testament demonstrates that, in the Hebrew, Torah is thematically central, and, in the Greek, prophecy (Barton, *Oracles of God*, 21–3).

[117] Childs, *Introduction to the Old Testament*, 97–100.

[118] See Metzger's comment that what is remarkable about the Bible in the

textual criticism, for although we cannot be certain of precisely where the current best texts deviate from the biblical autographs, that 'fuzziness' at the margins does not itself make it illegitimate to identify the Bible with the Word of God, as a basis for faith and practice.[119]

Why Focus on the Final Form of the Bible?

Childs offers various reasons for his advocacy of the final form of biblical texts as the object of biblical interpretation. Three prominent reasons may be identified: one hermeneutical, one literary, and one theological. At a basic hermeneutical level, the final form offers at least a common object of study as the grounds for theological reflection.[120] Childs thinks that this is a positive advantage over historical criticism, which often bases a great deal on reconstructions of phenomena behind the text which, given our necessarily limited knowledge of the history of ancient Israel and its texts, could only ever remain conjectural, and so of little practical value for the church's contemporary theological appropriation of Scripture.[121] Second, from a

early church is not that some 'fringe' books were debated over several centuries, but that in congregations scattered across a huge geographical area a high degree of unanimity over which books to include in the canon and which to exclude was reached in the first two centuries (Metzger, *The Canon of the New Testament*, 254).

[119] Childs seems to have come to a similar position to this in his later work, *Biblical Theology of the Old and New Testaments*. According to Provan, he thinks that '[j]ust because the outer limits of the Christian canon remained unsettled, or because the role of translations was assessed differently among various groups of Christians, the conclusion cannot be drawn that the church has functioned without a scripture or in deep confusion. The areas of disagreement, in fact, have made little theological or practical difference.' Childs therefore now talks about 'the *search* for the Christian Bible', which Provan rejects as inconsistent with his actual exegetical practice, in which 'Childs seems to know exactly which OT he is working with, on the whole; and it is largely the same OT as before' (Provan, 'Canons to the Left of Him', 12–16). To call the position we have suggested—i.e. within the context of a predominantly established canon debates continue over a few marginal books, with some 'fuzziness' tolerated at the edges of the canon—a *search* for a Christian Bible is to use too strong a term.

[120] Childs, 'The Exegetical Significance', 79. In his desire for a commonly agreed object of study Childs shares a concern similar to E. D. Hirsch; see ch. 4. [121] Childs, *Introduction to the Old Testament*, 40.

literary point of view, the texts as we have them are not con-
ducive to the kind of analysis which historical criticism wishes
to perform. This is so because in the Old Testament 'the
various elements have been so fused together as to resist easy
diachronic reconstructions which fracture the witness of the
whole'.[122] Third—theologically, and most importantly—only the
final form 'bears witness to the full history of revelation. . . .
It is only in the final form of the biblical text in which the
normative history has reached an end that the full effect of this
revelatory history can be perceived.'[123]

The hermeneutical argument does not carry much weight,
since it just takes for granted that historical criticism was wrong
to assume that the easier path is not necessarily the better—
that, despite the attractiveness of 'simply' reading the final
form, we must not be distracted from the difficult task of recon-
structing earlier textual layers. The literary argument depends
on a similar implicit appeal. No historical critic in fact suppos-
es that diachronic reconstruction is easy. Rather, realizing that
the supposed historical layers of a biblical text cannot be split
apart as neatly as a piece of slate tapped gently at the right
point, the critic attempts to push beyond whatever mechanisms
of resistance are built into the final form of the texts, in order
to treat supposed earlier witnesses with full integrity.

This leaves us with the theological basis which Childs gives
for his advocacy of final-form reading. Many of Childs's read-
ers have found this third and most significant argument, as the
centre of his approach, especially difficult to accept. Barr argues
that, for all that Childs attacks historical criticism, his approach
differs from it not so much in framework and method, but
simply in 'its will to focus on a different *segment* of historical
and literary development, namely the approach to the final
text'.[124] Childs's conception of 'canon', which ties together the
text and its writing-community, suggests that this observation
is basically correct. This must raise for Childs the question of

[122] Childs, *Old Testament Theology*, 11.

[123] Childs, *Introduction to the Old Testament*, 76.

[124] Barr, *Holy Scripture*, 103. In fact, Childs's conscious attitude to histori-
cal criticism, in both theory and practice, is more ambivalent than Barr sug-
gests. From Provan's (very different) point of view, Childs accepts too many
of the conclusions of historical criticism uncritically (Provan, 'Canons to the
Left of Him', 25–9).

why the text, that is, the interpretation, of one particular com-
munity at a particular point in Israel's history should be privi-
leged. Douglas Knight objects to this privileging of the final
redacting and canon-forming community, which he thinks over-
emphasizes what had, he admits, been 'a neglected phase' in the
development of the biblical literature.[125] His main accusation is
that Childs does not exercise enough suspicion in his hermen-
eutical attitude to the compilers and redactors of the final form,
for his approach must assume what cannot be known for cer-
tain, namely, that their motives were both pure and entirely
theological, rather than ideological, political, or sociological.
Rudolf Smend insists that each stage of the biblical tradition
must be attended to equally, 'precisely because their [the bibli-
cal redactors' and compilers'] theological judgement cannot
be trusted'.[126] Brett concludes that Childs offers only a weak
response to the suggestion that 'the final form is simply a monu-
ment to the victors of vicious conflict', and that the suspicion
arises that below the surface he is invoking a doctrine of the
Holy Spirit to justify a privileging of the final form of the
texts.[127]

Behind such objections appears to lie a disagreement with
Childs over the nature of divine revelation in history. If God is
thought of as revealing himself to his people in increasing
measure over time, in the course of a teleological process of
salvation worked out within history, then there is a prima facie
case for privileging the witness of the later communities who
were witnesses to the greatest extent of that revelation. Childs
does not articulate it as such, but that seems to be his underly-
ing view of revelation. A reading of the Old Testament which
assumes this view of revelation will naturally give theological
privilege to the later compilers of the final form of the canoni-
cal texts. It is their historical location, rather than some special
moral quality of trustworthiness which they supposedly pos-
sessed and earlier writers supposedly lacked, that gives their
text theological priority. By contrast, behind the objections of
those who criticize Childs on this point may lie a history-of-

[125] Knight, 'Canon and the History of Tradition', 130.
[126] Brett, *Biblical Criticism in Crisis?*, 97, summarizing Smend's position.
[127] Ibid., 133–4. This latter suggestion will be developed below in relation
to a doctrine of biblical inspiration.

religions approach which treats the Old Testament as a set of responses to a divine revelation which is accessible to all from the beginning, and is not given and developed in any special way in the particularities of history. In this view, every Israelite generation has the same possibility for insight into and understanding of 'revelation'.

In fact, Brett rightly points out that Childs's position involves something more subtle than simply trusting the judgements of one community, or of a small number of communities, towards the end of the Old Testament period. Childs, he says,

has not arbitrarily privileged the canonizing generations over all the others; he has repeatedly affirmed that much old material has found its way into the final form. However, he is disposed to accept the decisions of the successive biblical communities as both theologically and exegetically important. He has shown no desire to remake decisions about the relative value of the variety of theological traditions found in the Bible.[128]

Childs's canonical approach is therefore fundamentally a hermeneutics of trust, not suspicion, applied to successive generations of canonical redactors and compilers.

An overall defence of a hermeneutics of trust was offered in the previous two chapters of this work. In addition, two particular points may be made here in support of Childs's position. First, it may be asked what a biblical canon which really was the end-product of ideological conflicts—a canon written by the winners—would look like. It would most likely be theologically quite homogeneous, for history written by the winners of a long fight usually tells only one story. The Old Testament, however, tells a wide variety of narrative and theological stories. Goldingay argues that '[d]ifferent groups had grasped aspects of the truth and each of those aspects came to be part of the canon. This may itself reflect the need for consensual as well as conflict models of the social processes that generated the canon.'[129] Second, Childs has partly created for himself the problem of having to trust an unknowable number of editorial decisions by agreeing with historical-critical biblical scholarship that a long and murky process of redaction does indeed lie behind the final form of the biblical texts. The apparent

[128] Ibid., 97–8. [129] Goldingay, *Models for Scripture*, 107.

problem of trusting in relatively inscrutable theological judge-
ments would be alleviated somewhat if those judgements could
be seen both as fewer in number and perhaps as more broadly
accepted by the wider religious community of Israel. This
would be the case if a much lower level of redactional activity
were posited behind the texts. Provan points out that increas-
ingly careful reading of the final form of the texts has, in some
recent scholarship, led to a revised understanding of the redac-
tors as skilful and careful 'authors' in their own right, who did
far more than crudely piece texts together. The more artful a
supposed redactor can be shown to be, the more he begins to
look like the text's author, and the less his existence as a redac-
tor needs to be posited in order to account for the features of
the text. John Barton calls this the phenomenon of 'The Dis-
appearing Redactor'.[130] For example, R. W. L. Moberly refers
to work done on the Genesis flood narrative which explains the
features of the text in terms of the narrative art of its writer and
not of its prehistory. He concludes that it is likely that the more
final-form reading is practised on biblical texts in this way, the
more the results will justify the practice.[131]

This may alleviate anxiety over Childs's alleged hermeneuti-
cal gullibility to some extent, but it does not in itself offer a full
defence of his privileging of the final form. Why should one not
seek to look behind even one redactorial act, to discover if it in
fact wilfully or incompetently repressed an earlier and better
theological insight? A discerning Old Testament redactor with
access to an earlier stage of revelation might possibly have
borne better witness to God than a later one who, although he
had a longer and fuller history of revelation to look back on, had
various personal theological and political axes to grind. Childs's
lack of clarity on the *locus* of the authority of the Bible, which
was discussed above, resurfaces here. It has been argued that,
in the wake of the failure of the Biblical Theology Movement
to offer a convincing *material* principle to mark off the canon of
Scripture as normative, he has offered a purely *formal* principle,

[130] Barton credits Alec Motyer with being the source of this phrase (Barton,
Reading the Old Testament, 56–8, 219 n. 24). See also Provan, 'Canons to the
Left of Him', 27–8.
[131] R. W. L. Moberly, *At the Mountain of God: Story and Theology in
Exodus 32–34*, JSOT Supplement Series (Sheffield: JSOT Press, 1983), 27.

which will be able to tell us what to do with the biblical texts but will never be able to tell us why we should do it.[132] It is important to remember this scholarly context. Childs's predominant concern is not so much to advocate a hermeneutic of final-form reading of the Bible per se but to offer a new framework for the doing of biblical theology, following the failure of the Biblical Theology Movement. He arrives at final-form reading since he thinks it offers the best way forward for biblical theology, but in so doing pays insufficient attention to justifying it as a valid exegetical principle. This failure explains why, even in the work which represents the culmination of his career, *Biblical Theology of the Old and New Testaments*, Childs has made little progress towards explaining how his christological readings of the Old Testament avoid becoming the arbitrary imposition of Christian interpretation. As Noble points out, Childs shows what the early church did with the Old Testament, and himself reads Old Testament texts in a similar way, without ever showing that they were right—right, that is, from the viewpoint of the Old Testament—to do what they did.[133]

Brett attempts to supplement Childs's advocacy of the final form by seeking hermeneutical support in Gadamer's notion of the 'classic text'. According to Brett, Gadamer sees classic texts as illustrative of the principle that 'human life is deeply marked by the historical influences which can never be totally illuminated by critical reflection'.[134] The classic text is one which has proved itself by speaking for itself in each new situation; it is 'an exemplary written tradition which has demonstrated its validity throughout the vicissitudes of time'.[135] Brett argues that final-form reading can then be justified thus: 'It is the final form which has continued to demonstrate its truthfulness in new situations to those who have been transformed and tested by their conversation with this classic text.'[136] Noble, however, argues that the notion of a 'classic text' cannot rightly be

[132] Noble, *The Canonical Approach*, 31–2; Barr, *Holy Scripture*, 135.

[133] Noble, *The Canonical Approach*, 73–6.

[134] Brett, *Biblical Criticism in Crisis?*, 135.

[135] Ibid., 142–3.

[136] Ibid., 146. David Tracy has appropriated at length the concept of a 'classic text' for Christian theology; he summarizes his use of it in Tracy, *On Naming the Present*, 109–19.

applied to the Bible, precisely because the problem of the Bible in the world is that it, or at least significant parts of it, 'have largely *failed* to display the contemporaneity which the church expects of its Scriptures'.[137] Even if one argued that Childs belongs to a strand of Christianity for which the Bible has in fact never ceased to be a 'classic text', Noble's point simply reappears in another form: on what basis does Childs want to categorize the experience of his particular community as normative for those Christian communities for which the Bible *has* ceased to function as a classic text? Given Gadamer's conception, it is not clear on what basis one would even want to reinstate a previously 'classic' text in its former role, except perhaps for reasons of nostalgia, nor how one would justify the attempt. Noble is right to conclude that, for these reasons, Brett's attempt to find support for Childs's final-form readings in general hermeneutics fails; he argues that Childs's work ultimately requires *theological* supplementation from a doctrine of biblical inspiration.

The Canonical Approach: Multiple and Single Authorship

Noble suggests that, below the surface of Childs's advocacy of 'canonical context' as the appropriate one for biblical interpretation, quite a strong doctrine of inspiration seems to be doing a lot of work.[138] Indeed, in the course of his work Childs has occasionally appealed to inspiration. His analysis of the demise of the Biblical Theology Movement, in an early work, is that '[o]ne of the major factors in the breakdown of the Biblical Theology Movement was its total failure to come to grips with the inspiration of Scripture'. Childs sympathizes with this failing, saying that (what he calls) the fundamentalist tendency to attach a theory of inerrancy to inspiration had brought the doctrine into disrepute, and that the liberal attempt to relate inspiration to the religious imagination of the biblical writers did not offer 'a solid theological alternative'. The Biblical Theology Movement basically replaced the inspiration of Scripture with a theology of Scripture as revelation, and Childs concludes that

[137] Noble, *The Canonical Approach*, 283.
[138] Ibid, 30–1.

this was a failure: 'The strain of using orthodox Biblical language for the constructive part of theology, but at the same time approaching the Bible with all the assumptions of Liberalism, proved in the end to cause an impossible tension.' Childs then offers his own rather vague description of inspiration, which is more a statement of how the doctrine functions, than a formal definition of it: 'the claim for the inspiration of Scripture is the claim for the uniqueness of the canonical context of the church through which the Holy Spirit works'.[139] However, in his later work Childs has not clarified this tentative understanding of inspiration, nor reflected at length on the extent to which his own biblical theology might be dependent on a doctrine of inspiration. Since he judged that the same omission contributed greatly to the demise of the Biblical Theology Movement, this is a sizeable gap in his own overall biblical-theological project.

Noble has attempted to develop a stronger ground for Childs's basic approach by supplementing his work with a doctrine of inspiration. He points out that Childs's contention that the meaning of a biblical text should be arrived at by interpreting it in the context of the whole canon 'is formally equivalent to believing that the Bible is so inspired as to be ultimately the work of a single Author'.[140] The closest Childs comes to a recognition of this is when he speaks of 'canonical intentionality'. However, he has regularly left this term quite vague, presumably because to clarify what he means by it would require the kind of discussion of single divine authorship of the canon and its relation to the authorial activity of the human Bible-writers which he has avoided. This, however, is all that Noble says directly on the inspiration of the Bible; he is concerned, instead, to go on to discuss how the invocation of the single divine authorship of the Bible should affect exegesis. His basic suggestion, though, is persuasive, and in the subsequent section a fuller discussion of the inspiration of Scripture will be offered, as a necessary supplement to Childs's canonical approach to Scripture.

Noble invokes divine authorship of the whole Bible in order

[139] Childs, *Biblical Theology in Crisis*, 103–4. See also his claim that revelation may not be appealed to apart from inspiration (Childs, 'The Sensus Literalis', 92).

[140] Noble, *The Canonical Approach*, 340.

to answer the question of how a particular text can be interpreted in a canonical context, and be said to mean something which the original writer could not possibly have intended. 'A model of the canon which posits God as its ultimate author at least opens up the possibility that the book of Isaiah speaks of things beyond the natural knowledge of the historical prophet —for example, that it anticipates the birth and death of Jesus.'[141] In fact, God's single authorship of the Bible, in its traditional orthodox Protestant form, is invoked, as we shall see, not in the first instance to justify a canonical hermeneutic, but as a theological description of the truth and authority of the Bible, asserting that God's special operation in the production of the Bible was such that it speaks truly and authoritatively of him.

We stay for the moment with the question of how a text may be said to 'mean' something which its (human) author could not possibly have intended. Within general hermeneutics, E. D. Hirsch has recently offered a conception of authorial intention which, it is argued, is helpful here. Hirsch's essay warrants discussion here for two reasons. First, it provides a description of authorial intention which will allow us to think of some Christian interpretations of the Old Testament as justified by the Old Testament itself, and not as eisegetical impositions. This is intended to provide part of the justification for Childs's Christian readings of Old Testament texts which he himself does not. This is a general hermeneutical account of what the 'Scripture interprets Scripture' principle implies about the human authorship of Scripture. Second, to invoke the canonical context of a biblical book as the appropriate one for its interpretation seems to conflict with the importance, argued for in Chapter 4, of respecting authorial intention in interpretation. Does the ascription to a biblical text of a 'canonical intention' represent the overriding of the human intention by an implicit claim about divine intention?[142] In light of the discussion of intertextuality earlier in this chapter, and the construals of

[141] Ibid., 343.

[142] According to Watson, 'how the christological orientation of the Old Testament texts is to be rendered in such a way as to preserve rather than to suppress their particularity is . . . the only serious theological question that Old Testament theology must face' (Francis Watson, *Text and Truth: Redefining Biblical Theology* (Edinburgh: T. & T. Clark, 1997), 203).

speech and authorship offered in Chapters 3 and 4, the same question can be phrased thus: does 'canonical intratextuality' conflict with Wolterstorff's claim about the responsibilities which accrue normatively to readers and the rights which accrue normatively to authors?

In his essay, Hirsch argues that, in the production of what he calls 'transhistorical' or 'transoccasional' writings, by which he means particularly the texts of literature, law, and religion, 'one almost always intends "contents" that go beyond the literal contents of one's mind'.[143] For example, describing Augustine's attitude to Moses as the author of the book of Genesis, which Augustine developed as a justification of his allegorical biblical exegesis, Hirsch says: 'The historical Moses *intended* readers to apprehend relevant truths that he, Moses, did [*sic*] not and could not be directly aware of.'[144] Hirsch argues, following Gadamer, that the future application of a text is part of its meaning.[145] Hirsch takes this step because the burden of his article is to argue for the legitimacy of allegorical interpretations. It is possible, though, to accept his observation on trans-occasional authorial intentions, without construing it, as Hirsch does, as an argument in defence of allegorical interpretation, and without adopting his consequently broadened definition of the 'meaning' of a text.

An example from the poem found in Isaiah 52: 13—53: 12, illuminated by a detailed reading of the text by David Clines, may prove illustrative. The main characters in this text, and its main focus, are referred to by the author only by pronouns: I, he, we, and they. Clines begins by documenting the scholarly disagreements over the identities of three of these four *personae*—'he', 'we', and 'they' (the fourth, 'I', is almost certainly Yahweh)—and concludes of the passage that 'it is of its essence that unequivocal identifications are not made and that the poem in this respect also is open-ended and allows for multiple interpretations'.[146] He then analyses, concentrating on 'the text

[143] E. D. Hirsch, Jr., 'Transhistorical Intentions and the Persistence of Allegory', *New Literary History* 25 (1994), 549–67, at 552.

[144] Ibid., 557.

[145] Ibid., 552. Although this partial acceptance of Gadamer seems to represent something of a shift from his earlier work, discussed in ch. 4, Hirsch does not discuss the point.

[146] David J. A. Clines, *I, He, We, and They: A Literary Approach to Isaiah*

itself, that is, in the first place, irrespective of its context', certain relationships between those four *personae*, for these relationships are central to the text. He argues that the centre of the poem is the relationships in which 'he' figures—that is, relationships with each of 'I', 'we', and 'they'. The 'I'/'he' relationship has 'a dual aspect': 'I' supports 'him' but also lays suffering on him. Similarly 'we' begin by scorning 'him', but end up appreciating him. In the 'he'/'they' relationship, 'there is again a contrastive duality, of non-involvement and involvement', in that 'they' begin by merely looking at him and hearing of him, being astonished by him, and end up being involved with him, as he is proved innocent in their sight, bearing their guilt and 'suffering in intervention for them'.[147] In light of these ambiguous references to unnamed characters, and borrowing the concept of a 'language event' from E. Fuchs and G. Ebeling,[148] Clines argues for a formalist view of this text as possessing a life of its own, and giving rise to multiple meanings, in that the world projected by the text 'seizes' different readers in different ways.[149]

Clines knows well the problems that historical-critical readings of this poem ran into, for they read the text as primarily conveying information about historical references, but in a form which, for modern readers at least, is rather cryptic. To avoid this difficulty, he wants to treat the text in isolation from its literary or historical context. Since meaning requires some context, Clines invokes instead the multiple contexts of multiple readers, which give rise to multiple meanings. However, in doing so Clines ignores the fact that there are some things about the historical and literary context of the poem which can be known without us first having to crack a historical code now virtually incomprehensible to us, and which allow us to say some quite determinate things about the writer's intention.[150]

53, Journal for the Study of the Old Testament Series 1 (Sheffield: Journal for the Study of the Old Testament, 1976), 33. I am grateful to Stewart Weaver for his own detailed reading of this text, and for calling my attention to Clines's text and also to the work of John Oswalt and Christopher Seitz on Isaiah referred to below.

[147] Clines, *I, He, We, and They*, 37–9.
[148] Ibid., 53–6.
[149] Ibid., 59–65.
[150] John Oswalt argues against Clines's 'multiple meanings': 'while we may

Isaiah[151] writes about the servant of Yahweh in the context of a hopeful orientation to the future beyond the exile, in expectation that Yahweh will come and rescue his people. That is, he looks for Yahweh to disambiguate the means by which Yahweh will definitively save Israel, both within and exceeding the general pattern of his saving acts already revealed through, for example, Moses, who is himself regularly dubbed 'the servant of the Lord'.[152] G. B. Caird explains rather more simply how language may be oriented to the future in this way: a speaker can make a statement about a referent 'which contains enough general truth to make it readily transferable to another . . . [describing] in some detail a person whose identity is not yet known'. This, he says, is analogous to a detailed 'Situation Vacant' notice.[153]

The question of whether or not Isaiah 53 'speaks about Jesus' is a vexed one, and it invites superficial answers on both sides. However, in light of our adoption of Clines's basic reading of the text itself, and of our conclusion that it should be read, *contra* Clines, in its immediate and undisputed literary and theological context, we may say that the text itself invites the kind of disambiguation of its future-oriented central themes which the New Testament provides in its portrayal of Jesus Christ.[154]

agree that what the text says is capable of several applications, we may not say that we do not know what is being said. Thus it is possible to describe in considerable detail the character and work of the Servant. How and to whom this should apply may be a matter of inference and deduction, but the intention of the material itself is clear enough' (John N. Oswalt, *The Book of Isaiah: Chapters 40–66*, The New International Commentary on the Old Testament (Grand Rapids and Cambridge: Eerdmans, 1998), 377–8).

[151] This is shorthand for the writer inferred from the intention embodied in the text; nothing is necessarily implied about the actual composition or formation of the book of Isaiah.

[152] Exod. 14: 31; Num. 12: 7–8; Deut. 34: 5; Josh. 1 *passim*; 8: 31–3; 11: 12, 15; 22: 2–5; and many other Old Testament references.

[153] G. B. Caird, *The Language and Imagery of the Bible* (Grand Rapids and Cambridge: Eerdmans, 1997 (1980)), 57–8. See also: 'The servant is not just one more individual prophet in a long line of prophets stretching back to Moses; the servant is that history of prophecy individualized, especially in respect of that history as still awaiting fulfillment' (Christopher R. Seitz, *Word Without End: The Old Testament as Abiding Theological Witness* (Grand Rapids and Cambridge: Eerdmans, 1998), 189).

[154] 'Precisely when understood "in its own terms", the Old Testament itself raises the question of its relation to the New' (Watson, *Text and Truth*, 197).

A christological interpretation of Isaiah 53 is not necessarily an imposition from outside on 'the Old Testament itself', any more than is the appointment of an excellent candidate for a job vacancy an external imposition on the meaning of the advertisement for the job. Such an interpretation must, and can, if the New Testament's witness to Jesus as the promised Messiah of Israel is to be taken seriously, demonstrate that it is not an imposition, by arguing that it supplements the Old Testament text in a way which is precisely in accord with what is determinate in that text's future orientation.

Such future disambiguation of Isaiah 53 does not add a specificity of meaning to the Old Testament text which it previously lacked, as Hirsch would suggest. For Hirsch, in contexts in which Isaiah is not taken to refer to Jesus of Nazareth, the text lacks that 'meaning'. In the terminology of speech act theory, Isaiah's speech act, according to Hirsch, retains its identity only at the level of the locution; it takes on different propositional contents, and perhaps also different illocutionary forces, in different contexts. This, somewhat surprisingly, given his substantial earlier work, seems to move Hirsch in the direction of Stanley Fish. It is preferable to apply the argument of Hirsch's essay to a christological interpretation of Isaiah in the following way. The claim that 'Isaiah 53 refers to Jesus Christ' is a claim to the effect that the Old Testament author performs a textual speech act with an illocutionary stance of future expectation, the propositional content of which is a minimal description of a certain being, whom he only names 'he', who exists in a certain set of determinate relationships with regard both to Yahweh and to two groups of people, 'we' and 'they'. Whether or not Isaiah also had a particular person in mind as the referent of this passage is probably impossible for later readers to determine, as Clines suggests; what is clear is that the openness of his text to the future establishes a second level of reference, the propositional content of which is left indeterminate, but which he nevertheless intends. That is, in Hirsch's language, the writer of Isaiah 53 intended a 'content' that went beyond the possible literal content of his mind. His determinate ambiguity sanctions the following of historical and intertextual threads to a wider historical and literary context. When the New Testament claims to identify Jesus of Nazareth as Isaiah's

servant, this is a claim whose validity is to be established to a significant extent by reading Isaiah's text. A christological interpretation of the Old Testament is therefore justified not simply by reference to the New Testament, but exegetically from within the Old Testament itself.[155]

Therefore, it can be said that Isaiah referred to Jesus Christ, without claiming that the meaning, that is, the propositional content and illocutionary force of his text, has changed. First, the illocutionary force of his text remains the same; second, although Christians may be able now to say that they know more than Isaiah did about the propositional content intended by his speech act, that is only the case by virtue of his orienting his text towards a certain kind of future disambiguation; it does not change its propositional content. Thus, Isaiah's future-oriented ambiguity invites future disambiguation of the 'he' (and 'we' and 'they') of his text, within the limits of what he has said determinately about the relationships and activity of the 'he' with regard to Yahweh and humankind.

It is illuminating to contrast the Old Testament with the New in this context. Like the Old Testament, the New has a future orientation, both to the life of the church in the present as the body of Christ and to the future coming again of Christ as Lord. In respect to both, the New Testament is open to a certain kind of disambiguation. With respect to the church, it does not specify the details of the out-workings of faithful practice in every possible situation. In that it will be applied to situations of which its writers could have known nothing, it is, as almost all Christian writers have of course recognized, materially insufficient to legislate in detail for any and every situation.[156] With respect to the events of the parousia, the Bible's apocalyptic language leaves many details uncertain, as may be inferred from the multiple interpretations to which the book of

[155] See Noble's argument against John Sawyer, that Isa. 7: 14 cannot be said to refer to the virgin birth simply on the basis that Matt. 1: 23 interprets it that way: 'the exegetically and theologically important question, I would argue, is whether Matthew 1 *has* understood Isaiah 7, or whether it has imposed an alien meaning on it' (Noble, *The Canonical Approach*, 345).

[156] See the discussions of the material aspect of the historical doctrine of the sufficiency of Scripture in ch. 2; this point will be picked up in the concluding section of this chapter, in order to clarify exactly what is meant by asserting Scripture to be sufficient with regard to this future orientation.

Revelation has given rise. However, unlike the Old Testament, the New leaves no possibility of future disambiguation of the identity of the one through whom Yahweh will bring the history of salvation to final consummation, nor of the fundamental means by which he will achieve this. The New Testament is oriented to a future in which the identity of the one to come and the nature of his relationships with Yahweh and humankind are already decisively known—in accordance with, and in more explicit detail than, Isaiah 53.[157] As regards the identification of the *locus* of God's saving action, and of what is necessary to be known about that saving action in order to respond in faith, in the texts of the New Testament there is no intended 'content' which exceeds the content of the writer's mind; the situation is no longer vacant. The New Testament thus orients itself to the future not by speaking as the Old Testament does of an unnamed 'he', but by referring back to the crucified and risen Christ of the first century.[158] It opens to the future by closing the canon back on itself.[159]

Paul Noble develops what he calls 'a new typology', which is similar to what has been argued from this reading of Isaiah 53 about the intention of individual Old Testament texts and canonical reading. He picks up Robert Alter's concept of 'type-scenes', taking as an example the type of 'the encounter with the future betrothed at the well', and tracing how such scenes in the Old Testament set a pattern for the coming of the husband-

[157] To take another Old Testament text: the one who names himself 'I am', or 'I will be' (Exod. 3: 14), is, and from our temporal perspective has now named himself, the Father of the Son, who reveals himself through the Son (John 1: 18; 14: 9–11).

[158] Where the Old Testament does appeal to the past, primarily to the Exodus and the Mosaic covenant, it serves as a reminder to Israel of Yahweh's past and consequent future faithfulness, tying them in to the history which will lead them from those past events to the *new* thing which Yahweh will one day bring about (e.g., Jer. 31: 31–3). In the New Testament, by contrast, the new thing has already happened; what is to come is only its experiential fullness and the revelation to the world of its now hidden reality (Rom. 8: 18–25; 1 John 3: 1–3).

[159] '[T]he doctrine of fulfilment so basic to early Christianity meant that there was a finality about the New Covenant which would rub off on the collection of books which came to embody it and bear its title' (Frances Young, *The Art of Performance: Towards a Theology of Holy Scripture* (London: Darton, Longman & Todd, 1990), 41).

Messiah to an unlikely woman in John 4.[160] This, he says, gives
the Old Testament independent integrity: 'There is a prin-
cipled way of deciding from the Old Testament itself what is
and is not typologically significant. . . . [I]dentifying a recurrent
pattern means that there is a basis in the stories themselves for
deciding which are their significant features.'[161] It is a 'new'
typology because it avoids fanciful pietistic typologies, the
development of which, argues Noble, led eighteenth-century
rationalistic scholars to insist that the text has only one mean-
ing, thereby killing off all typology.[162]

 This account of authorial intentionality articulates, in a way
that Childs does not, how a single over-arching intentionality
may arise out of a mutually referring set of chronologically
diverse texts, each embodying a set of different individual
authorial intentions. (The earlier sections dealing with Ricoeur,
Bakhtin, and intertextuality suggested how the same could be
the case with a *thematically* diverse set of texts.) Childs gener-
ally identifies this single intentionality as a unified human
witness to divine revelation, rather than as the voice of God. In
light of his objection that historical criticism ignored the theo-
logical function of Scripture, and of his rejection of George
Lindbeck's possibly non-realist intratextual hermeneutics,[163] it
seems that Childs wants an approach which treats the final form
of the Bible as in some way referring uniquely and truly to God.
If the truth of biblical language about God is to be anchored in
this way, a doctrine of the inspiration of the Bible is required.
The Bible's single authorial intention must be ascribed to
God's authorial activity. Only so can the theological normativ-
ity of the Bible, which Childs wants to argue for, be properly
grounded. The doctrine of inspiration exists not in the first
instance to justify a 'Scripture interprets Scripture' approach or
a 'final-form' approach to biblical interpretation, but rather to
explain the basis of the claim that the Bible speaks uniquely and

[160] Noble, *The Canonical Approach*, 313–19.
[161] Ibid., 322–4. See also Watson: 'Typological exegesis cannot be clearly
demarcated from "ordinary" exegesis, for typological exegesis is precisely
what *these* texts require if their true nature is to be brought to light' (Watson,
Text and Truth, 205).
[162] Noble, *The Canonical Approach*, 310–11.
[163] See Childs, *Biblical Theology of the Old and New Testaments*, 723.

truly of God. We turn, then, to a defence of the tradition of Protestant orthodoxy, which holds that in the production of the Bible, at the level of both individual texts and the canon as a whole, human and divine intentions operated *concursively*.

SUPPLEMENTING SCRIPTURE WITH DIVINE ACTION: THE CANON AND INSPIRATION

Noble's suggestion that Childs's advocacy of final-form canonical interpretation requires supplementation from a strong doctrine of inspiration will now be taken up and developed. In the main, the traditional orthodox Protestant version of the doctrine, as articulated most extensively by B. B. Warfield, will be defended against contemporary critiques and alternative notions of inspiration. Warfield's understanding of the Bible as inspired will be supplemented with some of the concepts developed in the first section on intertextuality, in order to rectify some problems which may be identified in his account.

B. B. Warfield's Doctrine of Biblical Inspiration

The Princeton theologian B. B. Warfield is the writer who has written in most detail and with greatest skill in defence of the orthodox Protestant doctrine of the inspiration of Scripture. His presentation of the doctrine will be outlined, and the widespread modern rejection of it and recent alternative versions of biblical inspiration will be discussed.[164] The doctrine of inspiration is, for Warfield, an assertion that the Bible is God's book because he is its ultimate author. What he calls 'the church doctrine of inspiration' views Scripture as 'a book which may be

[164] We are treating Warfield as representative of an older tradition. It has been alleged that nineteenth-century Princetonians introduced an innovation over earlier Protestant orthodoxy by asserting the inerrancy of the original autographs of Scripture (see Jack B. Rogers and Donald K. McKim, *The Authority and Interpretation of the Bible: An Historical Approach* (San Francisco: Harper & Row, 1979)). For a detailed and convincing rebuttal, see John D. Woodbridge, *Biblical Authority: A Critique of the Rogers/McKim Proposal* (Grand Rapids: Zondervan, 1982). Although Warfield derives inerrancy from inspiration, we are dealing here solely with inspiration, on which Warfield is in agreement with earlier Protestant orthodoxy.

frankly appealed to at any point with the assurance that what-
ever it may be found to say, that is the Word of God'.[165] Of
'inspiration' as used in the Westminster Confession of Faith,
which Warfield sees himself as defending, he says that it was 'a
technical term in common theological use at the time, by which
the idea of divine authorship, in the highest sense of the word,
is conveyed'.[166] This is important; for Warfield, 'inspiration' is
a technical term invoked to refer to what he takes to be the
Bible's thoroughly divine origin. He does not mean by anything
he says about biblical inspiration to assert anything about the
mechanics of the composition of the biblical texts; again on the
Westminster Confession of Faith, he says that the 'most out-
standing fact' about its doctrine of inspiration is that it asserts
the fact of inspiration without formally defining its nature.[167]
Reformed theology in general, he asserts, takes the mode of
inspiration to be 'inscrutable';[168] he argues that the key passage
in 2 Timothy 3: 16 asserts that 'the Scriptures are a Divine
product, without any indication of how God has operated in
producing them'.[169] He therefore means carefully to distance
himself from the theory of mechanical dictation which came to
be held by a number of writers in the seventeenth century.[170] It
is in fact possible to use the term 'dictation' to refer to God's
activity towards the biblical writers, he says, but thereby to
stress only Scripture's divinity, and not to regard the biblical
authors as mere writing-instruments in the hands of God, all of
whose personal characteristics are completely overridden in the
process of the composition of the texts.[171]

[165] B. B. Warfield, *The Inspiration and Authority of the Bible* (Philadelphia:
Presbyterian & Reformed, 1948), 106.

[166] B. B. Warfield, *Selected Shorter Writings of Benjamin B. Warfield*, ii, ed.
John E. Meeter (Phillipsburg: Presbyterian & Reformed, 1973), 581. These
shorter pieces will be referred to regularly here, alongside his longer articles,
because they often provide clear summaries of his longer arguments.

[167] Warfield, *Selected Shorter Writings*, ii. 572.

[168] Warfield, *Inspiration and Authority*, 420.

[169] Ibid., 133.

[170] He lists the Lutherans Quenstedt, Calov, and Hollaz, the Reformed
Heidegger and Buxtorf, the Anglican Hooker, and the Puritan John White as
examples of those who did hold a 'mechanical dictation' view (Warfield,
Selected Shorter Writings, ii. 543).

[171] On this basis he defends Gaussen, an influential nineteenth-century
orthodox writer on inspiration (Warfield, *Inspiration and Authority*, 421 n. 4).

Warfield argues that his doctrine of inspiration does not involve the extension of a prophetic model of revelation to the entire Bible, as the theory of mechanical dictation does. He does call inspiration a form of revelation, but says that it represents a different form of revelation from prophetic revelation: it differs from prophecy 'precisely by the employment in it . . . of the total personality of the organ of revelation, as a factor'.[172] Warfield's regular term for this difference is the 'concursive operation' of divine and human factors in the production of the Bible. 'By "concursive operation" may be meant that form of revelation illustrated in an inspired psalm or epistle or history, in which no human activity—not even the control of the will— is superseded, but the Holy Spirit works in, with and through them all in such a manner as to communicate to the product qualities distinctly superhuman.'[173] The human writers are therefore not passive instruments in the hands of God; nor, on the other hand, are we to think of their books as basically their own production, with God intervening at various points to protect them from error. Rather, the Holy Spirit works confluently, 'in, with and through them', with the result that the Bible in its entirety is God's book.[174] Warfield is particularly hard on any writer who argues that an increased recognition of the human aspect of Scripture must lead to a corresponding shrinkage of the divine aspect. The two aspects do not compete with one another for space in the production of Scripture, he argues, but rather are both fully present. He therefore came to prefer to speak not of divine and human 'elements' in Scripture, but of divine and human 'aspects' or 'sides'.[175] The result of 'concursive operation' is that 'every word is at once divine and human'.[176]

This 'concursive operation' functions both in the actual composition of the writing and in its preparatory stages. Inspiration, says Warfield, covers the preparation of both the material and the writer. '[God] prepared a Paul to write [the epistles],

[172] Warfield, *Inspiration and Authority*, 94.
[173] Ibid., 83.
[174] Ibid., 95.
[175] A. N. S. Lane, 'B. B. Warfield on the Humanity of Scripture', *Vox Evangelica* 16 (1986), 77–94, at 78.
[176] Warfield, *Selected Shorter Writings*, ii. 545–6.

and the Paul he brought to the task was a Paul who sponta-
neously would write just such letters.'[177] At the end of this long
process comes 'inspiration' in its technical sense: an 'additional
Divine operation' which allows the product to rise above mere
human attainment.[178] This is inspiration proper, to which the
doctrine of the inspiration of Scripture refers, and it is to be dis-
tinguished from 'other divine activities operative in the pro-
duction of the Scriptures', such as the preparation of material
and writer.[179] This technical sense of inspiration is the sense
intended by those whom Warfield calls the 'exact writers', in
comparison with writers who treat the interaction of human
and divine agency in exactly the same way with regard to both
the Bible's composition and the preparation of material and
writer.[180]

It is vital to realize that the notion of 'concursive operation'
is a particular expression of a fundamental doctrine of God:
'The philosophical basis of this conception is the Christian idea
of God as immanent as well as transcendent in the modes of his
activity.' It is analogous, he says, to the functioning of provi-
dence and grace.[181] The Bible is, we might say, for Warfield the
doctrine of providence put into writing. This immediately sug-
gests an analogy between the doctrine of Scripture and Christ-
ology; Warfield insists, however, that the analogy is only par-
tial, since he proposes no hypostatic union of divine and human
in Scripture.[182]

The function of Scripture, conceived of as inspired in this
way, is that through it God speaks directly to Christians. There
is no need, says Warfield, for the reader 'to make his way to God
painfully, perhaps even uncertainly, through the words of His
servants . . . but [he] can listen directly to the Divine voice itself
speaking immediately in the Scriptural word to him'.[183] This
provides Christian believers, whose hope in Christ is bound up
with the trustworthiness of the Bible, with the very thing on
which a historical faith such as Christian faith must lean: 'a firm

[177] Warfield, *Inspiration and Authority*, 155.
[178] Ibid., 158.
[179] Warfield, *Selected Shorter Writings*, ii. 615.
[180] Ibid., ii. 632.
[181] Ibid., ii. 546.
[182] Warfield, *Inspiration and Authority*, 162.
[183] Ibid., 158.

basis of trust for all the details of teaching and all the items of promise'.[184]

It is important to note what this last claim does not entail for Warfield. He does not establish an inspired Scripture as the formal basis of its own authority—though its inspiredness may, once established, be used to support its authority:

> If . . . the apostles were appointed by Christ to act for him and in his name and authority in founding the Church—and this no one can doubt; and if the apostles gave the Scriptures to the Church in prosecution of this commission—and this admits of as little doubt; the whole question of the authority of the Scriptures is determined. . . . But when inspiration has once been shown to be fact, it comes mightily to the reinforcement of their authority.[185]

Similarly, he states: '[The Scriptures] we first prove authentic, historically credible, generally trustworthy, before we prove them inspired.'[186] Nor does he establish an inspired Scripture as the formal basis of Christian truth in general: 'Inspiration, in its more exact sense, cannot come into the discussion until theism, the reality of revelation, the authenticity and historical credibility of the Scriptures, the divine origin and character of the religion which they present, and the general trustworthiness of their presentation of it, have already been established.'[187] He

[184] Ibid., 121–2.

[185] Warfield, *Selected Shorter Writings*, ii. 537–40. This suggests that Warfield is not vulnerable to the charge that 'evangelicals have attempted to account for the authority of Scripture with reference to inspiration rather than to revelation' (Kern Robert Trembath, *Evangelical Theories of Biblical Inspiration: A Review and Proposal* (New York and Oxford: Oxford University Press, 1987), 67). [186] Warfield, *Inspiration and Authority*, 210.

[187] Warfield, *Selected Shorter Writings*, ii. 632. See also: 'there is a sense in which it would not be true to say that the truth of Christian teaching and the foundations of faith are suspended upon the doctrine of plenary inspiration, or upon any doctrine of inspiration whatever. They rest rather upon the previous fact of revelation. . . . [T]he supernatural origin and contents of Christianity, not only may be vindicated apart from any question of the inspiration of the record, but, in point of fact, always are vindicated prior to any question of the inspiration of the record. We cannot raise the question of whether God has given us an absolutely trustworthy record of the supernatural facts and teachings of Christianity, before we are assured that there are supernatural facts and teachings to be recorded. The fact that Christianity is a supernatural religion and the nature of Christianity as a supernatural religion, are matters of history; and are independent of any and every theory of inspiration' (Warfield, *Inspiration and Authority*, 121).

defends the Westminster Confession of Faith against the charge
that, since it excludes the Apocrypha from the canon on the
basis that it is not inspired, it wishes to prove inspiration first
and canonicity second, noting that the Confession lists the
books which it does regard as canonical, and only consequently
asserts the fact of their inspiration.[188] A clearly rationalist tone
is evident here in Warfield's conception of how biblical author-
ity is discerned and defended, and this probably eclipses some-
what the stress found in Reformation and post-Reformation
writers on the witness of the Holy Spirit to Scripture.[189]

That this rationalism does not imply a formalist approach to
the authority of the biblical canon can be demonstrated by
enquiring into the basis which Warfield offers for his doctrine
of inspiration. The only basis he offers for the doctrine is not
some a priori theological assumption about God's truthfulness,
but what he takes to be the case in the Bible's content—what he
calls 'exegetical fact'.[190] He asserts his doctrine of biblical inspi-
ration because he believes that 'Christ and his apostles are his-
torically shown to have taught the plenary inspiration of the
Bible.'[191] He argues on the basis of John 10: 34 ff. that for Jesus
'[i]t belongs to Scripture . . . down to its most minute particu-
lars, that it is of indefectible authority'.[192] He knows that by
'Scripture' Jesus means the Hebrew Scriptures, and argues for

[188] Westminster Confession of Faith, 1. 2; Warfield, *Selected Shorter Writings*, ii. 562.

[189] John Woodbridge and Randall Balmer, who otherwise defend Warfield's doctrine of Scripture, make this criticism of him (John D. Woodbridge and Randall H. Balmer, 'The Princetonians and Biblical Authority: An Assess-ment of the Ernest Sandeen Proposal', in D. A. Carson and John D. Wood-bridge (eds.), *Scripture and Truth* (Leicester: Inter-Varsity Press, 1983), 245–79, at 271).

[190] Warfield, *Inspiration and Authority*, 180.

[191] Ibid., 122–3; see also 128.

[192] Ibid., 140–3. In this brief summary of Warfield's arguments it may seem that he indulges in proof-texting. In fact, he wants to distance himself from the mistakes of 'the older dogmaticians', who, he says, relied too much on iso-lated proof-texts. He wishes to learn from 'the whole body of modern schol-arship' to seek '"a form of Scripture proof on a larger scale than can be got from single texts"' (ibid., 198). The last quotation here is from Schleier-macher, and Warfield quotes it with approval. It is beyond the scope of this chapter to investigate whether or not Warfield's exegetical practice lives up to his aim; however, prima facie the detailed nature of many of his discussions suggests that his main mode of biblical exegesis is far from simplistic.

the legitimacy of placing the New Testament on the same level.[193]

In particular, Warfield devotes a long discussion to the meaning of the adjective θεόπνευστος, which is applied to 'all Scripture' in 2 Timothy 3: 16, arguing against the views of two scholars, H. G. A. Ewald and Hermann Cremer. He notes that Cremer, in the second edition of Herzog's *Realencyklopaedie* (1880), defines θεόπνευστος as 'inspiring its readers', and he traces this view back to Ewald.[194] Neither writer, though, wishes to give the word a fully active sense; they regard its meaning as being nearer to 'full of God's Spirit' than 'God-breathing'.[195] Warfield's criticism is that Ewald and Cremer can conceive of only two options for the translation of the word: 'God-inspired', a wrong translation which uncritically follows the Vulgate's misleading translation *inspirata*, and their own, which Warfield alternatively terms 'God-imbued'.[196] He proposes a third option, which he claims is the most likely in the canonical context in which 2 Timothy is set. In this context, which ultimately includes the creation narratives of Genesis, the breath of God is thought of not as that which 'in-spires' or fills something with God, but as a creative force by which God brings things into being.[197] Warfield concludes that the word θεόπνευστος 'is primarily expressive of the origination of Scripture, not of its nature and much less of its effects'.[198] He then goes on to provide a detailed survey of uses of the word in non-Christian ancient Greek literature, on the basis of which he concludes that in no case does it speak of 'even such a quasi-active idea as that of "redolent of God." Everywhere the word appears as purely passive and expresses production by God.'[199] The absoluteness of this conclusion rather overstates what Warfield has in fact succeeded in demonstrating from extra-biblical study, for elsewhere he reports from his study of the sixth edition of Liddell and Scott's Greek lexicon that, of the eighty-six compounds of θεος ending in -τος which he discovered there, at least seventy-five refer to 'a result produced by God'. Warfield

[193] Warfield, *Selected Shorter Writings*, ii. 634–5.
[194] Warfield, *Inspiration and Authority*, 247.
[195] Ibid., 277–8. [196] Ibid., 283.
[197] Ibid., 285–6. [198] Ibid., 296.
[199] Ibid., 272.

acknowledges that this statistic does not prove his case conclusively, but argues that it points to his translation of the word as the most plausible.[200]

As we turn now to discuss some recent alternative notions of biblical inspiration, it will become evident both that much of what has been presented here of Warfield's doctrine has been found inadequate, but also that what is rejected is sometimes a quite different understanding of Warfield's doctrine from the one offered here.

Response I: Biblical Inspiration the Same Yesterday and Today

A number of contemporary writers wish to give the term 'inspiration' a broader reference than the specific, technical sense which Warfield gives it. James Barr asserts that God just does not 'straightforwardly communicate articulate thoughts or sentences to men', and that we cannot conceive of how God—'by his Spirit, shall we say?—somehow guided' the Bible-writers. Rather, '[t]oday I think we believe, or have to believe, that God's communication with the men of the biblical period was not on any different terms from the mode of his communication with people today'. Pleading that he is 'only a spare-time theologian', Barr does not say what that universal mode might be.[201]

Similarly, Paul Achtemeier argues that we must think of the Holy Spirit continuing to inspire present-day reading and proclamation of Scripture in the same way as he inspired its production, if Scripture is not to become a museum-piece. 'The same Holy Spirit at work in the production of inspired Scripture is also at work, *and in the same way*, in the production of the proclamation of inspired Scripture.'[202] This is so, for Achtemeier, because inspiration is located in the interrelationships of the elements of tradition, of new situations which require reinterpretations of that tradition, and of the activity of those who compose, shape, and compile that material.[203]

[200] Warfield, *Inspiration and Authority*, 281–2.

[201] James Barr, *The Bible in the Modern World* (London: SCM Press, 1973), 17–18, p. ix.

[202] Paul J. Achtemeier, *The Inspiration of Scripture: Problems and Proposals* (Philadelphia: Westminster Press, 1980), 143 (italics added).

[203] Ibid., 131–4.

Although he does not want the composing, shaping, and compiling of the canon to continue, describing it as a foundation which does not need to be relaid,[204] Achtemeier thinks that the on-going relationships between the first two elements are sufficient for 'the inspiration of Scripture' to be a continuing divine activity.

A third contemporary writer, William Abraham, defines inspiration thus: '[God] inspires in, with, and through his special revelatory acts and through his personal guidance of those who wrote and put together the various parts of the Bible.'[205] Since God continues to inspire people to faith by his special revelatory acts, Abraham conceives of God's inspiring activity as continuing beyond the closure of the canon.[206] Finally, Kern Robert Trembath goes beyond Barr, Achtemeier, and Abraham in that he wishes to say nothing about God's activity in the production of the Bible. For him, '"the inspiration of the Bible" should be taken to refer . . . to the fact that the church confesses the Bible as God's primary means of inspiring salvation within itself'.[207] This definition identifies biblical inspiration with the Bible's perlocutionary effect.

None of these writers offers a convincing account of the closure of the canon, although in practice none wishes to allow for additions to it or continuing redaction of it. Achtemeier sees the canon as a foundation which does not need to be relaid—but if the Holy Spirit is still working in present-day believers in the same way as in the past, inspiring reinterpretation of received traditions, it is not at all clear why the foundation should not be altered. The New Testament is itself 'only' an inspired reinterpretation of received Old Testament traditions in the light of a new situation. Similarly, Abraham grounds the closure of the canon in the fact that in it is 'recorded and enshrined' the divine speaking to prophets and apostles, and the account of God's actions in history.[208] However, since he also thinks that God still 'inspires' by speaking and by his saving acts in this same

[204] Ibid., 135, 144–5.
[205] William J. Abraham, *The Divine Inspiration of Holy Scripture* (Oxford: Oxford University Press, 1981), 67.
[206] Ibid., 71–2.
[207] Trembath, *Evangelical Theories*, 5.
[208] Abraham, *The Divine Inspiration*, 90.

way, it is not clear on what basis Abraham can be certain that canonical texts are not still being authored.

In the following discussion, under two headings, we shall focus on the approaches to biblical inspiration offered by Abraham and Trembath, since they both develop their notions in explicit contrast to Warfield and the tradition he exemplifies. This dialogue will allow us to clarify the tradition which Warfield represents, and to offer a defence of it.

'Deductive' and 'inductive' approaches to biblical inspiration

Both Abraham and Trembath call their approach to the inspiration of the Bible 'inductive', and contrast it favourably with what they call the 'deductive' approach of the Warfieldian tradition. '[D]eductivist approaches to biblical inspiration begin by discussing and formulating a doctrine of God'; since the formulated doctrine asserts that God cannot lie, deductivists must explain how Scripture can be called the Word of God in a way that ensures its truthfulness.[209] However, each writer has a different understanding of an opposing 'inductive' approach. For Trembath, 'inductivists' take biblical inspiration 'to refer primarily to effects which the Bible has among those persons who call it inspired. Only then do they attempt to account for how it is that the Bible may be taken as the vehicle of inspiration.'[210] His focus is on the effects that the Bible has in the lives of believers. Abraham's inductivists 'consciously attempt to work out a position on inspiration that will accommodate the results of inductive study [of the Bible]'.[211] By this, Abraham seems to mean the results of historical-critical study of the Bible, which he characterizes, somewhat naively, as 'a natural and honest study of the Bible'.[212] Warfield's doctrine of inspiration, which leads to a view of the Bible as inerrant, is immune, says Abraham, to modification in the light of observations made about the phenomena of the text.[213]

We may respond first to both together. John Woodbridge

[209] Trembath, *Evangelical Theories*, 8; see also Abraham, *The Divine Inspiration*, 16.
[210] Trembath, *Evangelical Theories*, 47.
[211] Abraham, *The Divine Inspiration*, 40.
[212] Ibid., 29.
[213] Ibid., 21–2.

notes that the basic distinction between old orthodox 'deduc-
tive' and new 'inductive' approaches to biblical inspiration is
not itself a new one: it was made in the second half of the nine-
teenth century, for example by the contributors to the volume
Essays and Reviews. Woodbridge comments: 'Obviously, neither
party was solely deductivist or inductivist in approach.'[214]
Although it is rather fruitless to attempt to establish the precise
amounts of logical inductiveness (in Abraham's sense) and
deductiveness on each side, it may be noted that Abraham's
and Trembath's work, along with that of Barr and Achtemeier,
is noticeably lacking in (inductive) biblical exegesis, in com-
parison with Warfield. Most striking in this comparison is the
imbalance in attention given to the key biblical word θεό-
πνευστος. Trembath excuses his lack of discussion of the word
by suggesting that it is hard to know what the term means, since
it is a New Testament *hapax legomenon*, and we do not know the
identity of the Scriptures of which the writer predicates it.[215]
Abraham is confident that it refers to the Septuagint texts
which Timothy would have used, and also knows what the
word means, asserting that the question of how to translate the
opening phrase of the verse is an 'irrelevant issue', for all that
is said is that Scripture is inspired.[216] To this 'irrelevant issue'
Warfield devotes a lengthy article, which aims to question the
very thing which Abraham assumes—namely, that the correct
English translation of the word in this text is 'inspired'.[217]
Trembath's agnosticism and Abraham's uncritical confidence
both seem weak in the face of Warfield's detailed scholarship
on this question. Neither writer makes significant reference to
Warfield's discussion of this issue; in addition, neither deals
at any length with Warfield's exegesis of Scripture's self-
testimony and of the attitude of Jesus and the apostles to Scrip-
ture. These gaps must be considered a serious shortcoming in
the work of Abraham and Trembath. They may suppose that
Warfield's exegetical conclusions have been predetermined by
his prior convictions about what must be the case a priori

[214] Woodbridge, *Biblical Authority*, 225 n. 23.
[215] Trembath, *Evangelical Theories*, 6.
[216] Abraham, *The Divine Inspiration*, 93.
[217] 'God-Inspired Scripture': ch. 6 of Warfield, *Inspiration and Authority*;
see discussion above.

with God and consequently with the Bible, but they ignore the fact that Warfield does offer an exegetical defence of his doctrine of inspiration on grounds which are open to exegetical challenge.[218]

As regards Abraham in particular, Warfield in fact seems at one point to anticipate his advocacy of a particular kind of inductive approach. It may not be objected, he argues, that the nature of inspiration 'is to be inferred by induction from the phenomena of Scripture, and not learned from the teaching of Scripture'. This is so because once the general 'evidences' have established Scripture's trustworthiness, any scriptural phenomena apparently inconsistent with that trustworthiness are to be categorized as 'difficulties' yet to be explained.[219] This comment goes to the heart of the disagreement between the orthodox Protestant doctrine of biblical inspiration and contemporary criticisms of it, and the different categories of 'induction' and 'deduction' which Abraham introduces rather blur the issue. It is not a question of induction or deduction at all, but of which of the Bible's different 'phenomena' one regards as fundamentally revelatory of its true character. Warfield privileges what he takes to be the good historical grounds for seeing the Bible as trustworthy—a conclusion which accords, he argues at length, with its constant teaching about itself. He acknowledges that there are difficulties with the doctrine of inspiration, but asserts that Christians believe it primarily because Christ and the apostles believed it.[220] Abraham prefers to let the observations

[218] Warfield's biblical exegesis, to the extent that it argues for biblical inerrancy, has indeed been both challenged and defended in some detail: see e.g. James D. G. Dunn, 'The Authority of Scripture According to Scripture', *Churchman* 96 (1982), 104–22, 201–25; Roger Nicole, 'The Inspiration and Authority of Scripture: J. D. G. Dunn Versus B. B. Warfield', *Churchman* 97 (1983), 198–215; 98 (1984), 7–27. See also Goldingay, drawing on a comment by W. C. Kaiser: 'it is strange to multiply discussion of topics such as inspiration and revelation without reconsidering the biblical material that relates to these concepts, as if Gaussen and Warfield had said it all' (Goldingay, *Models for Scripture*, 13).

[219] Warfield, *Selected Shorter Writings*, ii. 632–3.

[220] Warfield, *Inspiration and Authority*, 128. In an essay on critical biblical scholarship, Warfield argues that the New Testament writers' claim that Scripture is inspired can be tested by asking whether or not their claims were accepted by their contemporaries who were able to assess them (he says they were), and by assessing whether or not 'contradictory phenomena' are present

of historical-critical scholarship win out over biblical self-testimony, and then tries to provide some general semantic content for the word 'inspiration' as a description of God's activity in relation to the Bible, as he has now come to see it. Which of the two selects the right phenomena as determinative for the nature of inspiration will continue to be debated; thus far, though, Abraham's attack has missed the point and basis of Warfield's doctrine.

Turning now to Trembath, his book makes clear that his particular 'inductive' version of biblical inspiration is forged in response to the rather acrimonious debates over biblical inerrancy conducted in the United States in the late 1970s and early 1980s. Although Abraham's work is also marked by these debates, only Trembath deals with inerrancy in some detail. He concludes his book with a chapter on the topic, in which he argues that 'the inerrancy position makes the maturing of faith dependent on a purely intellectual concept: the evaluation of truth claims. . . . [Growth in salvation] occurs entirely outside of the believer; in systematic terms, it calls only for *notitia* rather than *fiducia*.'[221] The 'greatest advantage' of his theory of inspiration, he says, 'is that it does not shift the focus of Christian belief away from the saving presence of God among believers'.[222]

It may be that the doctrine of the sufficiency of Scripture necessarily implies the inerrancy of Scripture; it is not proposed to enter the complex discussion of biblical inerrancy in any detail here. However, granting for the moment that sufficiency does entail inerrancy, it is possible that the concepts on which the present re-articulation of the sufficiency of Scripture is based may also be used as the basis for a re-working of the inerrancy of Scripture. For example, the ontological link between persons and language established by speech act theorists

in their writings (he judges they are not). He discusses a few particular instances of alleged error in the Bible, and concludes that as biblical criticism continues its work increasing numbers of alleged errors are being shown not to be errors at all (Warfield, *Inspiration and Authority*, 423 ff.). Our point here is simply that Warfield's defence of biblical inerrancy, being in large part exegetical, is open to rebuttal.

[221] Trembath, *Evangelical Theories*, 97–8.
[222] Ibid., 115.

and Nicholas Wolterstorff, and the construal of Scripture as the dynamic speech act of God offered at the end of Chapter 3, write God's living and active reality into doctrines of Scripture so fundamentally that Trembath's concern that to focus on biblical inerrancy attracts attention away from the activity of God amongst his people might be alleviated. Such an understanding of inerrancy would focus not only, as in recent debates, on the factual accuracy of propositions, but even more on God's inerrant faithfulness in being true to the word of the illocutionary acts that he performs in Scripture, and his inerrant ability to bring about in the lives of believers by his Spirit the salvific perlocutionary act which he intended.[223] This suggests that there is the possibility of a much more profound debate about biblical inerrancy than that conducted in recent American skirmishes.

A human analogy for biblical inspiration

Having rejected Warfield's understanding of inspiration, Abraham tries to reconceive the term by analogy with its meaning in everyday usage. 'We need to pursue in its own right an analysis of the concept of inspiration', he says, examining the

[223] A further point may also be made here. Trembath fears that 'deductivists' 'reinforce the idea that biblical inspiration is an objective property of the words of the Bible which may be discerned by believer and unbeliever alike' (Trembath, *Evangelical Theories*, 68). He concludes that the confession of the inspiration of Scripture has usually been taken to mean that 'the uniqueness of the Bible could be entirely explained by examining the Bible itself rather than by examining the effect that it mediates to the believing community' (ibid., 70–1). He seems insufficiently aware that Reformed theology, at least before the nineteenth century, asserted both that the Bible possesses certain 'objective properties' and that we come to discern its authority primarily by the action of the Holy Spirit. The Westminster Confession of Faith provides one of the best examples: 'We may be moved and induced by the testimony of the Church to an high and reverent esteem of the Holy Scripture, and the heavenliness of the matter, the efficacy of the doctrine, the majesty of the style, the consent of all the parts, the scope of the whole, (which is to give all glory to God), the full discovery it makes of the only way of man's salvation, the many other incomparable excellencies, and the entire perfection thereof, are arguments whereby it doth abundantly evidence itself to be the Word of God; yet, notwithstanding, our full persuasion and assurance of the infallible truth, and divine authority thereof, is from the inward work of the Holy Spirit, bearing witness by and with the word in our hearts' (Westminster Confession of Faith, 1. 5).

use of the word 'inspire' as applied to human agents, before attempting to understand its use when applied to God's activity. Abraham thinks that much confusion has resulted from a failure to engage in this process, which he regards as the very process by which we come to describe what is meant by the analogous use of such verbs as 'love', 'know', and 'forgive', when used of God's action.[224] Abraham gets at what he calls the 'root meaning' of 'inspire' by considering the case of a teacher inspiring his students. The characteristics of this situation are chiefly that there can be degrees of inspiration in different students, that the students' own talents are not nullified, and that the students may well commit what the teacher considers to be errors, since they are not exclusively under his influence.[225] While acknowledging that this model is too 'intellectualist' to be a perfect analogy for a theological use of 'inspire', since God 'inspires in, with, and through his special revelatory acts and through his personal guidance of those who wrote and put together the various parts of the Bible',[226] Abraham largely builds his conception of divine inspiration on the three characteristics of this model. Trembath uncritically accepts that the everyday model of 'inspiration' provides a legitimate analogy with divine inspiration. He also develops it further than Abraham, arguing that in a situation in which a teacher is said to have inspired a student, 'inspiration is more a predicate of the student than of the teacher'.[227] This observation supports his definition of inspiration as referring not to the Bible itself but to its effects in the lives of believers. The theological notion of biblical inspiration is for him all about the experience of being inspired.

This analogy, however, introduces confusion rather than clarification into discussions of biblical inspiration, especially when it is offered as a better model of inspiration than Warfield's. First, Abraham and Trembath both miss Warfield's explanation that his use of 'inspiration' is derived from his biblical exegesis and especially his philological research into the meaning of θεόπνευστος. It is not likely that this will produce a

[224] Abraham, *The Divine Inspiration*, 61–2.
[225] Ibid., 63–4.
[226] Ibid., 67.
[227] Trembath, *Evangelical Theories*, 65.

semantic content similar to the contemporary everyday seman-
tic content of the English word 'inspire'. As Howard Marshall
points out, the evidence rather counts against the legitimacy of
Abraham's assumption that he can transfer the field of meaning
and usage of the English word 'inspire' to the Greek word θεό-
πνευστος.[228] Warfield himself also points out the same problem
inherent in this methodology (either anticipating someone
making this mistake, or finding it current in his own day—he
does not say which) in a passage to which neither Abraham nor
Trembath respond, but with which they would have done well
to interact.[229]

Second, the human analogy obscures the theological convic-
tions which undergird the Warfieldian technical definition of
'biblical inspiration'. It was noted above that Warfield regards
his notion of 'concursive operation' as resting on 'the Christian
idea of God as immanent as well as transcendent in the modes
of his activity', and as analogous to providence and grace.[230]
The reworkings offered by recent writers, including Abraham
and Trembath, seem to be governed partly by unarticulated
objections to Warfield's notions of divine providence and divine
immanence and transcendence—on both of which he stands in
a long orthodox tradition.[231] Bruce Vawter, for example, who
has produced one of the most influential Roman Catholic ver-
sions of biblical inspiration of recent times, building on the
work of Karl Rahner, argues that the recognition of the influ-
ence of a writer's social and linguistic context on the words he
is able to choose in order to communicate has made it harder to
postulate concursive divine and human actions in relation to the
actual words of the Bible.[232] This argument, though, carries
weight only if one has a very wooden conception of provi-
dence—one which cannot conceive of God acting concurrently
with the limitations of human situatedness.[233]

[228] I. Howard Marshall, *Biblical Inspiration* (Carlisle: Paternoster Press,
1995 (1982)), 40. [229] Warfield, *Inspiration and Authority*, 154.

[230] Warfield, *Selected Shorter Writings*, ii. 546.

[231] J. I. Packer argues provocatively that to deny that the Bible is fully
authored by both human beings and God is to deny divine providence, sub-
stituting deism for Christian theism (J. I. Packer, *'Fundamentalism' and the
Word of God* (London: Inter-Varsity Fellowship, 1958), 80–1).

[232] Bruce Vawter, *Biblical Inspiration* (London: Hutchison, 1972), 128.

[233] Vawter's implied notion of providence would not seem to be able to cope

The question of divine providence comes closest to the sur-
face in the work of Abraham and Trembath in a particular
charge which both level at 'deductivists': that they wrongly
equate inspiration with divine speaking. For Abraham, this is
'the fundamental problem' of the 'deductive' approach.[234] This
is in effect the claim that the Warfieldian tradition wrongly
extends a prophetic model of divine–human interaction to the
divine–human interaction operative in the production of the
whole Bible. Vawter makes the same point: 'scriptural inspira-
tion must have been as diverse as the human efforts that con-
spired to produce the Scripture'.[235] Warfield, however, does not
treat the whole Bible as divinely dictated prophecy in this way,
for he distinguishes, as was noted above, revelation by prophe-
cy from revelation by inspiration precisely in that the latter
takes into account the 'total personality' of the human agent.[236]
He does not think of divine inspiration as an act of speaking; the
verbs he uses most regularly to describe God's action in the
production of the Bible aim to describe it as a providential act:
safeguarding 'a record of his will' in written form, 'communi-
cat[ing] to the product qualities distinctly superhuman', guid-
ing and superintending,[237] and so on. Abraham argues that,
although Warfield does not use the vocabulary of 'dictation' to
describe inspiration, he has retained the concept, offering a
notion of revelation as 'a kind of telepathic dictation without the
writer being aware of it', and that, whenever the emphasis is on
the *words* of the Bible as divinely given, there is 'a carry-over
from a dictation theory'.[238] In this he is effectively rejecting
Warfield's view of divine providence. Warfield's notion of bib-
lical inspiration is not a theory of divine dictation if one accepts
Warfield's understanding of divine providence.

with the assertion that in the events leading up to the crucifixion of Jesus God
was both freely acting to go to the cross and working concurrently through the
actions of those (very limited, situated) people who handed him over, called
for his execution and nailed him to the cross.

[234] Abraham, *The Divine Inspiration*, 37. See Trembath, *Evangelical
Theories*, 67–8.
[235] Vawter, *Biblical Inspiration*, 163.
[236] Warfield, *Inspiration and Authority*, 94.
[237] Warfield, *Selected Shorter Writings*, ii. 632; *Inspiration and Authority*,
83, 95.
[238] Abraham, *The Divine Inspiration*, 36–7.

In conclusion, therefore, it is suggested that further creative work on biblical inspiration would be most fruitfully conducted by engaging at length with the doctrines of divine immanence and transcendence, and of divine providence, as well as with the tradition of biblical exegesis which Warfield exemplifies. This would help to avoid the confusions introduced by Abraham and Trembath when they give new semantic content to the word 'inspiration' in light of their particular exegetical and theological assumptions. Here it has not been possible to open up such discussions, since much preliminary work is required in order to recover the precise nature of Warfield's understanding of inspiration, as representative of a particular tradition. If the portrayal of Warfield's doctrine given here is accurate, then it may be judged to escape many of the criticisms most often directed at it. It is then also the case that much contemporary discussion of biblical inspiration is blurred by its failure to acknowledge that its fundamental disagreement with Warfield lies in questions of divine providence.

Response II: Biblical Inspiration and the Gospel of Jesus Christ

Wolfhart Pannenberg has recently articulated an alternative account of the inspiration of Scripture. He criticizes '[the] use [of the inspiration of Scripture] in seventeenth-century Protestant theology in the attempt to justify a formal concept of scriptural authority before any discussion of the biblical writings'.[239] In this period, he says, both Reformed and Lutheran theologians began to extend inspiration to 'the act of recording itself', thus equating God's Word with the actual wording of Scripture. The motivation for this alleged shift was the fear that 'the scripture principle of the Reformation might be abandoned if scripture no longer stood outside human judgment as a divine authority that is inviolable both as a whole and in detail. . . . Once one concedes that anything in scripture is of human origin, its divine authority is lost.'[240] Pannenberg has in mind specifically Lutheran theologians, but on the substantive points

[239] Pannenberg, 'On the Inspiration of Scripture', 214. In this short article Pannenberg clarifies some points he makes in his *Systematic Theology*, i and ii, trans. Geoffrey W. Bromiley (Grand Rapids: Eerdmans, 1991–4).

[240] Pannenberg, *Systematic Theology*, i. 32.

they were in agreement with Reformed theologians.[241] Thus, Pannenberg objects to what he takes to be the use of the divine inspiration of Scripture as a formal principle on which the divine authority of Scripture was grounded.

Pannenberg wishes to correct this, locating inspiration not in the wording of Scripture but in its content, the gospel of Jesus Christ. He argues that the conclusion that the New Testament writings 'participate in some way in . . . divine inspiration . . . is valid only insofar as those writings witness to the Pauline gospel of God's saving activity in Jesus' death on the cross and in his resurrection. . . . Certainly, the Scriptures are to be understood as divinely inspired in the literal concreteness of their wording, but only insofar as they witness to the gospel of Jesus Christ.'[242] This argument relates to Pannenberg's overall theological programme in that it allows for objectivity in historical knowledge of Jesus Christ: 'the statement that scripture is inspired presupposes conviction as to the truth of the revelation of God in the person and history of Jesus Christ . . . This conviction has its basis elsewhere.'[243]

What is intriguing about this statement, in light of the foregoing discussion, is that both Pannenberg and Warfield deny that biblical inspiration is the ground of biblical authority. Like Pannenberg, Warfield locates the basis of the conviction of the truth of divine revelation in Jesus Christ elsewhere than in the divine inspiration of Scripture, as was noted above: 'These [Scriptures] we first prove authentic, historically credible, generally trustworthy, before we prove them inspired.' Even if the Bible-writers were no more than 'credible reporters of revelations of God . . . their testimony would be entitled to belief'.[244] Where Warfield differs from Pannenberg is in what follows from the conclusions of his biblical exegesis. For Warfield, 'Christ and his apostles are historically shown to have taught the plenary inspiration of the Bible'[245]—that is, this can be demonstrated without presupposing the divine inspiration of

[241] This was argued briefly in ch. 2.

[242] Pannenberg, 'On the Inspiration of Scripture', 213, 215.

[243] Pannenberg, *Systematic Theology*, ii. 463–4.

[244] Warfield, *Inspiration and Authority*, 211–12, quoting (in the latter statement) George P. Fisher.

[245] Ibid., 122–3.

the Scriptures—which makes the doctrine 'a very important and valuable element' in the Christian faith. 'In such circumstances their inspiration is bound up inseparably with their trustworthiness, and with all else that we receive on trust from them.'[246] For Pannenberg, by contrast, the conviction of the truth of God's revelation in Christ is found by distinguishing the 'Christ-event', which 'has meaning in itself', from the New Testament witness to that event.[247]

Warfield's doctrine of inspiration does not exercise the kind of function which Pannenberg rules out for the doctrine—that is, as a formal conception of scriptural authority, prior to any discussion of the Bible or the gospel of Jesus Christ. However, his exegetical consideration of the Bible and the gospel does lead him to hold a view of biblical inspiration which gives the Bible a secondary, rather than foundational, role as a formal principle in theology. The Bible is the only trustworthy means by which the gospel of Christ is mediated to us. It is therefore for Warfield, in this sense, but only in this secondary sense, the *principium cognoscendi* of the gospel.

Pannenberg has developed his notion of inspiration in response to what he takes to be that held by post-Reformation orthodox Protestant theologians. As was noted in Chapter 2, the seventeenth-century theologian Francis Turretin exercised some influence on nineteenth-century Princetonian theology. Turretin has often been cited as a particular exponent of the use of inspiration, allied with a strong doctrine of biblical inerrancy, as a formal principle of biblical authority in abstraction from the content of Scripture. Jack Rogers and Donald McKim have been particularly harsh: 'Turretin predicated the authority of the Bible on the claim that it was verbally inerrant. He was willing to rest the whole weight of Scripture on the point of one particular.'[248] They generalize thus: 'Among Protestant scholastics, the doctrine of inspiration was refined and the locus of scriptural authority shifted away from the Reformation em-

[246] Warfield, *Inspiration and Authority*, 211–12.

[247] Wolfhart Pannenberg, 'What Is a Dogmatic Statement?', in Pannenberg, *Basic Questions in Theology*, i (London: SCM Press, 1970), 182–210, at 197–8.

[248] Rogers and McKim, *Authority and Interpretation*, 176; also 172–84 *passim*.

phasis on the Holy Spirit's witness to Christ towards rational argumentation to *prove* Scripture's inspiration.'[249]

The central thesis of Rogers' and McKim's work—that post-Reformation Protestant scholastics introduced an innovation by extending biblical infallibility to include all the words of the Bible, and all the incidental details which the Bible relates—elicited a book-length and almost point-by-point rebuttal from John Woodbridge.[250] In addition, W. Robert Godfrey has responded that the placing of the *locus* on Scripture in a formal position in Turretin's *Institutio Theologiae Elencticae*, prior to his discussion of the actual content of the gospel, does not by itself constitute a move to a formal conception of biblical authority. Turretin was attempting to respond in kind to the main challenges presented to orthodox Protestant theology in the seventeenth century, which were precisely formal ones, particularly those coming from Socinians and Roman Catholics. This particular ordering of individual *loci*, which served an apologetic purpose, is not, however, evidence that in his overall theological outlook Turretin systematically neglected the central importance of Scripture's content, the saving message of the gospel.[251] In the *locus* on Scripture, according to Godfrey, Turretin argues that the authority of Scripture is established by its own self-testimony and by the marks which God has impressed upon it. Of the latter, the internal marks 'are more significant', and they are primarily to do with the content of Scripture: 'the matter of Scripture (Christ and the gospel), the style, the form (the harmony of the doctrine), and the end (the glory of God and the salvation of men)'.[252]

[249] Ibid., 166. Rogers and McKim regard Turretin's advocacy of the divine inspiration of the Hebrew vowel-points, given bold expression in the Formula Consensus Helvetica (1675), to which Turretin was a significant contributor, as '[t]he most notable implication of Turretin's concentration on the form of Scripture' (ibid., 180).

[250] Woodbridge, *Biblical Authority*. Of Rogers' and McKim's treatment of Turretin, Woodbridge points out that they seem to be entirely dependent for their view of his writings on a single secondary source, and that an M.Th. thesis written in 1958 (Woodbridge, *Biblical Authority*, 116–17).

[251] Robert W. Godfrey, 'Biblical Authority in the Sixteenth and Seventeenth Centuries: A Question of Transition', in Carson and Woodbridge, *Scripture and Truth*, 221–43, at 237.

[252] Godfrey, 'Biblical Authority', 239, summarizing Francis Turretin, *Institutio Theologiae Elencticae*, ii. 4. 9. Godfrey suggests that Turretin may be

Nor is it true that the Spirit is absent from Turretin's account, for he assumes that Scripture's 'marks' do not testify to the authority of Scripture in and of themselves, but only insofar as they are taken up by the Holy Spirit. On the question of 'The Knowledge of Scriptural Authority', he says:

When the French Confession says (article 5), 'We believe the books of Scripture to be canonical, not so much by the common consent of the church as by the witness and internal urging of the Holy Spirit,' by 'Holy Spirit' must be understood the Spirit speaking both in the Word and in the heart. So the same Spirit, acting objectively in the Word to set forth the truth, acts efficiently in the heart to impress the truth on our minds, and so is very different from fanatical enthusiasm.[253]

This is not a rationalist account of scriptural authority, but an attempt to steer a course between Roman Catholicism and 'enthusiasm', relating the testifying work of the Spirit intrinsically to the semantics of the gospel of Jesus Christ conveyed by the Scriptures.

In sum, Turretin grounds the authority of Scripture in the truth of the content of the gospel of Jesus Christ, and this content can only be derived from the interpretation of Scripture. The assurance of the truth of this content, and therefore of the supreme authority of Scripture in the passing-on of the gospel of Christ, is impressed on believers by the Holy Spirit working objectively in the Word and subjectively in the believer's heart. This is some way from Pannenberg's portrayal of seventeenth-century Protestant theology as grounding biblical authority in a formal principle of biblical inspiration. For Turretin, as for Warfield, Scripture functions as a formal principle in theology in a secondary, not a foundational, sense. It *comes* to function as a formal principle, but that function is not grounded formalistically. Its formal functioning is secondary because of its derivation, as was observed in the treatment of Turretin in Chapter 2, from the christocentric nature of theology. This is

more rationalist than Calvin on this topic, in that he thinks of Scripture's marks as being useful in coming to accept the Bible as authoritative, whereas Calvin treats them as 'very useful aids' only for believers (Godfrey, 'Biblical Authority', 240).

[253] Turretin, *Institutio*, ii. 6. 14 (translation taken from Francis Turretin, *The Doctrine of Scripture: Locus 2 of Institutio Theologiae Elencticae*, ed. and trans. John W. Beardslee (Grand Rapids: Baker, 1981)).

one of the main topics which Turretin discusses in the first *locus* of his *Institutio*—a section which has regularly been overlooked in negative assessments of his doctrine of Scripture.

Warfield's Doctrine of Inspiration and Canonical Polyphony

At the beginning of this chapter, reference was made to Pannenberg's observation that the doctrine of biblical inspiration disintegrated 'primarily because the idea of a doctrinal unity among all the sentences of Scripture without any contradiction among them, an idea that followed from the doctrine of literal inspiration, could not be defended in the long run. It was falsified by observations of scriptural exegesis.'[254] Warfield, of course, held very strongly to the idea of doctrinal unity in Scripture. One of the most striking features of his doctrine of biblical inspiration is his persistent use of the term 'oracle(s) (of God)' and its cognates as a description of the Bible. The regularity with which he uses the term might suggest an insensitivity to and flattening of the complex and diverse nature of the canon, and a consequent glossing over of the difficulties involved in moving from the canon of Scripture to theology. Warfield offers other descriptions of the Bible, some of which similarly suggest a rather static conception of Scripture. He calls the Scriptures 'a compact mass of words of God', and says that the New Testament writers regarded the Old Testament as 'nothing other than the crystallized speech of God'.[255] The highest expression of this 'oracular' view of Scripture comes in his recommendation that each book or sentence be conceived of 'as an unmediated divine word coming directly to the soul'.[256]

In the first place, it is evident that Warfield does not mean in practice what the word 'unmediated' in the latter phrase might suggest. For example, he employed, as we have seen, a high level of philological rigour in order to determine the precise meaning of biblical words, and wished to disassociate himself from the practice of proof-texting. Thus he did not believe that correct belief could simply be read straight off the pages of the biblical texts, especially the translated biblical texts. (This is

[254] Pannenberg, 'On the Inspiration of Scripture', 212.
[255] Warfield, *Inspiration and Authority*, 147, 406.
[256] Ibid., 388–9.

one reason why Warfield cannot properly be called a precursor of American fundamentalism.) It seems, in fact, that Warfield's use of 'oracular' as a description of the Bible has a single aim: to articulate the claim that Scripture is to be permanently identified with the Word of God. At one point he says that the church doctrine of inspiration views Scripture as 'a book which may be frankly appealed to at any point with the assurance that whatever it may be found to say, that is the Word of God'. There follows immediately the comment that the Bible is 'an oracular book'.[257] The latter description is best understood in his text as no more than a summary of the immediately preceding statement. As far as the content of his argument is concerned, then, Warfield's use of the language of 'oracle(s)' adds nothing substantive to the claim that 'what Scripture says, God says', and that with no other instance of human linguistic activity may this identification be made in the same way.

The simple answer to the question of why Warfield chooses to describe his view of the Bible in terms of 'oracles' is that it is a term which the New Testament uses for the Old Testament as a whole, or possibly for just the Torah or the Decalogue.[258] However, in his essay on 'The Oracles of God' it becomes evident that a significant influence on Warfield's choice of terminology is Philo, for whom, he says, every passage of Scripture is a λόγιον, and whose most common term for the Bible as a whole is probably οἱ χρησμοί.[259] Warfield has been judged, fairly it seems, to have been 'paralyzed by Philo' on this point, for the New Testament's uses of τὰ λόγια τοῦ θεοῦ provide no warrant for 'any leveling of biblical passages to a "compact mass of words" like some gigantic and tedious pagan χρησμός.[260]

The significance of this point is that it is often alleged that Warfield's doctrine of inspiration flattens the diversity of the biblical witness to the Word of God. Trembath argues that the doctrine of plenary biblical inspiration affirms that the Word of God is found wherever one looks in the Bible.[261] Colin Gunton

[257] Warfield, *Inspiration and Authority*, 106.
[258] e.g. Rom. 3: 2; Warfield, *Inspiration and Authority*, 148.
[259] Warfield, *Inspiration and Authority*, 384–7.
[260] Douglas Farrow, *The Word of Truth and Disputes About Words* (Winona Lake: Carpenter, 1987), 104.
[261] Trembath, *Evangelical Theories*, 92.

rejects the doctrine because he wants to 'dispense with the need to wring equal meaning out of every text'.[262] In fact, it can be argued that Warfield does have a nuanced understanding of the relationship between the Bible and the Word of God. He rejects proof-texting; he acknowledges the progressive and historical nature of revelation; and in practice his description of Scripture is determined christocentrically, since he privileges what he takes to be Christ's view of Scripture. His 'oracular' view of the Bible does not leave him insensitive to literary genres or unable to identify interpretative centres in the Bible. What Warfield lacked, simply by virtue of his particular historical location, were the conceptualities which would have allowed him to articulate, and to put more consciously into exegetical practice, a sophisticated approach to the genre, literary characteristics and illocutionary force of the whole biblical text being studied. Such conceptualities, suggestions for which were outlined in the first section of this chapter, allow for a more nuanced description of how the various statements and literary units in the Bible function in relation to one another than the model suggested by the description of the Bible as 'a compact mass of words of God'.

Nevertheless, this does not destroy the legitimacy of the single claim which Warfield's entire corpus on inspiration attempts to uphold: that God is the ultimate author of Scripture. Much depends on how the word 'says' is understood in Warfield's fundamental axiom, 'What Scripture says, God says.' It has been argued in previous chapters that speaking is a much richer and more complex activity than has often been realized, and in this chapter that Scripture speaks in complex polyphonic ways. The recognition that Scripture 'says' many things in various ways only signals the end of the 'church doctrine' of inspiration if it is assumed that God can only 'say' in one way. Warfield's axiom can survive, and even flourish, if a recognition of the complexity both of speech itself and of polyphonic Scripture is allowed to modify our understanding of what 'God says', and how he says it. The basic structure of Warfield's doctrine of biblical inspiration does not crumble

[262] Colin E. Gunton, *A Brief Theology of Revelation* (Edinburgh: T. & T. Clark, 1995), 66.

with the removal of the language of 'oracles', and can be constructively developed by supplementation from the notions of speech and canonical polyphony which have been proposed here.

CONCLUSION

The first section of this chapter argued that language, both in its referential capacity and more fundamentally as a means by which persons act in relation to one another, should be conceived of as fundamentally polyphonic. This model of language was offered as philosophical support for Paul Ricoeur's 'intratextually realist' account of the polyphonic diversity of Scripture. Reflecting specifically on the biblical canon, the canonical hermeneutics of B. S. Childs were examined, and found to be lacking on the question of the justification of final-form readings and inter-canonical interpretations of the Bible which he practises. A general hermeneutical basis for such canonical readings of Scripture was identified in a recent suggestion made by E. D. Hirsch. In order to supplement Childs's work with a specifically theological basis, we turned to a discussion of the inspiration of Scripture. It was argued that the strong doctrine of inspiration held by the Protestant orthodox, and as articulated especially by B. B. Warfield, can, with certain modifications of Warfield's terminology, withstand much of the attack directed at it. That is, Warfield's doctrine of the inspiration of Scripture functions not as a formal principle invoked prior to a discussion of, and therefore grounding the authority of, the content of the gospel and the biblical texts, but as an exegetical conclusion drawn from the testimony of Christ and of the apostles to Scripture. Scripture comes to function as a *principium cognoscendi*, but only in a secondary sense. For Warfield, both the authority and sufficiency of Scripture are derived from the authority of Christ.

As a basis for an 'intratextual' approach to Scripture, this conception of biblical inspiration establishes biblical intertextuality not as an endlessly self-referential web of literary patterns, as in deconstructive models of intertextuality, but as a web of literary and thematic patterns which ultimately focus on one central individual. Biblical intertextuality has an intern-

ally established centre and *telos*. It is in him that the uniqueness and ultimately the authority of the Bible is located.

It may still be objected that nevertheless an extended discussion of a particular attribute of Scripture, such as that offered in the present work, represents an implicit challenge to the supremacy of Jesus Christ, the subject-matter of Scripture, who is actually present in its reading and proclamation. Ultimately, it might be thought, one cannot serve two masters; one must choose between Christ and Scripture, between Christology and the doctrine of Scripture as the content of God's speech. John Barton puts it simply: 'Christians are not those who believe in the Bible, but those who believe in Christ.'[263] Barth makes a similar point in his 'equation of God's Word and God's Son', which he establishes as 'a real and effective barrier' against what 'the later form of older Protestantism' made of church proclamation: 'a fixed sum of revealed propositions which can be systematised like the sections of a corpus of law'.[264] This also lies behind Gunton's concern, referred to above, that Christians should not encumber themselves with a doctrine of Scripture which requires them to make every biblical text equally meaningful.[265] This is equivalent to a warning that it is possible to make Scripture too sufficient; the doctrine of Scripture, including the confession of the sufficiency of Scripture, must not be allowed to extend beyond its christological limits. It amounts to a rejection of the legitimacy of the Bible functioning as what we have called a secondary *principium cognoscendi*, established non-formalistically.

William Abraham has recently developed this objection to the orthodox Protestant doctrine of Scripture in a lengthy historical and theological study. He draws a sharp distinction between Scripture viewed as canon and Scripture viewed as criterion. He argues that the canon of Scripture should be set alongside other normative ecclesial canons; among these he lists creeds, liturgy, the Fathers, sacraments, and iconography. Scripture should function in the church as a means of grace by

[263] John Barton, *People of the Book? The Authority of the Bible in Christianity* (London: SPCK, 1988), 83.

[264] Karl Barth, *Church Dogmatics* I/1, trans. G. W. Bromiley (Edinburgh: T. & T. Clark, 1975), 137.

[265] Gunton, *A Brief Theology of Revelation*, 66.

which people are brought to faith and made wise for salvation, not as an epistemological criterion of truth and knowledge.[266] However, a process which began with Aquinas and gathered pace through the Reformation and beyond has turned Scripture into precisely such an epistemological criterion. This pushes Abraham back to the patristic period to find examples of Scripture being treated properly as canon and not as criterion. In fact, he acknowledges that many of the Fathers do use Scripture 'epistemically'. In defending Scripture as a standard and norm (i.e. canon) of teaching, they did develop, he says, 'tacit epistemological commitments', such as the apostolicity of the biblical material, the relation between Christ and the apostles, the special divine revelation in Christ, and the divine inspiration of the biblical writers. However, he argues, the Fathers did not systematize these 'tacit commitments' into the form of an epistemological criterion.[267] The Rule of Faith, for example, was not an epistemic norm but 'a norm of orthodoxy and heresy'.[268]

These patristic examples suggest that a sharp distinction between 'canon' and 'criterion', on which Abraham's whole work rests, cannot in fact be maintained. A 'norm of orthodoxy and heresy' cannot but function epistemically. The church will regularly face, both from within and from without, the challenge to explain and defend the source of what it believes—and rightly so, given the provocative nature of its message to itself and to the world. 'On what basis is what you say true?', is a question which the church cannot shrug off. This challenge requires believers to defend the legitimacy of their tacit epistemological commitments—and for this defence some kind of systematic 'canonization' of one's epistemological norms, insofar as they are also theological norms, becomes necessary. Anyone who refuses to offer a reasoned theological and epistemological defence of his beliefs in this way will be guilty of obscurantism at either an individual level ('Don't ask questions, just believe me') or an ecclesial level ('What we believe is right because *we* believe it'). The refusal of epistemology in theology and church-

[266] William Abraham, *Canon and Criterion in Christian Theology: From the Fathers to Feminism* (Oxford: Clarendon Press, 1998), 1–2, 6–7.

[267] Ibid., 140–1.

[268] Ibid., 36 n. 17.

life can therefore lead quickly into the idolatrous grounding of authority either in oneself or in one's religious community. This theological position is rightly both ridiculed and feared, both within and outside the church.

Abraham's book skilfully keeps the two concepts of 'canon' and 'criterion' distinct by portraying 'criterion', as a description of a certain kind of theological use of Scripture, as an epistemologically all-sufficient criterion: 'A list of religious documents drawn up by a Church is simply not a candidate for a criterion of rationality, justified belief, or knowledge.'[269] However, this kind of philosophical sufficiency was not what was in view theologically when the epistemological elements of patristic theology were slowly systematized and made normative (as, indeed, were other elements of patristic theology). Instead, the systematization of the epistemological aspects of theology serves only to ground the fundamental theological truths of Christology and soteriology. The church must have grounds external to itself from which it can proclaim and explain that its biblical message of salvation in Christ is true and not false. It must also have a prophetic and historical ground external to itself by which it can consciously escape inventing an idolatrous version of Christ. A collection of divinely inspired texts which constitute the explanatory prelude to, the direct witness to, and the immediate practical reflection on the divine self-revelation in Christ are exactly suited to providing that ground. Scripture is the only criterion by which the church can, and a necessary criterion by which the church must, test that what it proclaims and lives out as the gospel of Christ is in fact faithful to the reality of God's self-revelation in Christ. This is not a wide-ranging philosophical criterion which the church only develops when it comes under the unfortunate influence of general epistemological theory, but a theological criterion given to it by which, empowered by the Holy Spirit, it may keep its proclamation and life faithful to its head. Scripture *is* a means of grace, by which people are brought to faith and made wise for salvation. Since to come to faith is also to come to a knowledge of the truth, Scripture's function is also in part epistemological.

The formulators of the orthodox Protestant doctrine of the

[269] Ibid., 12.

sufficiency of Scripture, for example, saw very clearly that
Christ, the material content of Scripture, is unavoidably served
by his relation to the formal aspect of Scripture.[270] The content
of Scripture is ultimately the living Christ, and our knowledge
of the identity of Jesus of Nazareth as the promised Messiah
of Israel, the Saviour of the World, the head of the church,
and the risen, ascended, and coming Lord, is established and
renewed by the sufficiency of the canon of Scripture to witness
to him as this one and no other. The primacy of Jesus Christ in
revelation and in church life is secured, rather than threatened,
by the orthodox Protestant confession of scriptural sufficien-
cy.[271] If 'Jesus Christ' is set up as the sole unquestionable prin-
ciple of the self-interpretation of Scripture, the 'centre' in the
light of which other parts of Scripture are judged not to witness
truly to him, to fall short of his gospel—which is the direction
in which Pannenberg's account of biblical inspiration tends—
then the 'Jesus Christ' in terms of whom we read Scripture will
be a Jesus Christ whose identity is formed for us only partly by
Scripture—probably by those parts which most appeal to us.

It is important to clarify what is not entailed in this claim for
the sufficiency of Scripture. Francis Watson, along with several
others, notes the lack in Childs's work of a theological justi-
fication for his actual approach to biblical interpretation. That
has been addressed here by supplementing Childs's canonical

[270] See ch. 2.

[271] This is not intended as an argument for a 'flattening' literalistic inter-
pretation of Scripture, particularly of those parts of the Old Testament which,
in the course of progressive revelation, do not have 'literal' authority over
believers today. 'Literal', though, is here in scare-quotes because, as argued
earlier in this chapter, the Old Testament itself refers to what for it is an
unnamed coming reality. For Christian believers, obedience to the 'literal'
sense of e.g. Old Testament food laws in the context of the canon would there-
fore mean adherence to Christ's warning that it is not what goes into us that
makes us unclean but what comes out of us (Mark 7: 15). Literal sense, which
is always contextually defined, is therefore to be distinguished from literalistic
sense, which is not. See Vanhoozer's comment that 'the literal sense—the
sense of the literary act—may, at times, be indeterminate or open-ended'
(Vanhoozer, *Is There a Meaning?*, 313). Nor is it to deny the necessity of
recognizing tropes in Scripture; as has long been acknowledged, the 'literal
sense' of a text can be metaphorical, if that is its intended meaning. See e.g.
Beryl Smalley's comment in this regard on the twelfth-century writer Hugh
of St Victor (Beryl Smalley, *The Study of the Bible in the Middle Ages*, 3rd edn.
rev. (Oxford: Blackwell, 1983), 93), referred to in ch. 2.

approach to the Bible with a doctrine of biblical inspiration. Watson argues: 'It is one thing to describe the formal outlines of the canonical object, over against an interpretative tradition that has rendered it invisible; it is quite another to assert, as Childs does, the *adequacy* and *sufficiency* of the canon for guidance of the community into truth.' Watson thinks that Childs's portrayal of the community of faith guided by the canon does not match reality, for the Bible cannot do the work in the church now which Childs wants it to do. Among the vital things which the canon does not tell us, Watson points out, are: that its truth lies 'not in the individual text but in the complementarity and balance established by the entire collection'; whether or not we may prefer one text over another; what status is to be given to the Septuagint; 'how to cope with its apparent contradictions, improbabilities, and other difficulties'; and whether and how its authority 'is to be co-ordinated with other kinds of authority'.[272]

The majority of Protestant orthodox theologians have indeed not, in their doctrinal assertion of the sufficiency of Scripture, declared these questions to be clearly resolved. The canon has rarely been declared to be sufficient for 'guidance of the community into the truth', if by that is meant that a relatively easy and definitive resolution of theological, interpretative, and applicational questions may be read off the surface of the canonical texts. A question such as that of the status of the Septuagint will be decided by complex historical considerations.[273] As regards the claim for Scripture's errorlessness, by contrast, Warfield goes to the evidence which he finds in the text itself, championing Jesus' witness to the nature of Scripture over critical observations about the Bible's apparent 'phenomena'. Human reason, used not as an absolute philosophical

[272] Watson, *Text, Church and World*, 43–4. For a similar observation about the insufficiency of the canon, see Frances Young's comment on Irenaeus: 'proper performance of scripture for Irenaeus depends in the end not on canons of interpretation offered by the scriptures themselves . . . but rather on the 'plan of salvation', on what we might call the Christian kerygma, on a framework belonging to the particular community which designates these books as authoritative, a framework related to these books but "extra" to them' (Young, *The Art of Performance*, 60).

[273] This question was referred to briefly above in the treatment of B. S. Childs.

foundation, but instrumentally, is required to reach the conclusion that Jesus is the centre of Scripture; it is certainly required to argue that he is the exegetical centre in precisely the way Warfield sees him, and to argue exegetically for a balanced complementarity between the texts in their corporate witness to him. Such a use of reason is also required, along with a theological hermeneutic, if we are to assess interpretations which relegate the authority of one text below that of another.[274] The Westminster Confession of Faith provides one of the strongest confessions of the sufficiency of Scripture, while also ascribing this kind of role to reason.[275] The canon of Scripture does not itself explicitly provide a sufficient set of 'canonical' interpretative frameworks, which would decide all historical questions about it, and especially all questions of biblical interpretation and present-day application. It is in that sense insufficient. Indeed, to find resources for the reconstruction of the doctrine of the sufficiency of Scripture outside Scripture, as has been done throughout this work, is a necessary strategy in theological formulation, and not a performative denial of the doctrine.

However, the doctrine defended here assumes a realist epistemology, such as that to which Watson also holds. According to this view, the content and structure of the canon of Scripture—as is the case with every speech act—is sufficiently 'there', sufficiently real, external to the reader, to resist interpretative frameworks which are inappropriate to it, and to allow discernment of their inappropriateness. That is, the canon, both in its individual texts and in their determinate interrelationships, is sufficient to determine a spiral of constantly revised frameworks which enable ever fuller hearing of its message, that is, ever fuller knowledge of what the Bible says of the character and

[274] Goldingay offers three models for assessing such interpretations, and for interrelating the diversity of the Bible's material: privileging those biblical texts which offer 'the high points of insight' on a theme; looking for internal canonical critical principles; simply accepting a diverse unsystematic witness to a complex reality (Goldingay, *Theological Diversity*, 58, 98 ff., 184).

[275] 'All things in Scripture are not alike plain in themselves, nor alike clear unto all; yet those things which are necessary to be known, believed, and observed for salvation, are so clearly propounded, and opened in some place of Scripture or other, that not only the learned, but the unlearned, *in a due use of the ordinary means*, may attain unto a sufficient understanding of them' (Westminster Confession of Faith, 1. 7 (italics added)).

actions of God. The more the Bible is read through a variety of interpretative frameworks, and the more those frameworks are revised in light of the texts, the more what is and is not there in the canon as a whole will be discerned. (Becoming clear on which matters the Bible does not speak clearly about is nearly as important in church life as determining what it does say.) Although sufficient to determine this spiral, the canon does not of course enforce it on any reader; for the spiral to be realized, readers must read with care and self-suspicion.[276] This notion of what it is to read has been outlined by N. T. Wright, broadly as an epistemology of critical realism, and narrowly as a 'hermeneutic of love': 'Each stage of the process [of reading] becomes a *conversation*, in which misunderstanding is likely, perhaps even inevitable, but in which, through patient listening, real understanding (and real access to external reality) is actually possible and attainable.'[277] The material content for these interpretative frameworks will necessarily come in part from outside the Bible and outside the community which wishes to read the Bible; the recognition that no individual or community can ever exhaustively grasp the God who comes to the world polyphonically must make Christians open to this reality. However, all interpretative frameworks, whatever their origin, are to be, and can be, revised by the Scripture whose reading they enable.

[276] Dialogue with Bible-readers from other communities is a crucial part of 'careful reading', and a vital means for becoming rightly suspicious of one's own prior readings: 'faced with the fragmentation of the sociolinguistic community to which the Canon and the canons of interpretation belong, self-consciousness needs to be fostered about the various interpretative frameworks brought to the text, inherited as they are from differing group traditions within Christianity, and based partly on abstraction of intratextual elements, partly on extratextual theological assumptions. Then the Canon of scripture which we hold in common, and the frameworks we do not, can be integrated through tough theological thinking and dialogue of a creative kind' (Young, *The Art of Performance*, 62–3).

[277] N. T. Wright, *The New Testament and the People of God* (London: SPCK, 1992), 64. Wright here acknowledges a debt to Ben F. Meyer's work on 'critical realism' and the New Testament. See also Vanhoozer: 'hermeneutic rationality is a matter of putting one's interpretations to critical tests, not of putting them on secure foundations. . . . The rationality of an interpretation is essentially a function of its ability to endure critical enquiry' (Vanhoozer, *Is There a Meaning?*, 301). He argues at length that the form and content of a speech act can be known with 'relative adequacy' (ibid., 281–366).

In sum, a principle of 'canonically limited polyphony' is proposed, which would establish three necessary conditions, collectively forming a sufficient condition, for the 'naming' of the God of revelation. God must be named polyphonically. To name him in only one way would be to view and know his reality in only one dimension. And God must be named by a limited polyphony. To name him in limitless ways is not to name him at all. And to seek to delimit the polyphony by any other criterion than by the canon of Scripture is to risk naming a God after our own image.[278] The formal aspect of the sufficiency of Scripture, then, the rule of Scripture as its own interpreter, is best viewed as a vital doctrinal statement of the necessary and sufficient conditions for the 'naming' of God. Since it is sufficient in this way and for this purpose, Scripture is insufficient to provide warrant for dogmatism about knowledge. Since no one may ever grasp the full polyphonic self-revelation of God at one time, no one ever succeeds in fully nailing God down.[279] (Only idols are susceptible to nailing down; they even require it, sometimes.[280])

In that it is God himself who by a personal act gives himself to us by giving us the semantic means by which we may name him, the sufficiency of the canon of Scripture can be defined in terms of Scripture as a speech act of God. Scripture is sufficient for the continued performance of the illocutionary act which God once performed in the preparation for, in the witness back

[278] Metzger summarizes recent attempts, especially in continental Europe, to discern 'a canon within the canon'. He comments that such attempts, along with such historical positions as Luther's qualms over the epistle of James, always succumb to arbitrariness, because they fail to envisage situations in which the books proposed as marginal could become of vital significance for the church: 'New Testament scholars have the responsibility as servants of the Church to investigate, understand, and elucidate, for the development of the Christian life of believers, the full meaning of every book within the canon and not only of those which may be most popular in certain circles and at certain times. Only in such a way will the Church be able to hear the Word of God in all of its breadth and depth' (Metzger, *The Canon of the New Testament*, 282).

[279] This point is informed by what Vanhoozer calls 'The Christian morality of literary knowledge': 'the claim that there is knowledge is not the same as the claim that one possesses it or that the possession of such knowledge allows one to impose one's opinions on others. There is always something more that can be said in an argument' (Vanhoozer, *Is There a Meaning?*, 302).

[280] See Isa. 41: 7.

to, and in the actuality of, his self-revelation in his appearing in human flesh. '[Jesus] is, as it were, encompassed by textuality: preceded by writings that prepare his way before him, followed by the writings of those who cannot but speak of what they have seen and heard.'[281] This specific web of textuality, in its propositional and illocutionary acts, is sufficient for God to say what he has to say to humankind about his redemptive act in Jesus Christ.

[281] Watson, *Text and Truth*, 27.

6

Conclusion

To recap: conceptual resources found in literary theory, hermeneutics, and the philosophy of language have been used in order to reconstruct the basis of a contemporary formulation of the Christian doctrine of the sufficiency of Scripture. Three historical elements of that doctrine were identified: God speaks, and Scripture is the primary medium of that speech; Scripture contains everything necessary to be known for salvation and for faithful Christian discipleship; the canon of Scripture as a whole is self-interpreting. Each of these three elements may be meaningfully and coherently re-articulated. Scripture may be conceived of as a divine speech act, identified permanently with the Word of God. Scripture, as text, is sufficient for that speech act, bearing propositional content and conveying illocutionary force. The Scriptures, as textual canon, are sufficient for the continued performance of the illocutionary act which God once performed in the culmination of the history of redemption in Jesus Christ.

To make this kind of assertion is inevitably to adopt a certain attitude with regard to the authority of the Bible. When doctrines of Scripture are being discussed, what many Christians are eager to defend, and what many others are keen to deny, are particular positions on the authority of the Bible. After all, we rightly want to know what the practical force of a particular doctrine will be, if we are to assess its faithfulness and appropriateness as a Christian confession. And discussions about the authority of the Bible are themselves highly charged because of debates on certain practical questions that divide Christians—debates in which each side either stands on or rejects the authority of the Bible to determine the faithful Christian position on a particular question. For example, in many parts of the church questions of the role of women in ordained ministry and of the legitimacy of homosexual practice are currently very

prominent. It is not to be inferred from the orthodox doctrine of Scripture recommended here that simple answers can be given to these, or any other, controversial exegetical questions. What the doctrine of the sufficiency of Scripture does recommend is the absolute necessity of careful, faithful, and subtle biblical exegesis as Christians try to listen for the divine voice on these issues; the doctrine is however insufficient to determine the exegetical results in advance.

Thus, to assert the sufficiency of Scripture is not to imply that all questions of the functioning of Scripture in church and theology have been solved. However, it *is* to choose Scripture as one's supreme authority in Christian life and theology, and to decline other theological options. In his influential work on the uses of Scripture in recent theology, David Kelsey says that 'a theologian who marshals his proposals under the emblem "Let theology accord with scripture" does not thereby announce that he has made a methodological decision, but only that he has taken on an awesome array of methodological problems.'[1] Kelsey is right on the latter point: the end of biblical interpretation is never reached, and the precise nature of Scripture's relationship to other sources of authority in theology will never be exhaustively mapped out. Yet a theologian who works under the banner "Let theology accord with Scripture" has made a very significant choice. He has chosen not to be confronted with some other 'awesome array' of methodological problems, but instead with the particular 'awesome array' which arises once a faithful engagement with Scripture is taken to be central to the theologian's task. A faithful engagement with Scripture, it has been argued throughout, is one which looks for the speech act, made up of propositional and illocutionary acts, which is in fact performed in and by the text, and which then seeks to submit to the perlocutionary effect which that speech act intends to bring about.

In this mode of Bible reading, it is not only the content but the literary form of biblical texts which will come to be authoritative, since literary form is a significant bearer of the illocutionary force of a literary text. A book of laws is authoritative in a different way from how a narrative is authoritative, or a book

[1] David H. Kelsey, *The Uses of Scripture in Recent Theology* (London: SCM Press, 1975), 111.

of poems, or a doctrinal exposition. If the whole Bible is reduced to one of these literary genres—as if it were all doctrine, all poetry, all narrative, or all law—then the authority of the Bible as a whole is not being respected, however loudly that is declared to be the case. To apply individual verses from the book of Leviticus, for example, exactly as they stand in the text, as law to the life of the contemporary Christian is not faithful submission to the authority of the Bible, but an act of violence against it. The way in which a particular biblical book functions authoritatively is determined in large part by its literary form.

Kelsey draws a further distinction—one often made—between a text's properties and its use: 'When a theologian says it ["Scripture is authoritative for theology"], he does not so much offer a descriptive claim about a set of texts and one of its peculiar *properties*; rather, he commits himself to a certain kind of activity in the course of which these texts are going to be *used* in various ways.'[2] However, the 'use' of any text, including the Bible, always implies a claim about its 'properties'. Once a text has come to be viewed as having the properties of a personal speech act, then to 'use' it in a certain way is simply to act in ways either ethically appropriate or ethically inappropriate to the nature and properties of the text. Only if a text is an inert, non-personal entity which can never determine its own proper usage does this distinction between 'property' and 'use' hold good. This is true for the Bible simply as a text like any other. Moreover, the particular theological use of the Bible as supreme authority in Christian life and theology is based on the further claim that it has the properties not just of a personal speech act but of a divine personal speech act. Again, use follows from convictions about textual properties. Doctrines of Scripture, making as they do statements about the properties and consequent appropriate uses of Scripture, are therefore necessary in theological and ecclesial life. They demonstrate to Christians as well as to others that our use of the Bible ought not to be merely arbitrary, determined by the inherited biblical practices of our particular community. Our use of the Bible must instead be continually reformed, so that we read it and interpret it as it determines.

[2] Kelsey, *The Uses of Scripture*, 89.

Kelsey thinks that the Bible is insufficient for this task of determining the way in which it is to be read. It is 'utterly unrealistic', he argues, to expect a doctrine of Scripture

to identify *the* way in which scripture can 'control' theology so as to keep it Christianly apt. . . . Surely, Christianly speaking, it would be improper even to hope for that. For the full *discrimen* by which theological proposals are finally to be assessed includes the active presence of God. No 'theological position' would presume to tell us how to use scripture so as to 'guarantee' that God will be present to illumine and correct us. Theological proposals are concerned with what God is now using scripture to do, and no degree of sophistication and theological methodology can hope to anticipate that![3]

However, God's present use of Scripture does not override the literary and theological properties of the text, nor does it erase the nature of the Bible as a speech act. Whatever 'God is now using scripture to do' he does precisely by means of the intrinsic features of the text, in the act of bringing about in believers by the Holy Spirit the perlocutionary effect appropriate to the illocutionary act represented by the text. The Holy Spirit does not make a wax nose of Scripture. God's active presence now in the church by his Spirit always guides, leads, and speaks in accordance with his activity by the Spirit in the inspiring ('breathing out') of the texts of Scripture. Thus, theological proposals which would be faithful to God should seek authorization precisely by paying attention to the means (illocutions performed through locutions) by which, in and through these texts, God bestows his presence (brings about the perlocutionary effect) on the church. There is then a single 'way in which scripture can authoritatively "control" theology'. It has the status not of a precise 'theological position' but of an ethical readerly attitude to the illocutionary acts by which God conveys Christ to us in Scripture. It is not that God's presence is 'guaranteed' by this 'way'; that would be a tendentious way to characterize it. Rather, Christ is faithfully conveyed to us by the polyphonic literary and generic diversity of Scripture. The Holy Spirit acts first to enable understanding and discernment of the Christ so conveyed to us in Scripture, and supremely to stir up in us faithful and active response to him.

[3] Ibid., 215–16.

In our introduction, it was suggested that one factor which in many minds counts most strongly against the legitimacy of the doctrine of the sufficiency of Scripture is not a theological one, but instead arises from observations of the life of those Christian communities which adhere most strongly to the doctrine. Their adherence to the sufficiency of Scripture does not necessarily 'work' to make them more faithful in Christian discipleship than those groups which do not subscribe so clearly to the doctrine. However, it does not follow from these practical failings, from these apparent performative contradictions of it, that the doctrine of the sufficiency of Scripture is dangerous, useless, or unnecessary. The necessity of distinguishing fundamentally between text and community, illocution and perlocution, has been argued throughout as central to the confession of scriptural sufficiency. No doctrine pretends to be able to guarantee faithful Christian practice. (Only in the case of Scripture does the author of a text himself possess the capacity to bring about the intended perlocutionary effect in his addressees.) The doctrine of the sufficiency of Scripture legislates precisely for the inevitable dynamic by which communities of Christian faith drift from faithful living and thinking, domesticating the voice of God in accordance with their own prior convictions and biases. By its confession of the doctrine, the church reminds itself of the supplement which its life and word always need, remembering, in hope of continual restoration, where the redemptive voice of God may unfailingly be heard.

It is sometimes felt, further, that the central position recommended for the Bible here mistakes the nature of the object of faith in Christian faith. Biblical texts are authoritative because certain people—the human authors, such as the apostle Paul, or the subject of the texts, supremely Christ—are authoritative; Christian faith is directed towards persons, not a book.[4] As a statement of the object of Christian faith this is incontrovertible. Whenever someone attempts to prove a point with the words, 'The Bible says . . .', the suspicion is understandably aroused that the true bases of Christian faith are being distorted. However, once all uses of language are conceived of as

[4] e.g. James Barr, *Holy Scripture: Canon, Authority, Criticism* (Oxford: Clarendon Press, 1983), 48; John Barton, *People of the Book? The Authority of the Bible in Christianity* (London: SPCK, 1988), 83.

speech acts, it becomes questionable whether this kind of invocation of biblical authority is necessarily problematic in this way. To give an everyday example: there does not seem to be a significant semantic difference between saying to someone, 'I trust you', and saying, 'I trust all the promises and assertions you have addressed to me.' The speech act, as an act of a person, is a kind of extension of that person. Of course, utterances beginning, 'The Bible says . . .', may abuse the Bible by proof-texting; the point is that this need not be the case with the kind of commitment to biblical authority implied by the sufficiency of Scripture. To trust the God of revelation and to trust Scripture, that is, to trust the speech acts it represents, can be and ought in practice to be regularly one and the same action.

It is important to locate the proposals offered in the present work in relation to the collection of views of the Bible often labelled 'fundamentalist'. Given what has just been argued about biblical authority, and about the frequent identity of the statements 'The Bible says . . .' and 'God says . . .', the question cannot be avoided. What has been argued throughout this book differs from what is usually referred to as 'Christian fundamentalism' in three significant respects. First, whereas much fundamentalism short-circuits the difficulties of biblical interpretation by proof-texting, textual meaning has been defined here in terms of literary genre. If anything, this increases the complexity of the task of biblical interpretation, at least on certain topics, rather than simplifying it. Thus, no particular position is being smuggled in on certain contentious issues of biblical exegesis, such as those concerning gender and sexuality. Although it has been argued that certain interpretative methodologies, from proof-texting through to free-playing intertextuality, are illegitimate, no single interpretative methodology has been proposed as the only right one. This is not to decide in advance that Scripture does not speak in favour of one side of the debates on these issues; it is rather to appeal to anyone wishing to argue a point in some way based on Scripture for greater faithfulness in exegesis to the nature of the texts which all sides share in common. Faithfulness to the nature of biblical texts includes faithfulness to their nature as complex literary texts. This is a second way in which the present proposals are not fundamentalist, for the practice of faithfulness to

the nature of Scripture includes the acknowledgement both that Scripture is God's speech act and that God speaks polyphonically. This calls for epistemological humility in the biblical interpreter, who must recognize that no reader ever fully grasps the content of the texts. The present work is also not properly characterized as 'fundamentalist' for a third reason—namely, that it has been conducted through discussion with a variety of academic disciplines, both critiquing them and being informed by them. Fundamentalism is usually marked by hostility to secular culture in general and especially to its intellectual trends. By contrast, speech act theory has been both adopted and baptized in the present work, entirely from outside Christian theology, on the basis that it makes a significant contribution to the formulation of Christian doctrines of Scripture.

This use of non-theological concepts in theological formulation raises the question of the relationship between special and general hermeneutics. This question can be asked at various levels of the arguments offered here. Is the sufficiency of Scripture a special case of the general principle of textual sufficiency outlined in Chapter 4, or is the latter inferred from the former? Is the obedience due to God in Scripture a special case of the ethical responsibility which all readers owe to all authors, or is the latter learned from the former? Does speech act theory tell us how to conceive of the Bible, or does the Bible somehow pick out speech act theory as an appropriate interpretative framework through which to think of it? Do we supplement the Bible, or does it supplement us? It may seem that we have supplemented the Bible, supremely with the conceptualities offered by speech act theory.

One specific biblical point and one general philosophical point may be made here, in answer to these questions. First, a strong case can be made from exegesis of numerous biblical texts that the Bible itself holds a clear speech-act view of language in general and of God's speech in particular. A few examples can be given here. In the opening chapter of the book of Genesis, God creates by an act of speaking: he speaks and it is so. It is when God puts his own words into the mouth of the prophet Jeremiah that the latter has authority to destroy and to build nations (Jeremiah 1: 9–10). God speaks about his own word as accomplishing the purpose for which he sends it

(Isaiah 55:10–11). Protestant theologians have traditionally construed the biblical doctrine of justification as a divine *declaration* of acquittal. God's *calling* of individuals is an integral part of the means by which he brings them through to glorification (Romans 8: 28–30). Further examples could be multiplied. What happens when the Bible is read with speech act theory at the front of one's mind is that these aspects of the biblical texts are more clearly discernible. A speech-act model of language is not imposed on the Bible, but is discerned, from a particular interpretative standpoint, already to be there.[5] This leads to the second, philosophical answer to the question of the relation of special and general hermeneutics. In the act of reading we inevitably interpret the Bible through various grids and frameworks; but the Bible, if we are careful readers, will gradually refine them, so that we are ever more able to hear the Word addressed to us. If we thus 'supplement' the Bible, that is only an initial epistemological gesture by which it may bring a vital semantic and illocutionary supplement to us, as we become the people being formed in faithful response to the God speaking in it. This is the critical-realist epistemology referred to at the end of Chapter 5. The present proposals are therefore offered as a conceptual framework which, when Scripture is conceived of by means of it and read in light of it, may be corrected by Scripture where it imposes distortions on the text. As an epistemological attitude towards the text, this is no 'special' biblical hermeneutic.

Epistemologically, then, we only come to know the semantic content of a text by this process of hermeneutical imposition and faithful listening to the text's confirmation of and resistance to our reading. Ontologically, we conceive of texts rightly by

[5] Thus, while adopting conceptualities from a contemporary branch of the philosophy of language, we have attempted to heed Devitt and Sterelny's warning regarding twentieth-century philosophy of language: 'Attention has focused so heavily on language that the metaphysical issue has tended to disappear; or to be redefined in linguistic terms; or worst of all, to be confused with linguistic issues. In general, the philosophy of language has become too big for its boots' (Michael Devitt and Kim Sterelny, *Language and Reality: An Introduction to the Philosophy of Language* (Oxford: Blackwell, 1987), 188). Hans Frei and George Lindbeck, along with deconstructive writers (see ch. 4), might be cited as examples of writers who have been adversely affected by the attempts of the philosophy of language to overreach itself.

the conceptual supplementation of them with the determinate relationships they have with authors, readers, and speech situations. By these conceptual means, a doctrine of the sufficiency of Scripture has been outlined which may not be misunderstood as a doctrine of the self-sufficiency of Scripture.

The various 'logics of supplementarity'[6] by which the present work has come to conceive of textual ontology in general and the Bible in particular are therefore very different from the 'logic of supplementarity' by which Derrida reads Rousseau's texts. Speech act theory introduces personal agency as an ineradicable and necessary level of description into the conception of language, while Derrida abolishes it. Persons can and do impose on the play of signifiers such that they are able to act on other people and on themselves by the performance of intersubjective illocutionary acts; signifying systems are supplemented by personal agency. Derrida and others allege it to be a necessary condition of the performance of an illocutionary act that an articulation of a complete grammar of the speech-context be possible. Finding the condition unattainable, he decides that speech act theory offers an invalid model of language-use. This 'all-or-nothing' approach to conceiving of speech acts turns out to be a rather wooden way of thinking about the complexities of language-use. Between the eschatological 'all' of fully grasping the completeness of the polyphony of biblical meaning and the nihilistic 'nothing' of having no knowledge of God lies the adequacy of knowing in part. Analogously, between Derrida's deliberately unattainable demand that contexts be distinguished from one another in every particular and his consequent conclusion that all is context in the same way and at the same level (*il n'y a pas de hors-texte*[7]), lies the actuality of the performance by subjects of speech acts.

Thus, the notion of an illocutionary act does not necessarily presuppose the kind of absolute presence, the strict distinction

[6] This is Jonathan Culler's phrase (Jonathan Culler, *On Deconstruction: Theory and Criticism After Structuralism* (London: Routledge & Kegan Paul, 1983), 105).

[7] 'There is nothing outside of the text'; literally, as the translator inserts in parentheses, 'there is no outside-text' (Jacques Derrida, *Of Grammatology*, trans. Gayatri Chakravorty Spivak (Baltimore and London: Johns Hopkins University Press, 1976), 158 (original italics removed)).

between 'outside' and 'inside', 'text' and 'context', which
Derrida undermines.[8] We should probably not talk of a text as
supplemented by persons at all, for that may be taken as an act
of addition to a previously posited absolute metaphysical pres-
ence. It is because he is suspicious of any move of this kind that
Derrida appeals to the deconstructive force at work in the
semantic ambiguity of the word 'supplement'. Instead, to con-
ceive of a text from the first simply ought to be to conceive of
the means of the performance of an intersubjective act—to con-
ceive of a text in a certain set of relations.

In response to Derrida, the form of speech act theory which
has been appropriated in this book is the one which most clearly
highlights its ethical implications. Given this view of language,
it soon becomes clear that persons, actions, and words are tied
inextricably together. (Wolterstorff's concept of the 'normative
standings' ascribed to speakers, discussed in Chapter 3, was
central here.) This ethical way of construing texts as always
existing in a certain set of personal relations clearly leads into
questions of anthropology which lie beyond the present scope.
It may be, for example, that, just as to conceive of a speech act
is to conceive of persons, so to conceive of a person is, at least
in part, to conceive of the speech acts by which she acts on
others and by which others act on her. Such an anthropology
is quite different both from the inherited modernist views of
the self as essentially a monad, and from post-modern views
of the self as essentially fractured and unstable. In the intro-
ductory chapter, reference was made to Catherine Pickstock's
rehabilitation of pre-Reformation sacramental theology, carried
out in the attempt to escape Derrida's critique of modernist
metaphysical presence. She gives that sacramental theology
an anthropological twist, arguing that 'the liturgical subject,
although constituted through deferral and supplementation, is
nonetheless a coherent and analogically repeated subject, unlike

[8] Reflecting on the distinction between grammatical science and dialectics
in Plato's writings, Derrida writes: 'If truth is the presence of the *eidos*, it must
always, on pain of mortal blinding by the sun's fires, come to terms with
relation, nonpresence, and thus nontruth. It then follows that the absolute
precondition for a rigorous difference between grammar and dialectics (or
ontology) cannot in principle be fulfilled' (Jacques Derrida, *Dissemination*,
trans. Barbara Johnson (London: Athlone Press, 1981), 166).

the subject of modernity and postmodernity alike'.[9] Just the same may be said, in the light of speech act theory, and especially of Wolterstorff's ethical version of it, of the linguistic subject. This subject is constituted through the supplementation of the speech acts by which he is addressed, and through his own speech acts. This linguistic subject is perhaps more likely to serve as the basis for a universal anthropology than the liturgical subject. One writer, expounding Kierkegaard's concepts of spirit and presence, claims something very like this, grounding individual human being on a divine 'call' (speech act) which calls forth my speech:

> In the end, I am able to speak in my own name, and the same for you, that is, I am able to speak with reflexive integrity, only if I am willing to hear, willing to be alert to, my unique vocation, my unique calling *by* my own name to speak *in* my own name. . . . This call constitutes the transcendental ground of my unique being; it is the condition of my freedom; the condition of my unique dynamic historical presence in the world before some other; it is the condition of my existence as spirit.[10]

This linguistic anthropology can therefore be expressed as a theological anthropology: it is God's call to us, in our creation, in the sending of his Son, and in the repeated performance of the speech acts of Scripture that call us to faith in Christ, that makes us who we are. We are creatures whose relationship to our creator is constantly expressed in his call to us. God's call on us through Scripture is a divine word, calling us to life-changing faith in Christ. Scripture is a word which, as Vanhoozer puts it, requires to be 'incarnated' and 'embodied' in human existence.[11] The doctrine of Scripture is then as integrally related to theological anthropology as it is to doctrines of God, Christ, and Spirit.

Scripture therefore sits at the heart of the salvific will and

[9] Catherine Pickstock, *After Writing: On the Liturgical Consummation of Philosophy* (Oxford: Blackwell, 1998), p. xv.

[10] Ronald L. Hall, 'Spirit and Presence: A Kierkegaardian Analysis', in Robert L. Perkins (ed.), *International Kierkegaard Commentary. Either/Or* Part I (Macon: Mercer University Press, 1995), 271–85, at 285. I am grateful to Myron Penner for calling my attention to Hall's essay.

[11] Kevin J. Vanhoozer, *Is There a Meaning in This Text? The Bible, the Reader and the Morality of Literary Knowledge* (Leicester: Apollos, 1998), 440.

plan of God. The doctrine of Scripture which has been reconstructed through these chapters rests on the belief and claim that God's act of salvation has universal efficacy only by virtue of its particular historical outworking. Jesus Christ is now the exalted Lord precisely because on a certain day in a particular location he did not shun death. God is therefore such that he retains his full divine identity, indeed, demonstrates the nature of his divine identity, by taking to himself a certain created specificity, namely the human individual Jesus of Nazareth. This specific act of revelation in the person of Christ includes complex propositional content and involves the taking of an illocutionary stance. The subsequent communication of this personal revelatory act requires an illocutionary act performed by means of a locutionary act—and it is for the performance of this that Scripture is sufficient. If the doctrine of the sufficiency of Scripture is scandalous, that scandal is only borrowed from the scandal of the particularity of divine revelation in Jesus Christ. The doctrine of the sufficiency of Scripture is an outworking of the economy of God's self-definition in the salvific and revelational acts in history which culminated in his coming into history as Jesus of Nazareth.

BIBLIOGRAPHY

ABRAHAM, WILLIAM, *The Divine Inspiration of Holy Scripture*. Oxford: Oxford University Press, 1981.
—— *Canon and Criterion in Christian Theology: From the Fathers to Feminism*. Oxford: Clarendon Press, 1998.
ACHTEMEIER, PAUL J., *The Inspiration of Scripture: Problems and Proposals*. Philadelphia: Westminster Press, 1980.
AICHELE, GEORGE, and GARY A. PHILLIPS, 'Introduction: Exegesis, Eisegesis, Intergesis', *Semeia* 69/70 (1995), 1–18.
ALTHAUS, PAUL, *The Theology of Martin Luther*, trans. Robert C. Schultz. Philadelphia: Fortress Press, 1966.
AMES, WILLIAM, *The Marrow of Theology*, trans. and ed. John D. Eusden. Boston and Philadelphia: Pilgrim Press, 1968.
APPOLD, KENNETH G., *Abraham Calov's Doctrine of* Vocatio *in its Systematic Context*, Beiträge zur historischen Theologie 103. Tübingen: Mohr Siebeck, 1998.
AQUINAS, *Summa Theologiae*. Blackfriars, 1964–.
ATHANASIUS, *Contra Gentes*, Nicene and Post-Nicene Fathers 4, ed. Philip Schaff and Henry Wace. Grand Rapids: Eerdmans, 1957.
ATKINSON, J. MAXWELL, and JOHN HERITAGE (eds.), *Structures of Social Action: Studies in Conversation Analysis*. Cambridge: Cambridge University Press, 1984.
ATTRIDGE, DEREK, 'Introduction: Derrida and the Questioning of Literature', in Jacques Derrida, *Acts of Literature*, ed. Derek Attridge. New York and London: Routledge, 1992, 1–29.
AUGUSTINE, *On Christian Doctrine*, Nicene and Post-Nicene Fathers 2, ed. Philip Schaff. Grand Rapids: Eerdmans, 1956.
AUSTIN, J. L., *How To Do Things With Words*, 2nd edn. Oxford: Clarendon Press, 1975.
BAKHTIN, MIKHAIL, 'Discourse in the Novel', in Bakhtin, *The Dialogic Imagination*, ed. Michael Holquist, trans. Caryl Emerson and Michael Holquist. Austin: University of Texas Press, 1981, 259–422.
—— *Problems of Dostoevsky's Poetics*, Theory and History of Literature 8, ed. and trans. Caryl Emerson. Manchester: Manchester University Press, 1984.

——'The Problem of Speech Genres', in Bakhtin, *Speech Genres and Other Late Essays*, University of Texas Press Slavic Series 8, trans. Vern W. McGee, ed. Caryl Emerson and Michael Holquist. Austin: University of Texas Press, 1986, 60–102.

BARR, JAMES, *The Bible in the Modern World*. London: SCM Press, 1973.

——*Holy Scripture: Canon, Authority, Criticism*. Oxford: Clarendon Press, 1983.

——'The Literal, the Allegorical, and Modern Biblical Scholarship', *Journal for the Study of the Old Testament* 44 (1989), 3–17.

BARTH, KARL, *The Epistle to the Romans*, trans. Edwyn C. Hoskyns. London: Oxford University Press, 1933.

——*Church Dogmatics*. Edinburgh: T. & T. Clark, 1956–75.

——*Evangelical Theology: An Introduction*, trans. Grover Foley. London: Weidenfeld & Nicolson, 1963.

BARTHÉLEMY, DOMINIQUE, 'La place de la Septante dans l'Église', in Barthélemy, *Études d'Histoire du Texte de l'Ancien Testament*. Göttingen: Vandenhoeck & Ruprecht, 1978, 111–28.

BARTHES, ROLAND, *Writing Degree Zero*, trans. Annette Lavers and Colin Smith. New York: Hill & Wang, 1967.

——'The Death of the Author', in Barthes, *Image Music Text*, trans. Stephen Heath. London: Fontana, 1977, 142–8.

BARTON, JOHN, *Reading the Old Testament: Method in Biblical Study*. London: Darton, Longman & Todd, 1984.

——*Oracles of God: Perceptions of Ancient Prophecy in Israel After the Exile*. London: Darton, Longman & Todd, 1986.

——Review of Roger Beckwith, *The Old Testament Canon of the New Testament Church*, *Theology* 90 (1987), 63–5.

——*People of the Book? The Authority of the Bible in Christianity*. London: SPCK, 1988.

——*The Spirit and the Letter: Studies in the Biblical Canon*. London: SPCK, 1997.

BASIL OF CAESAREA, *De spiritu sancto*, Nicene and Post-Nicene Fathers 8, ed. Philip Schaff and Henry Wace. Grand Rapids: Eerdmans, n.d.

BAUCKHAM, RICHARD (ed.), *The Gospels for All Christians: Rethinking the Gospel Audiences*. Grand Rapids and Cambridge: Eerdmans, 1998.

BEAL, TIMOTHY K., 'Ideology and Intertextuality: Surplus of Meaning and Controlling the Means of Production', in Danna Nolan Fewell (ed.), *Reading Between Texts: Intertextuality and the Hebrew Bible*. Louisville: Westminster John Knox Press, 1992, 27–39.

DE BEAUGRANDE, ROBERT, and WOLFGANG DRESSLER, *Introduction to Text Linguistics*. London and New York: Longman, 1981.

BECKWITH, ROGER, *The Old Testament Canon of the New Testament Church*. London: SPCK, 1985.

——'A Modern Theory of the Old Testament Canon', *Vetus Testamentum* 41 (1991), 385–95.

BEISSER, FRIEDRICH, *Claritas scripturae bei Martin Luther*. Göttingen: Vandenhoeck & Ruprecht, 1966.

BERKOUWER, G. C., *Holy Scripture*, trans. and ed. Jack B. Rogers, Studies in Dogmatics. Grand Rapids: Eerdmans, 1975.

BLOCHER, HENRI, 'The "Analogy of Faith" in the Study of Scripture', in Nigel M. de S. Cameron (ed.), *The Challenge of Evangelical Theology: Essays in Approach and Method*. Edinburgh: Rutherford House, 1987, 17–38.

BOOTH, WAYNE C., 'Introduction', in Mikhail Bakhtin, *Problems of Dostoevsky's Poetics*, Theory and History of Literature 8, ed. and trans. Caryl Emerson. Manchester: Manchester University Press, 1984.

BRAY, GERALD, *Biblical Interpretation: Past and Present*. Leicester: Apollos, 1996.

BRETT, MARK G., *Biblical Criticism in Crisis? The Impact of the Canonical Approach on Old Testament Studies*. Cambridge: Cambridge University Press, 1991.

BROMILEY, GEOFFREY W., 'The Church Fathers and Holy Scripture', in D. A. Carson and John D. Woodbridge (eds.), *Scripture and Truth*. Leicester: Inter-Varsity Press, 1983, 199–220.

——'The Authority of Scripture in Karl Barth', in D. A. Carson and John D. Woodbridge (eds.), *Hermeneutics, Authority and Canon*. Leicester: Inter-Varsity Press, 1986, 271–94.

BROOKS, CLEANTH, 'The Heresy of Paraphrase', in Brooks, *The Well Wrought Urn: Studies in the Structure of Poetry*. London: Methuen, 1968, 157–75.

BUCKLEY, MICHAEL J., *At the Origins of Modern Atheism*. New Haven and London: Yale University Press, 1987.

BULLINGER, HEINRICH, *The Decades of Henry Bullinger*, trans. H. I., ed. Thomas Harding. Cambridge: Parker Society, 1849.

CAIRD, G. B., *The Language and Imagery of the Bible*. Grand Rapids and Cambridge: Eerdmans, 1997 (1980).

CALVIN, JOHN, *Institutes of the Christian Religion*, Library of Christian Classics 20–21, ed. John T. McNeill, trans. Ford Lewis Battles. Philadelphia: Westminster Press, 1960.

CAPUTO, JOHN D., *The Prayers and Tears of Jacques Derrida: Religion Without Religion*. Bloomington and Indianapolis: Indiana University Press, 1997.

CHADWICK, HENRY, 'Introduction', in *Lessing's Theological Writings*,

ed. Chadwick. London: A. & C. Black, 1956.

CHILDS, BREVARD S., 'Interpretation in Faith: The Theological Responsibility of an Old Testament Commentary', *Interpretation* 18 (1964), 432–49.

——*Biblical Theology in Crisis*. Philadelphia: Westminster Press, 1970.

——'The Exegetical Significance of Canon for the Study of the Old Testament', *Vetus Testamentum Supplements* 29 (1977), 66–80.

——'The Sensus Literalis of Scripture: An Ancient and Modern Problem', in Herbert Donner et al. (eds.), *Beiträge zur alttestamentlichen Theologie*. Göttingen: Vandenhoeck & Ruprecht, 1977, 80–93.

——*Introduction to the Old Testament as Scripture*. Philadelphia: Fortress Press, 1979.

——'A Response', *Horizons in Biblical Theology* 2 (1980), 199–221.

——*Old Testament Theology in a Canonical Context*. Philadelphia: Fortress Press, 1985.

——*Biblical Theology of the Old and New Testaments*. London: SCM Press, 1992.

CIOFFI, FRANK, 'Intention and Interpretation in Criticism', in David Newton-de Molina (ed.), *On Literary Intention*. Edinburgh: Edinburgh University Press, 1976, 55–73.

CLAYTON, JAY, and ERIC ROTHSTEIN, 'Figures in the Corpus: Theories of Influence and Intertextuality', in Clayton and Rothstein (eds.), *Influence and Intertextuality in Literary History*. Madison: University of Wisconsin Press, 1991, 3–36.

CLEMENT OF ALEXANDRIA, *Stromateis* VII, Library of Christian Classics 2. London: SCM Press, 1954.

CLINES, DAVID J. A., *I, He, We, and They: A Literary Approach to Isaiah 53*, Journal for the Study of the Old Testament Series 1. Sheffield: Journal for the Study of the Old Testament, 1976.

——*Job 1–20*, Word Biblical Commentary 17. Dallas: Word, 1989.

COCHRANE, ARTHUR C. (ed.), *Reformed Confessions of the 16th Century*. London: SCM Press, 1966.

COLE, GRAHAM, 'Sola Scriptura: Some Historical and Contemporary Perspectives', *Churchman* 104 (1990), 20–34.

COMSTOCK, GARY, 'Truth or Meaning: Ricoeur versus Frei on Biblical Narrative', *Journal of Religion* 66 (1986), 117–40.

——'Two Types of Narrative Theology', *Journal of the American Academy of Religion* 55 (1987), 687–717.

CONGAR, YVES M.-J., *Tradition and Traditions: An Historical and Theological Essay*, trans. Michael Naseby and Thomas Rainborough. London: Burns & Oates, 1966.

CRAIG, KENNETH M., JR., *Reading Esther: A Case for the Literary Carnivalesque*. Louisville: Westminster John Knox Press, 1995.

CRITCHLEY, SIMON, *The Ethics of Deconstruction: Derrida and Levinas*. Oxford: Blackwell, 1992.

CROSS, F. L., and E. A. LIVINGSTONE (eds.), 'The Immaculate Conception of the BVM', in *The Oxford Dictionary of the Christian Church*, 3rd edn. Oxford: Oxford University Press, 1997, 821–2.

CULLER, JONATHAN, *The Pursuit of Signs: Semiotics, Literature, Deconstruction*. London and Henley: Routledge & Kegan Paul, 1981.

——*On Deconstruction: Theory and Criticism After Structuralism*. London: Routledge & Kegan Paul, 1983.

DASENBROCK, REED WAY, 'Taking It Personally: Reading Derrida's Responses', *College English* 56 (1994), 261–79.

DERRIDA, JACQUES, *Of Grammatology*, trans. Gayatri Chakravorty Spivak. Baltimore and London: Johns Hopkins University Press, 1976.

——'Living On: Border Lines', in Harold Bloom et al., *Deconstruction and Criticism*. London and Henley: Routledge & Kegan Paul, 1979, 75–176.

——*Dissemination*, trans. Barbara Johnson. London: Athlone Press, 1981.

——*Limited Inc.*, trans. Samuel Weber and Jeffrey Mehlman, ed. Gerald Graff. Evanston: Northwestern University Press, 1988.

——*The Gift of Death*, trans. David Wills. Chicago and London: University of Chicago Press, 1995.

——'Faith and Knowledge: The Two Sources of "Religion" at the Limits of Reason Alone', trans. Samuel Weber, in Jacques Derrida and Gianni Vattimo (eds.), *Religion*. Cambridge: Polity Press, 1998, 1–78.

DEVITT, MICHAEL, and KIM STERELNY, *Language and Reality: An Introduction to the Philosophy of Language*. Oxford: Blackwell, 1987.

DOWEY, EDWARD A., JR., 'The Word of God as Scripture and Preaching', in W. Fred Graham (ed.), *Later Calvinism: International Perspectives*, Sixteenth Century Essays and Studies 22. Kirksville: Sixteenth Century Journal Publishers, 1994, 5–18.

DUNN, JAMES D. G., 'The Authority of Scripture According to Scripture', *Churchman* 96 (1982), 104–22, 201–25.

EAGLETON, TERRY, *Literary Theory: An Introduction*. Oxford: Blackwell, 1983.

EBELING, GERHARD, '"Sola Scriptura" and Tradition', in Ebeling, *The Word of God and Tradition: Historical Studies Interpreting the Division of Christianity*, trans. S. H. Hooke. London: Collins, 1968, 102–47.

ERIUGENA, JOHN SCOTUS, *Periphyseon (The Division of Nature)*, trans. I. P. Sheldon-Williams, rev. John J. O'Meara. Montreal: Bellarmin; Washington: Dumbarton Oaks, 1987.

EVANS, G. R., *The Language and Logic of the Bible: The Earlier Middle Ages*. Cambridge: Cambridge University Press, 1984.

——*The Language and Logic of the Bible: The Road to Reformation*. Cambridge: Cambridge University Press, 1985.

FARKASFALVY, D., 'Theology of Scripture in St. Irenaeus', *Revue Bénédictine* 78 (1968), 319–33.

FARROW, DOUGLAS, *The Word of Truth and Disputes About Words*. Winona Lake: Carpenter, 1987.

FEWELL, DANNA NOLAN, 'Introduction: Writing, Reading, and Relating', in Fewell (ed.), *Reading Between Texts: Intertextuality and the Hebrew Bible*. Louisville: Westminster John Knox Press, 1992, 11–20.

FISH, STANLEY, *Is There a Text in This Class? The Authority of Interpretive Communities*. Cambridge, Mass.: Harvard University Press, 1980.

FISHBANE, MICHAEL, *Biblical Interpretation in Ancient Israel*. Oxford: Clarendon Press, 1985.

FODOR, JAMES, *Christian Hermeneutics: Paul Ricoeur and the Refiguring of Theology*. Oxford: Clarendon Press, 1995.

FORD, DAVID, *Barth and God's Story*, Studies in the Intercultural History of Christianity 27. Frankfurt am Main: Peter Lang, 1981.

FOUCAULT, MICHEL, 'What Is an Author?', in Josué V. Harari (ed.), *Textual Strategies: Perspectives in Post-Structuralist Criticism*. Ithaca, NY: Cornell University Press, 1979, 141–60.

FOWL, STEPHEN E., *Engaging Scripture: A Model for Theological Interpretation*. Oxford: Blackwell, 1998.

——'The Role of Authorial Intention in the Theological Interpretation of Scripture', in Joel B. Green and Max Turner (eds.), *Between Two Horizons: Spanning New Testament Studies and Systematic Theology*. Grand Rapids and Cambridge: Eerdmans, 2000, 71–87.

FREI, HANS W., *The Eclipse of Biblical Narrative: A Study in Eighteenth and Nineteenth Century Hermeneutics*. New Haven and London: Yale University Press, 1974.

——*The Identity of Jesus Christ: The Hermeneutical Bases of Dogmatic Theology*. Philadelphia: Fortress Press, 1975.

——'The "Literal Reading" of Biblical Narrative in the Christian Tradition: Does It Stretch or Will It Break?', in George Hunsinger and William C. Placher (eds.), *Theology and Narrative: Selected Essays*. New York and London: Oxford University Press, 1993, 117–52.

FREUND, ELIZABETH, *The Return of the Reader: Reader-Response Criticism*. London and New York: Methuen, 1987.

FRIEDMAN, SUSAN STANFORD, 'Weavings: Intertextuality and the (Re)Birth of the Author', in Jay Clayton and Eric Rothstein (eds.), *Influence and Intertextuality in Literary History*. Madison: University of Wisconsin Press, 1991, 146–80.

GADAMER, HANS-GEORG, *Truth and Method*, 2nd rev. edn., trans. rev. Joel Weinsheimer and Donald G. Marshall. New York: Crossroad, 1990.

GEISELMANN, JOSEF RUPERT, *Die Heilige Schrift und die Tradition*. Freiburg: Herder, 1962.

GEORGE, TIMOTHY, *Theology of the Reformers*. Nashville: Broadman, 1988.

GERRISH, B. A., *The Old Protestantism and the New: Essays on the Reformation Heritage*. Edinburgh: T. & T. Clark, 1982.

GODFREY, ROBERT W., 'Biblical Authority in the Sixteenth and Seventeenth Centuries: A Question of Transition', in D. A. Carson and John D. Woodbridge (eds.), *Scripture and Truth*. Leicester: Inter-Varsity Press, 1983, 221–43.

GOLDINGAY, JOHN, *Theological Diversity and the Authority of the Old Testament*. Grand Rapids: Eerdmans, 1987.

——*Models for Scripture*. Grand Rapids: Eerdmans, 1994.

GRAFF, GERALD, 'How Not to Talk about Fictions', in Graff, *Literature Against Itself: Literary Ideas in Modern Society*. Chicago: University of Chicago Press, 1979, 151–80.

——'What Was New Criticism?', in Graff, *Literature Against Itself: Literary Ideas in Modern Society*. Chicago: University of Chicago Press, 1979, 129–49.

GUNTON, COLIN E., *A Brief Theology of Revelation*. Edinburgh: T. & T. Clark, 1995.

HÄGGLUND, BENGT, *Die Heilige Schrift und ihre Deutung in der Theologie Johann Gerhards*. Lund: CWK Gleerup, 1951.

HALL, RONALD L., 'Spirit and Presence: A Kierkegaardian Analysis', in Robert L. Perkins (ed.), *International Kierkegaard Commentary*. *Either/Or* Part I. Macon: Mercer University Press, 1995, 271–85.

HANSON, R. P. C., *Tradition in the Early Church*. London: SCM Press, 1962.

HARRIS, HARRIET A., 'Should We Say That Personhood Is Relational?', *Scottish Journal of Theology* 51 (1998), 214–34.

HARRISVILLE, ROY A., and WALTER SUNDBERG, *The Bible in Modern Culture: Theology and Historical-Critical Method from Spinoza to Käsemann*. Grand Rapids: Eerdmans, 1995.

HAUERWAS, STANLEY, *Unleashing the Scriptures: Freeing the Bible from Captivity to America*. Nashville: Abingdon, 1980.

HAYS, RICHARD B., *Echoes of Scripture in the Letters of Paul*. New Haven and London: Yale University Press, 1989.

HELM, PAUL, *The Divine Revelation: The Basic Issues*. London: Marshall, Morgan & Scott, 1982.

HEPPE, HEINRICH, *Reformed Dogmatics*, rev. Ernst Bizer, trans. G. T. Thomson. London: George Allen & Unwin, 1950.

HERITAGE, JOHN, and J. MAXWELL ATKINSON, 'Introduction', in J. Maxwell Atkinson and John Heritage (eds.), *Structures of Social Action: Studies in Conversation Analysis*. Cambridge: Cambridge University Press, 1984.

HIRSCH, E. D., JR., *Validity in Interpretation*. New Haven and London: Yale University Press, 1967.

——*The Aims of Interpretation*. Chicago and London: University of Chicago Press, 1976.

——'Transhistorical Intentions and the Persistence of Allegory', *New Literary History* 25 (1994), 549–67.

HOLQUIST, MICHAEL, 'Introduction', in M. M. Bakhtin, *Speech Genres and Other Late Essays*, University of Texas Press Slavic Series 8, ed. Caryl Emerson and Michael Holquist, trans. Vern W. McGee. Austin: University of Texas Press, 1986.

HOY, DAVID COUZENS, *The Critical Circle: Literature, History and Philosophical Hermeneutics*. Berkeley, Los Angeles, and London: University of California Press, 1978.

HUNSINGER, GEORGE, *How To Read Karl Barth: The Shape of His Theology*. New York and Oxford: Oxford University Press, 1991.

IRENAEUS, *Against Heresies*, Ante-Nicene Christian Library 5, ed. Alexander Roberts and James Donaldson. Edinburgh: T. & T. Clark, 1868.

JEFFREY, DAVID LYLE, *People of the Book: Christian Identity and Literary Culture*. Grand Rapids and Cambridge: Eerdmans, 1996.

JUHL, P. D., *Interpretation: An Essay in the Philosophy of Literary Criticism*. Princeton: Princeton University Press, 1980.

JÜNGEL, EBERHARD, *The Doctrine of the Trinity: God's Being Is In Becoming*. Edinburgh: Scottish Academic Press, 1976.

——*Karl Barth: A Theological Legacy*, trans. Garrett E. Paul. Philadelphia: Westminster Press, 1976.

——*God as the Mystery of the World: On the Foundation of the Theology of the Crucified One in the Dispute Between Theism and Atheism*, trans. Darrell L. Guder. Edinburgh: T. & T. Clark, 1983.

——'Anthropomorphism: A Fundamental Problem in Modern

Hermeneutics', in Jüngel, *Theological Essays*, trans. and ed. J. B. Webster. Edinburgh: T. & T. Clark, 1989, 72–94.

KELLY, J. N. D., *Early Christian Doctrines*, 5th edn. rev. London: A. & C. Black, 1977.

KELSEY, DAVID H., *The Uses of Scripture in Recent Theology*. London: SCM Press, 1975.

KLAUBER, MARTIN I., 'Continuity and Discontinuity in Post-Reformation Theology: An Evaluation of the Muller Thesis', *Journal of the Evangelical Theological Society* 33 (1990), 467–75.

KNIGHT, DOUGLAS A., 'Canon and the History of Tradition: A Critique of Brevard S. Childs' Introduction to the Old Testament as Scripture', *Horizons in Biblical Theology* 2 (1980), 127–49.

KNOWLES, DAVID, *The Evolution of Medieval Thought*, 2nd edn., ed. D. E. Luscombe and C. N. L. Brooke. London and New York: Longman, 1988.

KRIEGER, MURRAY, *The New Apologists for Poetry*. Minneapolis: University of Minnesota Press, 1956.

KRISTEVA, JULIA, *Desire in Language: A Semiotic Approach to Literature and Art*, ed. Leon S. Roudiez. New York: Columbia University Press, 1980.

——*Revolution in Poetic Language*, trans. Margaret Waller. New York: Columbia University Press, 1984 (1974).

——*The Kristeva Reader*, ed. Toril Moi. Oxford: Blackwell, 1986.

KÜMMEL, WERNER GEORG, *The New Testament: The History of the Investigation of its Problems*. London: SCM Press, 1973.

LAFARGUE, MICHAEL, 'Are Texts Determinate? Derrida, Barth, and the Role of the Biblical Scholar', *Harvard Theological Review* 81 (1988), 341–57.

LANE, A. N. S., 'Scripture, Tradition and Church: An Historical Survey', *Vox Evangelica* 9 (1975), 37–55.

——'B. B. Warfield on the Humanity of Scripture', *Vox Evangelica* 16 (1986), 77–94.

——'*Sola Scriptura*? Making Sense of a Post-Reformation Slogan', in Philip E. Satterthwaite and David F. Wright (eds.), *A Pathway into the Holy Scripture*. Grand Rapids: Eerdmans, 1994, 297–327.

LENTRICCHIA, FRANK, *After the New Criticism*. London: Athlone Press, 1980.

LESSING, *Lessing's Theological Writings*, ed. Henry Chadwick. London: A. & C. Black, 1956.

LEVINE, MICHAEL, 'God Speak', *Religious Studies* 34 (1998), 1–16.

LINDBECK, GEORGE A., *The Nature of Doctrine*. London: SPCK, 1984.

——'Barth and Textuality', *Theology Today* 43 (1986), 361–76.

Lotz, David W., '*Sola Scriptura*: Luther on Biblical Authority', *Interpretation* 35 (1981), 258–73.

Lundin, Roger, Clarence Walhout and Anthony C. Thiselton, *The Promise of Hermeneutics*. Grand Rapids and Cambridge: Eerdmans, 1999.

Luther, Martin, *Luther's Works*. Saint Louis: Concordia Publishing House; Philadelphia: Fortress Press, 1955–86.

——*The Bondage of the Will*, trans. J. I. Packer and O. R. Johnston. Edinburgh: James Clarke, 1957.

McCormack, Bruce L., *Karl Barth's Critically Realistic Dialectical Theology: Its Genesis and Development 1909–1936*. Oxford: Clarendon Press, 1995.

——Review article: 'Graham Ward's *Barth, Derrida and the Language of Theology*', *Scottish Journal of Theology* 49 (1996), 97–109.

McGrath, Alister, *The Intellectual Origins of the European Reformation*. Oxford: Blackwell, 1987.

Marshall, I. Howard, *Biblical Inspiration*. Carlisle: Paternoster Press, 1995 (1982).

——'"To Find Out What God Is Saying": Reflections on the Authorizing of Scripture', in Roger Lundin (ed.), *Disciplining Hermeneutics: Interpretation in Christian Perspective*. Leicester: Apollos, 1997, 49–55.

Metzger, Bruce M., *The Canon of the New Testament: Its Origin, Development, and Significance*. Oxford: Clarendon Press, 1987.

Milbank, John, *The Word Made Strange: Theology, Language, Culture*. Oxford: Blackwell, 1997.

Moberly, R. W. L., *At the Mountain of God: Story and Theology in Exodus 32–34*, JSOT Supplement Series. Sheffield: JSOT Press, 1983.

Moore, Stephen D., *Literary Criticism and the Gospels: The Theoretical Challenge*. New Haven: Yale University Press, 1989.

——*Mark and Luke in Poststructuralist Perspectives: Jesus Begins To Write*. New Haven and London: Yale University Press, 1992.

——'Are There Impurities in the Living Water that the Johannine Jesus Dispenses? Deconstruction, Feminism, and the Samaritan Woman', *Biblical Interpretation* 1 (1993), 207–27.

——*Poststructuralism and the New Testament: Derrida and Foucault at the Foot of the Cross*. Minneapolis: Fortress Press, 1994.

——'The Beatific Vision as a Posing Exhibition: Revelation's Hypermasculine Deity', *Journal for the Study of the New Testament* 60 (1995), 27–55.

——'True Confessions and Weird Obsessions: Autobiographical Interventions in Literary and Biblical Studies', *Semeia* 72 (1995), 19–50.

MOORE, STEPHEN D., 'Gigantic God: Yahweh's Body', *Journal for the Study of the Old Testament* 70 (1996), 87–115.
——*God's Gym: Divine Male Bodies of the Bible*. New York and London: Routledge, 1996.

MORGAN, ROBERT, with JOHN BARTON, *Biblical Interpretation*. Oxford: Oxford University Press, 1988.

MORSON, GARY SAUL, 'Who Speaks for Bakhtin?', in Morson (ed.), *Bakhtin: Essays and Dialogues on His Work*. Chicago and London: University of Chicago Press, 1986, 1–19.

MORSON, GARY SAUL (ed.), *Bakhtin: Essays and Dialogues on His Work*. Chicago and London: University of Chicago Press, 1986.

MORSON, GARY SAUL, and CARYL EMERSON, *Mikhail Bakhtin: Creation of a Prosaics*. Stanford: Stanford University Press, 1990.

MULLER, RICHARD A., *Post-Reformation Reformed Dogmatics*, ii: *Holy Scripture: The Cognitive Foundation of Theology*. Grand Rapids: Baker, 1993.

MURRAY, JOHN, *Collected Writings of John Murray*, ii: *Systematic Theology*. Edinburgh: Banner of Truth Trust, 1977.

NEUFELD, DIETMAR, *Reconceiving Texts as Speech Acts: An Analysis of 1 John*. Leiden: Brill, 1994.

NEWTON-DE MOLINA, DAVID (ed.), *On Literary Intention*. Edinburgh: Edinburgh University Press, 1976.

NICOLE, ROGER, 'The Inspiration and Authority of Scripture: J. D. G. Dunn Versus B. B. Warfield', *Churchman* 97 (1983), 198–215; 98 (1984), 7–27.

NOBLE, PAUL R., *The Canonical Approach: A Critical Reconstruction of the Hermeneutics of Brevard S. Childs*. Leiden: Brill, 1995.

NORRIS, CHRISTOPHER, *Derrida*. London: Fontana, 1987.
——*Deconstruction: Theory and Practice,* rev. edn. London: Routledge, 1991.

OBERMAN, HEIKO AUGUSTINUS, *The Harvest of Medieval Theology: Gabriel Biel and Late Medieval Nominalism*, rev. edn. Grand Rapids: Eerdmans, 1967.

OSWALT, JOHN N., *The Book of Isaiah: Chapters 40–66*, The New International Commentary on the Old Testament. Grand Rapids and Cambridge: Eerdmans, 1998.

PACKER, J. I., *'Fundamentalism' and the Word of God*. London: Inter-Varsity Fellowship, 1958.

PANNENBERG, WOLFHART, 'What Is a Dogmatic Statement?', in Pannenberg, *Basic Questions in Theology*, i. London: SCM Press, 1970, 182–210.
——*Systematic Theology*, i and ii, trans. Geoffrey W. Bromiley. Grand Rapids: Eerdmans, 1991–4.

——'On the Inspiration of Scripture', *Theology Today* 54 (1997), 212–15.

PATTE, DANIEL, *The Religious Dimension of Biblical Texts: Greimas's Structural Semiotics and Biblical Exegesis*, SBL Semeia Studies. Atlanta: Scholars Press, 1990.

PECKHAM, MORSE, 'The Intentional? Fallacy?', in David Newton-de Molina (ed.), *On Literary Intention*. Edinburgh: Edinburgh University Press, 1976, 139–57.

PHILLIPS, GARY A., '"What is Written? How are you Reading?" Gospel, Intertextuality and Doing Lukewise: Reading Lk 10:25–42 Otherwise', *Semeia* 69/70 (1995), 111–47.

PHILLIPS, TIMOTHY ROSS, 'Francis Turretin's Idea of Theology and Its Bearing Upon His Doctrine of Scripture', Ph.D. thesis. Vanderbilt University, 1986.

PICKSTOCK, CATHERINE, *After Writing: On the Liturgical Consummation of Philosophy*. Oxford: Blackwell, 1998.

PLETT, HEINRICH F., 'Intertextualities', in Plett (ed.), *Intertextuality*, Research in Text Theory 15. Berlin and New York: Walter de Gruyter, 1991, 3–29.

POLAND, LYNN M., 'The New Criticism, Neoorthodoxy and the New Testament', *Journal of Religion* 65 (1985), 459–77.

POLZIN, ROBERT M., *Biblical Structuralism: Method and Subjectivity in the Study of Ancient Texts*. Philadelphia: Fortress Press; Missoula: Scholars Press, 1977.

POYTHRESS, VERN SHERIDAN, 'God's Lordship in Interpretation', *Westminster Theological Journal* 50 (1988), 27–64.

PRATT, MARY LOUISE, *Toward a Speech Act Theory of Literary Discourse*. Bloomington and London: Indiana University Press, 1977.

PREUS, ROBERT D., *The Theology of Post-Reformation Lutheranism: A Study of Theological Prolegomena*. Saint Louis and London: Concordia, 1970.

PROVAN, IAIN, 'Foul Spirits, Fornication and Finance: Revelation 18 from an Old Testament Perspective', *Journal for the Study of the New Testament* 64 (1996), 81–100.

——'Canons to the Left of Him: Brevard Childs, His Critics, and the Future of Old Testament Theology', *Scottish Journal of Theology* 50 (1997), 1–38.

RAHNER, KARL, *Theological Investigations*, vi, trans. Karl-H. and Boniface Kruger. Baltimore: Helicon; London: Darton, Longman & Todd, 1969.

RANSOM, JOHN CROWE, *The World's Body*. London: Charles Scribner's Sons, 1938.

RATSCHOW, CARL HEINZ, *Lutherische Dogmatik zwischen Reformation*

und Aufklärung, i. Gütersloh: Gütersloher Verlagshaus Gerd Mohn, 1964.

REED, WALTER L., *Dialogues of the Word: The Bible as Literature According to Bakhtin.* New York and London: Oxford University Press, 1993.

RENDTORFF, ROLF, *Canon and Theology: Overtures to an Old Testament Theology,* trans. and ed. Margaret Kohl. Minneapolis: Fortress Press, 1993.

REVENTLOW, HENNING GRAF, *The Authority of the Bible and the Rise of the Modern World,* trans. John Bowden. London: SCM Press, 1984.

RICOEUR, PAUL, *Interpretation Theory: Discourse and the Surplus of Meaning.* Fort Worth: Texas Christian University Press, 1976.

——'Naming God', *Union Seminary Quarterly Review* 34 (1979), 215–27.

——*Hermeneutics and the Human Sciences: Essays on Language, Action and Interpretation,* ed. and trans. John B. Thompson. Cambridge: Cambridge University Press, 1981.

——'Toward a Hermeneutic of the Idea of Revelation', in Ricoeur, *Essays on Biblical Interpretation,* ed. Lewis S. Mudge. London: SPCK, 1981, 73–118.

ROBINSON, JOHN F., 'The Doctrine of Holy Scripture in Seventeenth Century Reformed Theology', Ph.D. thesis. University of Strasbourg, 1971.

ROGERS, JACK B., and DONALD K. MCKIM, *The Authority and Interpretation of the Bible: An Historical Approach.* San Francisco: Harper & Row, 1979.

RUTLEDGE, DAVID, *Reading Marginally: Feminism, Deconstruction and the Bible.* Leiden: Brill, 1996.

SAYE, SCOTT C., 'The Wild and Crooked Tree: Barth, Fish and Interpretive Communities', *Modern Theology* 12 (1996), 435–58.

SCHRAG, CALVIN O., *The Self after Postmodernity.* New Haven and London: Yale University Press, 1997.

SCHÜSSLER, HERMANN, *Der Primat der Heiligen Schrift als theologisches und kanonistisches Problem im Spätmittelalter.* Wiesbaden: Franz Steiner Verlag, 1977.

SEARLE, JOHN R., 'Austin on Locutionary and Illocutionary Acts', *Philosophical Review* 77 (1968), 405–24.

——*Speech Acts: An Essay in the Philosophy of Language.* Cambridge: Cambridge University Press, 1969.

——*Expression and Meaning: Studies in the Theory of Speech Acts.* Cambridge: Cambridge University Press, 1979.

——'What Is a Speech Act?', in Heimir Geirsson and Michael

Losonsky (eds.), *Readings in Language and Mind*. Oxford: Blackwell, 1996, 110–21.

SEITZ, CHRISTOPHER R., *Word Without End: The Old Testament as Abiding Theological Witness*. Grand Rapids and Cambridge: Eerdmans, 1998.

SMALLEY, BERYL, *The Study of the Bible in the Middle Ages*, 3rd edn. rev. Oxford: Blackwell, 1983.

SPINOZA, *Tractatus Theologico-Politicus*, in *The Chief Works of Benedict de Spinoza*, i, trans. R. H. M. Elwes. London: George Bell & Sons, 1883, 1–278.

STIBBE, MARK W. G., 'Structuralism', in R. J. Coggins & J. L. Houlden (eds.), *A Dictionary of Biblical Interpretation*. London: SCM Press, 1990.

STOUT, JEFFREY, 'What is the Meaning of a Text?', *New Literary History* 14 (1982), 1–12.

TANNER, KATHRYN E., 'Theology and the Plain Sense', in Garrett Green (ed.), *Scriptural Authority and Narrative Interpretation*. Philadelphia: Fortress Press, 1987, 59–78.

TAVARD, GEORGE H., *Holy Writ or Holy Church: The Crisis of the Protestant Reformation*. London: Burns & Oates, 1959.

TAYLOR, MARK C., *Erring: A Postmodern A/theology*. Chicago and London: University of Chicago Press, 1984.

THISELTON, ANTHONY C., 'The Parables as Language-Event: Some Comments on Fuchs's Hermeneutics in the Light of Linguistic Philosophy', *Scottish Journal of Theology* 23 (1970), 437–68.

——'The Supposed Power of Words in the Biblical Writings', *Journal of Theological Studies* 25 (1974), 283–99.

——*The Two Horizons: New Testament Hermeneutics and Philosophical Description with Special Reference to Heidegger, Bultmann, Gadamer and Wittgenstein*. Exeter: Paternoster, 1980.

——*New Horizons in Hermeneutics*. London: HarperCollins, 1992.

——'Authority and Hermeneutics: Some Proposals for a More Creative Agenda', in Philip E. Satterthwaite and David F. Wright (eds.), *A Pathway into the Holy Scripture*. Grand Rapids: Eerdmans, 1994, 107–41.

——*Interpreting God and the Postmodern Self: On Meaning, Manipulation and Promise*. Edinburgh: T. & T. Clark, 1995.

——Review article: 'Speech-Act Theory and the Claim that God Speaks: Nicholas Wolterstorff's *Divine Discourse*', *Scottish Journal of Theology* 50 (1997), 97–110.

TOOLAN, MICHAEL, *Total Speech: An Integrational Linguistic Approach to Language*. Durham, N.C., and London: Duke University Press, 1996.

TORRANCE, THOMAS F., *The Hermeneutics of John Calvin*. Edinburgh: Scottish Academic Press, 1988.

——*Karl Barth, Biblical and Evangelical Theologian*. Edinburgh: T. & T. Clark, 1990.

TRACY, DAVID, *On Naming the Present: God, Hermeneutics, and Church*. London: SCM Press, 1994.

TREMBATH, KERN ROBERT, *Evangelical Theories of Biblical Inspiration: A Review and Proposal*. New York and Oxford: Oxford University Press, 1987.

TURRETIN, FRANCIS, *The Doctrine of Scripture: Locus 2 of Institutio Theologiae Elencticae*, ed. and trans. John W. Beardslee. Grand Rapids: Baker, 1981.

——*Institutes of Elenctic Theology*, trans. George Musgrave Giger, ed. James T. Dennison, Jr. Phillipsburg, N.J.: Presbyterian & Reformed, 1992–4.

VANHOOZER, KEVIN J., 'The Semantics of Biblical Literature: Truth and Scripture's Diverse Forms', in D. A. Carson and John D. Woodbridge (eds.), *Hermeneutics, Authority and Canon*. Leicester: Inter-Varsity Press, 1986, 53–104.

——'A Lamp in the Labyrinth: The Hermeneutics of "Aesthetic" Theology', *Trinity Journal* 8 (1987), 25–56.

——'God's Mighty Speech-Acts: The Doctrine of Scripture Today', in Philip E. Satterthwaite and David F. Wright (eds.), *A Pathway into the Holy Scripture*. Grand Rapids: Eerdmans, 1994, 143–81.

——*Is There a Meaning in This Text? The Bible, the Reader and the Morality of Literary Knowledge*. Leicester: Apollos, 1998.

VAWTER, BRUCE, *Biblical Inspiration*. London: Hutchison, 1972.

VINCENT OF LÉRINS, 'The Commonitory', in *Early Medieval Theology*, Library of Christian Classics 9, trans. and ed. George E. McCracken and Allen Cabaniss. London: SCM Press, 1957.

WAGNER, ANDREAS, *Sprechakte und Sprechaktanalyse im Alten Testament: Untersuchungen im biblischen Hebräisch an der Nahtstelle zwischen Handlungsebene und Grammatik*. Berlin: Walter de Gruyter, 1997.

WALLACE, MARK I., *The Second Naiveté: Barth, Ricoeur and the New Yale Theology*, Studies in American Biblical Hermeneutics 6. Macon: Mercer University Press, 1990.

WARD, GRAHAM, *Barth, Derrida and the Language of Theology*. Cambridge: Cambridge University Press, 1995.

WARFIELD, B. B., *Selected Shorter Writings of Benjamin B. Warfield*, ii, ed. John E. Meeter. Phillipsburg: Presbyterian & Reformed, 1973.

——*The Inspiration and Authority of the Bible*. Philadelphia: Presbyterian & Reformed, 1948.

WARNKE, GEORGIA, *Gadamer: Hermeneutics, Tradition and Reason*. Stanford: Stanford University Press, 1987.

WATSON, FRANCIS, *Text, Church and World: Biblical Interpretation in Theological Perspective*. Edinburgh: T. & T. Clark, 1994.

——*Text and Truth: Redefining Biblical Theology*. Edinburgh: T. & T. Clark, 1997.

WEBER, OTTO, *Foundations of Dogmatics*, i, trans. Darrell L. Guder. Grand Rapids: Eerdmans, 1981.

WEBSTER, J. B., *Eberhard Jüngel: An Introduction to His Theology*. Cambridge: Cambridge University Press, 1986.

——'Hermeneutics in Modern Theology: Some Doctrinal Reflections', *Scottish Journal of Theology* 51 (1998), 307–41.

WELLEK, RENÉ, *A History of Modern Criticism*, i: *The Later Eighteenth Century*. London: Jonathan Cape, 1955.

——'The New Criticism: Pro and Contra', *Critical Inquiry* 4 (1978), 611–24.

WELLEK, RENÉ, and AUSTIN WARREN, *Theory of Literature*. London: Jonathan Cape, 1949.

WHITE, HUGH C., 'Introduction: Speech Act Theory and Literary Criticism', *Semeia* 41 (1988), 1–24.

WIMSATT, W. K., *The Verbal Icon: Studies in the Meaning of Poetry*. London: Methuen, 1970.

——'Genesis: A Fallacy Revisited', in David Newton-de Molina (ed.), *On Literary Intention*. Edinburgh: Edinburgh University Press, 1976, 116–38.

WIMSATT, W. K., JR., and MONROE C. BEARDSLEY, 'The Intentional Fallacy', in W. K. Wimsatt, *The Verbal Icon: Studies in the Meaning of Poetry*. London: Methuen, 1970, 3–18.

WIMSATT, WILLIAM K., JR., and CLEANTH BROOKS, *Literary Criticism: A Short History*, ii: *Neo Classical Criticism*. London: Routledge & Kegan Paul, 1957.

WITKAMP, L. TH., 'Jesus' Thirst in John 19:28–30: Literal or Figurative?', *Journal of Biblical Literature* 115 (1996), 489–510.

WOLTERSTORFF, NICHOLAS, *Divine Discourse: Philosophical Reflections on the Claim that God Speaks*. Cambridge: Cambridge University Press, 1995.

——'Will Narrativity Work as Linchpin? Reflections on the Hermeneutic of Hans Frei', in Charles M. Lewis (ed.), *Relativism and Religion*. Basingstoke and London: Macmillan, 1995, 71–107.

——'Reply to Levine', *Religious Studies* 34 (1998), 17–23.

WOODBRIDGE, JOHN D., *Biblical Authority: A Critique of the Rogers/*

McKim Proposal. Grand Rapids: Zondervan, 1982.

WOODBRIDGE, JOHN D., and RANDALL H. BALMER, 'The Princetonians and Biblical Authority: An Assessment of the Ernest Sandeen Proposal', in D. A. Carson and John D. Woodbridge (eds.), *Scripture and Truth*. Leicester: Inter-Varsity Press, 1983, 245–79.

WRIGHT, N. T., *The New Testament and the People of God*. London: SPCK, 1992.

YOUNG, FRANCES, *The Art of Performance: Towards a Theology of Holy Scripture*. London: Darton, Longman & Todd, 1990.

INDEX